Plein Air Painters of California

THE NORTH

Edited by

RUTH LILLY WESTPHAL

With Essays by

Janet Blake Dominik
Harvey L. Jones
Betty Hoag McGlynn
Paul Chadbourne Mills
Martin E. Petersen
Terry St. John
Jean Stern
Jeffrey Stewart
Raymond L. Wilson

Westphal Publishing

 Consulting
THOMAS KENNETH ENMAN

 Research assistance
JAN HOLLOWAY
YVONNE STOWE

 Editorial and copy
KENNETH CAVE
JANET B. DOMINIK

 Design and production
MICHELE M. PINTO

 The majority of color photography
CECILE KEEFE
San Francisco

 Color separations
FRITZ CORDES
Color-Ad, Buena Park, California

 Printing
CALIFORNIA LITHOGRAPH CORPORATION
Garden Grove, California

 Binding
NATIONAL BINDERY
Pomona, California

© Copyright 1986

WESTPHAL PUBLISHING
P.O. Box 19542 Irvine, Cailfornia 92713

All Rights Reserved

Library of Congress Catalog Card Number 86-50631
ISBN 0-9610520-1-5

DEDICATION

Margaret E. and Glen R. Lilly

ACKNOWLEDGMENTS

 The following individuals and institutions provided information and materials valuable in the preparation of this book. I gratefully acknowledge their fine cooperation.

Jerome Adamson
Adamson Duvannes Galleries
Judy Altshuler
Paul L. Andrieu
Nancy Van Norman Baer
Paul Bagley
Joseph Baird
Irena Barnes
Belvedere Tiburon Landmarks Society
Dr. and Mrs. Edward H. Boseker
Barbara Bowman
Marian Bowater
Zelma and William Bowser
G. Breitweiser
Robert Brennan
O. D. Brenner
California Historical Society
Jeanne and David Carlson
Carlson Galleries
Joseph Chow Associates
Elaine Cobos
James L. Coran
Donald W. Crocker
Crocker Art Museum
W. H. Cullin
Mrs. Justin Dart
Rick Deragon
DeVille Galleries
M. H. deYoung Memorial Museum
Sandra and Bram Dijkstra
Christine Droll
Suzann Dunaway
Robert D. Ehrlich
Jeanette Parkes Ewing
J. David Farmer
Alfredo F. Fernandez
Timothy L. Fielder
The Fieldstone Company
Morton H. Fleischer
Stephen J. Fletcher
John Garzoli Fine Art
Gibson, Dunn and Crutcher
Jeff Gunderson
Sherrill Henderson
William Hendricks
Mary Hendrickson
Barry Heisler
Mark Hoffman
Susan E. Holmer
Harry L. Hufford
Edan M. Hughes
Jerry Jackson
Mr. and Mrs. Morris R. Jeppson
Frances Johnson
Madalyn and Philip Johnson
Fred E. Keeler
Richard Kerwin
Kerwin Galleries
M. R. Kluse
Jane Olaug Kristiansen
Carmen Lacey
Laguna Art Museum
Helen and David Laird
Oscar Lemer
Frank Leonard
Thomas J. Logan
Maxwell Galleries
Betty Hoag and Thomas McGlynn
Martin Medak
Lorna F. and John A. Meyer
Sally Mills
Mills College
Philip Molten
Monterey Peninsula Museum of Art
Monterey Public Library
Montgomery Gallery
Elizabeth B. Murch
Mark B. Nelson
Robert R. Neuhaus
Ted Nittler
The Oakland Museum
Louis F. Parente
Penny L. Perlmutter
Martin Petersen
Petersen Galleries
Ray Redfern
Redfern Gallery
Michael Redmon
Mr. and Mrs. Victor Reiter Jr.
John D. Relfe
Lynn S. Salgado
San Diego Museum of Art
San Francisco Art Institute
San Francisco Museum of Modern Art
Santa Barbara Historical Society
Santa Barbara Museum of Art
Santa Barbara Public Library
Judy Savage
A. Jess Shenson
Ben Shenson
Sherman Foundation Library
Johanna Raphael Sibbett
Paul Signorelli
George Stern
George Stern Fine Arts
Mr. and Mrs. Jean Stern
Jeffrey Stewart
Stewart American Art
Laura Sueoka
Carolyn Tanzola
Ann and Sutton Titus
University Art Museum, Santa Barbara
University Library, Davis
Mr. and Mrs. Anthony R. White
Rory White
Rory White Fine Art
Cleland O. Whitton
Barrett H. Willson
Raymond L. Wilson
WIM Fine Arts
Dr. and Mrs. Bernard H. Wittenberg
Mireille P. and Philip R. Wood

SPECIAL ACKNOWLEDGMENTS

 I am especially grateful to:

Nan and Roy Farrington Jones

for so generously accessing for us their monumental and unique slide file which provided incalculable assistance in the research.

Betty Hoag and Thomas A. McGlynn

for so kindly and readily sharing their archives and their efforts.

John Garzoli	James M. Hansen	Mark Hoffman
Walter Nelson-Rees	Kent L. Seavey	Jean Stern
Jeffrey Stewart		

for the hours and the efforts in finding paintings, photographs and relevant materials.

Marc D'Estout	Peter Fairbanks	William Hendricks
Harvey Jones	Philip E. Linhares	Lisa Peters
Terry St. John	Donald C. Whitton	

for generous and essential assistance in their particular provinces.

Jan Holloway

as the "resident" representative and research assistant in San Francisco, through thick and thin, from start to finish.

ABOUT THIS BOOK

The text of this book has been written by several contributors who are introduced on page ix. Their work includes general essays about the style and development of the art, about the artists' associations, training institutions and museums. The "Society of Six" painters are treated in one essay, as are Arthur and Lucia Mathews. Twenty-five other painters are the subject of individual essays, illustrated in separate sections.

For quick reference, information about each of these painters is presented on the first page of his or her section. The page numbers for these appear in bold type in the index. Entries under "Memberships," "Awards" and "Public Collections" in most cases are partial, representative listings. The "Public Collections" category refers either to collections in which the painter was represented or is presently represented.

In most cases, illustrations of a painter's work appear within that painter's section. Exceptions may be found by consulting the "List of Paintings" page viii which is inclusive and groups the works alphabetically by artist.

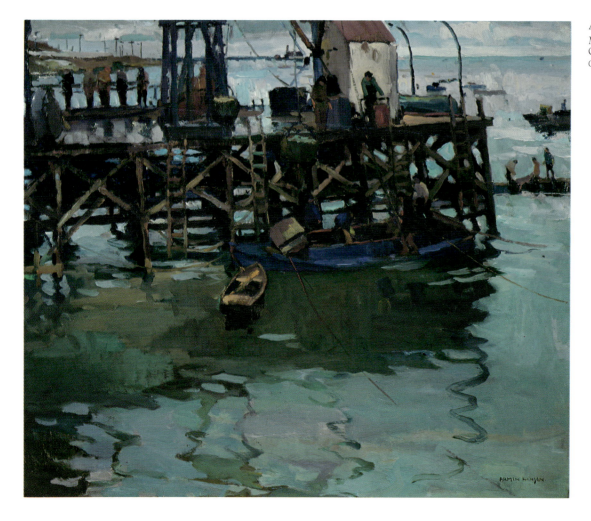

ARMIN HANSEN
Monterey Wharf, c. 1920
Oil on canvas, 33½ x 39 inches
Courtesy Collection of The Oakland Museum

TABLE OF CONTENTS

LIST OF PAINTINGSviii

ESSAY CONTRIBUTORS ix

A RECOLLECTION x
 by Louis Siegriest

INTRODUCTION 1

TOWARDS IMPRESSIONISM
IN NORTHERN CALIFORNIA 5
 by Raymond L. Wilson

BEGINNINGS OF THE ART
ASSOCIATIONS

 The San Francisco Art Association . . . 17
 by Betty Hoag McGlynn
 The Santa Cruz Art League 18
 by Betty Hoag McGlynn
 The Carmel Art Association18
 by Betty Hoag McGlynn
 The Arts in Santa Barbara 20
 by Janet B. Dominik

CALIFORNIA ART AT THE OAKLAND
MUSEUM:
MEMORIES OF THE BEGINNINGS . . . 23
 by Paul Chadbourne Mills

THE PAINTERS

 Carl Oscar Borg 32
 Anne Bremer 38
 Henry Joseph Breuer. 42
 Giuseppe Cadenasso 46
 Emil Carlsen. 52
 Colin Campbell Cooper 58
 Paul Dougherty. 64
 E. Charlton Fortune 68
 John Gamble 74
 Percy Gray 80
 Armin Hansen. 86
 Clark Hobart 92
 Xavier Martinez 98
 Arthur Mathews104
 Lucia Mathews.104
 Francis McComas.110
 Thomas McGlynn114
 Mary DeNeale Morgan.120
 Bruce Nelson126
 Eugen Neuhaus132
 John O'Shea136
 Jules Pages142
 Charles Rollo Peters148
 Gottardo Piazzoni.154
 Joseph Raphael160
 William Ritschel166
 Theodore Wores172

THE SOCIETY OF SIX179
 by Terry St. John

NOTES193

BIBLIOGRAPHY201

INDEX203

LIST OF PAINTINGS

Carl Oscar Borg
Barriers of the Desert p. 34
California Landscape p. 37
The Golden Hour p. 33

Anne Bremer
The Blue Coat p. 40
Carmel p. 41
Old Fashioned Garden p. 39
Still Life p. 40

Henry Joseph Breuer
The Cliffs, San Francisco p. 44
In Mission Canyon, Santa Barbara p. 43
Santa Barbara p. 45

Giuseppe Cadenasso
Lake Aliso p. 47
Marin Marshes p. 49
Tonal Piece p. 50
Untitled (#35) p. 48

Emil Carlsen
Blue, White and Gold p. 55
The Brook p. 53
Self Portrait p. 52
Sunlit Wood p. 56
White Asparagus p. 54

William Clapp
Estuary Dwellings p. 182
Houses along the Estuary p. 181
Monday Wash p. 181

Colin Campbell Cooper
Blue Mandarin Coat p. 61
The Green Bench p. 63
The Magic City, San Diego p. 62
New York Public Library p. 59
Self Portrait p. 58
Upper Main Street, Nantucket p. 60

Paul Dougherty
Blue Gale p. 65
The Inlet p. 65
Rocks and Surf p. 67
Summer Morning p. 66

E. Charlton Fortune
Before Sunset p. 70
The Cabbage Patch p. 72
Monterey Bay, 1916 p. 71
Monterey Bay, 1918 p. 15
Summer Morning, St. Ives p. 69

John Gamble
California Wildflowers p. 77
Fog on the Coast p. 79
Looking Down River p. 76
Poppies and Lupines p. 75
Poppies and Yellow Lupines, Point Lobos p. 78
Self Portrait p. 74
Wild Buckwheat, Point Lobos p. 75

August Gay
Hatton Dairy Ranch, Carmel p. 184
Monterey Street Scene p. 185

Seldon Gile
Fisher Houses p. 182
Oldag's Wharf, Tiburon p. 191
Sausalito p. 179
View of Bridge p. 183

Percy Gray
Field of Flowers p. 85
Mt. Tamalpais p. 83
Pine Tree on the Mesa, Inverness p. 84
Salinas Valley p. 82
Stand of Great Oaks, Monterey Bay p. 81

Armin Hansen
The Farm House p. 89
Launching the Lifeboat p. 91
Making Port p. 29
Monterey Wharf p. vi
My Worktable p. 87
Running Free p. 89
Salmon Trawlers p. 90
Shipyard No. 1 (etching) p. 88

Clarence Hinkle
Woman in a Hammock p. 3

Clark Hobart
Blue Bay—Monterey p. 95
Carmel Dunes p. 94
Melba, Pacific Grove p. 97
A Windy Day p. 93

William Keith
California Alpine Grandeur p. 27
Carmel Bay p. 7

Maurice Logan
The Grand Chute p. 189
Point Richmond p. 186

Fernand Lungren
Spring Street Looking South p. 19

Xavier Martinez
The Bay p. 99
Contra Costa p. 102
Green Moon p. 101
Self Portrait p. 98
Women at the Well p. 103

Arthur Mathews
The Bay of Monterey p. 106
Dancing Ladies p. 105
Monterey Cypress p. 107
Monterey Oaks p. 25

Lucia Mathews
Pine Tree #3 p. 109
Scene, Panama-Pacific International Exposition p. 109
Self Portrait p. 108

Francis McComas
California Twilight p. 111
Monterey Bay p. 113
Monterey Twilight p. 113
The Mountain p. 112

Thomas McGlynn
Figures on the Shore p. 119
The Grove p. 116
Mighty Oak p. 118
Quietude p. 115
Sunshine and Shadow p. 117
Winter's Lace p. 118

Mary DeNeale Morgan
A Bit of Pacific Grove p. 125
Carmel Valley Ranch p. 123
Monterey Coast p. 124
Monterey Cypress p. 122
October Golden House p. 121

Bruce Nelson
Orchard in Santa Clara Valley p. 127
Pacific Grove Shoreline p. 129
Santa Clara Valley p. 128
The Summer Sea p. 129
The Village p. 131

Eugen Neuhaus
Berkeley Hills and San Pablo Bay p. 134
Landscape p. 133
L'Avenue de la Vacherie p. 134
Whaler's Cove, Point Lobos p. 135

John O'Shea
- *Cove and Bathers, Laguna Beach* p. 141
- *Point Lobos from Pescadero Point* p. 137
- *Sea Beyond the Rocks* p. 139
- *Sea Pool* p. 138
- *Upland Solitude* p. 140

Jules Pages
- *The Blue Tablecloth* p. 144
- *Brittany Hills* p. 146
- *Court of Abundance, 1915 P.P.I.E.* p. 12
- *Lucky Baldwin Ranch, Arcadia* p. 145
- *Rags, Bottles and Sacks* p. 147
- *San Francisco Harbor* p. 143

DeWitt Parshall
- *Eucalyptus and Fog* p. 21

Charles Rollo Peters
- *House on the Rim* p. 150
- *Houseboats and Wharf Nocturne* p. 151
- *Monterey Landscape–Dusk* p. 149
- *Tamalpais from Belvedere* p. 153

Gottardo Piazzoni
- *California* p. 156
- *In the Studio* p. 155
- *Reflections* p. 159

Joseph Raphael
- *Apples* p. 163
- *Autumn Market* p. 162
- *Fisherman by the Bank* p. 164
- *Self Portrait* p. 160
- *Tea in the Garden* p. 165

Granville Redmond
- *Passing Shadows* p. 1

William Ritschel
- *Bit of California Coast—Pt. Lobos* p. 171
- *Mammoth Cove* p. 167
- *Moonlit Pool* p. 4
- *No Man's Land* p. 169
- *The Path to the Sun* p. 170
- *Thaw on 125th Street, N.Y.C.* p. 168

Louis Siegriest
- *Trees in Fall* p. 187
- *Untitled (House with Garden)* p. 187

Bernard von Eichman
- *China Street Scene #2* p. 190

Theodore Wores
- *Garden of the Potter Hotel, Santa Barbara* p. 173
- *The Golden Gate from Baker Beach* p. 175
- *Plum Blossoms, Los Gatos, California* p. 176
- *Sunshine and Cherry Blossoms, Nogeyana, Yokohama* p. 174

ESSAY CONTRIBUTORS

JANET BLAKE DOMINIK
Art historian, writer and curator specializing in early California art.

HARVEY L. JONES
Senior Curator of Art, The Oakland Museum since 1970. He has curated many exhibitions of California art, among which are *Mathews: Masterpieces of the California Decorative Style*, 1972; *Impressionism: The California Views*, 1981; *Arthur and Lucia Mathews: The California Decorative Style*, 1985.

BETTY HOAG MCGLYNN
Art historian, writer and contributor to numerous historical publications. She is the daughter of Montana artist Elizabeth Lochrie and daughter-in-law of Thomas A. McGlynn.

PAUL CHADBOURNE MILLS
Curator and Head of The Oakland Museum Art Department, 1954-1970; Director of the Santa Barbara Museum of Art, 1970-1982. He is currently an art consultant, guest curator and is active in the field of flags.

MARTIN E. PETERSEN
Curator of American Paintings, San Diego Museum of Art.

TERRY ST. JOHN
Artist, Associate Curator of Art, The Oakland Museum. Among the exhibitions he has curated are *The Society of Six*, 1972 and *Louis Sigriest Retrospective*, 1972.

JEAN STERN
Art historian, Director of Petersen Galleries, Beverly Hills, California. Specializing in early California art, he has produced several comprehensive catalogs on major artists of the era.

JEFFREY STEWART
Art historian, Director, Stewart American Art, San Francisco.

RAYMOND L. WILSON
Art historian, writer, lecturer at San Francisco State University. He is a regular contributor to the scholarly literature on American art in the West.

 I'll never forget my first oil painting of blossoms on the fruit trees. I was seventeen and we were painting in Montclair above the Temescal district of Oakland. I sat in back of Gile (Selden Connor Gile) and watched what he was doing and carried on from there. After I finished my canvas he said, "It looks pretty good and you got good color." I was tickled to death. I began to join Society of Six members regularly, particularly Gay (August Gay) and Gile. I became more interested in landscape painting after I met him. I was at his cabin all the time. Later, I would stay for dinner. Gile didn't like to drive and we would walk to spots, even though I had my folk's car.

In 1915 I went to the Panama-Pacific International Exposition and was more interested in the Spanish figurative painter Ignacio Zuloaga than the great French Impressionists. In 1919, after Gay moved to Monterey to live in the Stevenson House, I first met C.S. Price who shared the bottom floor with him. We met other artists there, such as Myron Oliver and the Bruton sisters. Although I never met Armin Hansen or Francis McComas, the artists talked about them. At Saturday night parties many artists and writers flocked into Gay's Stevenson House apartment, but I can't remember their names now. In Carmel I frequently observed Ritschel (William Ritschel) painting pictures of tide pools on the rocks overlooking the ocean. He was a very clever man doing high-class potboilers. Gradually, I became aware of other painters such as the Berkeley Water School with John Haley and others.

Although the "Six" were mainly interested in our own little group, we were aware of the conservative painters that became the "Sanity in Art Group" and laughed at their corny images. Artists more to my liking were artists such as Piazzoni (Gottardo Piazzoni) and Armin Hansen, and I painted with the "Six" at his ranch in the Carmel Highlands although I never met him there. Although the "Six" painted in a group, we all worked quite differently. Some of us were even influenced by the Blue Four that we saw at the Oakland Art Gallery in the 1920s. We were a group that were aware of "art moderne" movements in the San Francisco Bay area, but stuck with landscape as a point of departure. I started with it and it intrigued me so much I never left it. Even today I paint the landscape. People say I am an abstract painter, but I am not. Although the "Six," particularly Bernard von Eichman, experimented with abstraction, we didn't chase after ideas such as Picasso's. We saw poor imitations of French modern painters—by sticking with the landscape we were more able to develop our own ideas.

I knew little of Southern California landscape painters. I wasn't aware of a group such as the Eucalyptus School of painters. Up here, Cadenasso (Giuseppe Cadenasso) painted groves of eucalyptus by Mills College in Oakland. He was quite a good painter that our group liked.

With the Depression and World War II the landscape changed, with people in poverty living in trailers and national defense requiring balloons filling the skies. Shacks were put up by down-and-out people in the Thirties. The Oakland Estuary was full of people living in huge iron pipes. One lady built a house on stilts. We called the settlements on the estuary "Hoovervilles."

Even though our pallets shifted from bright colors to grayer ones, it wasn't because of my awareness of what other artists were doing. I did my own thinking and my palette changed completely.

Louis Bassi Siegriest
Interview with Terry St. John, March, 1986

INTRODUCTION

Plein Air Painters of California: the North completes the two volume set begun with *Plein Air Painters of California: the Southland,* and concentrates on a specific group of professional painters who, during the early 1900s, maintained studios from Santa Barbara north. To designate Santa Barbara as in "the north" is only an arbitrary decision. Indeed the whole concept of north and south as related to these painters is an arbitrary one for many of them traveled and painted throughout the state and could be claimed rightfully by both regions. Granville Redmond is a good example. Treated in the first book for his years in Los Angeles and his association with Charlie Chaplin, his absence in this volume could be viewed as an omission, for he was trained in San Francisco and lived many years in various Northern California locations. Clarence Hinkle, also discussed in the first volume, spent his retirement years in Santa Barbara, attracting a generation of young artists to his studio there. On the other hand, Carl Oscar Borg who divided his time between Los Angeles and Santa Barbara is treated in this volume. Further, many of the artists who exhibited in the early years of the Del Monte Art Gallery on the Monterey Peninsula were refugees from San Francisco following the 1906 earthquake and are included here. But the Del Monte also served as a haven and part-time home for several Southern Califonians, most notably, Jean Mannheim

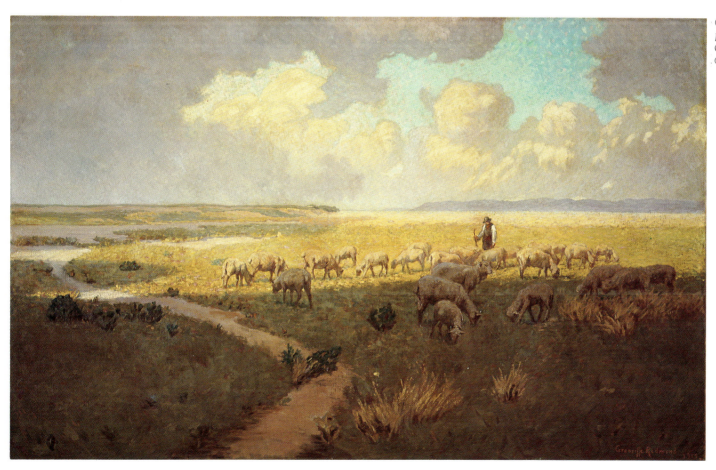

GRANVILLE REDMOND
Passing Shadows, 1907
Oil on canvas, 33 x 53 inches
Courtesy Petersen Galleries, Beverly Hills

who is included in the first volume. Such are the exigencies and foibles of a simple geographic categorization!

Less capricious but equally discretionary was the selection of the painters to be included. As with the first volume, the major parameters were a birthdate generally between 1860 and 1900, living and painting in California for a substantial period between 1890 and 1940, a painting style in the *plein air* tradition, a professionalism that produced a body of critical comment and assessment during the painter's lifetime, a high quality of work, and, of course, accessibility of the paintings today. That the oeuvre of certain artists may be lost from public view in private collections, or that some artists chose not to enter the conventional competitions and exhibitions of their time placed them beyond the scope of research and, of course, assessment.

A most difficult parameter of the selection process was style. Many of the northern artists were inveterate experimenters, and the mature work of an individual might cover the spectrum from Romantic Realist to Expressionism. While many painters who produced some Post-Impressionist, Expressionist or pre-Abstract work are included, those whose characteristic work is exclusively so defined are not. Two exceptions are August Gay and Bernard von Eichman who are discussed for their membership in the Society of Six.

To return to the north-south dichotomy, the painters in the two regions experienced quite different environments, both physically and culturally. The San Francisco Art Association, from which the major training institution evolved, was established two or three decades before comparable organizations formed in Southern California. The Bohemian Club, founded in San Francisco in 1872, promoted a close fraternity of artists, journalists, writers, social leaders and art patrons. And, by the turn of the century, such was the tradition and conservatism established in the art community of Northern California that young artists there formed the California Society of Artists in 1902 as a reaction to what they perceived as restrictive, stifling attitudes. This came at a time when artists arriving in Southern California found few of their number, somewhat tenuous associations, no established art training institutions and meager public interest.

In addition to these differences were those of a physical nature, which reflect undeniably in the artistic output of the two regions. Harvey Jones wrote,

> "The cool gray fog and luminous haze common to northern coastal regions produce a rare quality of prevailing light that appears to be slightly tinged with a violet hue. In Southern California a more consistently brilliant sunshine provides a golden illumination that results in use of a generally lighter, warmer palette among painters working in the area."[2]

But again, easy classification is elusive, for while much of the northern work reflects the cooler light and concentrates on that area's coastal beauty, what of the clear, warm light of Fortune or Hobart? And the Fauvist colors of the Society of Six? In fact, both regions had their experimenters in the modernist concepts of color. And while much of the work has a distinct sense of place, more pervasive and characteristic of these painters is that each had an individual style that was clearly modern in the sense that it embodied that painter's emotional, intuitive response to his or her world.

What they also had in common, less fortunately, was their fall from prominence with the advent of World War II. The post-War years brought a wave of young art students intrigued by the innovations of modernism—Cubism and Abstract Expressionism in particular. The major art academies succumbed and eventually eschewed all evidence of "representationalism." Meanwhile, the majority of California's *plein air* painters had died or had come to the end of their careers. And they went quietly into obscurity. Renewed interest in their work which began in Southern California in the 1970s was predated in Northern California in both academic and museum settings. In the 1960s, Joseph Baird of the University of California, Davis, focused attention on the complete spectrum of California art and initiated and nurtured the collection of data which is now known as the Baird Archives at Davis. It is today one of the most comprehensive sources of information on the early artists, particularly the Northern Californians.

Paul C. Mills, the former director of both The Oakland Museum's Art Department and the Santa Barbara Museum of Art, was the first museum professional, in a leadership position, to envision the potential of California's early art. His essay in this volume chronicles the formative years of the leading institution in California with a demonstrated commitment to that work—The Oakland Museum.

Seen first only as a "regional" product, the work in this volume has more recently been cast in a broader perspective. *American Impressionism* published in 1984, was the first major publication on American art to include California's early Impressionist painters[3] Indeed, until the appearance of that book the only artists defined as American Impressionists in recognized national art publications were those who had lived, worked and exhibited along the East Coast. And the nation's major art museums, including the Whitney Museum of American Art, remain woefully unaware of, or perhaps are deliberately ignoring, early 20th Century American painting done beyond the confines of East Coast art colonies. Unwittingly, many of the most promising students of New York's Art Students League in the early 1900s guaranteed their own extinction as acknowledged "American" artists simply by boarding a train that carried them West[4] Perhaps, however, as the latter day interest in their art gains momentum, abetted by national publications, activity in major art auction houses and museum and gallery exhibitions, their role in American art may yet be thoroughly and objectively assessed.

R.W.

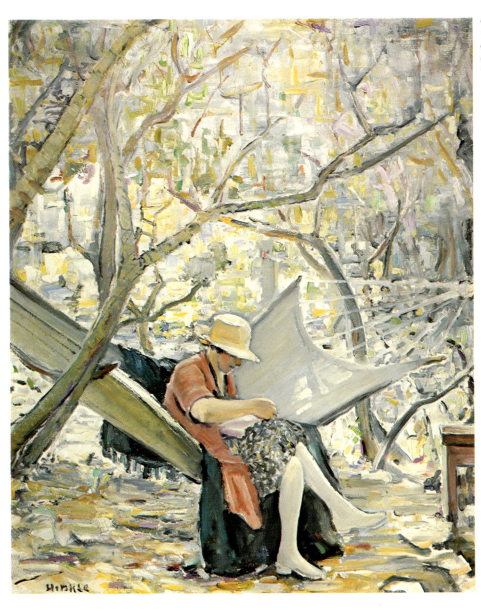

CLARENCE HINKLE
Woman in a Hammock, c. 1929
Oil on canvas, 36 x 30 inches
Courtesy Collection of Laguna Art Museum
Gift of Mabel Hinkle, 1960

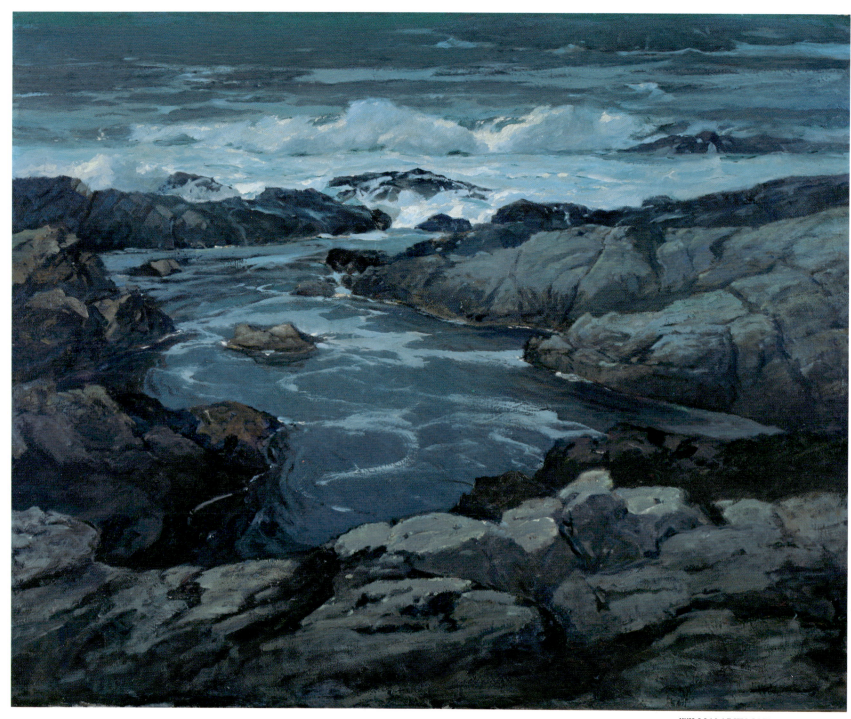

WILLIAM RITSCHEL
Moonlit Pool
Oil on canvas, 40 x 50 inches
Courtesy Monterey Peninsula Museum of Art

TOWARDS IMPRESSIONISM IN NORTHERN CALIFORNIA
by Raymond L. Wilson

Beginning in the 1890s painting in northern California underwent a profound alteration in form and subject matter, shifting from stirring scenes of mountain peaks and maritime adventures to smaller, more intimate and personal studies in mood and color. The shapes of forms changed too, from the familiar illusions of solidity and conventional spatial relations, to flatter, more purely decorative configurations.

These changes arose from three important developments: from a change in outlook and subsequently style, by William Keith, then the dean and most influential artist on the Pacific Coast; from a dramatic and far-reaching visit to San Francisco by George Inness, the Eastern landscape painter, in the spring of 1891; and from a young and vital generation of men and women returning to California from study in the intoxicating environments of turn-of-the-century New York and Paris, destined to lead a reshaping of northern California's pictorial ideals. These changes came slowly at first, gathered momentum at regular exhibitions, and finally won permanent endorsement and official sanction at the 1915 Panama-Pacific International Exposition held in San Francisco. There, a vast and kaleidoscopic Department of Fine Arts, crowded with exhibits from around the world helped shape the artistic future of the West.

Yet these were difficult and contentious years for northern California artists, marked by competition and conflict between old and new styles and between established artists and ambitious upstarts. How it all began is a story of despair over a prolonged slump in the art markets of the Far West which lasted for over a decade, starting early in the 1880s.

During most of the 1860s and 1870s, northern California artists enjoyed a rare and rewarding age of prosperity and public favor. But the collapse of the Nevada silver boom in 1878 placed a damper on sales of *objets d'art*; and a shift in taste by local patrons to the vogueish Europeans of the day eclipsed the popularity of resident artists.

For several years a moody stillness lingered over the once-lively and colorful artistic colony of San Francisco, then the capital of northern California art. Emil Carlsen, the still-life painter, arrived in San Francisco from New York in 1887 to take up duties as the newly-appointed director of the California School of Design, the educational wing of the San Francisco Art Association. Four years later, though, preparing to return to New York, he bitterly declared that, "I am going where people buy pictures, where there is an opportunity to exhibit them, and where a name means something."[1]

Some San Franciscans were in the market for pictures, but they were more often copies of old masters or pictures painted by sought-after Parisians like William-Adolphe Bouguereau, Jean-Louis Meissonier, or Jean-Léon Gérôme. Members of the French *Académie Royale de Peinture et Sculpture*, Bouguereau, Meissonier, Gérôme, and their fellow-academicians in France and elsewhere in Europe painted pictures which reflected traditional ideals: melodramas like Gérôme's *Sword-Dance in the Cafe*, owned by Charles Crocker, one of the Big Four transcontinental railroad builders; picture-postcard views like Mecklenburg's *The Grand Canal, Venice*, owned by General D.D. Colton, a San Francisco lawyer and finance director of the Central Pacific Railroad; or sweetly sentimental scenes like Vibert's *Duet of Love*, owned by Irving M. Scott, president of the Union Iron Works, the West Coast's largest shipbuilder.[2]

Students enrolled at the School of Design, facing severely reduced prospects at home, left to travel abroad to study. At first they headed for the Royal Academy at Munich, there to study with other Americans like Frank Duveneck and his followers, as did Toby Rosenthal, Theodore Wores, and Thaddeus Welch, three young northern Californians fresh from classes at the School of Design. Paris, however, was swiftly gaining a reputation as a center of energy and experiment and soon became a magnet for young artists from many countries.

Few would-be students, though, could pass the rigorous entrance examinations, which included fluency in the French language, of the École des Beaux-Arts, the official school of the Académie Royale. The chief and most popular alternative to the École was the Académie Julian which was, next to the École, the largest and most important art school in Paris. Julian's

fees were relatively modest and there were no preconditions or entrance requirements. Consequently it attracted large numbers of foreigners from many nations—Russians, Japanese, Brazilians, Britishers, and many Americans—among the latter, many northern Californians.

Rodolphe Julian was a colorful figure with no formal artistic training of his own, though he was a painter. He had grown up in a small village in the south of France and had been a prizefighter as a young man. When his days in the ring were over, he took his savings and started the Académie Julian in 1868. M. Julian was the manager of his school which had studios located in several Paris *Arondissements*. To serve as instructors Julian enlisted several well-known academicians on the faculty of the more prestigious École—Bouguereau, Gustave C.R. Boulanger, Jules J. Lefebvre, Tony Robert-Fleury, and Jean J. Benjamin Constant. Once a week subjects were given out to the classes, usually from the bible or mythology. The results were judged by the professors and there were regular competitions crowned by the frequent awarding of medals.[3]

This rather unremarkable program was enlivened, however, in some branches of Julian's by contact with the extramural work and personalities of certain prophetic figures just then battling the outrage and scorn of the establishment.

Among these branches were the "little studios" on the rue du Faubourg-St. Denis, where Maurice Denis, Pierre Bonnard, and Edouard Vuillard were studying in 1888 and 1889. The *massier* or monitor of the Faubourg studios at that time was Paul Sérusier, later to become an important member of the Nabis. Also enrolled at the Faubourg studios was Arthur F. Mathews, a young San Franciscan. Other northern Californians studying at Julian's in the late 1880s were Amédée Joullin, Ernest Peixotto, Elizabeth Strong, Charles Rollo Peters, Anna Krumpke, Will Sparks, Jules Pages, and Matilda Lotz.[4] These young Americans could observe firsthand the avant-garde crucible of Parisian art. Profoundly affecting their education, later to be manifested half a world away, were the works and personalities of Paul Gauguin, the muralist Pierre Puvis de Chavannes, and the characteristically flat, though boldly outlined, Japanese print, just then capturing the imagination and advocacy of artists like Vincent Van Gogh.

Exposure to Gauguin's ideas may have occurred at a moment recounted in a celebrated essay by Maurice Denis titled "The Influence of Paul Gauguin:" "Paul Sérusier," wrote Denis, "appeared in the Faubourg St. Denis studio one day in October, 1888, and showed us, not without a certain amount of mystery, a cigar-box cover on which could be seen a landscape later called 'The Talisman' painted by Sérusier under Gauguin's supervision. It seemed crude because of its synthetic formulation in purple, vermillion, Veronese green, and other pure colors—just as they had come out of the tube—with almost no white mixed in. 'How do you see this tree,' Gauguin had said, standing on one of the corners of the Bois d'Amour. 'Is it really green? Use green then, the most beautiful green on your palette. And that shadow, rather blue? Don't be afraid to paint it as blue as possible.' Thus, for the first time was presented to us, in paradoxical form, but unforgettably, the fertile concept of the 'flat surface covered with colors assembled in a certain order.'"[5]

Reinforcing the effect of the flat surface were Japanese woodcuts, imported to Paris in growing numbers in the 1880s by Samuel Bing, a dealer chiefly in Orientalia, and by others. During the later 1880s when many northern Californians were matriculating in Paris, there were regular public exhibitions of Japonisme and publication of illustrated books and periodicals on the subject. Add to this the extensive press coverage of Japonisme and it would be hard to conceive of any art student remaining unaware of this development.

In 1887, for instance, Vincent Van Gogh organized a show of colored woodcuts, seen for the first time in Paris, at the Café Le Tambourin. In the autumn of the following year Samuel Bing put on a show called the International Exhibition of Black and White, featuring the woodcuts of Utamaro. There were Japanese prints at the Paris International Exposition of 1889, and a major exhibition of Japonisme at the École des Beaux-Arts in 1890 at which works by Hiroshige, Hokusai, and Kunisada were represented.[6]

Another Parisian whose work excited admiration and imitation among the more experimentally-minded of Julian's students was that of Pierre Puvis de Chavannes. Puvis specialized in murals and easel paintings based on quasi-literary allegories. Haunting, gracefully endowed figures were often posed silhouetted in a dream-like Arcadia and painted

in subtly harmonized and muted tones, as in the often illustrated *Sacred Wood Beloved of the Arts and Muses*, painted between 1884 and 1887.

For young northern Californians in Paris, preparing to assume the leadership in bringing about a revival of art in the Far West, there was abundant inspiration in the revolutionary appeal and doctrines of Gauguin, Puvis de Chavannes, and the Japanese print. In the meantime, halfway around the world, San Francisco's largely dormant art colony was about to awaken and shrug off the apathy and depression of the 1880s.

In the spring of 1891, George Inness, probably America's most famous landscape painter, paid a visit to San Francisco where he was warmly welcomed by William Keith and other members of San Francisco's civic and social establishment. Keith made his studio available to Inness and together the two artists travelled to the Monterey Peninsula to paint. By the end of April both men were back in San Francisco, preparing for the spring exhibition of the San Francisco Art Association, the Pacific Coast counterpart, albeit on a much smaller scale, of the annual Paris Salon.[7]

On May 7 the exhibition opened with a reception hosted by the Art Association. Inness's painting, *Sunset Near Monterey*, was accorded a place of honor, and Keith showed four paintings: *Under the Oaks at Monterey, Near Monterey, Twilight in the Valley*, and *Landscape*.[8]

A week after the opening of the Art Association show and on the eve of Inness' departure for the East, the artist was feted at a lavish banquet given by Irving M. Scott. According to press accounts, a large number of socially and artistically prominent persons attended, including Claus Spreckels the sugar magnate, James Ben Ali Haggin, a Western industrialist and patron of Albert Bierstadt, and artists Keith, Raymond Dabb Yelland, director of the California School of Design, and two young soon-to-be-known artists recently returned from study in Paris, Amédée Joullin, and Arthur F. Mathews, also both instructors at the School of Design.[9]

Symbolically, the day after the Scott reception, while in Keith's studio, Inness was invited by his host to make changes in a painting titled *A Forest Interior*. Reportedly Inness took Keith's brush and palette and painted a vivid sunset in the center of the picture, covering a brooding bower of trees.[10]

A month later, in the June number of the *Overland Monthly*, a local journal, Charles Dorman Robinson, a native painter of growing renown, published an article titled "A Revival of Art Interest in California." The revival began, Robinson asserted, with a loan exhibition of paintings at the rooms of the San Francisco Art Association which took place shortly before the spring exhibition at which Inness and Keith had participated.

The loan exhibition consisted of the Irving M. Scott and W.H. Crocker collections in which "a few

WILLIAM KEITH
Carmel Bay
Oil on canvas, 49½ x 39½ inches
Courtesy Maxwell Galleries Ltd., San Francisco

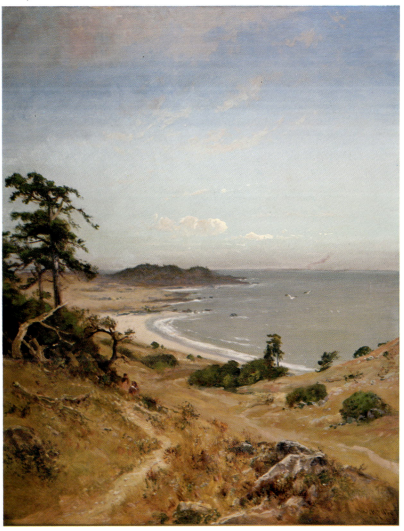

fair examples of the leading modern European schools, and also two or three passable of the older masters were shown."[11] Monet's *Sunlight Effect on the Riviera* and Pissarro's *Woodland Scene*, both owned by Mrs. W.H. Crocker, were on view as was Puvis de Chavanne's *Charity*. Representing the Barbizon school were Theodore Rousseau's *The Oaks*, Jean-François Millet's *Man with A Hoe*, and two by Camille Corot—*Evening* and *Dance of the Nymphs*—all owned by the Crockers. Irving Scott lent Charles Daubigny's *Spring* and *Autumn*.[12]

An important part of the loan exhibition, continued Robinson, was a painting by Inness whom he proclaimed "America's greatest landscape painter." That painting, wrote Robinson admiringly, "must be positive revelation to local artists who have never had an opportunity before closely to study his methods. His technique is bold and original in the extreme, yet it bears evidence of years of thought and experiment, of scholarly investigation and great mechanical skill. The subtle mastery with which the mystery of tone which envelops the whole picture is obtained is marvelous to the trained eye and hand. There is no linear drawing in the picture, yet it is a gem of drawing, there is no brilliancy of pigment anywhere upon the canvas; but not often before has one graced the walls of the Association which in its apparently low and subdued key of color shot forth such fiery gleams of nature's light as does this canvas."[13]

By the time that Robinson's article appeared, Arthur F. Mathews, returned from Europe, had been working in San Francisco for nearly two years and had launched himself on a career as a teacher and artist. In 1890 he was appointed to teach the life class at the California School of Design. Within two years' time the school and its parent, the San Francisco Art Association, had moved to new quarters on the crest of Nob Hill and into the vacant mansion of Mark Hopkins, one of the original Big Four transcontinental railroad builders. At this time the school also became affiliated with the University of California in Berkeley, across the Bay.

On the recommendation of the retiring director of the school, Raymond Dabb Yelland, Mathews was appointed the new director. Following his appointment, the latter immediately moved to restructure the curriculum of the school, utilizing the lessons learned in Paris. He deemphasized the traditional course in learning to draw from plaster casts of famous sculptures like the *Venus de Milo*, and made drawing from life models a requirement. Mathews also added a course in anatomy. Through this revamped curriculum were to pass many young talents destined to make major contributions to the resurgence of art in northern California and to the rise of Impressionism, such as Francis McComas, Xavier Martinez, Giuseppe Cadenasso, Gottardo Piazzoni, Joseph Raphael, Armin Hansen, Lucia Mathews, Charles Rollo Peters, and Maynard Dixon.

Two other events which were to be of considerable importance in leading to a revival and in setting the stage for the appearance of Impressionism in northern California were two international expositions, one midwestern and one local. They were the World's Columbian Exposition of 1893, held in Chicago, and the California Midwinter International Fair of 1894, held in San Francisco's Golden Gate Park.

A major international occasion, the World's Columbian became a showcase for some of America's leading planners, architects, and artists. Each state in the union had its own pavilion exhibiting its products and manufactures, but California was the only state to have its own art gallery housing works by resident artists. Norton Bush, a well-known northern California artist of the older generation, was placed in charge of the art exhibition.

Bush and his committee, which included William Keith, Arthur F. Mathews, the portrait-painter Mary Curtis Richardson, and William F. Jackson, selected ninety paintings for showing, about half of which were by women artists of northern California. The older generation of California painters was well represented with paintings by Charles Christian Nahl, Thomas Hill, and Jules Tavernier. But Keith and the younger Paris-trained group were strongly represented too. Keith showed four paintings whose titles suggest that they were of the smaller, more intimate quality of his new style, as may have been *Early Moonrise* and *The Deep Somber Woods*.[14]

That winter of 1893–94, several prominent San Franciscans led by M.H. de Young, publisher of the *San Francisco Chronicle*, decided to organize an exposition of their own, which being held in mid-winter would dramatize the appeal of California's mild and benevolent climate. Set in San Francisco's Golden Gate Park, there were hundreds of buildings and exhibits, even a recreation of a Gold Rush camp.

The art gallery showed works by living and deceased northern California artists as well as works by artists from other nations, especially from France and Poland. Keith was asked to head the selection jury for the California exhibit. As with the previous summer's World's Columbian Exposition, a rough balance was struck between old and new. Representing the living artistic establishment were Thomas Hill, Ernest Narjot, the genre painter, and Raymond Dabb Yelland. Keith was on view once again with four paintings, including *Deep Somber Woods* from the Chicago exposition. But of the fifty-one exhibitors in the category of California Local Artists, a majority were from the newcomers.[15]

Besides the Californians, there were in the French department, *A Field in Giverny* and *The Cliffs at Varengeville* by Claude Monet, *An Algerian Girl* by Renoir, *The Meadow* by Pissarro, and Alfred Sisley's *The Banks of the Marne*. The Barbizonists were also represented by Daubigny with two paintings and Corot with four. Press reviews of the California exhibit were favorable and public response was enthusiastic, winning for the contemporary point of view sooner rather than later, admittance, if not yet total acceptance into the mainstream of northern California's art life. Far from presenting a united front, however, the vanguard group was a diverse lot—made up of native northern Californians and immigrants, some with extensive training in art and others with comparatively little. Of the architects of Impressionism in northern California, two stood in the foreground—William Keith and Arthur F. Mathews.

Keith (1838–1911), a Scotsman and veteran of the peak years of the silver age as well as a survivor of the depression that followed, was a prophet of the new age. Years before the ascendancy of Mathews and before the arrival of Inness, Keith had been meditating on his art, searching for a new perspective on painting, one that would match the threads of his past experience with the new impressions gained from a stay in Europe during the years 1883–1885.

At a lecture delivered to the Longfellow Society at the University of California in 1888, Keith mused, "When I began to paint, I could not get mountains high enough nor sunsets gorgeous enough for my brush and colors. After a considerable number of years experience, I am contented with very slight material—a clump of trees, a hillside and sky; I find these hard enough, and varied enough to express any feeling I may have about them."[16]

Indeed, by the middle 1880s Keith's landscapes, limited to a more restricted horizon, were becoming more intimate and lyric in their mood. In this the Barbizon influence with its serene vistas and often shadowy forest scenes may have played a role. Titles like *In the Woods* from the 1884 Art Association exhibition and *Edge of the Wood* from the 1886 exhibition suggest clues to his development.[17]

Another factor which may have played a part in Keith's thought was a shift in taste among American collectors away from earlier landscape styles to the Barbizon mood. Included, for instance, in the collection of Collis P. Huntington, the railroad tycoon and resident of Nob Hill, were pictures by Narcisse Diaz who had specialized in scenes of dimly-lit forest interiors. In another instance, even Irving M. Scott, Keith's old friend and patron, bought Daubigny's *Spring* and *Autumn*. Mrs. W.H. Crocker, wife of the banker, owned *The Oaks* by Theodore Rousseau, Millet's *Man with a Hoe*, and two works by Corot—*Evening* and *Dance of the Nymphs*. Ever sensitive to subtle changes in art and taste, it would have been surprising if Keith had remained unaware of these developments.[18]

Alongside Keith, Arthur Frank Mathews (1860–1945) shared co-responsibility for bringing about the change in style from epic landscape to the first Impressionist experiments. Born in Wisconsin, Mathews was brought west with his family in 1866. His father was an architect who, shortly after arriving in California, established a practice in Oakland. By the age of twenty-five, having already apprenticed at his father's architectural offices, Mathews left for Paris, there to enroll at the Académie Julian.

Little of his work of those days has surfaced, but what has bears testimony to his allegiance to conventional illusionistic values. In later life he recorded little about what he must have seen and heard, to which his later work attests, of the dramatic developments in art occurring all about him during his tenure at the Académie Julian.

On Mathews' return to San Francisco in 1889 he began offering instruction in life drawing at the San Francisco Art Students League. A year later he was appointed to the faculty of the California School of Design. In his first year at the school Mathews taught the antique drawing and life classes and lectured on

artistic anatomy and composition. The next year Yelland resigned as director, recommending that Mathews be appointed to succeed him.[19]

As recounted earlier, Mathews moved rapidly to restructure the curriculum of the school, deemphasizing the antique classes and making requirements of life drawing and anatomy. He also quickly gained a reputation among the students as a tyrant, ruthlessly criticizing the efforts of beginners and promoting favorites over the heads of sometimes more deserving peers. Whether, for instance, Lucia Kleinhans was more deserving than her peers is open to question, but at any rate she was quickly promoted and not long afterwards became Lucia Mathews, the director's wife. Other Mathews' students were Francis McComas, Xavier Martinez, Gottardo Pizzoni, Anne Bremer, Armin Hansen, and Thomas McGlynn.

With Mathews' career, that of his wife Lucia, and those of his more promising students advancing smoothly, he had every reason to feel optimistic about the future. His serene horizon, however, was shattered on the morning of April 18, 1906, when a massive earthquake rumbled across northern California, striking hardest in San Francisco. Fires started almost immediately and with water mains broken by the shifting earth, conventional means of fighting the fires were quickly exhausted as wells and cisterns were drained. The gallery and studio districts were rapidly imperiled and while William Keith and a gallant few were able to rescue a handful of pictures, the flames soon drove them off, devouring in minutes the Montgomery block which contained many studios.[20]

After pausing, the inferno began leaping up Nob Hill in the direction of the old mansions of the railroad and silver kings and the Mark Hopkins Institute. Some pictures were saved and others were looted—exactly how many in each category will never be certain. What is certain is that the Mark Hopkins Institute, its library, its instructional apparatus, and its collections were carbonized on the afternoon of April 18. Two days later, with the ashes of the city still cooling, many artists began packing their belongings and looking for refuge abroad—to Oakland across the Bay, to the Monterey Peninsula to the south, and even to

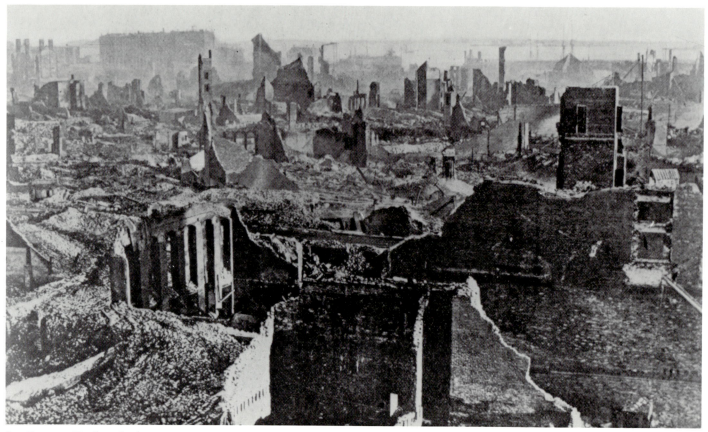

San Francisco Earthquake devastation, 1906 *Photo courtesy the Sherman Foundation, Corona del Mar, California*

Santa Barbara and Los Angeles.

San Francisco's busy and colorful art scene died with the city and for years afterwards a silence deeper even than that of the early 1880s lingered. Its artists remained in exile and a generation of students just beginning work at the Mark Hopkins Institute had fled to New York and Europe. The refugee art colony located on the Monterey Peninsula flourished, however, and early in 1907 the Hotel Del Monte opened the Del Monte Art Gallery. Among the participants at its first exhibition were Mathews, Xavier Martinez, John Gamble, Elmer Wachtel, and Eugen Neuhaus.[21] A few more years passed until finally, late in 1911, the year of Keith's death, a proposal for an international exposition, to be held in rebuilding San Francisco, was put forward.

Drawing up ambitious plans, the directors made space for a Department of Fine Arts—in which the United States section alone was ultimately to grow into an exhibit of more than 4,500 paintings. When plans for the Panama-Pacific International Exposition (P.P.I.E.) were made public, San Francisco's moribund art scene began to show signs of life. The tempo quickened in 1912 and 1913 and by 1914 plans for the Department of Fine Arts were firm—in addition to a very large European section with prominent exhibits by artists representing most of the major current styles, including the first American appearance of the work of the Italian Futurists, there was to be a large California exhibit with separate galleries for Arthur Mathews, Francis McComas, and the deceased William Keith. Besides serving on the advisory committee for the American West which passed on pictures to be exhibited at the Department of Fine Arts, Mathews had been appointed to the International Jury of Awards as were Francis McComas, Eugen Neuhaus, and Jules Pages.[22]

Opening in February of 1915 after intense anticipation, the P.P.I.E and especially the Department of Fine Arts were an instant hit and over the spring and summer attracted large crowds day after day. So successful, indeed, was the art exhibit, that it alone among the P.P.I.E. exhibits was continued over into 1916. For many younger artists and art students, it was often a first and certainly a prolonged opportunity to study the work of recent and emerging European and American masters in the latest vanguard styles.

The exhibit also won in the West general acceptance and endorsement for Impressionist styles—for the brilliant and vigorous work of the Nabis, for instance. Among the northern California exhibitors were Henry Joseph Breuer, Paul Dougherty and William Ritschel, awarded gold medals by the International Jury of Awards; the silver medallists, E. Charlton Fortune, Armin Hansen, Lucia Mathews, Bruce Nelson and Joseph Raphael; and the bronze medallists, Anne Bremer and Percy Gray.

The artistic and popular success of the Department of Fine Arts exhibits at the P.P.I.E. crowned the early years of Impressionism in northern California and at the same moment offered glimpses of the shapes that the future might take. It capped the career of Arthur Mathews and for many others it was an important milestone. Besides the P.P.I.E., circumstances, favorable and unfavorable, had much to do with the germination and flowering of Impressionism in northern California. The climate, natural disasters, and economic conditions all played a part. Of key importance were the talents and perseverance of figures such as Arthur Mathews, Charlton Fortune, Armin Hansen, and others like them. Without their

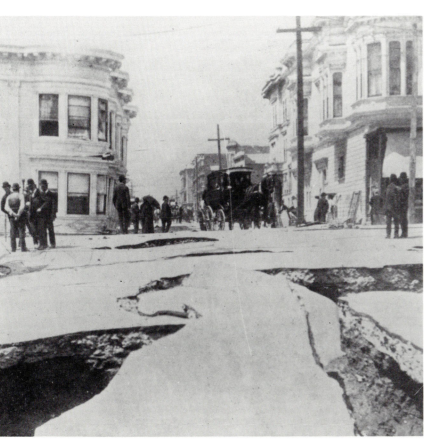

Photo courtesy the Sherman Foundation, Corona del Mar, California

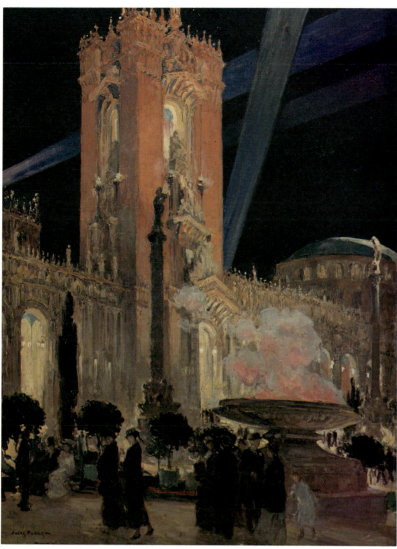

JULES PAGES
Court of Abundance, 1915 P.P.I.E.
Oil on canvas, 19 x 25 inches
Courtesy Victor Reiter Jr.

inspiring presence and vital contributions, Impressionism, which would have probably made its way west eventually, would certainly have made its appearance much later and perhaps without such a dramatic and eventful journey.

The range of techniques and tonal ensembles, from the boldly stated oaks of Francis McComas to the pellucid hues of Charlton Fortune revealed and heralded the spreading popularity of Impressionist methods and a changing order underway since William Keith's first Barbizon-inspired paintings began appearing in the middle 1880s. From the regions around San Francisco Bay came reflections on the tawny fields of Marin, the shaggy eucalypti of the Berkeley and Oakland hills, and the wind-blown dunes of San Francisco's developing western reaches. From the Monterey Peninsula came images of the gently curving Monterey Bay, the sharply silhouetted arabesques of cypress trees, and the craggy coastline south from Point Lobos.

Arthur Mathews, Francis McComas, Xavier Martinez, Gottardo Piazzoni, and Giuseppe Cadenasso, the latter perhaps the first in California to paint the foreign-born eucalyptus tree, were strongly represented with their idiosyncratic and synthetic blends of the decorative style—chiefly large flat areas of muted and deftly combined colors. Shifting away from the sinuous rhythms of Arthur Mathews, Francis McComas painted his stylized oaks and Southwestern pueblos with boldly outlined contours. Xavier Martinez's monotypes and paintings, like McComas's watercolors, were composed from a darker palette, resembling in their painterliness Whistler's seaside scenes. Cadenasso had claimed the eucalyptus for his own, painting them from the late 1890s, and Piazzoni, a muralist in an age of muralists, kept simplifying his forms until, with *Lux Aeterna*, he achieved a minimal, though stirring form of expression.

The synthetic style practiced by Mathews and his followers had approached its zenith a few years before. It continued to attract adherents, for instance, Thomas McGlynn, charmed by its apparent simplicity and elegance, but it was about to be eclipsed in popularity by methods associated with the éclat palette of the first generation of French Impressionists.

Defying easy classification, either by style or by region, and especially in the cases of Joseph Raphael and Jules Pages, two native-born, yet essentially

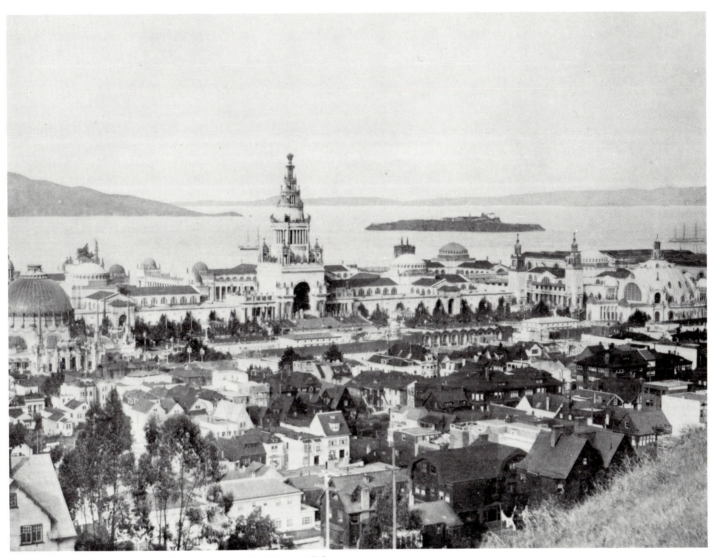
Main exhibit palaces, Panama-Pacific International Exhibition, 1915

expatriate artists, as a group they painted in bright, animated colors. They took to the shorelines, discovering atmospheric effects, and with surprising speed and audacity they began to explore the tactile values and charms of paint.

Anne Bremer and Mary DeNeale Morgan who started their careers painting the muted moods and harmonies of Barbizon and the next-generation tonalism of Mathews, perceived the abundant potential contained in a higher-keyed palette combined with the changing atmospheric effects characteristic of the Monterey Peninsula, particularly its misty fogs and hazy sunshine. Others such as Theodore Wores and John Gamble, both of whom also rose from darker beginnings—Wores from his training in Munich and Gamble from study with Mathews at the California School of Design—discovered the subtle appeal of the blue lupine and yellow poppy of the California coastline from San Francisco's western beaches to Santa Barbara.

Testaments to the difficulties of classification are the works of William Ritschel and Armin Hansen who applied paint in broad, textured strokes and in saturated ultramarines, deep reds, and glowing greens. Both were schooled in Germany, though Hansen was born in San Francisco, and both painted the sea, emphasizing color and composition.

Perhaps closest to the original French Impressionists in spirit and technique was Euphemia Charlton Fortune. Her light-washed and loosely composed scenes around Monterey suggested a measure of spontaneity lacking in the studied approach of her peers. Often vigorous, broadly brushed strokes are accented with small, flickering spots of brilliant color. William Merritt Chase, the distinguished and inspiring teacher of Impressionist techniques, taught a class at Monterey in the summer of 1914 at which Charlton Fortune may have been present. A luminous, but milkier light also characterized the painting of Bruce Nelson who found his inspiration in the shallow coves of Monterey Bay and the brightly-lit fields near the coast.

Sufficiently individualized were all these viewpoints that critics such as Michael Williams of the *San Francisco Chronicle* and Eugen Neuhaus, himself an exhibitor and a member of the International Jury of Awards, but also a prominent spokesman, foreswore generalizations, yet pronounced favorably on the developments. However, a palpable emphasis on composition and carefully harmonized colors hinted at a formal, academic approach to Impressionism rather than at a spontaneous response. Yet in most cases they brought an elegant and often compelling perspective to familiar places.

E. CHARLTON FORTUNE
Monterey Bay, 1918
Oil on canvas, 30 x 40 inches
Courtesy Mr. and Mrs. Anthony R. White

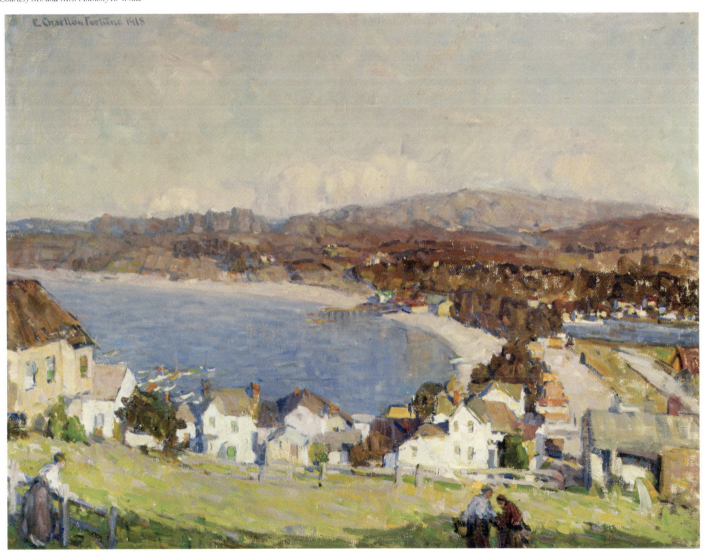

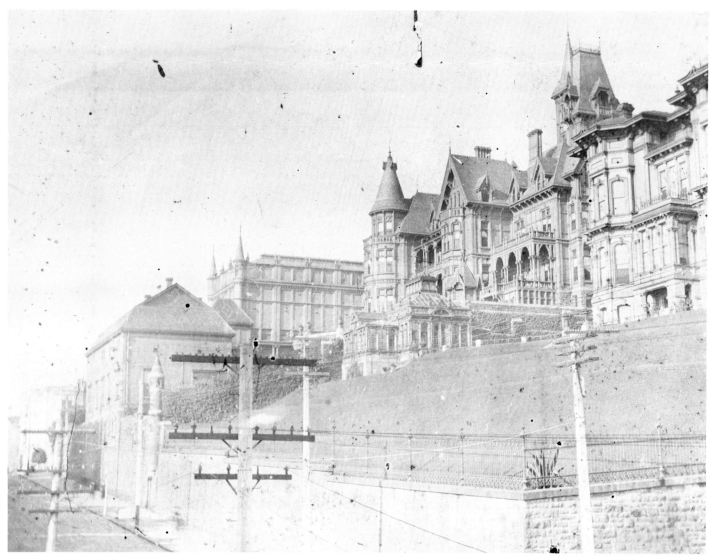
California School of Design, Stanford Mansion right, Mark Hopkins Mansion left

Photo courtesy Archives of Betty Hoag McGlynn

BEGINNINGS OF THE ART ASSOCIATIONS

The San Francisco Art Association

San Francisco's early artists had problems finding ways to make the public aware of their work. A solution was not found until the San Francisco Art Association was organized in 1871. Some sporadic exposure of paintings had been offered as early as 1851 when local artists were invited to show at the Mechanics Institute Fair. The artists made a valiant effort to help themselves when they formed a California Art Union in 1865; it lasted only two years. A similar San Francisco Artists' Union of 1868 lasted but a year. Finally, in March of 1871, a large number of concerned citizens and artists met at the library of the Mechanics Institute and formally organized the San Francisco Art Association. Its object was "the promotion and cultivation of the Fine Arts in the community." A large sector of the membership was (and continued to be) nonpainters but avid art patrons. A First Annual Exhibit of work by members was held in 1872.

In February of 1874 a dream was realized when the San Francisco School of Design opened in the association's rented rooms at 313 Pine Street. Most of the forty students were young women. Two years later the academy moved to 430 Pine where it was established unromantically above a fish market and poultry shop, adjoining rooms of the young Bohemian Club. The French government sent the new school a gift of fifty-five plaster copies of sculptures in the Louvre in gratitude for San Francisco's financial help during the Franco-Prussian War. When the crates were unpacked, one statue was found to be minus an arm, so the association sued the delivery company, Wells Fargo, and collected damages. The gorgeous amputee was the Venus de Milo.

The art association received a second gift in 1893; the city and state were given the many-turreted Hopkins mansion atop Nob Hill. The association at once affiliated with the University of California and changed the name of the school to the California School of Design. Its museum functions continued under the commemorative title of the Mark Hopkins Institute of Art. The 1906 earthquake and fire destroyed the structure. Almost before the embers cooled the San Francisco Art Association began building new headquarters over the debris. Now it rechristened the school the San Francisco Institute of Art.

In 1916 the association merged with the San Francisco Society of Artists (a group of avant-garde painters). That same year the association assumed directorship of the Museum of Modern Art, the city's first museum dedicated solely to the exhibition of fine art. It was located in the Palace of Fine Arts, that magnificent relic of the Panama-Pacific International Exposition. The name of the association's historic academy again was changed in 1917, to the California School of Fine Arts. In 1926 the students left Nob Hill and moved into quarters which the San Francisco Art Association had just built at 800 Chestnut Street. A merger took place in 1961, the association and school combining as the San Francisco Art Institute, by which name it is still known.

Betty Hoag McGlynn

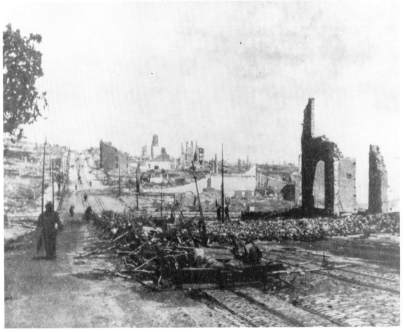

San Francisco Earthquake devastation, 1906
Photo courtesy the Sherman Foundation, Corona del Mar, California

The Santa Cruz Art League

The beautiful seaside village of Santa Cruz was a popular sketching ground for artists throughout the nineteenth century. Most influential in the 1890s was the *plein air* painter Frank Heath. Shortly after the turn of the century he organized the Jolly Daubers, a group who painted outside with him. In 1919 the Jolly Daubers metamorphosed into the Santa Cruz Art League which had a large membership of both artists and patrons. In 1928 the league held the first of its annual state-wide exhibitions of paintings by California artists. It set a high standard which was to be continued for three decades. Selection of work from many entrants was juried by respected professionals. (In 1929, for example, William P. Silva and William C. Watts selected 193 works.) The pictures were exhibited in three categories: oils, pastels, and watercolors. Each category received first and second prizes (from $500 down to $15 in 1929). Special awards also were given. All pictures were for sale, and the Santa Cruz Chamber of Commerce in 1929 contributed money for a special catalog listing the prices. The annual was circuited by the Western Association of Art Museum Directors and generated excitement throughout the state about the possibility of being accepted and the opportunity of seeing what others had been doing all year. Since the date was always early in the year, it did not conflict with the Oakland Art League's fall annual or the September State Fair in Sacramento.

It is commendable that the Santa Cruz Art League was able to maintain its shows throughout the Depression; possibly those cash awards were really appreciated by many of the contestants. At any rate, enter they did, most from the San Francisco area, followed closely by Oakland and Berkeley, with many from the Monterey Peninsula. Of course Santa Cruz was represented, and Southern California sent work from Los Angeles, San Diego, Laguna Beach, and Hollywood. Otherwise there was a cosmopolitan peppering: Belvedere, Morro Bay, Menlo Park, Fresno, Scott's Valley, Mill Valley, etc. Catalogs from the Santa Cruz annuals present a representative cross-section of early twentieth century California art.

Betty Hoag McGlynn

Carmel Art Association

Photo courtesy Archives of Betty Hoag McGlynn

The Carmel Art Association

Today the Monterey Peninsula is famous for its many art galleries. Granddaddy of them all, and most popular, is the Carmel Art Association, an artists' cooperative. Membership is granted only after severe jury selection. As a result the public, at no charge, can enjoy a constantly changing display of the area's finest art.

Carmel-by-the-Sea was established in 1903 by a pair of real estate developers with avowed intent to form a community of culture on beautiful Carmel Bay. They offered "creative people" such irresistible temptations as $50 building lots. Soon the woods and dunes were dotted by tents, lean-tos, shacks, and eventually cottages and mansions. Some people came as summer residents only; others were permanent. The first noted artist to build a home was Sydney Yard, shortly followed by his student Jessie Short; photographer Arnold Genthe; the Englishman Arthur Vachell; and Yosemite painter "Chris" Jorgensen. They were an active group. An Arts and Crafts Society was formed in 1905; two years later it acquired a clubhouse, and in 1922 built the Circle Theatre.

As the art colony grew, so did tourism, partly due to public zeal for traveling during those early days of the automobile. Visitors were attracted by the quaintness of Carmel-by-the-Sea. There were storybook houses. Trees grew in the middle of streets whose corner signs were whimsical. Above all, Carmel-by-the-Sea was the place to observe "real Bohemians." And the artists were eager to have those tourists see (and buy) their works. However, there were few places to properly display them. Both the Arts and Crafts Hall and the theater were inadequate. Only a few commercial galleries existed. A half dozen professionals printed invitations to the public to attend afternoon teas at their studios.* Such open houses were expensive for the hosts, and the visitors often got lost in the woods while hunting for the various cottages.

Finally, on August 8, 1927, twenty artists met in the studio of Josephine Culbertson to hear Jennie Vennerstrom Cannon, a new resident, tell about the founding of the Laguna Beach Art Association in 1918. Enthusiastically, a Carmel Art Association was organized along the same lines: to advance knowledge and interest in art, and to create a spirit of fellowship between local artists and the community.

The organization thrived, attracting members from nearby Monterey, Pacific Grove, Carmel Valley, Pebble Beach, and Big Sur. But the Depression brought rugged problems. In desperation, in the summer of 1931, an effort was made to arouse the public's pride in its art colony and to make people aware of the monetary crisis. An impressive exhibition was held of paintings by the four resident National Academicians: William Ritschel, Paul Dougherty, Arthur Hill Gilbert, and Armin Hansen. It turned the tide. By the end of 1933 the association was able to purchase the property where its charming galleries are still located, just a few steps from the post office in Carmel-by-the-Sea.

*Arthur H. Vachell, M. DeNeale Morgan, Ferdinand Burgdorff, Ida A. Johnson, Josephine M. Culbertson, Louise Fisher MacDougall

Betty Hoag McGlynn

FERNAND LUNGREN
Spring Street Looking South
Oil on canvas, 14 x 19 inches
Courtesy Fernand Lungren bequest, Collection University Art Museum, Santa Barbara

The Arts in Santa Barbara

During the 1920s the art community in Santa Barbara had a very active Community Arts Association which served through four branches: Drama, Music, Plans and Planting (for architectural development and guidelines), and the School of the Arts.[1] The four branches had developed as separate entities between the years of 1920 and 1922. On April 24, 1922, a charter for the nonprofit corporation "Community Arts Association of Santa Barbara" was obtained, the purpose of the association being "to afford individuals the opportunity for self-expression, training and education in music, drama, and the allied arts, and to aid in the cultural improvement of the people and in the beautification of the City of Santa Barbara."[2]

One of the most active members in the association was artist Fernand Lungren (1857-1932) through whose impetus the School of the Arts was founded in June 1920. Lungren had settled in Santa Barbara in 1906. The idyllic and beautiful area was already an attraction for artists, many of whom moved there, especially during the months after the San Francisco earthquake. In 1914 Lungren remarked that "as a field for artistic endeavor, it would be impossible to find a spot more favored than Santa Barbara."[3] By 1920 the resident artists included John Gamble (1863-1957), Carl Oscar Borg (1879-1947), Albert Herter (1871-1950), DeWitt Parshall (1864-1956), Douglass Parshall (b. 1899), and Thomas Moran (1837-1926).[4]

The school purchased the Old Dominquez adobe on the corner of Santa Barbara and Carrillo Streets, and, after some refurbishing, opened in November 1920. Classes were offered not only in the visual arts, but in music, drama, dance, and foreign language as well. Lungren taught illustration, Herter, the life class, and Borg, landscape. Funding was secured through donations and a modest tuition. In addition to instruction, the school held regular exhibitions in its gallery.

In November 1922 the Community Arts Association received from the Carnegie Corporation a grant of $25,000 a year for five years, the money to be distributed among the four branches. The grant was secured through the efforts of Dr. Henry Smith Pritchett, President of the Carnegie Corporation of New York and, at that time, a resident of Santa Barbara. After the 1925 earthquake which severely damaged the school, the Carnegie Corporation gave the association an additional $25,000 for the construction of a new school and, at the same time, extended the original grant through October 1, 1930.[5]

In 1923 Adele (Mrs. Albert) Herter (1869-1946) advised Lungren to persuade Frank Morley Fletcher (1866-1949), then head of the Edinburgh Royal College of Art, to teach a summer session at the school. Fletcher accepted the invitation and, at the end of the session, agreed to become the director of the school for the next three years. (Fletcher retained the position until 1930.) As the new director, Fletcher made recommendations which strengthened the sculpture and design departments, added a class in block printing, and also began teaching the life classes himself.

Parallel to the development of the Community Arts Association and the School of Art, was the development of the Santa Barbara Art Club, which was founded on June 9, 1924 by sixteen artists, among them Lungren, Gamble, Fletcher, Herter, Borg, DeWitt Parshall, Douglass Parshall, Edward Borein (1872-1945), and Colin Campbell Cooper (1856-1937).[6] Eighty-seven year old Thomas Moran was made an honorary member. The club was essentially an artists' cooperative with exhibitions of members held in the old Casa de la Guerra. Within less than a year the club, which became part of the Art League of Santa Barbara, had about fifty members. Besides showing the work of local artists, the league accepted traveling shows. In June 1927, at the invitation of the Biltmore Salon in Los Angeles, an exhibition by members of the league was held there.[7]

Although Santa Barbara continued to have an active artist colony for many years, unfortunately, in the 1930s, the Depression took its toll. With the expiration of the Carnegie Grant and donations declining, the Community Arts Association reluctantly closed the School of Arts. It was a sad commentary for a school which had, in such a short time, established a reputation of first rank among the art schools of the United States, with a faculty that included outstanding, award-winning artists. One of the last activities of the school was a commemorative exhibition in 1933 for its founder, Fernand Lungren, who had died the previous year.

Janet B. Dominik

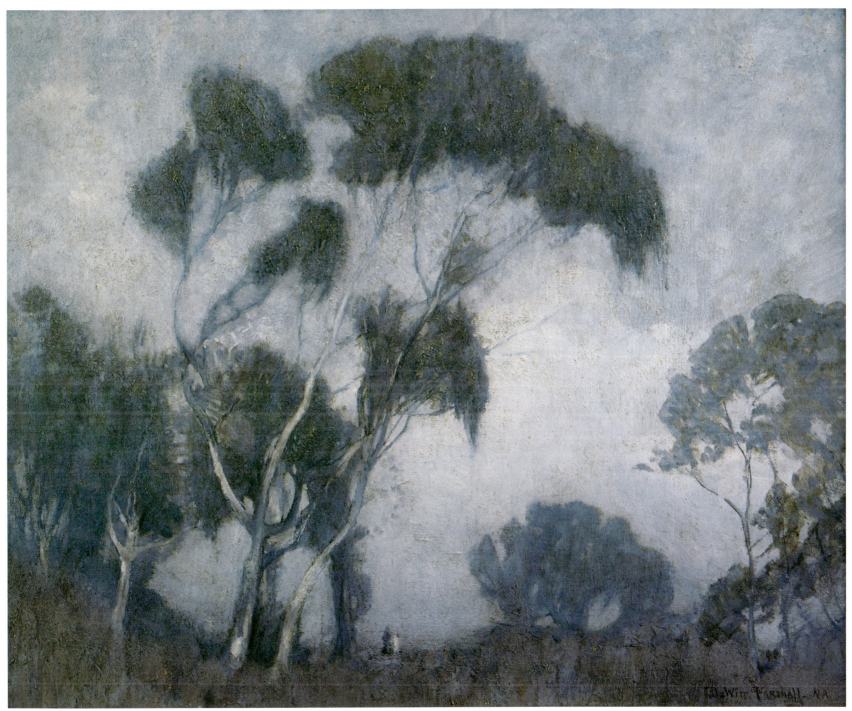

DeWITT PARSHALL
Eucalyptus and Fog
Oil on wood panel, 24 x 30 inches
Courtesy George Stern Fine Arts, Encino, California

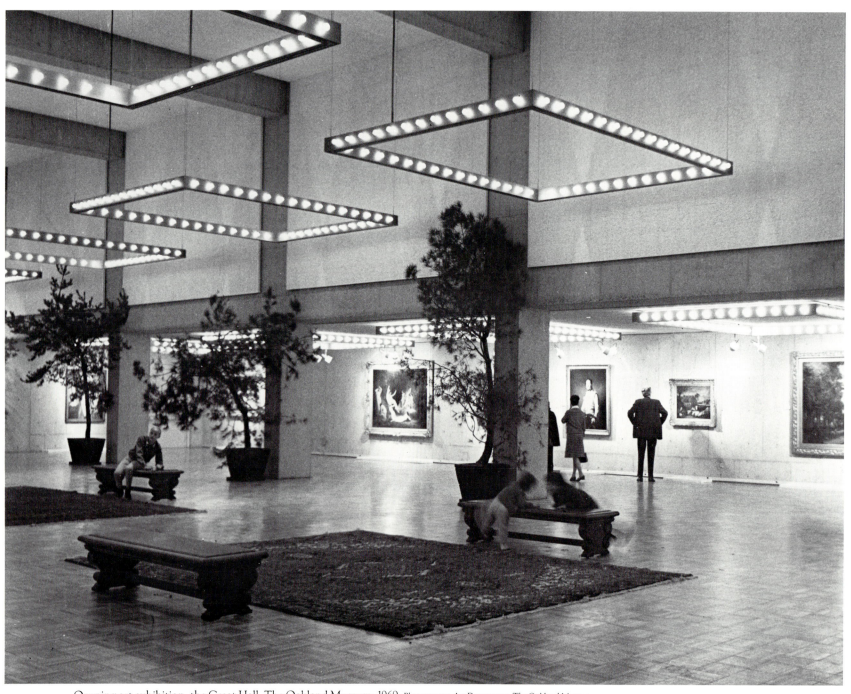
Opening art exhibition, the Great Hall, The Oakland Museum, 1969 *Photo courtesy Art Department, The Oakland Museum*

CALIFORNIA ART AT THE OAKLAND MUSEUM: MEMORIES OF THE BEGINNINGS
by Paul Chadbourne Mills

"Know that at the right hand of the Indies there is an island called California," wrote the author of a popular sixteenth century Spanish tale, a work not unlike some science fiction of today, full of almost-believable flying saucers. An island called California, "very close to that part of the Terrestrial Paradise, which was inhabited by black women without a single man among them, and they lived in the manner of Amazons." Cortez and his adventurers, once Mexico City was subdued, looked for new conquests in the "South Sea"—for rumored wonders which could turn out to be fact or fiction. They looked for a Northwest Passage. They looked for islands rich in pearls. They looked for black Amazons; they looked for California. Somehow the name stuck to the modest peninsula his men did find, and it has been pretty difficult to keep the yeasty chemistry of fantasy out of affairs in California ever since.

I, too, am sort of a latter-day adventurer, one who decided it was possible to conjure up a California, specifically a California of the Arts, at a time when only a few thought such a thing could be brought to exist, and persuaded the Oakland Museum to specialize in it, eschewing all other arts. By the middle of the twentieth century, even we art historians have been forced to give up most fantasy for fact, so any such vision of a California art had to be created out of real paintings, real sculptures, prints, pots and photographs, old ones from neglected parlors, museum basements and second hand stores, new ones from the studios of the artists themselves. It had to be created out of real facts, derived not from the standard art historical books, but from such sources as photocopies of long defunct San Francisco newspapers, gleaned by a corps of dedicated docents. Fortunately, it was really there, this California. Now, thirty-some years later, the Art of California is permanently enshrined in the galleries of the new Oakland Museum and enlivens its other spaces with temporary exhibitions. It speaks forth in books, and it prospers throughout the land.

So much for a beginning flourish. I have been asked to tell you how this adventure came to happen. Now let us settle down to the little tale itself.

What happened was partly the outcome of who I was. I was born in Seattle in 1924 and went through high school there. I was interested in architecture and the arts; not very popular fields, but the public schools there did give surprisingly good training in them then. I also started a career in journalism, which was more accessible than the arts, but I liked it less. World War II sent me off to the least and most civilized places in Alaska for several years. Then to Reed College in Portland, Oregon, and back to art, art history and philosophy of art, but also to uncertainties about them. I then made a plunge at pre-architecture and missed. I left for several years of newspaper work. I later returned to college at the University of Washington in Seattle, and fell into a job at the Henry Art Gallery there, as assistant to Melvin Kohler, who had a brilliant record for bringing new life, contemporary art and crafts and handsome installations to the gallery.

Whatever uncertainty and vacillation about careers I had experienced before stopped once I got planted at the Henry Gallery. I loved buildings, art, exhibitions, installations, public relations, film, television, research and a dozen other things. (I stayed that way for over thirty years; one-plus at the Henry Gallery, seventeen at the Oakland Museum, then twelve at the Santa Barbara Museum.[1])

The prelude to what we did with California art at Oakland occurred, looking back, in the basement storage area of the Henry Gallery. When Kohler's modern moves began, the old Henry collection, mostly Barbizon landscapes and similar works, ended up in that basement storage. I thoroughly enjoyed contemporary art, but something pulled me to these older paintings too. I especially liked a fresh little view of the Le Havre harbor by Eugene Boudin. I chose it as the topic of the undergraduate thesis which the university required of those who wanted to graduate in art history. I loved working on this thesis, and, engorged with naive aspiration, I wanted it to be the best and most comprehensive essay on Boudin ever written in English. Only gradually did I come to realize that it couldn't be. I had never seen the actual harbors, long beaches and cloudy skies where Boudin

worked; I had not seen the major assemblies of his paintings; I did not have access to the letters and other papers in the Boudin archives in the Le Havre museum. Instead of being able to write an essay which had substance in the real world of art history, I was just writing one more student essay, hardly meaningful outside the classroom. Without quite realizing it, I had set myself up to respond in the future especially to artists who had painted in an area I could also see, whose best works and whose research materials I had better access to than anyone.[2]

My move to Oakland came abruptly and was determined more by the fates than by design. Once there, I set out to enter the graduate school at Berkeley in art history, and sought a part-time job at the Oakland Art Gallery, (which we soon renamed the Oakland Art Museum and is known today as the Art Department of the Oakland Museum.) The museum turned out to be full time, and graduate school part time, with my Master's Degree not being received for several years. The museum, founded in 1916 as an outcome of the Panama Pacific International Exposition, had declined as others in the Bay Area had prospered, and its longtime artist-director, William Clapp, had recently retired. It had a long record of competitive annual exhibitions and other projects, but by now it looked awful; the sagging wicker chairs and rusty, teetering pedestal ashtrays matched the worn floor and the dirty skylights. Recalling what Mel Kohler accomplished at the Henry Gallery, we set out to transform the place, and we did. I was much aided by Jan, a school friend from Seattle whom I married in 1955, who, in the course of the next fifteen years, fed thousands in behalf of the museum and helped support our family through her successes in the wholesale apparel field.[3]

To a far greater degree than now, especially in the West, art museums were a learn-on-the-job trade, in which one's teachers were other more experienced museum professionals and one's classrooms were the meetings of the American Association of Museums and its regional councils of the College Art Association and of the Western Association of Art Museums.[4]

The Oakland Art Museum had a permanent collection of sorts. There were a dozen California paintings, good and bad, shading off to an attic-full of unclaimed leftovers from years of competitive shows, most of them dreary, but a few quite surprisingly marvelous. There was a collection of very marginal European paintings from one donor, seldom by the hands of anyone near the artists they hoped to be "close to." There was also a most curious collection of paintings the Czarist Russian government sent off to the 1915 Panama Pacific exposition, among them fine views of Russian churches by Nicholas Roerich and some gigantic scenes of cheerful peasant life on the steppes. They had all been left unclaimed by the succession of Russian revolutionary governments, and, after various other complications, they were sold at auction by the U.S. Customs Service to friends of the museum, who for better or worse, had donated them to us. The museum had no source of funds for purchases; the basic operating budget was supplied by the city, but purchases, prize money and such had to be gifts.

Once we had achieved a wholly different look for the galleries and had an exhibition program and an affiliate group going, the questions of the permanent collection drifted with increasing insistence to the top of current concerns. Whatever we did, I wanted us to be awfully good at it. There was simply no point in entering the fields of classic world art like the de Young Museum and Legion of Honor Museum across

Paul Mills in the old Oakland Art Museum, late 1950s
Photo courtesy Art Department, The Oakland Museum

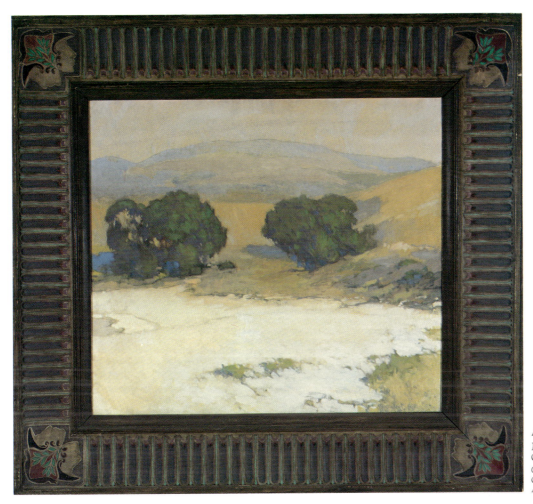

ARTHUR MATHEWS
Monterey Oaks
Oil on canvas, 23 x 26 inches
Courtesy Collection of The Oakland Museum,
Gift of Concours d' Antiques,
Art Guild of the Oakland Museum Association

the Bay; most of the works we had were more of a deficit to our reputation than an asset, and there was no fount of purchase money. We had a long record of presenting contemporary artists of various stylistic persuasions, and had a toe-hold in a field dominated by the San Francisco Museum of (now Modern) Art, but we had to be careful about it.

The legacy of my Boudin thesis was in mind; whatever we chose, we wanted to be central to the works, the subject matter and the research sources. That really meant doing something with California artists. In comparison with the earlier artists of my native Seattle, artists in California from the Yankee beginnings here had been abundant and able, however ignored they currently were. The San Francisco museums were hardly interested in earlier California art; they had some in storage, it turns out, but they were willing to lend, give or sell quite a few good pieces to us.

The choice of specializing in "The Art of California, from the Earliest Times to Present"—excluding Indian art, which was well handled by natural history museums—evolved with the logic of inevitability. I proposed our dedication to it somewhere along in 1954. There were natural allies for this policy. The publishers and editors of *The Oakland Tribune*, the Knowland family, had a great interest in California history and dedicated a lot of space to it, including a whole special page each Sunday. The Librarian of the Oakland Public Library, Dr. Peter T. Conmy, under whose administration we came, was a California history buff and was most supportive of a California History Room in the main library. They all found no trouble in supporting this proposal and did so consistently.

This was not the case in the art world, though. A lot of potential support the brash new curator was beginning to get faded and went sideways when this new specialization was announced. Some of the ground the Oakland Art Museum and I were beginning to gain was now lost, and we were both demoted back down a few steps.

The first painting we acquired for the new California collection was bought in 1954 from the San Francisco print dealer, R.E. Lewis, who had a less prejudiced eye outside the print field than some. It is a marvelously free and brushy oil painting by the French artist Jules Tavernier who had come across the plains to California doing a series of illustrations for *Harper's Weekly* in the 1870s and settled here. It depicts a "Frontiersman and Indian Woman" and cost $175. Without frame. The handyman at the museum and I made a frame for it by cutting down one of the unclaimed frames in the museum attic. Some indication of the reaction of much of the art world was given to us by Alexandre Rabow, a most charming and civilized French art dealer in San Francisco, who, with his wife, Rose, had become special friends. He saw the Tavernier the day we bought it. He was really quite hurt and disappointed we had acquired it. He simply couldn't concur with the choice of California art, and it was only out of his generosity of spirit that we stayed friends at all.

Paul Mills in his office at the old Oakland Art Museum, mid 1960s
Photo courtesy Art Department, The Oakland Museum

I must interrupt here to say something about underdogs. Having been put in the role of one, I learned to have special respect for them. The Oakland Art Museum was an underdog; even American art history was an underdog; certainly California art history was, and Oakland itself was an underdog. In comparison with the sophistication and civility of San Francisco just a few minutes across the Bridge, Oakland was often described by quoting Gertrude Stein, once an Oakland resident, who said, "The trouble with Oakland is, there's no there there." Through some imprecise inner alchemy, all of this went together. I also learned that underdogs worked harder, adapted better and cooperated more than the "overdogs" of success, who worked less, expected more from others and complained harder if they didn't get it. Creating a center for the art of California in Oakland was a natural rallying cry which brought us an amazing degree of support from the ambitious underdogs of the area.

This culminated when the three Oakland museums and their Association, upon the second try, succeeded in passing a municipal bond issue which funded the present marvelous new building; four blocks square, by a now-internationally-known architect (then an underdog!). But that is another story. With underdogs in mind, let us go back to the development of our California art program, and to some of the people who helped make it happen.

From the beginning, again perhaps because of my Boudin thesis experience, I saw the collecting of the art of California as necessarily accompanied by the study of it and the assembly of research information regarding it. I had been intrigued by the exotic name of the "Archives of Futurism," though I had no direct contact with it, and thought our research resources should be called "The Archives of California Art," and so we named it in 1954. Apparently this predates the naming of "The Archives of American Art" started at the Detroit Institute of the Arts by E.P. Richardson. Though we can take a certain pleasure in having been so early on the scene, the Archives of American Art began as a much grander project and has flourished and advanced much further since. There were always close relations between us and the American Archives leaders such as William Woolfenden and gradually, under the leadership in California of Paul Karlstrom and now Stella Paul, many of the dreams we dreamed so easily in the early

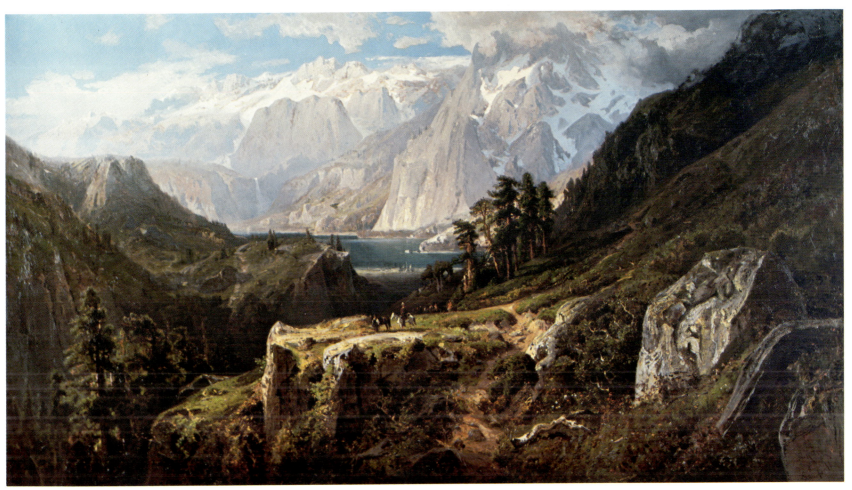

WILLIAM KEITH
California Alpine Grandeur, 1876
Oil on canvas, 39 x 70½ inches
Courtesy Maxwell Galleries Ltd., San Francisco

years are gradually beginning to happen in the light of day.

Within our museum, a lineage of dedicated researchers staffed our archives, among them Lewis Ferbraché who convinced us of the importance of the early San Francisco newspapers' documentation of artists' activities; Marjorie Arkelian, who did many things, notably research and write the catalogue of the Kahn Collection; and now Barbara Bowman. Throughout, volunteer committees, especially those drawn from the art docents which over months gleaned the old San Francisco newspapers, have been marvelously productive. I am sure there have been others, staff and volunteer, since my departure in 1970, who are also deserving of high praise.

The first large California collection acquired for the museum was the collection of the William Keith association, which inherited Keith's estate. Of all early California artists, Keith had the only ongoing support group. It met monthly in Keith's own Berkeley home as the guests of his niece, and they had lovingly preserved not only major paintings but his marvelous sketches and everything else of his. The collection came to us after the death of his niece. Keith was also the subject of the only major biography of a California artist published in the first half of the century.[5]

Warren Howell, of the distinguished fine book firm of John Howell in San Francisco, leaned toward the art side of California history and regularly handled works of art of some historic interest. He made it his business to be a patrician, but in fact he couldn't resist the action, wherever it lay—even in Oakland. He was a major agent seeking early depictions of California for Robert B. Honeyman, Jr., and introduced me to Honeyman, who lent a major selection of his collection to us in 1956 for our first major California exhibition and catalogue. That collection, large and quite a bit stronger on the history side than the art side, is now appropriately nearby at the Bancroft Library at Berkeley. Howell not only introduced us to Honeyman, many other works now in the collection at one time or another went through his hands.

A collector with strong interests in California art and our museum is Howard Willoughby, retired vice-president of Lane Publishing Company, publishers of *Sunset Magazine*. He bought and gave many California works to the museum, served on its governing commission and participated in many other ways. Most notably, he was able to scout out and acquire the entire estate of Edwin Deakin, which had been in storage for decades, and present it to the museum.

One of the most brilliant figures to dabble in California art was Billy Pearson, once a top racing jockey and a national television quiz show star, a collector and later an art dealer. Billy had a naturally good eye for everything he involved himself with: houses, clothes, women, art. His taste for objects and his easy ability to display them with stunning effect are hardly rivalled by those of anyone I have met since. Sniffing another adventure emerging, he took to California art and bought up many things great and small of high quality, some of them which he had heard about from me, many which he had found on his own. Not much later, the Kahn family, which had for long operated a major department store in Oakland, had the grace and generosity to make a major gift of funds to the museum to purchase the Kahn Collection of early California art which would stay in the community as evidence of the Kahn family's gratitude for the long years it had prospered there. The money, a total of $125,000 given in 1965, made possible the purchase of 71 paintings. Some of them singly would today be worth far more than the entire collection's initial dollar cost. The largest single group of purchases was the bulk of the California collection assembled by Pearson, including some of the collection's war-horses, such as the near-lifesize Tojetti "America" in her chariot.

If one is looking for giants in California art, certainly Arthur Mathews is one, and his wife, Lucia is a good ally and second. Their paintings, their furniture, their graphic art, their influence on architecture, and their teaching made them figures of singular importance. Harold Wagner, once a staff member of theirs, carefully assembled everything he could find over the years; paintings, sketches, furniture, graphics and memorabilia. With money earned by the Oakland Museum Association's Art Guild Concours d'Antiques under Elizabeth B. Graser, we were able to purchase most of it in 1965; Harold Wagner generously gave the rest of it. In 1972, the museum mounted a major travelling exhibition of the Mathews collection, with a fine catalogue written by Harvey Jones.[6] The Keith, Deakin and Mathews estates remain three major peaks in the painting

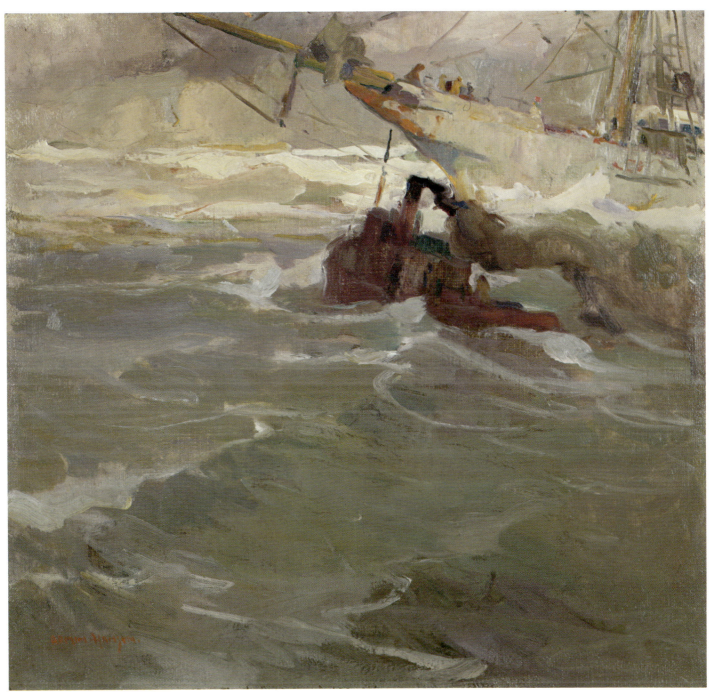

ARMIN HANSEN
Making Port
Oil on canvas, 30 x 32
Courtesy Mr. and Mrs. William A. Karges Jr.

collection.

Being essentially democratic in our outlook on the arts, we saw that the media of photography, prints, crafts and decorative arts were well represented from the beginning of our California collecting, exhibiting and researching. And much more could be said about the dedicated people and their efforts in these areas.[7]

When the Oakland Museum finally opened to the public in September 1969, I began to do something I hadn't done before: to stand back and listen to hear what people thought of what we had done, "to wait for the other shoe to drop," so to speak. It was a statement of Alfred Frankenstein, long time music and art critic of the *San Francisco Chronicle*, which gave me a subjective sense of recognition and conclusion. He was not particularly prone to be effusive, so his words were all the more surprising. He acknowledged my sixteen-year effort in behalf of California art and said, "The art section is going to realign the whole history of art in the United States. All the books will have to be rewritten in accordance with it…Its collection has actually been assembled over a great many years, much of it among paintings which until recently were scorned and rejected…" but upon its opening, "It suddenly makes California a major historic art center, like one of those volcanoes that appear overnight in a cornfield and are 15,000 feet high in a week."[8] There was no need to wait for acknowledgement after that!

Today, it is gratifying to see the fortunes of California art continue to expand, involving an increasing number of able historians and collectors, fine exhibitions, a number of notable publications such as this and a growing national and international awareness.

Now, keep your eyes open for black Amazons.

E. Charlton Fortune, c. 1915
Photo courtesy Monterey Peninsula Museum of Art

Francis McComas
Photo courtesy Monterey Public Library

THE PAINTERS

CARL OSCAR BORG (1879-1947)

BORN
March 3, 1879, Dals-Grinstad, Sweden

DIED
May 8, 1947, Santa Barbara, California

TRAINING AND STUDY
Self-taught
Study of Old Masters in Europe

STUDIO LOCATIONS
Los Angeles
San Francisco
Santa Barbara
Rome
Paris
Gothenburg, Sweden

RESIDENCES IN CALIFORNIA
Los Angeles
Santa Barbara
San Francisco

MEMBERSHIPS
Academy of Western Painters
California Art Club
California Water Color Society
Laguna Beach Art Association
National Academy of Design
Painters of the West
Printmakers Society of California
Salmagundi Club, New York City
San Francisco Art Club
San Francisco Society of Etchers
Société Internationale des Beaux Arts et des Lettres, Paris

AWARDS
First Prize, Painters Club of Los Angeles, 1909
Honorary Mention, International Exhibition at Vichy, 1913
Silver Medal, Versailles, 1914
Silver Medal, Panama-Pacific International Exposition,
 San Francisco, 1915
Gold Medal, Panama-California International Exposition,
 San Diego, 1916
Silver Medal, Société des Artistes Francais, 1920
Paul R. Mabury Purchase Prize, California Art Club, 1920
Huntington Prize, California Art Club, 1923
Silver Medal, Pacific Southwest Exposition, 1928
Gold Medal, Painters of the West, Los Angeles, 1928

PUBLIC COLLECTIONS
Henry Art Gallery, University of Washington, Seattle
M.H. de Young Memorial Museum, San Francisco
Gothenburg Ethnological Museum, Sweden
Los Angeles County Museum of Art
Monterey Peninsula Museum of Art
Lowie Museum of Anthropology, University of California, Berkeley
National Museum of American Art, Washington, D.C.
Phoenix Art Museum
Santa Barbara Museum of Art

In a biography on Carl Oscar Borg published in 1962, Raymond E. Lindgren noted that Borg was one of the few artists who had "reached the degree of excellence in attainment of the spirit and feeling of the desert and its life."[1] Although the Swedish-born artist was essentially self-taught, his work nevertheless ranks with that of other leading painters of the American West, including Charles M. Russell (1864–1926), Maynard Dixon (1875–1946), and Frank Tenney Johnson (1874–1939). In addition, his work as a *plein air* painter earned him fame early in his career, during the 1910s and 1920s.

Carl Oscar Borg was born on March 3, 1879 in Dals-Grinstad, Sweden, the son of Gustaf Borg and Kristina Olsdotter.[2] His father was a career soldier, often absent from home, and the family was quite poor. Borg began to draw at a young age, copying pictures from books. In 1894, at the age of fifteen, he was apprenticed to a house painter. The apprenticeship lasted four years during which time he learned to mix paints and create decorative wall motifs so popular in Sweden.

In the spring of 1899, now considered a "master painter," Borg traveled to Stockholm where he secured employment with a ship-painting firm. He found himself working on a ship as it sailed to France. The trip was the beginning of many years of travel as he searched for the means to attain his goal of becoming more than a painter, but a true artist.

He remained only briefly in France, then journeyed to London where he was able to find a position with George Johansen, a portrait and marine painter. There Borg tinted photographs and began to paint seascapes.

In April 1901 he sailed for the United States, securing free passage in exchange for paintings. For the next two years he traveled throughout the Eastern United States and Canada, working sporadically as a house painter and furniture painter. In 1903 he joined on as a seaman aboard the S. S. *Arizonian* bound for Hawaii and California. At the end of the voyage, he jumped ship in San Francisco and, lacking money, walked the railroad line to Los Angeles.

Settled at last in Los Angeles, Borg found work with a Danish photographer. He began to develop friendships with people in the art world, among them art dealer William A. Cole and *Los Angeles Times* art critic Antony Anderson. In May 1905 Borg submitted a watercolor for exhibition at the Ruskin Art Club. His circle of friends widened to include Idah Meacham Strobridge, owner of the gallery The Little Corner of Local Art, and George Lummis, editor of *Out West* magazine. It was through Lummis that Borg first became interested in the American Indians.

With encouragement from his new friends, he began developing confidence in his art. The first exhibition of his work was held at Steckel Galleries in April 1906. Although the reviews were mixed, the general consensus was that the artist had a promising future.[3]

For the next few years he continued to work and exhibit in Southern California. Artist William Wendt (1865–1946) became a close friend, someone Borg said taught him "more about painting than anyone else."[4] Borg spent the summmer of 1908 painting on the San Miguel Islands off the coast of Santa Barbara.

In the fall of 1908, art patron Mary Gibson sponsored him on a trip to Central America. The trip was fraught with peril from political insurgencies and dis-

CARL OSCAR BORG
The Golden Hour, n.d.
Oil on canvas, 24⅛ x 26⅛ inches
Courtesy the Fine Arts Museums of San Francisco, Skae Fund Legacy

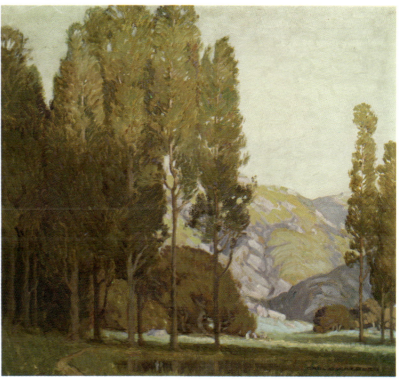

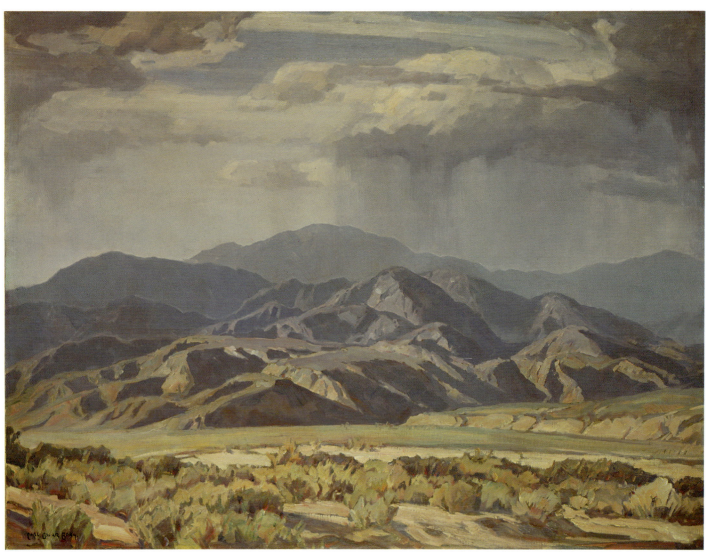

CARL OSCAR BORG
Barriers of the Desert, c. 1922
Oil on canvas, 30¼ x 40¼ inches
Courtesy John H. Garzoli Fine Art, San Francisco

ease, and Borg was briefly jailed as a spy. Nevertheless, he succeeded in taking photographs and making sketches in Honduras, San Salvador, Nicaragua, and Guatemala. He returned to California amid much fanfare in April 1909. In October paintings from that trip were exhibited at the Los Angeles Painters Club Exhibition at the Blanchard Gallery, and his work *La Puerta de Santa Clara* won first prize.

Despite his success, Borg remained financially insecure. However, in the summer of 1909 his work was brought to the attention of Phoebe Apperson Hearst (mother of William Randolph Hearst) who invited the artist to visit her at her home near San Francisco. Mrs. Hearst purchased two thousand dollars worth of paintings, one of which she donated to the University of California at Berkeley. She introduced him to important San Franciscans, and an exhibition was arranged at Helgesen's Gallery in April 1910.

Borg remained in San Francisco for the next several months. In September, with financial backing from Mrs. Hearst, he left for Europe, accompanied by

Dr. Gustavus Eisen, Curator of the California Academy of Science. The trip would last four years, during which time they visited Spain, Egypt, Italy, France, Switzerland, Holland, Belgium, and Sweden. From April 1911 to April 1912 Borg lived in Rome; for the last two years of the trip, from the fall of 1912 until 1914, the artist lived in Paris. Although he was disturbed by the extremely modernist works which he saw in Paris, he chose to remain and absorb as much as he could of European art. His own work received much attention. In January 1913, a one-man exhibition was held at the Jules Gautier Galerie. The exhibition, which included works shipped to France by Mrs. Hearst, was a huge success and reported in the Los Angeles press. French critics described his works as powerfully expressive, yet intensely poetic.[5]

With the outbreak of war, Borg returned to the United States. He stayed briefly at the Salmagundi Club in New York City where, in December 1914, an exhibition of his watercolors was held at Arthur H. Hahlo and Company. He then returned to San Francisco where for the next two years he worked out of a studio on Post Street. In the winter of 1915 he received first prize from the California Art Club, and in the spring he participated in the Panama-Pacific International Exposition, exhibiting five etchings and three paintings, one of which received a silver medal.

In 1916 Borg began what would be a life-long project—painting the desert of the Southwest and its native people. Phoebe Hearst arranged for him to go to Arizona to photograph and paint the Indians for the University of California Department of Ethnology. He lived with the Hopi and the Navajo and was profoundly moved by the experience. His paintings celebrated the spirit of the Indian and of the West. He would return every spring for fifteen years, establishing warm, lasting friendships with several tribal members. Some years later, reflecting on the predominance of the Indians in his art, Borg stated:

> The Indians, of course, interested me because to my mind they are the 'only Americans,' a fast disappearing race, and I wanted to try and preserve some of their customs and religions in a permanent form.[6]

In the best of these works Borg "evoke[s] in the spectator a powerful sense of wonder at the sadness and the dignity of man in nature."[7]

In August 1918 he married Madeline Carriel, a young art student from Los Angeles. The couple moved to Santa Barbara, and there he developed friendships with artists Thomas Moran (1837–1926), Edward Borein (1872–1945), and Charles M. Russell. He continued to make trips to Arizona and New Mexico, firmly establishing his reputation as a painter of the American Indian and the Southwest. His work was exhibited in Los Angeles at Kanst Galleries, Cannell and Chaffin, Stendahl Galleries, and the Los Angeles Museum.[8] Borg also taught at the Santa Barbara School of Arts.

Those who knew him described him as virile, versatile, and likeable, yet he could also be moody, nervous, and intense.[9] It was the latter traits that caused his wife considerable stress. She was also unhappy with the isolation she felt in Santa Barbara and longed to return to more familiar surroundings in Los Angeles. These personal problems were exacerbated by the fact that even with his success, Borg continued to struggle financially.

In 1924 he sold their home in Santa Barbara, and the couple returned to Los Angeles, moving to a studio-home in Hollywood. He met actor Douglas Fairbanks who hired him as art director and set designer for his movie *The Black Pirate*. Borg's work was so acclaimed that his services were in demand by other movie studios for the next several years.

In the early 1930s a combination of factors led to his becoming seriously depressed. He separated permanently from his wife, his career in Hollywood came to an end, and the influx of modernism in the arts found his work and that of other artists committed to realism no longer in favor. He did complete several commissions for book illustrations, including a series of twelve paintings for the covers of *Touring Topics* in 1931, which were later republished in the book *Cross, Sword, and Gold Pan* in 1936. He continued to work in gouache, watercolor, and drypoint etching, and began doing woodblock prints.

In April 1934 Borg returned to his native Sweden for a visit which would last until fall. On his return to the United States he was honored with an exhibition of his work at the Smithsonian Institution in Washington, D.C. In December the exhibition moved to the Grand Central Galleries in New York. He returned to Los Angeles where a retrospective of his work was held at the Biltmore Salon in the spring of 1935. That summer he moved back to Santa Barbara. Still he was not happy and decided to leave California again. In April 1936 he moved to New York City,

intending thereafter to spend the winters in California. Disillusionment continued to haunt him as he found his art more and more out of favor with the critics. In the summer of 1936 he returned again to Sweden.

In November 1936 he met Lilly Lindstrand, and they became engaged. He returned to the United States to settle his affairs and, while in New York in March 1938, he was elected an associate of the National Academy of Design. In June he returned to Sweden where in October he and Lilly were married. They settled in Gothenburg where the artist, with his eminent reputation became a prominent member of the community. In May 1939 a major exhibition of his work was held at Gummeson Gallery in Stockholm.

In September 1945, Borg and his wife returned to the United States, settling in Santa Barbara. On May 8, 1947 the artist succumbed to a heart attack. His love of the Southwest was reflected in the simple request in his will that his ashes be scattered in the Grand Canyon.

In the winter of 1948 a memorial exhibition of his work was held at Cowie Galleries in Los Angeles. Arthur Millier commented on the artist's versatility, noting that he was "less 'typed' than most California painters of his time. "Much of his choicest work…consists of watercolors and gouaches in which his forceful drawing and fresh notation of color are seen at their height…[his] dry points of the Southwestern Desert and its people…are among the finest ever made of that region…incisively drawn and dramatically composed."[10]

Janet B. Dominik

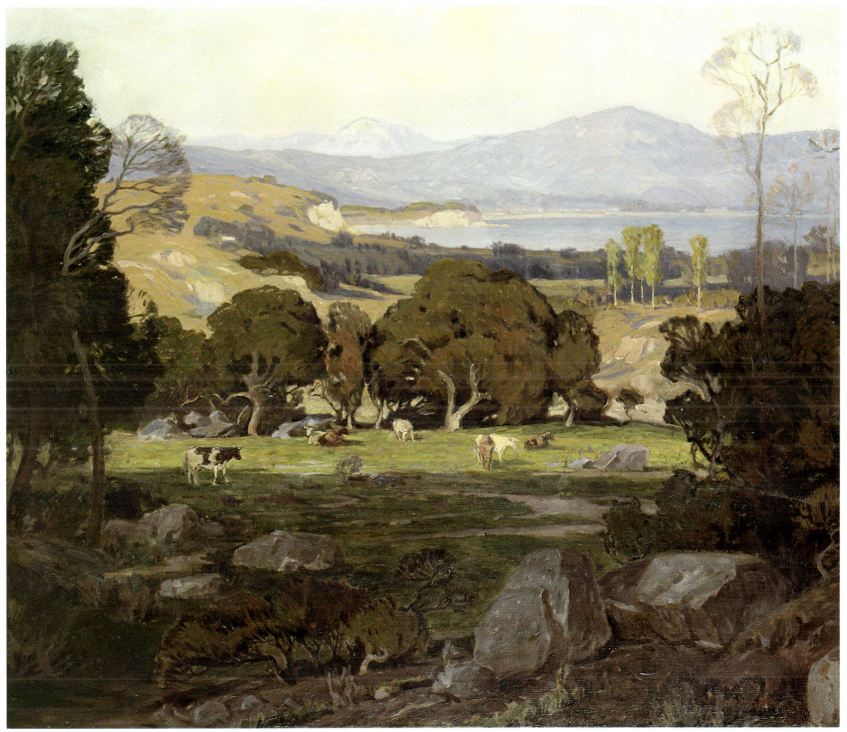

CARL OSCAR BORG
California Landscape, c. 1915
Oil on canvas, 36 x 43 inches
Courtesy The Fieldstone Company

ANNE M. BREMER (1868–1923)

BORN
May 21, 1868, San Francisco

DIED
October 26, 1923, San Francisco

TRAINING AND STUDY
California School of Design, San Francisco
Art Students League, New York City
Académie Julian, Paris

STUDIO LOCATIONS
San Francisco

RESIDENCES IN CALIFORNIA
San Francisco

MEMBERSHIPS
California Art Club
Sketch Club
San Francisco Art Association

AWARDS
Bronze Medal, Panama-Pacific International Exposition, 1915
Bronze Medal, San Francisco Art Association, 1918

PUBLIC COLLECTIONS
Mills College Art Gallery, Oakland
Monterey Peninsula Museum of Art
The Oakland Museum
San Francisco Museum of Modern Art

Photo courtesy Anne Bremer Memorial Library, San Francisco Art Institute

nne M. Bremer was one of the earliest converts to the ideas preached by Arthur F. Mathews, her one-time mentor. She also played an active role in the artists' club-life of San Francisco and occasionally tried her hand at poetry.

Born in San Francisco on May 21, 1868, to parents recently emigrated from Germany, Anne Bremer showed an early interest in drawing. She enrolled at the California School of Design, the educational arm of the San Francisco Art Association at a time when Emil Carlsen, the Eastern still-life painter, was serving as director of the school, probably about 1886–1888. A year or two later, probably between 1888 and 1889 she enrolled at the San Francisco Art Students League, taking lessons from Arthur Mathews, recently returned from Paris.

She joined the Sketch Club, a local artists' club whose membership was entirely female and which held regular annual exhibitions and sponsored outings to picturesque places like the Carmel seashore. In 1901 Anne Bremer left San Francisco for Paris, the magnet then for every artist with dreams of a successful career. She enrolled at the Académie Julian and a few months later she began taking lessons from Andre L'Hote, the modernist painter.

She returned to San Francisco, probably in 1902 as she exhibited two paintings at the First Exhibition of the California Society of Artists, a secessionist group in San Francisco, giving her address as 1318 Sutter Street. In 1905 she accepted an invitation to become president of the Sketch Club, an organization in the throes of change.

ANNE BREMER
Old Fashioned Garden
Oil on canvas, 20 x 24 inches
Courtesy The Mills College Collection

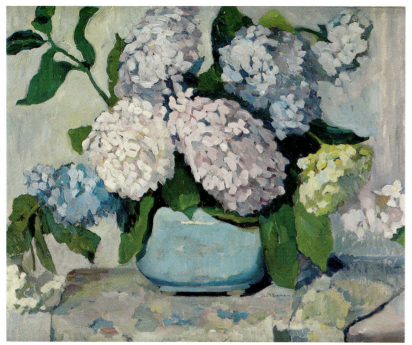

ANNE BREMER
Still Life, c. 1915
Oil on canvas, 25 x 30 inches
Courtesy Barrett H. Willson Fine American Paintings, San Francisco

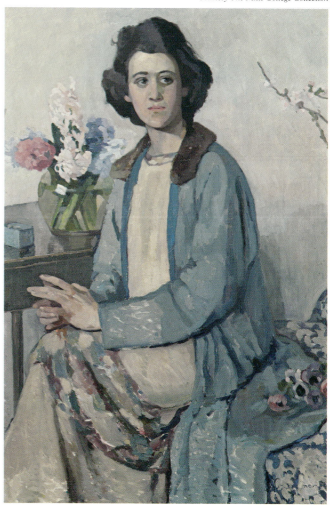

ANNE BREMER
The Blue Coat
Oil on canvas, 45¼ x 31¼
Courtesy The Mills College Collection

Organized in 1887, the Sketch Club exhibitions traditionally featured paintings of florals and still-life. With a new generation of members exposed to the stylistic upheavals in New York and Paris, auguries for change began to gather. Anne Bremer stood at the eye of the storm and her elevation to the presidency constituted symbolic recognition and endorsement of these changes.

The first evidence of a change was the spring, 1906 exhibition of the Sketch Club. The majority of paintings on view derived from various Impressionist ideas and among the exhibitors were E. Charlton Fortune, the club's treasurer, and Lucia K. Mathews. The show was a hit with the local press and art public, but an even greater upheaval was to strike within a month—the San Francisco earthquake and fire of April 1906.

Anne Bremer's studio, as with most of those of her fellow-artists, was destroyed, but she maintained her residence in the city, continuing to paint and to refine her thinking. She was a civic benefactress, contributing murals for various institutions and exhibiting at the Sketch Club, reestablished in temporary quarters. Another two years were spent in France in 1910–1912, and in 1915 the Group Jury for Paintings and Drawings of the Panama-Pacific International Exposition hung five paintings by her in the Department of Fine Arts. For her efforts she was awarded a bronze medal by the International Jury of Awards.

About this time her style began to undergo a change from the crepuscular palette of an earlier phase to a lighter, more vibrant and painterly technique. By this time too she had reopened a studio on Post Street in the rebuilding downtown San Francisco. Her place in San Francisco's art life firmly established, she continued to paint and exhibit when a premature illness began to erode her vigor. Diagnosed as leukemia, she suffered from the increasingly debilitative effects of the disease until her death on October 26, 1923. An occasional writer of poetry, an art closely allied to painting, she composed *The Dark Visitor* shortly before she died:

> She waits for me at night,
> And will not let me go
> Alone to bed;
> Clutches me tight,
> And chokes my throat, her head
> Heavy upon my chest.
> By cunning, grim deceit,
> She clasps me to her breast,
> With lead weighs down my feet,
> And sears my face with her hot breath,
> Sighing of ills and death.
>
> Dark wanton, false!
> In truth of sunlit day,
> Her perfidy exposed, shamefaced,
> She slinks away.

Raymond L. Wilson

ANNE BREMER
Carmel, 1925
Oil on canvas, 22¾ x 28 inches
Courtesy The Mills College Collection

HENRY JOSEPH BREUER (1860–1932)

Henry J. Breuer, 1918, by W.E. Dassonville
Photo courtesy Art Department, The Oakland Museum

BORN
August 16, 1860, Philadelphia, Pennsylvania

DIED
February 19, 1932, San Francisco, California

TRAINING AND STUDY
Art Schools in Buffalo, New York and Cincinnati, Ohio
Further studies in New York, Paris, and London
San Francisco Art Association, 1888-1894

STUDIO LOCATIONS
San Francisco
Santa Barbara
Pasadena

RESIDENCES IN CALIFORNIA
San Francisco
Santa Barbara

MEMBERSHIPS
The Bohemian Club
English Art Club, London
San Francisco Art Association
Society of American Artists, Paris

AWARDS
First Prize, The Boehmian Club, 1905
Silver Medal, Alaska-Yukon-Pacific Exposition, Seattle, 1909
Gold Medal, Panama-Pacific International Exposition, 1915

PUBLIC COLLECTIONS
Crocker Art Museum, Sacramento
Mills College Art Gallery, Oakland
The Oakland Museum

In 1905 artist John Donovan wrote to Henry J. Breuer applauding his skills as one of America's foremost landscape painters:

> You have not only the sentiment, but you get the grandeur and majesty of nature with the most wonderful quality of paint and purity of color. A man may well be happy to paint as you do.[1]

Breuer's happiness with his chosen vocation was reflected in the enthusiasm with which he pursued it. Although born and raised in the East, it was primarily in California that he found his inspiration.

Henry Joseph Breuer was born on August 16, 1860 in Philadelphia, Pennsylvania, the son of Joseph and Martha Breuer. His father was a German-born naturalized American. Breuer attended public schools in Philadelphia where he first revealed his natural artistic abilities. He attended art school in Buffalo, then in 1880 moved to Cincinnati where he continued to study while employed as a decorator for Rookwood Pottery.[2] He also worked as a lithographer and, in 1884, moved to New York where he found employment for a few years as a mural decorator.[3] During this period he visited San Francisco on two occasions. In 1888 he made the decision to settle permanently in California. After moving to San Francisco he obtained employment as a lithographer with the firm of Dickman and Jones and began to paint landscapes.

In 1891 Breuer married Fannie A. Palmer. For the next ten years he was an active member of the San Francisco art community, including serving as art editor for the *San Francisco Chronicle* from 1890 to 1892. In 1893 he and he wife traveled to London and Paris where he was reportedly impressed by the artists of the Barbizon School, especially the work of Corot. After his return to San Francisco he became the editor of *The Californian*, a San Francisco literary and art magazine, for which he provided many illustrations. He retained this position until 1902.[4]

In 1895 a major exhibit of Breuer's work was held at Keppel's Gallery in Chicago. The paintings, all of California, were described as "bathed in the vapory, opalescent atmosphere of twilight."[5] In San Francisco Breuer was an active exhibitor with both the San Francisco Art Association and the Bohemian Club. His works were praised for their restrained interpretations of the many moods of nature.[6]

In searching for subject matter, Breuer considered no area too remote or inaccessible. He had a specially built studio-wagon drawn by two horses in which he and his wife traveled up and down the Pacific Coast, from Oregon to Santa Barbara and inland, from Yosemite to the High Sierras. On these trips he would exchange paintings for provisions. He once remarked that he chose to paint "the grand and big and strong" and therefore often had "to travel far and endure much, but the game is worth the effort,…"[7] In 1904 Breuer and his wife spent several months in Pittsburgh and Cincinnati, living on a houseboat which served the same purpose as his studio-wagon. In Pittsburgh the boat was anchored in the Allegheny River, and from there the artist made many studies of the cityscape including a dramatic night scene showing the fiery glow of the furnaces of the steel mills.[8] After

HENRY JOSEPH BREUER
In Mission Canyon, Santa Barbara, 1902
Oil on canvas, 42¼ x 36½ inches
Courtesy Collection of The Oakland Museum

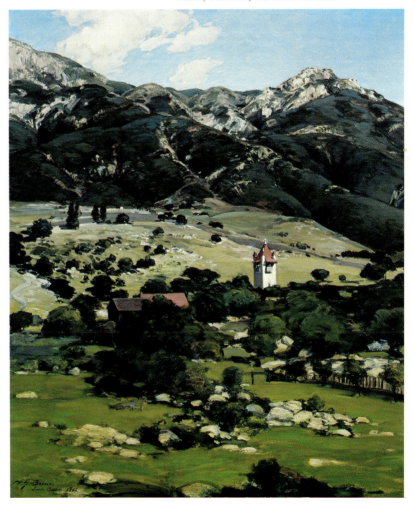

HENRY JOSEPH BREUER
The Cliffs, San Francisco, 1901
Oil on canvas, 24 x 20 inches
Courtesy Stewart American Art, San Francisco

a few months Breuer had the boat towed up the Ohio River to Cincinnati where he renewed old acquaintances.

Breuer returned to California in 1905, now considered one of the best landscape painters in the United States.[9] He exhibited with the Bohemian Club, sold eleven paintings, and received the one hundred dollar prize for best painting in the show. At the end of the year he had his first exhibition at Schussler's Gallery. Included in the show were a few works done shortly after his return from Europe while briefly under the influence of Corot. These works were described as "tender, refined, warm in color and broad in treatment."[10] The more recent works in the exhibition were larger, bolder, and direct, with pure color and "that crystal atmosphere that belongs to California after a rinsing rain."[11]

The artist spent the year 1906 in Santa Barbara. It was there that he renewed his acquaintance with Adolphus Busch, the St. Louis millionaire and art connoisseur, who had a winter residence in Pasadena.[12] Busch had begun acquiring Breuer's paintings in 1905, noting that he was "confident" that they would be greatly appreciated and increase in value over the years.[13] The following year Breuer made brief sojourns to Pasadena. His reputation as a favorite artist of Busch preceded him, and he was received with interest and enthusiasm by art patrons there.[14]

During his many trips throughout California and the West, Breuer made numerous studies and sketches on location from which he would later produce a finished painting. It was reported that he only completed five to six paintings a year due to his meticulous methods of study and observation.[15] He was an extremely versatile artist whose style could range from an elaborate, realistic study of nature to a more idealized interpretation. He was described as charming and modest, an "out-of-doors man," yet, due to his many travels, cosmopolitan and well-informed in all subjects.[16]

Over the next few years Breuer's reputation as a painter of the California landscape grew to an international level. His work was exhibited in Berlin and Munich in 1910, and he held a membership in the English Art Club in London. At the Panama-Pacific International Exposition in 1915, Breuer received the gold medal for his painting *Santa Inez Mountains*. The work was acquired by Frederick Tillman of San Francisco who was one of Breuer's leading patrons in that city. In 1919 Breuer exhibited a painting of Mt. Whitney at Rabjohn & Morcom's in San Francisco. The work was described as "a remarkably extensive panorama" of "extreme realism" presenting "an impression of the precision and care characteristic of Breuer."[17] Breuer's work was compared to that of Albert Bierstadt (1830–1902), not in the sense of a similarity of styles, but rather in the commonality of their subject matter and the reputations they developed as painters of the grandeur of California.[18]

Breuer died in San Francisco on February 19, 1932 after a long illness. A memorial exhibition of his work was held at the Palace of the Legion of Honor in September of that year.

Janet B. Dominik

HENRY JOSEPH BREUER
Santa Barbara, 1902
Oil on canvas, 33½ x 41 inches
Courtesy The Mills College Collection

GIUSEPPE CADENASSO (1858–1918)

BORN
January 2, 1858, Marogolla, Italy

DIED
February 11, 1918, San Francisco

TRAINING AND STUDY
Private lessons with Joseph Harrington
California School of Design (Arthur F. Mathews)

STUDIO LOCATIONS
San Francisco
Oakland
Alameda, California

RESIDENCES IN CALIFORNIA
San Francisco

MEMBERSHIPS
The Bohemian Club, San Francisco
San Francisco Art Association

AWARDS
Gold Medal, Alaska-Yukon-Pacific Exposition, Seattle, 1909
Gold Medal, California State Fair

PUBLIC COLLECTIONS
Boggs Collection, Shasta State Historic Park, California
The Bohemian Club, San Francisco
M. H. de Young Memorial Museum, San Francisco
Mills College Art Gallery, Oakland
Nevada State Capitol

Photo courtesy John H. Garzoli Fine Art, San Francisco

One of the most respected and popular artists in San Francisco during the late 1890s and early 1900s was Giuseppe Cadenasso, who was praised for his individuality and the consistent high quality of his work. Cadenasso found a quiet poetry in the beauty of the Northern California landscape which he deftly communicated with subdued tones in the media of both oil and pastel.[1]

Giuseppe Leone Cadenasso was born in Marogolla, Italy, near Genoa, on January 2, 1858.[2] His father was a tenant farmer on a large fig orchard. In 1867 the young Cadenasso emigrated to the United States with his uncle, who had purchased a small vineyard in Capay, California. Not content with rural farm life, Cadenasso, as soon as he was of age, traveled to San Francisco. There he obtained employment as a waiter at Coppa's Restaurant which was located near the artists' colony on Sacramento Street.

As a child Cadenasso had shown an interest in drawing, and he soon began expressing his artistic talents by sketching on the walls of the restaurant and by making crayon caricatures of the guests. His work attracted the attention of artist Jules Tavernier (1844–1889) who gave him encouragement. Tavernier subsequently introduced him to veteran artist Joseph Harrington (1841–1900) who consented to instruct Cadenasso at no charge. The young artist found employment in the studio of a local fresco painter, but soon lost the job apparently because his work was better than that of his employer.[3]

Having a fine, although untrained, tenor singing voice, Cadenasso next found work with the Tivoli Opera House. It was through his association with the opera that Cadenasso met Leah McKenzie, daughter of prominent San Franciscan Colonel John W. McKenzie, and, like Cadenasso, a semi-professional singer. They were married in 1884. During the early years of their marriage, Leah gave singing lessons and Cadenasso found work making crayon enlargements of photographs. After saving enough money he enrolled in the California School of Design where he studied under Arthur Mathews. While there he met and received encouragement from a fellow student, artist Granville Redmond (1871–1935), and also from an instructor, Raymond Yelland (1848–1900).[4] During this period he began exhibiting and sold his first painting, *The Gathering Storm*. To earn extra money he occasionally accepted a portrait commission, although he felt portrait painting to be "drudgery."[5]

After a few years of struggling, Cadenasso began to see the fruits of his labor. Art patron Hugh Tevis purchased $1,200 worth of paintings in one afternoon, and Morton Mitchell, another wealthy art patron, "hailed him as one of the few originals in landscape painting."[6] With their financial situation much improved, Cadenasso and his wife built a home

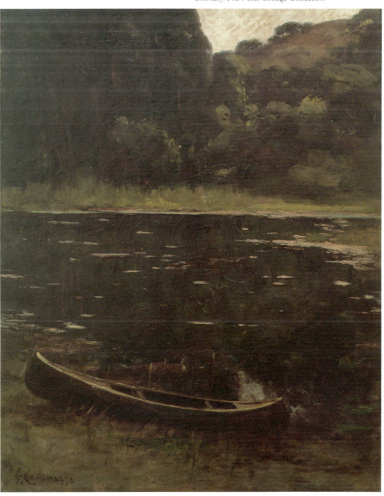

GIUSEPPE CADENASSO
Lake Aliso
Oil on canvas, 21 x 33¼ inches
Courtesy The Mills College Collection

on Russian Hill overlooking San Francisco Bay. In 1890 their only child, a son, Leone, was born.

Cadenasso was well liked and became a leader in the artistic community. His home was the scene of many gatherings of artists, musicians and literati. Many of these parties turned into impromptu concerts with both host and hostess leading the singing. A visitor to his studio commented that music seemed to inspire Cadenasso's art, noting that while painting he would sing with "dramatic fervor of the Italian temperment, a bit of 'La Boheme', or 'Pagliacci', or perhaps 'Faust'."[7]

Although many of his fellow artists traveled to Europe to further their artistic studies, Cadenasso remained in the San Francisco area throughout his career.[8] His art is therefore "purely Californian."[9]

Desiring only to interpret the beauty of nature, he found endless subject matter in the Northern California landscape—in the woods and fields, in the marshes, along the ocean shore. These were depicted with a sensitivity for light and atmosphere ranging from the veiled misty light of dawn to the subdued tones of evening. He preferred to work *en plein air*, painting small works utilizing both oils and pastels. Occasionally he would paint a larger canvas in his studio based on one of the smaller paintings. A favorite theme in his paintings was the eucalyptus tree, and it was for his sensitive interpretations that he became known as the "Corot of California."[10] In some paintings the inclusion of ethereal-like figures, usually women, enhanced the dream-like quality of the work. Cadenasso's art, in fact, may be seen as influenced by

GIUSEPPE CADENASSO
Untitled (#35)
Oil on canvas, 20³⁄₁₆ x 30³⁄₁₆ inches
Courtesy The Mills College Collection

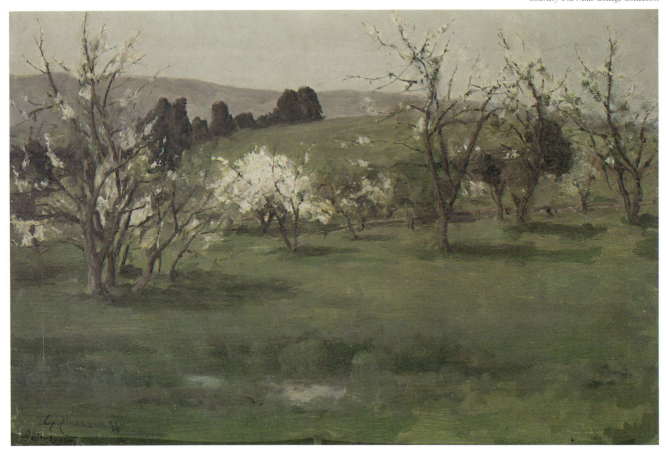

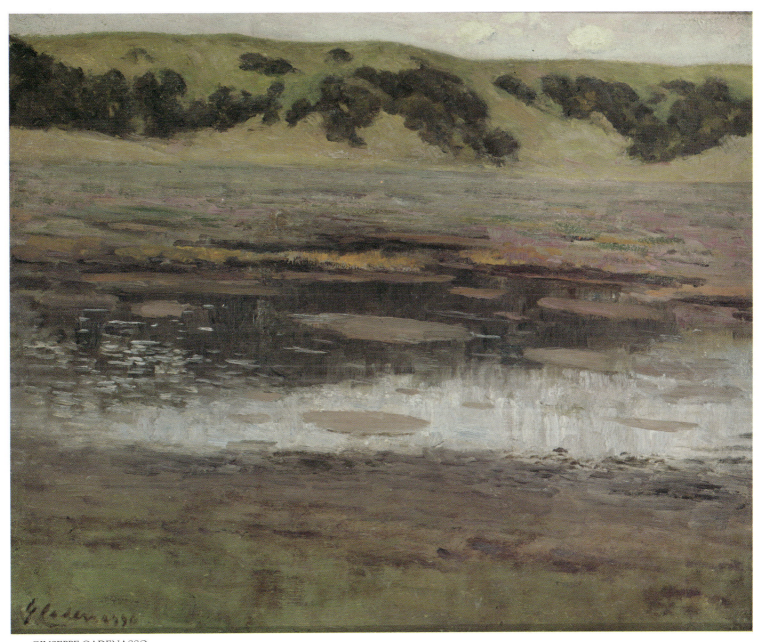

GIUSEPPE CADENASSO
Marin Marshes, c. 1900
Oil on canvas, 22 x 27 inches
Courtesy Joseph Chow Associates

the Barbizon painters and the later work of George Inness who had exhibited with William Keith at Morcom's Galleries in San Francisco in 1891.[11]

During the mid 1890s Cadenasso began actively exhibiting with both the San Francisco Art Association and with the Bohemian Club which he joined in 1896. In 1902 he was appointed a Professor of Art at Mills College in Oakland, a position which he held until his death.

The earthquake and fire of 1906 completely destroyed the artist's Post Street studio although, fortunately, his home was spared any damage. He moved his studio to Oakland, and, in November, exhibited over twenty paintings and pastels at the James D. Hahn Galleries. The exhibit was a critical and financial success. The following year another successful exhibition was held at Schussler's Gallery in San Francisco.

In 1909 Cadenasso moved his studio once again, this time to Alameda County where he found new landscape scenes to interpret. That same year his painting *Autumn*, which was painted in the area, received the gold medal at the Alaska-Yukon Exposition in Seattle. In 1910 the most impressive exhibit of his work was held at Helgesen Galleries on Sutter Street in San Francisco. His work was praised for its

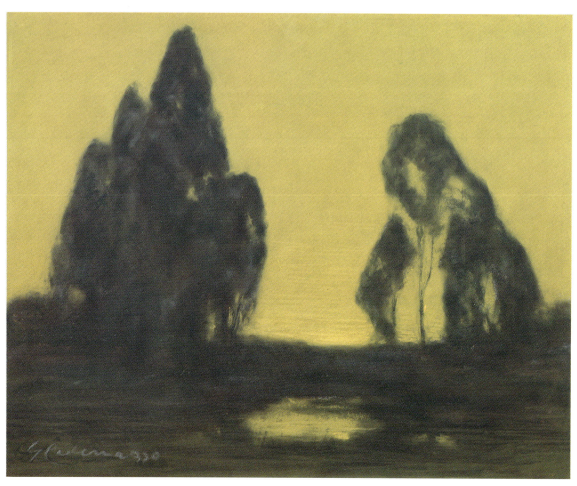

GIUSEPPE CADENASSO
Tonal Piece
Pastel, 20 x 16 inches
Courtesy Jerry Jackson

mystical, atmospheric qualities. Porter Garnett of the *San Francisco Chronicle* stated:

> The atmospheric qualities of [Cadenasso's] canvases are rich and pleasing. One almost feels the rich freshness of the fog. They are of his own creation, and as such, differ from the work of any of the coast artists…[12]

Another critic observed that the artist possessed "an individuality and a power of expression that unite to give his work distinction and permanent value."[13] Such praise tempered the criticism the artist received as being imitative of William Keith.[14] Laura Bride Powers, art critic for the *San Francisco Call*, defended Cadenasso, stating that he was not imitating another artist's methods, but rather was interpreting a similar mood in nature.[15]

Cadenasso died on February 11, 1918, as a result of injuries suffered when he was struck by a car in San Francisco. His passing was greatly mourned by the art world. J. Nilsen Laurvik, Director of the Palace of Fine Arts noted:

> Cadenasso's work, fine as it was, had not reached its zenith, I believe, and had he been spared a few years longer he would have created pictures whose beauty would have been reflected around the world. California art has suffered a great loss in his untimely death.[16]

At the time of his death the artist was working on a painting entitled *The Sign of the Eucalyptus*. As a memorial tribute to him, the Board of Parks Commissioners declared a group of eucalyptus trees in Golden Gate Park to be thereafter known as "The Cadenasso Group."[17]

Janet B. Dominik

SOREN EMIL CARLSEN (1853–1932)

EMIL CARLSEN
Self Portrait
Oil on canvas, 35½ x 29½ inches
Private collection

BORN
October 19, 1853, Copenhagen, Denmark

DIED
January 2, 1932, New York, New York

TRAINING AND STUDY
Danish Royal Academy, Copenhagen (Architectural Student)
Académie Julian

STUDIO LOCATIONS
Boston
Chicago
New York City
Paris
San Francisco

RESIDENCES IN CALIFORNIA
San Francisco

MEMBERSHIPS
American Federation of Arts, New York City
Century Association, New York City
Lotos Club, New York City
National Academy of Design
National Arts Club, New York City
Salmagundi Club, New York City
Society of American Artists, New York City

AWARDS
Gold Medal, Louisiana Purchase Exposition, St. Louis, 1904
Second Inness Prize, Salmagundi Club, 1904
Show Purchase Prize, Society of American Artists, 1904
Webb Prize, Society of American Artists, 1905
Temple Gold Medal, Pennsylvania Academy of Fine Arts, 1912
Lippincott Prize, Pennsylvania Academy of Fine Arts, 1913
Sesman Gold Medal, Pennsylvania Academy of Fine Arts, 1916
Inness Medal, National Academy of Design, 1907
Saltus Gold Medal, National Academy of Design, 1916
Carnegie Prize, National Academy of Design, 1919
Hurd Third Medal, Carnegie International, 1908
Bronze Medal, Buenos Aires, 1910
Silver Medal, National Arts Club, 1915
Medal of Honor, Panama-Pacific International Exposition, 1915
Gold Medal, Philadelphia Sesqui-Centennial Exposition, 1926

PUBLIC COLLECTIONS
Addison Gallery of American Art, Andover, Massachusetts
Albright-Knox Art Gallery, Buffalo Fine Arts Academy, New York
Art Institute of Chicago
Art Museum, Princeton University, Princeton, New Jersey
Brigham Young University Art Gallery, Provo, Utah
Brooklyn Museum, Brooklyn, New York
California Historical Society, San Francisco
Cleveland Museum of Art, Cleveland, Ohio
Corcoran Gallery of Art, Washington, D.C.
Dallas Museum of Fine Arts, Texas
Dayton Art Institute, Dayton, Ohio
Detroit Institute of Arts, Michigan
High Museum of Art, Atlanta, Georgia
Joslyn Art Museum, Omaha, Nebraska
Mills College Art Gallery, Oakland
Monterey Peninsula Museum of Art
The Metropolitan Museum of Art
Museum of Fine Arts, Houston, Texas
National Museum of American Art, Washington, D.C.
New Britain Museum of American Art, New Britain, Connecticut
North Carolina Museum of Art, Raleigh, North Carolina
Norton Gallery of Art, West Palm Beach, Florida
The Oakland Museum
Pennsylvania Academy of Fine Arts
Rhode Island School of Design
St. Louis Art Museum
San Diego Museum of Art
Santa Barabara Museum of Art
Seattle Art Museum
Toledo Museum of Art, Toledo, Ohio
Wadsworth Atheneum, Hartford, Connecticut
Worcester Art Museum, Massachusetts

Emil Carlsen was one of the most talented and versatile artists of his time. His career as a painter and teacher lasted nearly sixty years and brought him wide renown and considerable success. The four years that Carlsen spent in San Francisco might seem to be only a brief interlude, yet it was a period that was pivotal in his own development and one that had a strong and lasting impact on art in California.

Carlsen arrived in the United States in 1872 after receiving academic training as an architectural student at the Royal Academy in his native Denmark. His start was in Chicago where he worked as an assistant to the Danish painter Holst. When Holst returned to Denmark, Carlsen set up his first studio. The sculptor Leonard W. Volk, who had just organized the Chicago Art Institute, admired Carlsen and named him the first instructor of painting at the school. In 1875, at the suggestion of L.C. Earle, Carlsen went to Europe for more study and found his strongest influence in the work of Old Masters, particularly Chardin, in Paris. He formed friendships with French and American artists and returned to set up a studio in Boston. There he struggled for a time before his still life paintings began to gain notice. The dealer William Blakeslee, knowing that his clients disdained anything American, sent Carlsen to Paris with a commission to paint a number of floral paintings and send them back to New York.

Carlsen's agreement with Blakeslee enabled him to widen his contacts with French artists and to deepen his familiarity with the great museums. He was also able to form close ties with some of the many young Americans studying in Paris, including his lifelong friends Julian Alden Weir, Kenyon Cox and John Twachtman. In 1885 he passed a career milestone when two of his paintings were accepted by the prestigious Paris Salon, gaining Carlsen widespread

EMIL CARLSEN
The Brook, 1904
Oil on canvas, 34 x 34 inches
Courtesy Stewart American Art, San Francisco

EMIL CARLSEN
White Asparagus, 1891
Oil on panel, 24 x 18 inches
Courtesy William and Zelma Bowser

attention in the art world. By the time Carlsen returned to New York, his reputation was growing. He set up a midtown studio and continued to gain respect as a painter and teacher over the next two years.

By 1887 an art community had firmly established itself in San Francisco. The Art Union of 1865 flourished only briefly, but the Art Association founded in 1871 was much stronger. Its members were determined to perpetuate art in their young city, and in 1874 they created an art school designed to offer a rigorous program of classical study along the lines of the National Academy of Design and the best European academies. Under the strong leadership of its founding Director Virgil Williams the school succeeded and grew. When Williams died, a search was begun for a suitable successor. Mary Curtis Richardson, a wealthy and influential artist and supporter of the Art Association, gained word of Carlsen and went to New York to offer him the position of director. So, at the age of thirty-four, full of confidence and energy, Carlsen accepted the flattering offer and arrived in 1887.

San Francisco's art society heartily welcomed Carlsen. He joined the Bohemian Club, a fellowship of writers and artists similar to New York's Salmagundi Club, known for its jovial, if sometimes raucous, camaraderie. Carlsen enjoyed his new colleagues, and happily painted and taught in his new surroundings. He did not, however, like the tedium and politics which his position came to require, and resigned his directorship after two years. He continued to teach, both privately and at the newly formed, and considerably less formal, Art Students League. Geneve Rixford Sargeant, one of his students, remembered her teacher fondly:

> Carlsen was a man of high artistic ideals. It was a delightful and inspiring atmosphere in which the young students worked during the time at the League. It was a friendly group and an earnest one. Carlsen was liked and deeply respected by his class.[1]

Several of Carlsen's California pupils went on to successful careers as painters, including Anne Bremer, Guy Rose, Percy Gray, John Gamble, William Hubacek and Florinne Brown. They share a strong reliance on draftsmanship and composition. The Oakland Museum has a student work done by Rose, a still life arrangement laid out by Carlsen and painted in his class; Florinne Brown attended the same class and

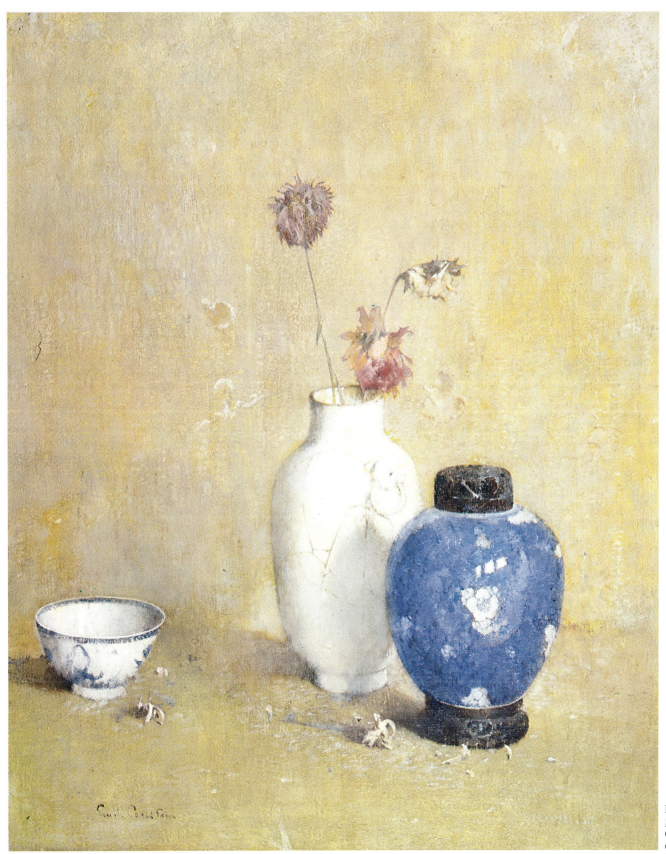

EMIL CARLSEN
Blue, White and Gold
Oil on canvas, 20 x 16 inches
Courtesy San Diego Museum of Art

painted the identical subject from the slightly differing perspective of her chair. Carlsen's work as a teacher is obvious in retrospect as a great legacy to California art.

Carlsen's association with Arthur F. Mathews began in 1889. Mathews was a local prodigy who was just returning, as had Carlsen four years previously, from extensive studies in Paris. The ideals, experience and sensibilities that the two men shared forged a strong bond between them. Both had received intensive academic training in draftsmanship and meticulous usage of materials and paint chemistry. Both showed great versatility as painters, with impressive proficiency with handling figures, interiors, still lifes, seascapes and outdoor landscapes. Mathews shared Carlsen's passion for teaching, and his long reign as Director of the Art Association's school (later called the School of Design, the Mark Hopkins Institute, and, at present, the San Francisco Art Institute) is legendary.

Also in 1889 Carlsen began to flirt with the notion of returning to New York City. His short trip back East caused a flurry of speculation in the San Francisco press that he was lost for good. Carlsen soon was back in town and seemed to affirm his intention to stay put by first setting up a new studio at 728 Montgomery and, secondly, by building a studio together with Mathews in San Rafael. For the next two years Carlsen was consistently productive, and received a lucrative commission to decorate the lavish mansion of William H. Crocker, painting murals and selecting furnishings. Several of Carlsen's major

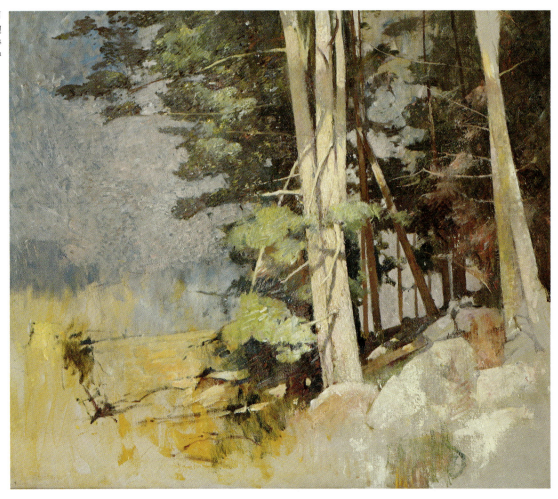

EMIL CARLSEN
Sunlit Wood
Oil on canvas, 39 x 45 inches
Courtesy Jane Olaug Kristiansen

paintings from this period, nearly all of them still lifes, survive in private and public collections. Despite the apparent lack of landscapes and figure paintings from Carlsen's California days, records show that he consistently featured them. It hardly seems likely that he went all the way to San Rafael by ferry just to paint still lifes.

Carlsen's ability to sketch from nature was the foundation for all his work, and he would do studies in ink, pencil, pastel, watercolor and oils. Many of his sketches became finished works in themselves, as well as being preparatory notetaking for subsequent easel paintings. He was legendary among his colleagues for his exquisite craftsmanship and mastery of techniques and materials. His use of a limited palette and uniquely textured paint surface combine to form an unmistakably personal style.

In 1891 Carlsen made his final decision to return to New York. He told his reasons to the *Chronicle*:

> I am going where people buy pictures, where there is an opportunity to exhibit them, and where a name means something. After two years, I find it unpleasant to be a pioneer in a place where the wealthier people get their pictures from Europe and the East, and the class of people that might like to purchase local paintings cannot well afford it.[2]

Carlsen's departure caused a wave of regret and bitterness seemingly disproportionate to a stay of only four years. Eugen Neuhaus summed up what many others felt in his *History and Ideals of American Art*:

> Carlsen's struggle for recognition in San Francisco in the 'eighties, where lesser men than he found unjustifiable encouragement, is a sad commentary upon the artistic sensibilities of the San Franciscans of that day. When he left the Pacific Coast to cast his lot with New York, the city of the Golden Gate lost one of her greatest artistic assets.[3]

Carlsen's career blossomed in New York, and was well chronicled in the art periodicals. He won countless prestigious awards and honors. Major institutions, including the Corcoran Gallery, the Metropolitan Museum, and the Pennsylvania Academy, purchased his most lauded paintings. He taught at both the National Academy and the Pennsylvania Academy for forty years. He married at age forty-three, and eventually built a home and studio near his close friends Weir and Hassam in Connecticut. He gained practically every sort of success he could ever have wished for and then some.

The greatness of Carlsen's sixty-year contribution to American art is undeniable. No less so is the effect of his four-year stay on art in California. As a painter and teacher, he gave San Francisco some of his modest sophistication and subtle strength.

Jeffrey Stewart

COLIN CAMPBELL COOPER (1856–1937)

BORN
March 8, 1856, Philadelphia, Pennsylvania

DIED
November 6, 1937, Santa Barbara, California

TRAINING AND STUDY
Pennsylvania Academy of Fine Arts
Académie Julian

STUDIO LOCATIONS
New York City
Santa Barbara

RESIDENCES IN CALIFORNIA
Santa Barbara

MEMBERSHIPS
American Federation of Arts
American Watercolor Society
California Art Club
National Academy of Design
National Arts Club, New York City
New York Society of Painters
New York Watercolor Society
Philadelphia Watercolor Club
Salmagundi Club, New York City
San Diego Art Guild
Santa Barbara Art Guild

AWARDS
W. T. Evans Award, New York Watercolor Club, 1903
Gold Medal, Pennsylvania Academy of Fine Arts, 1904
Commemorative Medal, St. Louis World Exposition, 1904
Gold Medal, Art Club of Philadelphia, 1910
Silver Medal, Buenos Aires Exposition, 1910
Silver Medal (watercolor), Panama-Pacific International
 Exposition, 1915
Gold Medal (oil), Panama-Pacific International Exposition, 1915
Walter Lippincott Prize, Pennsylvania Academy of Fine Arts, 1918
Honorable Mention, Sixth Annual Southern California Art
 Exhibition, 1931

PUBLIC COLLECTIONS
Cincinnati Museum of Art
Crocker Art Museum, Sacramento
Dallas Art Association
Luxembourg Collection, Paris, France
National Arts Club
The Oakland Museum
Pennsylvania Academy of Fine Arts
Reading Public Museum, Pennsylvania
Saint Louis Museum of Art
San Diego Museum of Art

COLIN CAMPBELL COOPER
Self Portrait
Oil on canvas, 21 x 15½ inches
Courtesy Sherrill Seeley Henderson

One of the twentieth century's greatest achievements is the modern skyscraper which provides a stage wherein contemporary man plays out his role in an industrialized and urbanized society. These towering monuments to man's creative and technical accomplishments provided Colin Campbell Cooper with his essential motif during his professional career as a painter. His later work was dominated by the natural beauty of the American West where he eventually settled. There he found a landscape sparkling in bright sunshine and essentially unscarred by the refuse of industrialization and the negligence of man.

Cooper was born into an economically well-off family of English-Irish descent in Philadelphia, March 8, 1856. His father, a practicing lawyer and a licensed physician, had a fondness for the arts. He and his wife encouraged the boy in his decision to pursue a career as an artist. The Philadelphia Exposition of 1876 had initially stirred the young Cooper's ambition.

The artist's earliest training was at the Pennsylvania Academy of Fine Arts where he received criticism from America's Old Master Thomas Eakins (1884–1916). After his first trip abroad in 1886, studying mostly in the Netherlands, he continued his training in Paris at the Académie Julian. He was following a traditional practice of many young American painters of the day who equated success with a French academic background. He appears to have been caught up in the naturalism, sound draughtsmanship, and the prominent *pleinairism* of France in the mid-eighties.

While he was never considered an expatriate, the aspiring artist's two trips were only the beginning of frequent sojourns abroad including repeated trips to

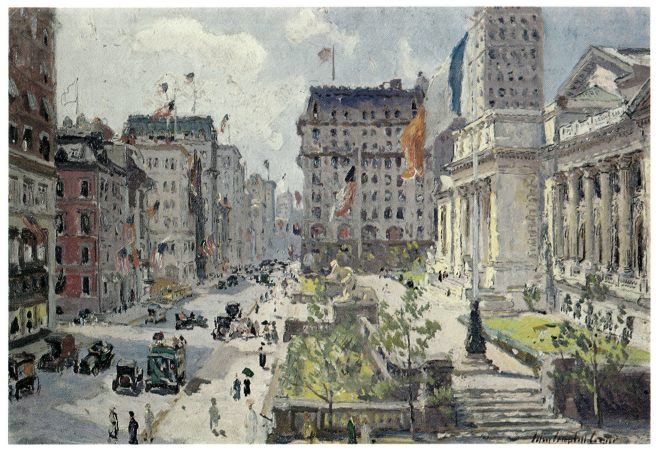

COLIN CAMPBELL COOPER
New York Public Library
Oil on board, 14 x 20 inches
Courtesy Sherrill Seeley Henderson

COLIN CAMPBELL COOPER
Upper Main Street, Nantucket
Oil on canvas, 25 x 30 inches
Courtesy San Diego Museum of Art

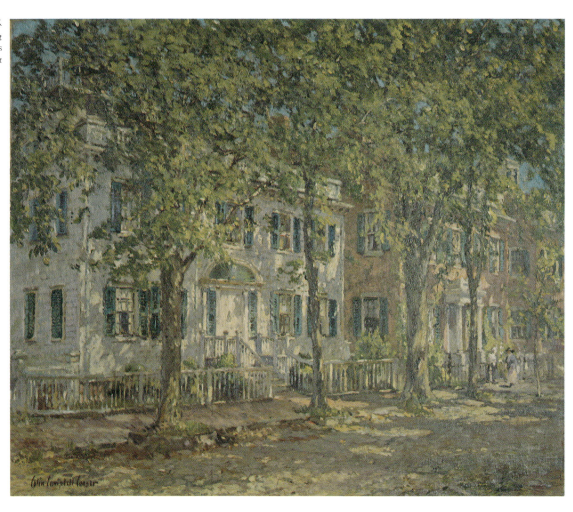

Belgium, France, Italy, and the Netherlands. Later, his peregrinations took him to exotic India where he stayed one year from 1913 to 1914. His fascination with architectural themes was insatiable. Mills wrote,

> Few artists of his school were able to conjure before us the cathedrals and palaces of the past with more ease, few were as able to show them flickering and glowing in shafts of sunlight or sleeping in sombre shadow.[1]

Having taken root when he became an instructor of watercolor and architectural rendering at the Drexel Institute in Philadelphia, from 1895 to 1897, the artist married Emma Lampert, a painter. The couple settled in New York where for the next twenty years, Cooper painted the street scenes which were to make him famous. He is credited with being the first artist to discover the aesthetic possibilities of the canyon-like beauty of city streets and modern skyscrapers, which he often depicted, veiled in seasonal mood with life teeming at every corner.[2] The French government purchased for the Luxembourg his *Fifth Avenue, New York*, a signal honor for an American painter.

In 1921, shortly after his wife died, Cooper settled in Santa Barbara where he was to become Dean of Painting at the Santa Barbara Community School of Arts. He had been to the West Coast as early as 1915 when he visited the expositions held in San Francisco and San Diego. In San Diego he painted the familiar California Tower, symbol of that Southern California community. He became prominently involved in Santa Barbara's community affairs and in 1927 married Marie Frehsee.[3] With the exception of two years spent in northern Europe and Tunisia, the artist

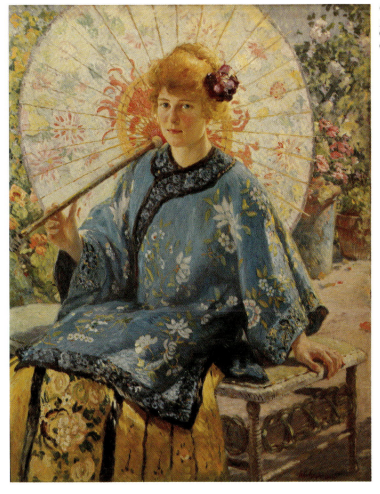

COLIN CAMPBELL COOPER
Blue Mandarin Coat
Oil on canvas, 46 x 36 inches
Courtesy Vose Galleries of Boston

COLIN CAMPBELL COOPER
The Magic City, San Diego
Oil on canvas, 38⅜ x 32⅜ inches
Private collection

spent the remainder of his life in Santa Barbara where he died November 6, 1937.

While Cooper may have missed the vitality of Eastern art circles, he had few if any regrets about his move.

> I find Santa Barbara so conducive to the sort of things a painter most craves—climate, flowers, mountains, seascapes, etc.—with a community interest in all sorts of artistic matters that I am compensated, to a degree, for the isolation from that artistic universe of America.[4]

He delighted in the effects of sunlight, and, as has been noted by others, his art was the embodiment of the impressionistic technique with its high keyed palette and broken brush stroke. Mills wrote,

> For all his work, he was a firm believer in the advantage of plein-air painting as opposed to working from sketches in the studio.[5]

The artist is quoted as noting that:

> There is something of the sparkle of the thing, not only in the big mass of light and shade, but in the little details which are like grace notes in a bar of music, that must be noted on the instant…My own work…reflects…my impressions of many diverse things which I have found of interest to record seen through a technical training. It requires no key or chart to explain its meaning…[6]

As an artist Cooper was a conservative. He bemoaned the direction modern art was taking when, "…all beauty is classed as sentimentality, therefore to be despised." For him modern art "is hopelessly depressing and banal."[7] While Cooper became famous for his architectural themes, his work actually covers an unusually wide range of subject matter, including mountains, gardens, flowers, interiors, portraits and figures. Such works as *Blue Mandarin Coat* attest to his powers of impressionistic figure portrayal and explain the latter day interest in this area of his endeavors. His years as an inveterate traveler are reflected in his remarkably diverse oeuvre. And being a late comer to California, his work is less identifiable with that locale than it is stylistically related to his contemporaries among the *plein air* painters of the region.

Martin E. Petersen

COLIN CAMPBELL COOPER
The Green Bench
Oil on board, 15 x 18 inches
Private collection

PAUL DOUGHERTY (1877–1947)

BORN
September 6, 1877, Brooklyn, New York

DIED
January 9, 1947, Palm Springs, California

TRAINING AND STUDY
Art Students League, New York (Robert Henri)
Self-taught in Paris, London, Florence, Venice, Munich, 1900-1905

STUDIO LOCATIONS
Tucson, Arizona
Carmel Highlands, California
Sebasco, Maine
New York City

RESIDENCES IN CALIFORNIA
Carmel Highlands

MEMBERSHIPS
American Watercolor Society
Bohemian Club, San Francisco
Carmel Art Association
Lotos Club, New York City
Salmagundi Club, New York City
National Academy of Design
Society of American Artists, New York City

AWARDS
Silver Medal, Carnegie International Exposition, 1912
Inness Gold Medal, Carnegie Prize and First Altman Prize, National Academy of Design, 1913
Gold Medal, Panama-Pacific Exposition, San Francisco, 1915
Palmer Memorial Prize, National Academy of Design, 1941

PUBLIC COLLECTIONS
Art Institute of Chicago
Carnegie Institute
Fort Worth Art Museum
Malden Public Library, Malden, Massachusetts
The Metropolitan Museum of Art
Minneapolis Institute of Art
Montclair Art Museum, New Jersey
Monterey Peninsula Museum of Art
Museum of Modern Art
National Collection of Fine Arts
National Gallery of Canada
St. Louis Museum
Toledo Museum of Art

Photo courtesy Mr. and Mrs. Arne Folkenborg Halle

The legal profession had little appeal for Paul Dougherty (1877–1947) who passed his bar examination in 1898. He only prepared himself for the profession to satisfy a family tradition and the wishes of parents who preferred he take up a more practical line of work other than that in an uncertain art career. His father, J. Hampden Dougherty, was a well-to-do lawyer and his family tree included a grandfather who delivered the American Declaration of War in 1812 only to be captured and imprisoned by the British. The romance of high adventure that spirited his ancestor seemed to dominate the genes of Paul, as he launched out as an artist.

As a painter he was showered with success and acclaim which came easy to him even as a twenty-one year old artist. All his pictures sold quickly and he won a great many prizes.

Essentially self-taught, the Brooklyn born painter studied briefly with Robert Henri in New York during the 1890s, and had some early training in perspective and form under Constantin Hertzberg. He had exhibited at eighteen at the National Academy of Design. By the turn of the century his path led to Europe's cultural centers—Florence, London, Paris, Munich,

PAUL DOUGHERTY
The Inlet (Monterey)
Oil on canvas, 34 x 36 inches
Courtesy John H. Garzoli Fine Art, San Francisco

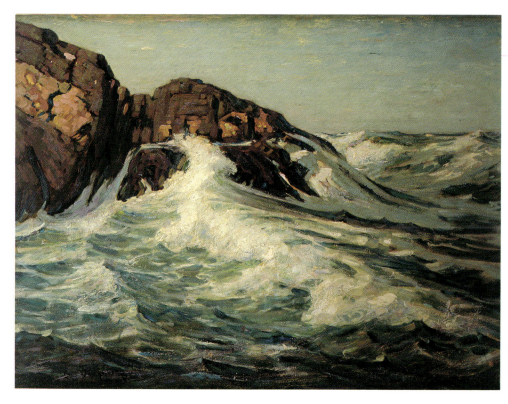

PAUL DOUGHERTY
Blue Gale, 1907
Oil on canvas, 36 x 48 inches
Courtesy John H. Garzoli Fine Art, San Francisco

Venice, where he independently studied and worked from 1900 to 1905. Dougherty first exhibited his work as a professional artist in the Paris Salon of 1901. It was the beginning of an extremely successful career. Having married Antje Bertha Lund, a Swedish music student he met in Paris, the couple returned to America to begin life together in New Jersey. Music was a second love of the artist, and although he played no instrument, he was profoundly appreciative.

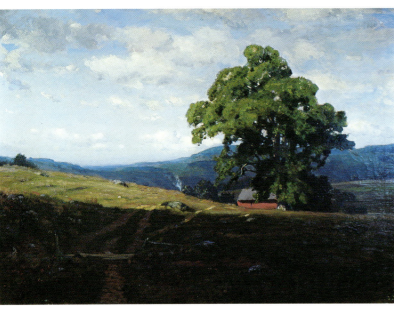

PAUL DOUGHERTY
Summer Morning, 1904
Oil on canvas, 26½ x 36¼ inches
Courtesy Mr and Mrs. Arne Folkenborg Halle

The marriage produced one daughter, but failed. He was to marry three more times to glamorous women, musicians and actresses.

In New Jersey he began painting seascapes which caused critics frequently to refer to the artist as the spiritual heir of Winslow Homer. His pictures were found to be too competitive by John Sloan. Dougherty preferred to paint 36 x 48 inch canvasses with a ship rounding the point far out on the horizon, gales forces and great waves knocking themselves high in the air as they hit coastal rock. According to one writer the artist rejoiced in "nature's more vigorous aspects, and he looked at her impersonally, objectively. This passion, for putting things down as they are rather than using them as a means of expressing his individual moods, is curiously enough, the key to the individual note which stamps his canvasses."[1] Despite the fame he achieved with his choice of subject matter, the artist did not want to be known as a marine painter, the description by which today's reference sources label him. He also painted competent still lifes and nudes which were exhibited successfully in New York's long established and reputable galleries.

From 1928 he and his third wife, Paula Gales, whom he married in San Diego, lived in Carmel and wintered in Tucson, Arizona. Works exhibited in the East at this time were noted, by reviewers, for their change in technique and palette contrasted with the earlier style. His first exhibition at MacBeth's had been in 1907, and, when he exhibited there in 1931, one unknown critic, for example, noted:

> Mr. Dougherty whose earlier reputation was based on his striking rendition of breaking surf on rocks has come into a new style since his western sojourning. Works are...brilliantly executed on a much looser technique and higher key than formerly. He has gained immeasurably with the years in every department of his art. Several of the earlier seascapes are here, but they are hardly to be mentioned in the same breath with the new western canvasses.[2]

The artist had been attracted to California by its climate, light, and fresh visions, conditions which motivated most of those early artists westward to California. Undoubtedly physical problems were another factor in Dougherty's move.

Arthritis prevented him from working the last four years of his life. He died at the age of 69 of cancer in Palm Springs on January 9, 1947, still a celebrated painter who had established a distinguished record of awards and accomplishments.

During his lifetime his work hung in galleries throughout the world including the Metropolitan Museum of Art, the National Gallery of Art, and the Carnegie Institute.

When a retrospective of his works was held in 1957, at the Portland (Maine) Museum of Art, any references and examples of his West Coast work was strangely missing. He had painted nearly twenty years in California.

Martin E. Petersen

PAUL DOUGHERTY
Rocks and Surf, 1919
Oil on canvas, 36⅛ x 48 inches
Courtesy John H. Garzoli Fine Art, San Francisco

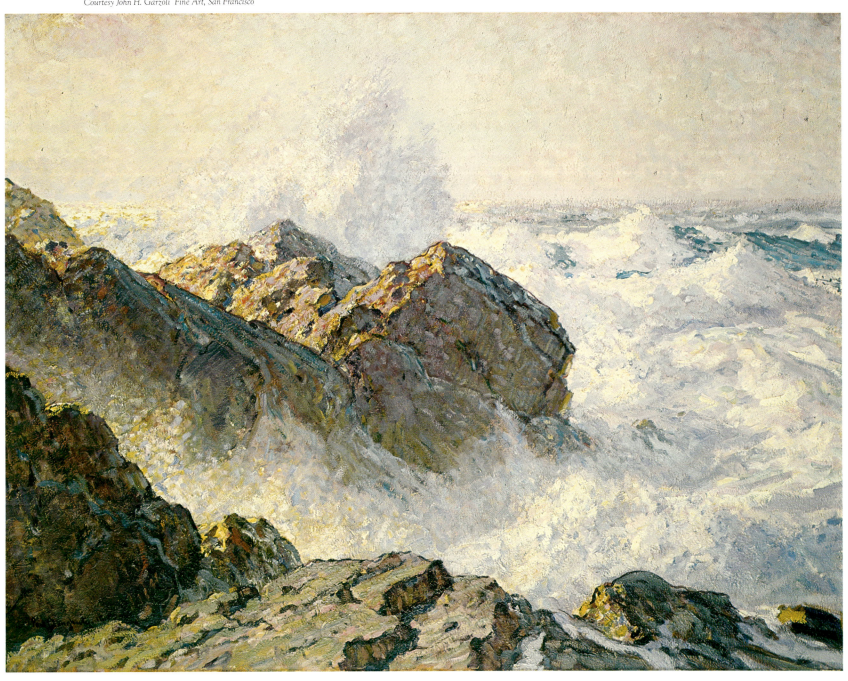

E. CHARLTON FORTUNE (1885–1969)

BORN
January 15, 1885, Sausalito, California

DIED
May 15, 1969, Carmel, California

TRAINING AND STUDY
Edinburgh College of Art, Scotland
St. John's Wood School of Art, London
Mark Hopkins Institute (Arthur Mathews)
Art Students League, New York City (Frank V. DuMond,
 F. Luis Mora, Albert Sterner)
William Merritt Chase

STUDIO LOCATIONS
San Francisco
St. Tropez
Monterey

RESIDENCES IN CALIFORNIA
Carmel-by-the-Sea
San Francisco
Monterey

MEMBERSHIPS
Art Students League, New York City
California Art Club
Liturgical Arts Society
The Monterey Guild
San Francisco Art Association
Society of Scottish Artists

AWARDS
Silver Medal, Panama-Pacific International Exposition,
 San Francisco, 1915
Silver Medal, Panama-California Exposition, San Diego, 1915
Silver Medal, Paris Salon, Societé des Artistes Français, 1924
Walter Prize,, San Francisco Art Association, 1921
First Prize (Oil), California State Fair, 1930

PUBLIC COLLECTIONS
Boggs Collection, Shasta State Historic Park, California
M. H. de Young Memorial Museum, San Francisco
Monterey Peninsula Museum of Art
The Oakland Museum

E. Charlton Fortune on the grounds of her studio, Monterey, 1915
Photo courtesy Monterey Peninsula Museum of Art

In May 1918 the San Francisco Art Association held its Annual Exhibition. Works by prominent artists such as Joseph Raphael, Armin Hansen, William Clapp, Clark Hobart, and E. Bruce Nelson were included. Yet one of the artists singled out for special mention in *The American Magazine of Art* was E. Charlton Fortune. Of her painting *The Senoras Garden*, J. Nilsen Laurvik wrote "…the impression of actual sunlight is rendered with a surety and vivacity that is destined to place this artist in the front rank of American painters."[1] Indeed, the artist had already established herself as an artist of prominence and influence both in California and in the East and would, in a few short years, make her presence known in the Paris Salon.

Euphemia Charlton Fortune was born on January 15, 1885, in Sausalito, California to William Rankin Fortune, a Scotchman, and S. Helen Herzberg.[2] Her father died when Effie, as she was known to her friends, was very young. Her mother recognized her artistic talents and encouraged her to become a portrait painter. Fortune's early schooling, at St. Margaret's Convent in Edinburgh, Scotland, did little to develop her talents. However, she later studied at the Edinburgh College of Art and in 1904 enrolled in St. John's Wood School of Art in London where she received general academic training. Returning to the United States in 1905, she began classes at the Mark Hopkins Institute of the San Francisco Art Association under Arthur Mathews. This was followed by a period of study at the Art Students League in New York City under Frank Vincent DuMond, F. Luis Mora, and Albert Sterner. While there she was fortunate to meet William Merritt Chase who was to

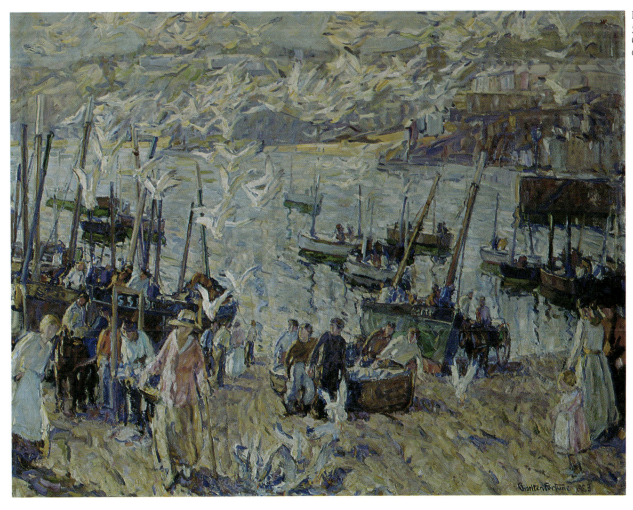

E. CHARLTON FORTUNE
Summer Morning, St. Ives, 1923
Oil on canvas, 37 x 44 inches
Courtesy Monterey Peninsula Museum of Art

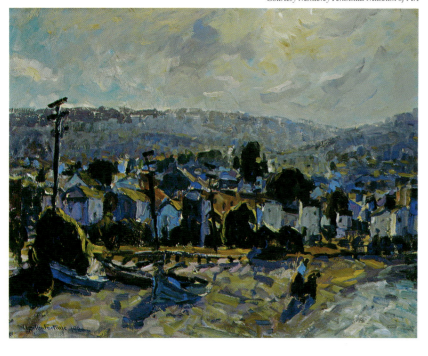

E. CHARLTON FORTUNE
Before Sunset, 1920
Oil on canvas, 18 x 14 inches
Courtesy Monterey Peninsula Museum of Art

have a profound effect on her work.[3]

By the time Fortune left the Art Students League she was already earning a living as a portrait painter. In 1910 she traveled to Europe visiting and painting in Scotland, Ireland, England, and France. She was invited to exhibit at the Royal Scottish Academy and at the Liverpool Art Gallery. She also received many portrait commissions and illustrated an article on Scotland for *Harper's Magazine*.

In 1912 the artist returned to California and settled in Carmel-by-the-Sea which, by this time, had an established artists' colony. The following year she moved to a studio home at 1351 Sutter Street in San Francisco and held an exhibition of her work. Both her portraits and impressionistic landscapes received much attention and favorable criticism.

As her reputation grew so did her influence. It was at her urging that William Merritt Chase was invited to teach at the Carmel Summer School in 1914.[4] Also in 1914, Fortune established a studio in Monterey where she gave private lessons and periodically hosted large outdoor painting groups. She was described as "a wonderful person to be with, …[having] a keen intellect…full of wit."[5] In 1915 she received silver medals at both the Panama-Pacific International Exposition in San Francisco and the Panama-California Exposition in San Diego.

Returning to Europe in 1921 she spent time in London, Cornwall, Paris, Cannes, and St. Tropez. She was especially fond of St. Tropez which, at that time, was not yet the popular tourist spot it was to become. Fortune found the simple fishing village and picturesque harbor to be excellent subject matter for her painting. During this period she exhibited at The Royal Academy in London, The Royal Academy in Edinburgh, at the Society of Scottish Artists, and with the Société des Artistes Français. In 1924 her painting *St. Ives Harbour* won a Silver Medal at the Paris Salon.[6]

Fortune returned to the United States in 1927 and settled in Monterey. That year an exhibition of her work was held at the Beaux Arts Galerie in San Francisco and at the Oakland Art Gallery. Her work was also included in many group exhibitions throughout California. In 1930 her painting *Santa Barbara* won First Prize at the California State Fair. She was further honored to exhibit at the Pennsylvania Academy of Fine Arts in 1932.

Early criticism of Fortune's paintings was highly

E. CHARLTON FORTUNE
Monterey Bay, 1916
Oil on canvas, 30 x 40 inches
Courtesy Collection of The Oakland Museum

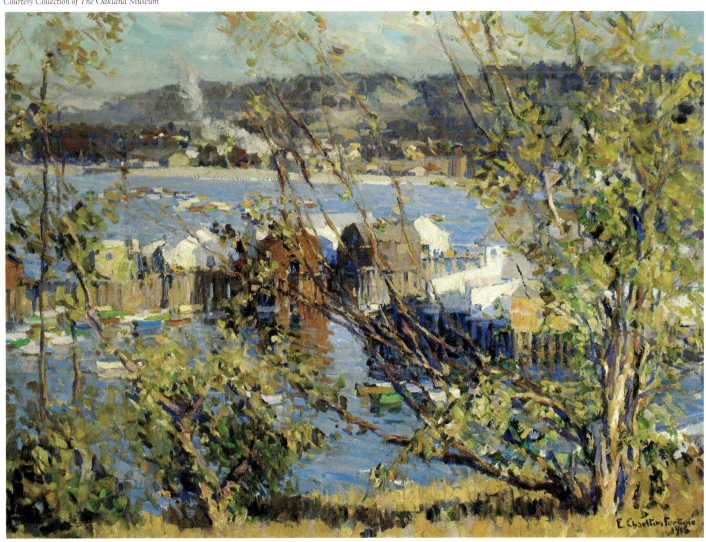

favorable, the work described as "bold, strong," and "brilliant."[7] Writing in the *San Francisco Chronicle*, Anna Cora Winchell referred to the artist's employment of the "modern method," i.e. the impressionist technique of broken color, used to gain "a great luminosity and filtered lights,…always with a view to gaining a new interpretation of the subject rather than to present the subject itself."[8] The next year Winchell described *Monterey Bay* (which had received the $100 Prize at the San Francisco Institute of Art) as her "masterpiece," noting that "its scope and color at a late afternoon hour are wonderfully true and beautiful."[9] Over sixty years later John Caldwell reaffirmed Winchell's praise, describing Fortune's early work as "an almost pure form of American Impressionism" and comparing *Monterey Bay* to the work of Edward Redfield and J. Alden Weir.[10]

Another early critic remarked upon the "mystical quality" of some of Fortune's work, a quality evoked perhaps by "the half-suggested figures" seen in such works as *Summer Landscape* and *The Cabbage Patch*.[11] The artist received further praise for her successful blending of impressionist methods and color with the modern concept of form.[12] Porter Garnett described Fortune as "a colorist in whose best work one may see the poetic quality shining through a technical manner at once delicate, bold, and assured."[13]

Several years later, however, her exhibition at the Beaux Arts Galerie was received with some unfavorable criticism, the work described as having radically

E. CHARLTON FORTUNE
The Cabbage Patch, c. 1914
Oil on canvas, 20 x 24 inches
Courtesy Ann and Sutton Titus

changed[14] and lacking in vitality.[15] Fortune felt such criticisms to be fueled by the so-called modernists who she felt created works as "UNLIKE Nature as possible" and devoid of emotion.[16]

At the same time the artist, a devout Roman Catholic, objected to the modern movement encroaching on the sanctity of the Church, what she considered to be "an extremely noncatholic desire for personal expression and the necessity 'to be different at all cost.' "[17] In 1928 she founded the Monterey Guild which was dedicated to the redecoration of Catholic churches with art "worthy of inclusion in museums."[18] For the remainder of her career she focused her attention on the activities of the Guild which provided original art to over thirty churches and cathedrals in the United States. At the International Exposition at Treasure Island in 1939, photographs were displayed of the interior of St. Angela's Church at Pacific Grove which was the Guild's first project. Fortune receive high praise and honors from the Liturgical Arts Society and, in 1956, received the *Pro Ecclesia et Pontiface* Medal, highest honor of the Catholic Church, for a 16 x 25 foot mosaic at the Immaculate Conception Cathedral in Kansas City, Missouri.

Fortune continued to travel often to Europe and, although she talked of plans to retire in Scotland, lived in Carmel Valley, California from 1964 until her death on May 15, 1969, at the age of eighty-four.

Janet B. Dominik

E. Charlton Fortune in her studio, Portsmouth, 1950 *Photo courtesy Monterey Peninsula Museum of Art*

JOHN MARSHALL GAMBLE (1863–1957)

BORN
November 25, 1863, Morristown, New Jersey

DIED
April 7, 1957, Santa Barbara, California

TRAINING AND STUDY
San Francisco School of Design (Virgil Williams, Emil Carlsen)
Académie Julian (Jean-Paul Laurens, Benjamin Constant)
Académie Colarossi, Paris

STUDIO LOCATIONS
San Francisco
Santa Barbara

RESIDENCES IN CALIFORNIA
San Francisco
Santa Barbara

MEMBERSHIPS
American Federation of Arts
Foundation of Western Artists
Santa Barbara Art Association
San Francisco Art Association

AWARDS
Gold Medal, Alaska-Yukon-Pacific Exposition, Seattle, 1909

PUBLIC COLLECTIONS
Auckland Museum of Art, New Zealand
The Boggs Collection, Shasta State Historic Park, California
California Historical Society, San Francisco
Crocker Art Museum, Sacramento
The Oakland Museum
Santa Barbara Historical Society

JOHN GAMBLE
Self Portrait
Oil on canvas, 20 x 16 inches
Courtesy Santa Barbara Historical Society

In 1956, at the age of 93, John Marshall Gamble was considered the "Dean of Santa Barbara Artists." He had spent most of his life painting his beloved California wildflowers and, in the past few years, had been slowly losing his eyesight. He worked in his garden of desert plants and did not paint very much. When questioned by an interviewer about his remarkable passion for floral painting, he replied:

> I never painted them as flowers at all. I didn't even think of them as flowers while I was painting. They were just color patches to me. I simply liked the way they designed themselves across the field.[1]

Born in Morristown, New Jersey, on November 25, 1863, Gamble grew up in Auckland, New Zealand, where his father was stationed in the capacity of agent for the Pacific Mail Steamship Company. Young Gamble did not like the climate in New Zealand and, in 1883, went to live and study art in San Francisco.

In 1886, he entered the San Francisco School of Design and studied under Virgil Williams (1830–1886) and Emil Carlsen (1853–1931). To support himself, he worked as a court typist and a cafeteria cook.[2] For all American art students of the day, a length of study in France was *de rigueur*, so in 1890, Gamble embarked on a three year stay in Paris. He enrolled in the Académie Julian, where he took classes with Jean-Paul Laurens (1838–1921) and Benjamin Constant (1845–1902), two of the teachers most popular among the large colony of American students in France. Gamble also studied at the Académie Colarossi, which along with the Julian were the most readily available schools to American artists.

In 1893, he returned to San Francisco and began an active routine of exhibitions at the San Francisco Art Association as well as several Eastern organizations such as the Philadelphia Art Club and the American Watercolor Society in New York.[3]

In the ensuing years, Gamble established a large following and an emerging national reputation as a painter of wildflowers. Pursuing an annual routine of seasonal travel to the southern part of California for sketching the springtime displays of wildflowers, he would return to San Francisco to exhibit and sell his remarkable paintings. The long list of flowers which would appear in his works included blue and yellow lupines, monkey flowers, sage, wild lilacs, wild buck-

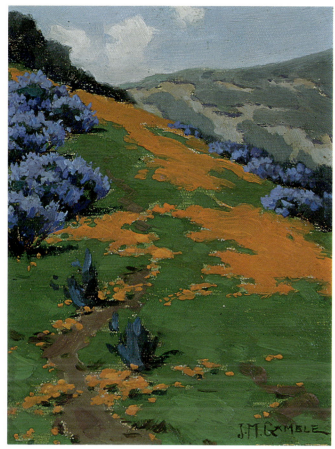

JOHN GAMBLE
Poppies and Lupines
Oil on canvas, 9 x 7 inches
Private collection

JOHN GAMBLE
Wild Buckwheat, Point Lobos
Oil on canvas, 20 x 26 inches
Private collection

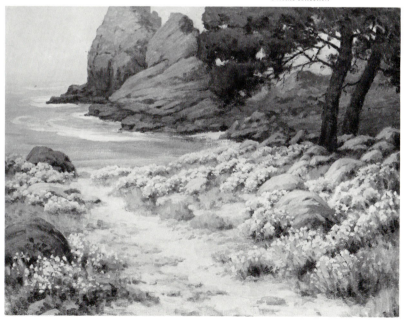

wheat and owl's clover, among others. However, the single most popular flower which appears in the majority of his paintings was the California poppy, in its distinctive masses of yellow and orange-yellow blooms.

To the stolid San Francisco art community, Gamble's colorful paintings were startling and many doubted their veracity. Among visiting Easterners, they were considered pure fabrications. But a trip to the countryside in springtime would always prove the doubters wrong, and Gamble's paintings became famous for their dramatic truthfulness and were given the affectionate label of "Gamble's Prairie Fires."[4]

In 1904, Gamble sent a painting entitled *The Golden Poppy* to the Louisiana Purchase Universal Exposition in St. Louis.[5] By this time, he was selling his works in several Eastern galleries and his status in San Francisco was confirmed when he was commis-

JOHN GAMBLE
Looking Down River
Oil on canvas, 20 x 30 inches
Courtesy Gibson, Dunn & Crutcher

JOHN GAMBLE
California Wildflowers
Oil on canvas, 25 x 40 inches
Private collection

sioned to paint a large scene of California poppies for the lobby of the St. Francis Hotel.[6] Later that year, he made his first trip to the High Sierras. Paintings done there were shown that fall at the San Francisco Art Association.[7] It appears that his change of subject matter was not well received since he rarely returned to the mountains for inspiration, choosing instead to remain with his rolling hills of wildflowers.

On April 18, 1906, San Francisco was devastated by an earthquake and resultant fire. Gamble's studio was completely destroyed. The fire burned everything. Of his inventory, only three paintings which were out with an art dealer survived.[8] By the end of the year, he had made the decision to leave San Francisco and live in Los Angeles where his close friend Elmer Wachtel was established. On the trip south he arrived in Santa Barbara on Christmas Eve and was so taken by the beauty of the town and landscape that he altered his plans and settled permanently in that small coastal community.

In 1909, he sent a painting to the Alaska-Yukon-Pacific Exposition in Seattle, Washington, and was awarded a gold medal.[9] That same year, he toured the Middle East and upon his return in 1910, painted at the Grand Canyon.

By the 1920s, Gamble was recognized as the preeminent Santa Barbara painter. His fame as a painter of wildflowers grew to national proportions and he had trouble getting enough paintings together for exhibitions. Visitors to his studio were disappointed to find only a few paintings for sale as he claimed that he was under contract with Eastern dealers to buy everything he could send them.[10]

In 1925, at the age of 62, he accepted a post on the Santa Barbara Architectural Board of Review. In this capacity, which he retained for the rest of his life, he served as color advisor on new construction in Santa Barbara, which was undergoing a nearly complete

rebuilding due to the earthquake of June 29, 1925. Thus, part of the beauty and charm of present day Santa Barbara is due to Gamble's role during this period.

As he grew older, he painted less frequently and rarely took his annual trips to chronicle the wildflowers. He would occasionally participate in community art exhibitions but his failing eyesight severely affected his ability to paint. He had one of his last major exhibitions at Stendahl Galleries in Los Angeles in 1938, after a hiatus of several years.[11] He died after a brief illness, at the age of 93, on April 7, 1957.[12]

During his lifetime, Gamble was both praised and criticized for his uniquely colorful style of painting. The noted art writer Antony Anderson said of Gamble's paintings in 1911: "His color is brilliant, beautiful, arresting, at times so pure that it inclines to crudity..."[13]

Many of his reviews are summed up by describing his work in terms of one particular color tone, such as "blue picture with blue fog..." or his wildflower landscapes appearing as merely "purple patches of color..." Yet, in retrospect, the genuine appeal of Gamble's paintings, which have found a wide and lasting popularity, is his distinctive treatment of subject and color which is, to the learned viewer, undeniably and instantly recognizable as the work of John Gamble. In 1916, Anderson wrote,

> Mr. Gamble's popularity as a painter, I am inclined to think, is due to the fact that he makes the note in California landscape intelligible to the layman. He transcribes that note as simply and directly as possible, and with much sincerity. His poetry is not subtle—the touch in his lyrical note is not poignant—but its aim is truth.[14]

Jean Stern

JOHN GAMBLE
Poppies and Yellow Lupines, Point Lobos, c. 1905
Oil on canvas, 20 x 30 inches
Courtesy Paul Bagley

JOHN GAMBLE
Fog on the Coast
Oil on canvas, 20 x 30
Courtesy James M. Hansen

PERCY GRAY (1869 – 1952)

Photo courtesy Donald C. Whitton

BORN
October 3, 1869, San Francisco, California

DIED
October 10, 1952, San Francisco, California

TRAINING AND STUDY
California School of Design (Emil Carlsen)
Art Students League, New York City
William Merritt Chase

STUDIO LOCATIONS
New York City
San Francisco
Alameda, California
Monterey, California
San Anselmo, California
Portola Valley, California

MEMBERSHIPS
The Bohemian Club
Carmel Art Association
The Family, San Francisco
Society for Sanity in Art

AWARDS
Bronze Medal (Watercolor), Panama-Pacific International
 Exposition, San Francisco, 1915
First Prize (Watercolor), Arizona Art Exhibition, Phoenix, 1915
Prize, Golden Gate International Exposition, Treasure Island, 1940

PUBLIC COLLECTIONS
California Historical Society
Crocker Art Museum
The Fine Arts Museum of San Francisco
Monterey Peninsula Museum of Art
National Museum of American Art, Washington, D.C.
The Oakland Museum

The delicately veined limbs and wispy foliage of oaks and eucalypti, often colored in transparent shades of blue and green were Percy Gray's signature. Occasionally, he did an Indian portrait or painted a rocky shoreline, and from time to time he etched his oaks on copper plates with a jeweler's intense and painstaking concern for fine detail.

Descended from a family of artists, Percy Gray was born in San Francisco on October 3, 1869. Showing a taste and a talent for art, he enrolled, as did many of his art-minded contemporaries, at the California School of Design at the Mark Hopkins Institute on Nob Hill overlooking the city, in the fall semester of 1886, coinciding with the arrival of the new director of the School of Design, the Eastern still-life painter, Emil Carlsen.

The times for artists and would-be artists in San Francisco and the West in general were difficult, with few opportunities to practice fine art. Opportunities to practice commercial illustration, however, were a little brighter, especially since the invention and swift adoption of the various means of photomechanical reproduction. Among these were the half-tone and photogravure processes which replaced the laborious and time-consuming method of cutting woodblocks from drawings, a technique upon which the editors of *Harper's Weekly* depended for many years. Consequently, newspapers and magazines of the late 1880s and early 1890s began publishing more and more illustrations and in so doing the demand for illustrators grew.

Many young San Francisco artists were drawn to the papers and to local magazines like the *Overland*

PERCY GRAY
Stand of Great Oaks, Monterey Bay
Watercolor, 15 x 21 inches
Courtesy Mr. and Mrs. William A. Karges Jr.

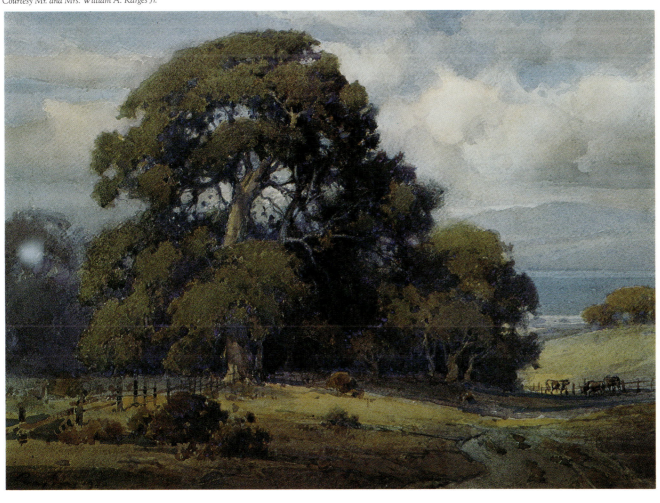

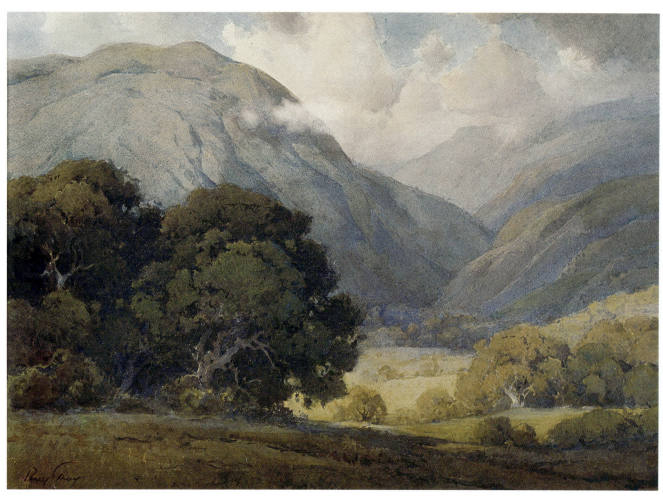

PERCY GRAY
Salinas Valley
Watercolor, 20 x 28 inches
Courtesy Kerwin Galleries, Burlingame, California

Monthly. Among them were Maynard Dixon (1875–1946), Joseph Raphael, Xavier Martinez, Granville Redmond (1871–1935) and Will Sparks (1862–1937). Percy Gray joined the art department of the *San Francisco Call* in 1891 and set to work alongside Will Sparks, a feature writer who illustrated his own stories. Gray's years as an illustrator with its demands for overall representation and emphasis on linearity may be a strong clue to the later refinement of his style. Frustrated by the still-moribund San Francisco art scene, Percy Gray left his birthplace for New York City in 1895, taking on arrival a job as an illustrator at William Randolph Hearst's *New York Journal* to support himself and enrolling to study at the Art Students League where among the distinguished faculty of that day he took instruction from William Merritt Chase (1849–1916), just then emerging from a preoccupation with painting interiors.

In the portentous year of the earthquake and fire in San Francisco, Percy Gray returned home. The local art scene after April 18 was, if anything, in a more desperate condition than it had been in the 1880s and 1890s. Yet apparently having saved some of his money from his years as a newspaper artist, Gray was able to travel, visiting the landscape monuments of the Northwest and Southwest. He began exhibiting at the Del Monte Lodge Art Gallery, located in the old Southern Pacific Railroad hostelry on the Monterey Peninsula. The Del Monte exhibitions, with the obliteration of San Francisco's art quarter,

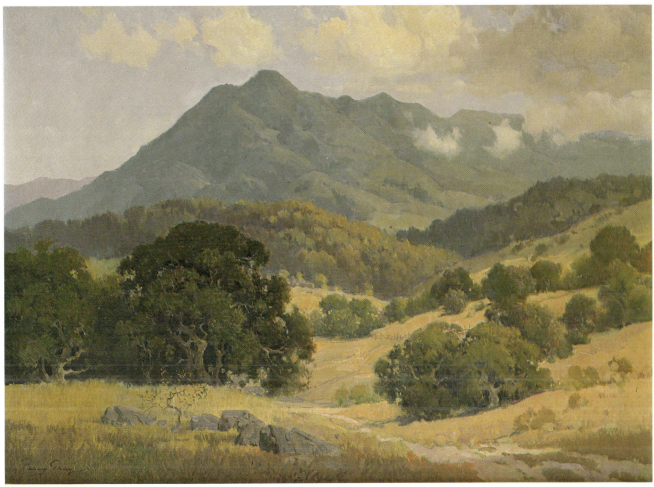

PERCY GRAY
Mt. Tamalpais
Oil on canvas, 26 x 36 inches
Courtesy James L. Coran and Walter Nelson-Rees

became, for a few years, the principal public exhibition venue for artists in northern California.

With the announcement in the fall of 1911 of plans for an international exposition in San Francisco to be held in 1915, the local art scene began to show signs of a belated revival. By this time, too, Percy Gray had evidently settled on the style with which he is identified. In 1915, for instance, at the First Exhibition of California Artists at the Golden Gate Park Musuem, now the M.H. de Young Memorial Museum, he showed *Eucalyptus Tree,* and in the same year he showed *Out of the Desert: Oregon,* at the Panama-Pacific International Exposition. For this work he received a bronze medal given by the International Jury of Awards, a member of which was his old

Percy Gray in his studio, the Sherman Rose House, Monterey, 1926 *Photo courtesy Donald C. Whitton*

PERCY GRAY
Pine Tree on the Mesa, Inverness, 1906
Watercolor, 12 x 20 inches
Courtesy Cleland and Katherine Whitton Collection

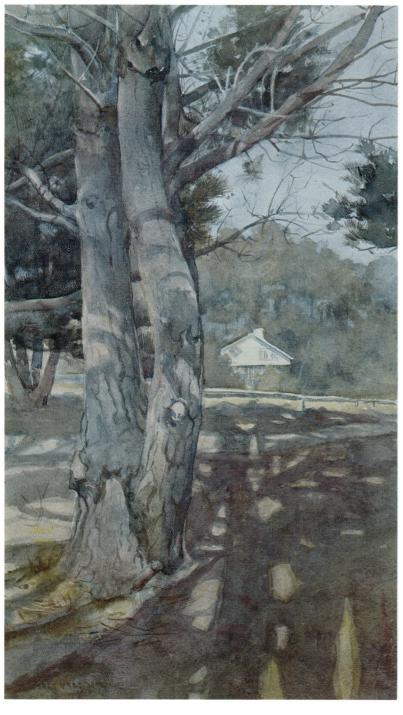

teacher, William Merritt Chase.

At last accorded recognition as a fine artist, Percy Gray's career seemed secure. In 1919 he opened a studio in the Montgomery Block, a large square brick building dating from the 1850s, located at 628 Montgomery Street in San Francisco.

At the age of fifty-four in 1923 he married Leone Phelps of Burlingame and shortly thereafter the couple moved to Monterey, then a thriving colony of artists and art galleries. In 1938 the Grays moved again, from Monterey to San Anselmo in Marin County to the north of San Francisco. By this time winds of change had begun to blow through the northern California art scene with what Percy Gray regarded as uncontrolled and destructive force. Acting on his judgment, he along with Theodore Wores and other artists of his generation, joined the local branch of a nationwide organization—the Society for Sanity in Art, a group dedicated to preserving traditional pictorial values. He continued to paint his oaks and eucalyptus trees, finding a ready and stable market for his pictures. After a short illness, Percy Gray died in San Francisco on October 10, 1952.

Raymond L. Wilson

PERCY GRAY
Field of Flowers
Watercolor, 16 x 20 inches
Private collection

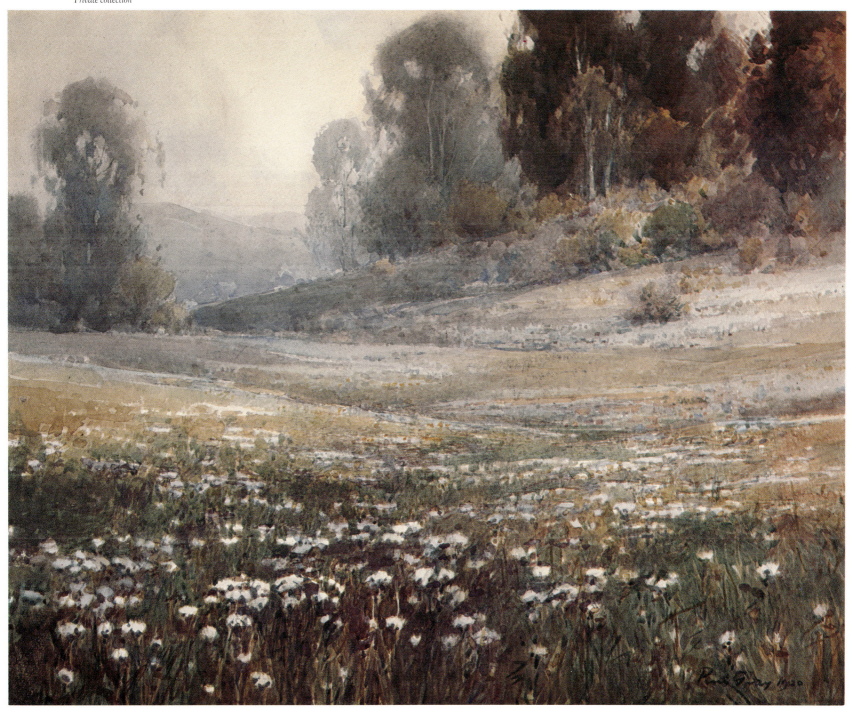

ARMIN C. HANSEN (1886–1957)

BORN
October 23, 1886, San Francisco, California

DIED
April 23, 1957, Monterey, California

TRAINING AND STUDY
Mark Hopkins Institute of Art
Akademie Stuttgart, Germany

STUDIO LOCATIONS
San Francisco
Monterey

RESIDENCES IN CALIFORNIA
San Francisco
Monterey

MEMBERSHIPS
California Society of Etchers
Carmel Art Association
National Academy of Design
Salmagundi Club, New York City
San Francisco Art Association
Société Royale des Beaux-Arts, Brussels

AWARDS
First Prize, International Exposition, Brussels, 1910
Silver Medal, Panama-Pacific International Exposition,
 San Francisco, 1915
Purchase Prize, San Francisco Art Association, 1915
Gold Medal (Drawing), San Francisco Art Association, 1919
Gold Medal (Painting), San Francisco Art Association, 1919
First Hallgarten Prize, National Academy of Design, 1920
Gold Medal, Printmakers Society of California, 1923
Ranger Fund Purchase Prize, National Academy of Design, 1924

PUBLIC COLLECTIONS
Cleveland Museum of Art
M. H. de Young Memorial Museum, San Francisco
Library of Congress
Los Angeles County Museum of Art
Monterey Peninsula Museum of Art
Newark Museum
National Academy of Design
The Oakland Museum
San Diego Museum of Art
San Francisco Museum of Art

Photo courtesy Art Department, The Oakland Museum

side from his multiple roles as a painter, etcher, and teacher, Armin Hansen was one of the very few American Impressionists to train in Germany at a time when it was fashionable to seek one's education in Paris. Painted often in the darker, more brooding palette of the first generation of German Impressionists, Hansen's work in general is expressive of a solemn, even sombre, mood. His German experience and his German teacher, Carlos Grethe and Grethe's artistic philosophy are the principal clues to Hansen's style. His choice of a career, however, probably owed more to the influence of his father, the Western painter and illustrator, H.W. Hansen.

Born in his father's adopted city of San Francisco on October 23, 1886, Armin Hansen received his first instruction in art at home. Upon reaching maturity he enrolled at the Mark Hopkins Institute's California School of Design, located in an old mansion built by a railroad tycoon atop Nob Hill. His course of study went smoothly until April of 1906 when the San Francisco earthquake and fire destroyed the school and all of its instructional apparatus. Faced with the problem of continuing his training, Hansen, as with many of his fellow-students, looked toward Europe. But instead of France and Paris, Hansen booked passage for Hamburg, not far from his father's birthplace in the narrow neck of land connecting Denmark with Germany.

Arriving in the fall of 1906, and after a little sightseeing, Hansen made his way to the Akademie Stuttgart, applying to study with Carlos Grethe, a

ARMIN HANSEN
My Worktable, 1917
Oil on canvas, 30¼ x 36
Courtesy Harold L. Settlemier

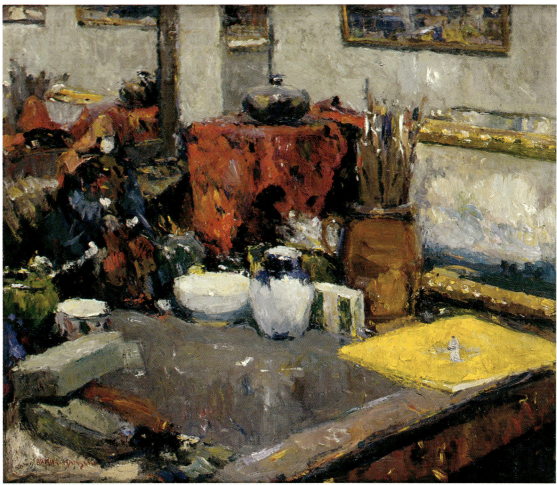

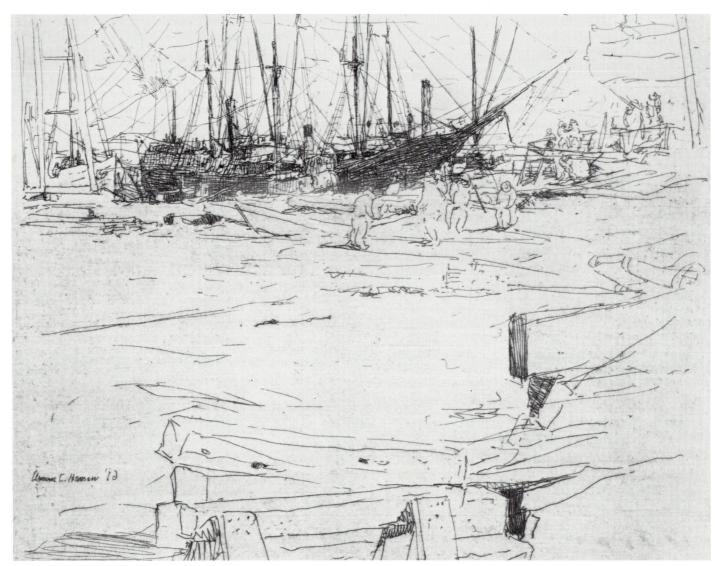

ARMIN HANSEN
Shipyard No. 1
Etching

member of the faculty there. Grethe, born in Uruguay of émigré parents, was an important figure in the German Sezessionist movement. Taking its name from the American War Between the States, the Sezessionists were a rebellious band of younger artists determined to change the ways salon juries were chosen and the general structure of the art academies. Grethe, while a professor at the Karlsruhe Akademie in Baden-Baden, was invited along with a few like-minded colleagues to revamp the curriculum at the Akademie Stuttgart in 1898, and it was into this atmosphere of ferment and change that Armin Hansen entered.

Grethe himself painted and made colored lithographs in an impressionist style, favoring scenes of busy harbors and maritime adventures. For figures he searched for types, rather than for particular individuals, much as Hansen was later to do as a painter and etcher. Once, in a letter to a friend, Grethe wrote "…To paint a subject realistically affords me no satisfaction. My aim is to raise the individual model, the individual action into a type, and this can

be achieved only when one emancipates oneself thoroughly from nature studies."

About the summer of 1908 Hansen departed Stuttgart for the lighter atmosphere of the Flemish coast near the resort towns of Nieuwpoort and Ostend, one of Grethe's favorite sketching locales. In 1910 Hansen was apparently already demonstrating some promise as an artist as his painting *Maree Basse* was accepted by the jury for exhibition at the Royal Salon in Brussels. By 1912, after six years abroad, he was ready to return home, arriving in San Francisco in late fall.

He immediately set up a studio and joined in the growing excitement surrounding the organization of the Panama-Pacific International Exposition. Opening in San Francisco in February of 1915, the P.P.I.E. featured a vast art exhibit at which Hansen showed six etchings and two paintings, winning a silver medal for *The Belated Boat* and *At the Breakfast Table*. In 1916 he moved his studio and residence to the Monterey Peninsula where the picturesque sardine fishing industry and Sicilian and Portuguese fishermen were to furnish an inexhaustible fund of subject matter for the next forty years of his life. From the piers and docks and wharves, and from the sand beaches and rocky coves Hansen viewed men and their struggle with the sea from countless angles, continuously refining his material over the years, exhibiting up and down the West Coast and occasionally in New York. In 1948 he was elected to full membership in the National Academy of Design, submitting *Men of the Dogger Bank* as his diploma piece. Armin Hansen died in Monterey on April 23, 1957.

Raymond L. Wilson

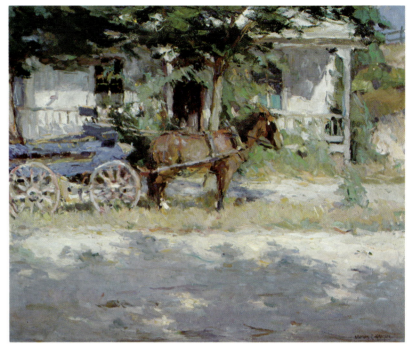

ARMIN HANSEN
The Farm House, 1916
Oil on canvas, 30 x 36 inches
Courtesy Petersen Galleries, Beverly Hills

ARMIN HANSEN
Running Free
Oil on board, 18 x 22 inches
Courtesy Petersen Galleries, Beverly Hills

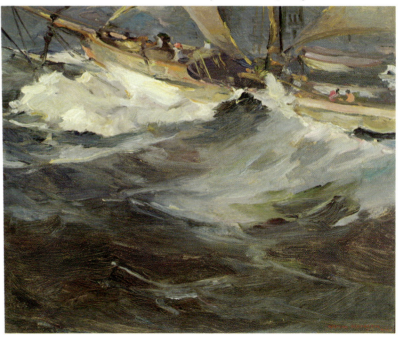

ARMIN HANSEN
Salmon Trawlers, 1918
Oil on canvas, 47 x 53 inches
Courtesy Mrs. Justin Dart

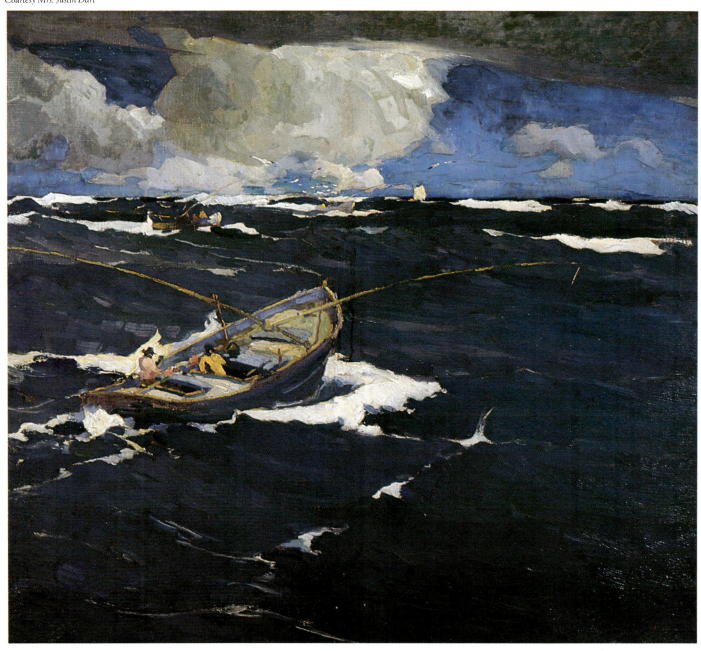

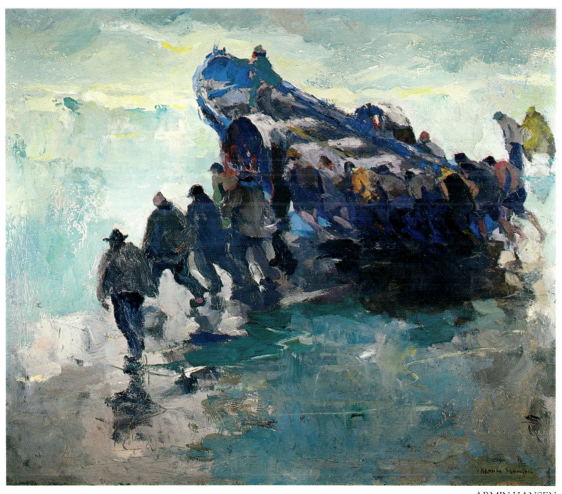

ARMIN HANSEN
Launching the Lifeboat
Oil on canvas, 25 x 36 inches
Private collection

CLARK HOBART (C. 1870s – 1948)

Photo courtesy Art Department, The Oakland Museum

BORN
c. 1870s, Rockford, Illinois

DIED
February 23, 1948, Los Gatos, California

TRAINING AND STUDY
Mark Hopkins Institute of Art
Art Students League, New York (Robert Blum and George Bridgman)
Further studies in Paris

STUDIO LOCATIONS
Monterey
San Francisco

RESIDENCES IN CALIFORNIA
Monterey
San Francisco
Campbell

MEMBERSHIPS
The Bohemian Club
California Society of Etchers
San Francisco Art Association
San Francisco Society of Artists

AWARDS
Silver Medal (Monotypes), Panama-Pacific International Exposition, 1915
Crocker Prize, San Francisco Art Association, 1918
Gold Medal (Portraits), San Francisco Art Association, 1920
First Award, San Francisco Art Association, 1922

PUBLIC COLLECTIONS
M. H. de Young Memorial Museum, San Francisco
Mills College Art Gallery, Oakland
Monterey Peninsula Museum of Art
The Oakland Museum

An artist who was active in the San Francisco art community for only a brief period, from approximately 1913 to 1925, Clark Hobart nevertheless earned critical acclaim for his work which included both paintings and monotypes. He was noted for the full color effects in both mediums, the intensity of his color a reflection of the brilliant California sun.

Hobart was not a Californian by birth. He was born in Rockford, Illinois during the 1870s, the exact date unknown.[1] With his parents, Robert Hobart and Mary S. Clark, he moved to California sometime during his childhood. Little is known about this period of his life.

Hobart's art education began with a few years of study at the Mark Hopkins Institute of the San Francisco Art Association. He then moved to New York where he studied at the Art Students League under Robert Blum and George Bridgman. In 1898 he won a student competition to paint four panels in the Ethnology Building of the Pan-American Exposition in Buffalo, New York. He furthered his studies with three years of work in Paris. He returned to New York in 1903 where he remained for the next several years employed as the art editor of *Burr-McIntosh Monthly* magazine.[2]

Sometime during 1911 or 1912, Hobart returned to California settling in Monterey. The earliest records of exhibition of his works indicate his inclusion in a show at the Del Monte Hotel in 1913. He also began exhibiting with the San Francisco Art Association of which he was a member.

CLARK HOBART
A Windy Day, c. 1916
Oil on canvas, 24 x 30 inches
Courtesy Carlson Gallery, San Francisco

CLARK HOBART
Carmel Dunes
Oil on canvas, 16 x 24 inches
Courtesy G. Breitweiser

It was in the spring of 1915 that Hobart's monotypes were introduced by N.R. Helgesen at his gallery in San Francisco. The thirty-six works received considerable attention and acclaim.[3] The nature of the monotype—a single edition print made by placing a sheet of paper over a still-wet painting done on a glass or copper plate—usually restricted the artist to a limited palette and a simple composition. By necessity an artist had to work very rapidly. Hobart said that most of his works were completed in thirty minutes or less.[4] He revealed his skill as a painter and a draftsman in these works, which were praised for "their originality, their color, and for their imaginative qualities."[5] Many of Hobart's monotypes were unusual in that the artist included figures in the compositions, a daring move which evoked this comment:

> It is simply wonderful how the artist succeeded in getting so much motion and so much modeling into these graceful delicate figures despite the difficulties of the painting and printing process.[6]

Later that year Hobart exhibited several monotypes at the Panama-Pacific International Exposition and received a silver medal which was the highest award conferred upon works in that medium. Robert B. Harshe noted that the artist succeeded in attaining "full color effects"[7] and J.E.D. Trask stated that the artist's control of the process was "remarkable."[8]

The critical attention received by Hobart's monotypes generated invitations to the artist to exhibit his works in other galleries in California and in the East. He was invited to the Pennsylvania Academy of Fine Arts Annual Exhibition in Philadelphia in November 1915, and exhibited in New York City at Kennedy & Company, at the Architectural League, and at the National Academy of Design during 1916. His works were also shown in Los Angeles at the Museum of History, Science and Art in 1915 and 1918.

In the spring of 1916, Hobart moved his studio to San Francisco, taking over what had once been Carl Oscar Borg's studio on Post Street.[9] His paintings began to receive critical attention and were frequently noted for their Cézannesque forms and strong, Post-Impressionistic coloring. His works included both landscapes and portraits, the artist concentrating on the former during the summer months when it was pleasant to travel around the Bay Area. Many of his works show the blaze of color of a landscape lit by the intense noon-day sun. Hobart told one reviewer:

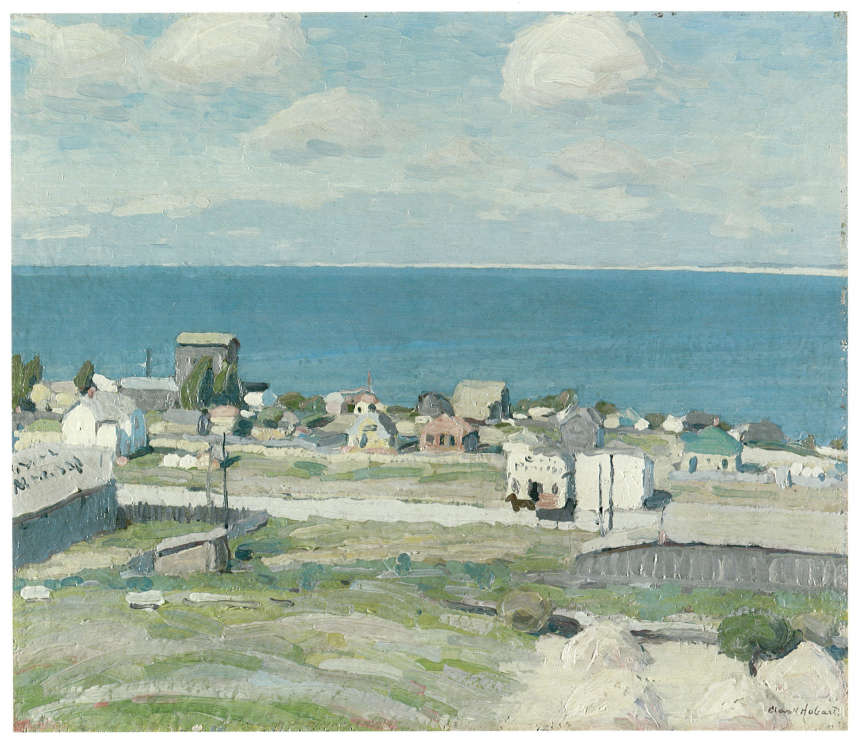

CLARK HOBART
Blue Bay, Monterey, c. 1915
Oil on canvas, 20 x 24½ inches
*Courtesy the Fine Arts Museums of San Francisco,
Skae Fund Legacy*

> Everything I paint I go after with a definite purpose, not merely here and there but to grasp and set down the masses of nature affected as they are by the elements and the varied composition of their structure.[10]

His allegiance to Cézanne was also noted by the Eastern art critic Willard Huntington Wright who spent several months in San Francisco during 1919. He described Hobart's landscapes as "Cézannesque in vision and manner," having "excellent structural qualities and harmonious linear design."[11] This can especially be seen in *Blue Bay, Monterey*, which had been exhibited at the Panama-Pacific International Exposition and was acquired by the M.H. de Young Museum in 1916.

The characteristics of strong form and coloring are seen in Hobart's portrait and figural works as well. However Wright noted that these paintings were more eclectic, reflecting a multitude of influences ranging from the work of Robert Henri and Manet to the tradition of Frans Hals and John Singer Sargent.[12] Wright was also critical of Hobart's depiction of a landscape scene behind his sitter stating that the artist was following the style of Ignacio Zuloaga, the Spanish Post-Impressionist. Yet such a tradition in portraiture dates back to the Renaissance and thus this is hardly a fair criticism.[13] Overall Hobart was praised for his skill in capturing the personality of his sitters whom he depicted in natural poses. The works were described as "modern and strong" with a wide range of color.[14] One of his most important portraits was that of artist Gottardo Piazzoni which was acquired by the San Francisco Art Association in 1919. That same year a number of Hobart's paintings were exhibited by the Seattle Fine Arts Society in Seattle, Washington.

During the early 1920s, Hobart received numerous prizes and awards for his works. He was commissioned to paint portraits of many prominent Californians and was also active as a muralist and interior designer. His work was included in a traveling exhibition of twenty-two Western painters organized by the Western Association of Art Museums in 1922. In 1923 the Bohemian Club honored him with a one-man retrospective exhibition.

In September 1923, Hobart married Mary Young, an artist and historian who was, at that time, head of the art department of Mission High School. In December he was one of eight San Francisco painters shown in a special exhibition organized by N.R. Helgesen.[15] The artist's inclusion in the exhibition, which also featured the work of Gottardo Piazzoni, Maynard Dixon, Armin Hansen, Joseph Raphael, and Bruce Nelson, firmly established the importance and merit of his work.

In 1924 Hobart and his wife opened The Hobart Studio on Montgomery Street, specializing in antiques, draperies, reproductions, and planning of interiors.[16] Together they completed the decor of the Cardinal Hotel in Palo Alto. The following year they moved the studio to Sutter Street. After 1925 Hobart's activities as a painter and exhibitor declined. In 1926 he resigned as a member of the Board of Directors of the San Francisco Art Association.[17] Exhibition records indicate that he exhibited three monotypes at the Bohemian Club Annual Exhibition in 1929, and his portrait of Piazzoni was shown at the California School of Fine Arts in 1930. It is not clear why he became semi-retired at a relatively young age. At the time of the WPA research (1937) he and his wife were living in Campbell in Santa Clara county. Mary Hobart died in 1946, and Clark Hobart died on February 23, 1948 in Los Gatos, California, after an illness of several months.[18]

Janet B. Dominik

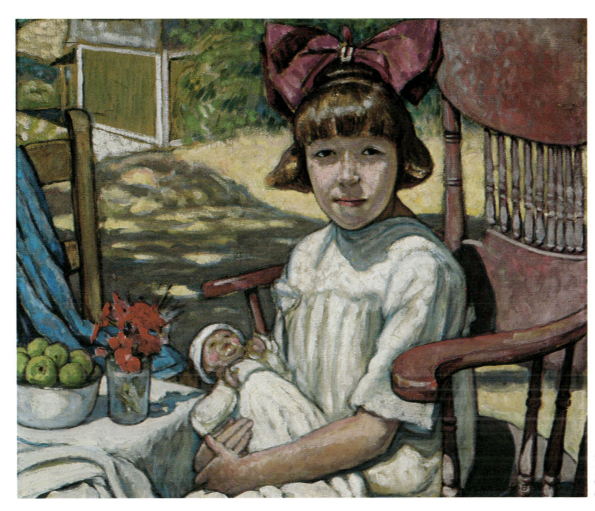

CLARK HOBART
Melba, Pacific Grove, 1918
Oil on canvas, 19½ x 24½ inches
Courtesy Monterey Peninsula Museum of Art

XAVIER MARTINEZ (1869–1943)

BORN
February 7, 1869, Guadalajara, Mexico

DIED
January 13, 1943, San Francisco, California

TRAINING AND STUDY
California School of Design (Arthur Mathews)
Ecole des Beaux-Arts (Jean-Léon Gérôme, Eugène Carrière)

STUDIO LOCATIONS
San Francisco
Oakland

RESIDENCES IN CALIFORNIA
San Francisco
Oakland

MEMBERSHIPS
The Athenian Club, Oakland
The Bohemian Club, San Francisco
San Francisco Art Association

AWARDS
Gold Medal, San Francisco Art Association, 1895
Honorable Mention, International Exposition, Paris, 1900
Gold Medal, California School of Arts and Crafts, 1915
Honorable Mention (Etching), Panama-Pacific International Exposition, San Francisco, 1915

PUBLIC COLLECTIONS
Carmel Museum of Art
Crocker Art Museum, Sacramento
M. H. de Young Memorial Museum, San Francisco
Mills College Art Gallery, Oakland
Monterey Peninsula Museum of Art
The Oakland Museum

XAVIER MARTINEZ
Self Portrait, 1902
Oil on canvas, 16 x 13 inches
*Courtesy Collection of The Oakland Museum,
Gift of Dr. William S. Porter*

Perhaps one of the most interesting figures in the art scene of San Francisco during the first decades of this century was Xavier Martinez. Mexican by birth, with a mixture of Spanish and Indian blood, he came to San Francisco in the early 1890s to study at the California School of Design. Within a short time he became a part of the Bohemian crowd. Always sporting a crimson, flowing necktie with his thick, black hair tied back with a leather thong, Marty, as he was called, was a colorful character, a description which seems somewhat at odds with the subtle and low key qualities of his art.[1]

Martinez was born in Guadalajara on February 7, 1869 and christened Javier Timoteo Martinez y Orozco.[2] His father, Margarito Martinez y Suarez, was a leather craftsman who specialized in fine bookbinding. As a child, Martinez showed an aptitude for drawing. His father's cousin, a sign painter, taught the young Martinez the techniques of fresco painting and how to grind and mix both oil paints and watercolors.

In 1893 Martinez traveled to San Francisco where he was sponsored for enrollment in the California School of Design by Rosalia La Bastida de Coney, wife of the Consul General for Mexico in San Francisco.[3] His first year of studies was somewhat disappointing, primarily due to his difficulty with the English language. However, during his second year he showed remarkable improvement, received many awards, and was appointed an assistant to Arthur Mathews.

After graduation in 1897, Martinez went to Paris and enrolled in the Ecole des Beaux Arts. He studied in the ateliers of Jean-Léon Gérôme (1824–1904) and Eugène Carrière (1849–1906). During the years he spent studying in France, he was able to travel to Italy and Spain where he was especially impressed by the fresco work of Giotto and El Greco. In 1900 he received an honorable mention at the Paris International Exposition for his portrait of Miss Marion Holden, a fellow student from San Francisco. While in Paris he apparently became friends with James A.

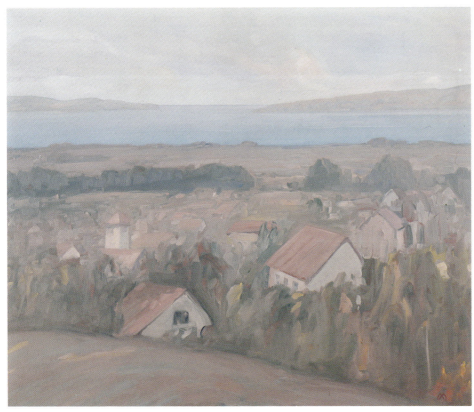

XAVIER MARTINEZ
The Bay, 1918
Oil on canvas, 30 x 36 inches
*Courtesy Collection of The Oakland Museum,
Gift of Dr. William S. Porter*

McNeill Whistler (1834–1903) whose work had a profound influence on him.[4]

Martinez returned to San Francisco in 1901 and opened a studio on Montgomery Street which soon became a center for the Bohemian crowd. He concentrated on figural work and cityscapes. In 1904 he returned to his native Mexico, later exhibiting works from that trip at the Bohemian Club. In 1905 he made another trip to Mexico, this time visiting Guadalajara with Maynard Dixon. Shortly after their return an exhibit of twenty-five paintings by Martinez was held at Vickery, Atkins & Torrey Gallery. Included in the exhibits were scenes of Paris and Mexico as well as works depicting the local landscape. The show was well received by both the public and the critics.[5] Porter Garnett described the paintings as "remarkable for their light and their suggestion of light."[6] The entire exhibition was then sent to Macbeth Galleries in New York City where it was likewise well received.[7]

The 1906 earthquake and fire destroyed Martinez' studio on Montgomery Street. He was invited to stay with his friend, author Herman Whitaker, who had a home in the Piedmont Hills. His paintings of the area, such as *Piedmont Landscape*, captured the charm of the region with a "beautiful simplicity."[8]

While staying with Whitaker, Martinez fell in love with one of his daughters, Elsie. They were married on October 17, 1907.[9] Shortly afterward they moved into the studio-home he had built in Piedmont. Martinez painted a lovely portrait of his wife as she

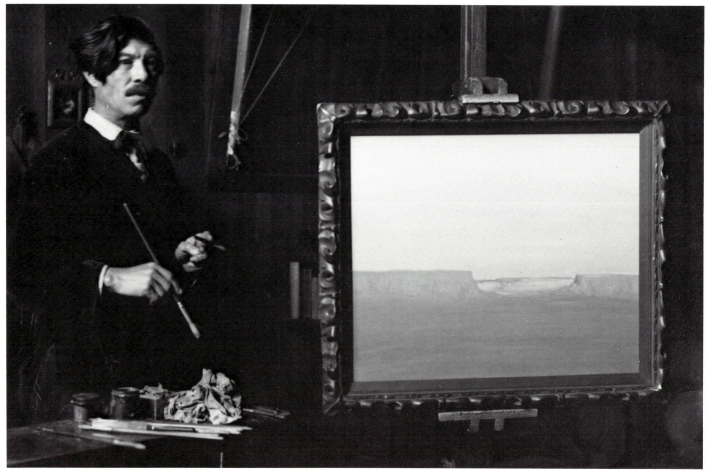

Xavier Martinez in his studio

Photo courtesy James L. Coran and Walter Nelson-Rees

sat by the window overlooking the Bay, *Afternoon in Piedmont*.

The Martinez home became a haven for the *avant-garde*. Every Sunday there was an open house with plenty of food, wine, and lively discussion. Among the many guests was novelist Jack London whose portrait was painted by Martinez as part of a commission from Arthur B. Davies for six portraits of Western men and women to be exhibited in the East.[10]

In 1908 Martinez joined the teaching staff of the California School of Arts and Crafts, a position which he retained until 1942, the year before his death.[11] In October of 1908, he spent two weeks in Monterey with Charles Rollo Peters.

Early in the winter of 1909 another exhibit of Martinez' work was held at Vickery's Art Gallery in San Francisco. One critic described his landscapes as appropriately expressive, noting:

> The gray effects so noticeable in California scenery are particularly well-rendered...Lowering, sublime skies, glints of somber, lurid coloring, long lines of violet, orange, or purple, or tawny streaks of light, all subdued to fine harmony and melting into each other,...[12]

During the summer of 1913, Martinez and Francis McComas spent two months on a Hopi Indian reservation in Arizona. Always aware and proud of his Indian heritage, Martinez must have felt a special kinship to the people and the land. His paintings of the region are quietly suggestive with a warm,

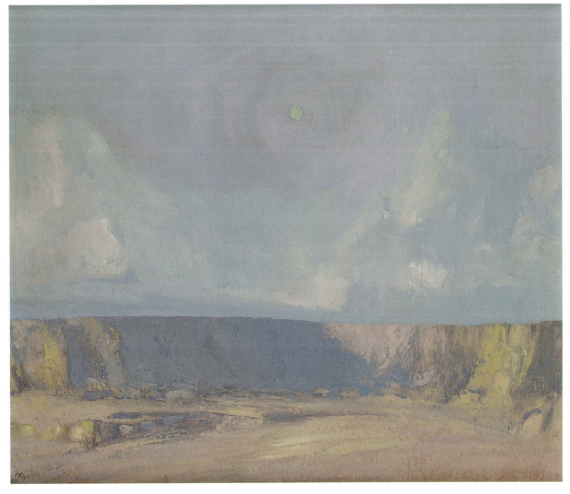

XAVIER MARTINEZ
Green Moon
Oil on board, 30 x 35½ inches
Courtesy James L. Coran and Walter Nelson-Rees

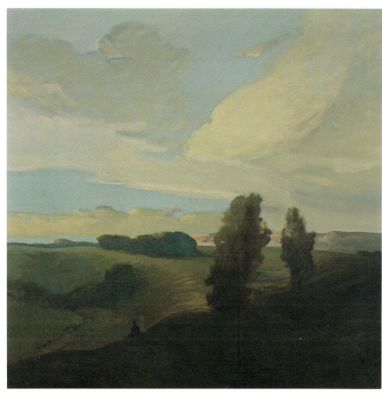

XAVIER MARTINEZ
Contra Costa
Oil on canvas, 36 x 36 inches
Courtesy Collection of The Oakland Museum

glowing light.

Most of Martinez' work may be described as tonalist, having a low-key, limited palette and blurred forms.[13] The work seems to be specifically influenced by Whistler who reduced his compositions to "the most essential and mood-producing elements."[14] Like the work of his friend Charles Rollo Peters, many of Martinez' paintings are of nocturnal subjects as seen in *The Bridge*, *Apache Dance*, and *The Green Moon*. An early critic beautifully described *The Green Moon*:

> A little sweep of desert sand mysteriously scintillant in the light of the setting sun: a shadow bathed mesa rising, towering and forbidding, to cruelly silhouette itself against the sky and the deep mystery of the green moon hanging low in the sky, relentlessly usurping the sun's brilliantly dying glow. Through it all is felt the brooding silence of the desert."[15]

William H. Gerdts described the "suggestive beauty" of tonalist work as offering "a realm of suspended reality in which we may seek a gratification in the emotive powers of nature."[16] It is that quality which gives the works a universal appeal. To Porter Garnett, "no painter in California...more closely approached universality in his art, none may be said to represent a particular school more completely" than Xavier Martinez.[17]

In 1923 Martinez and his wife separated.[18] Elsie and their daughter went to live with a friend, Harriet Dean, who lived nearby. The separation was amicable, and Elsie continued to look after Martinez' needs. In the late 1930s Elise and Harriet moved to Carmel.[19] In 1942, hampered by poor health, Martinez retired from teaching and went to live again with Elsie. Six months later he died at the age of seventy-three.

Janet B. Dominik

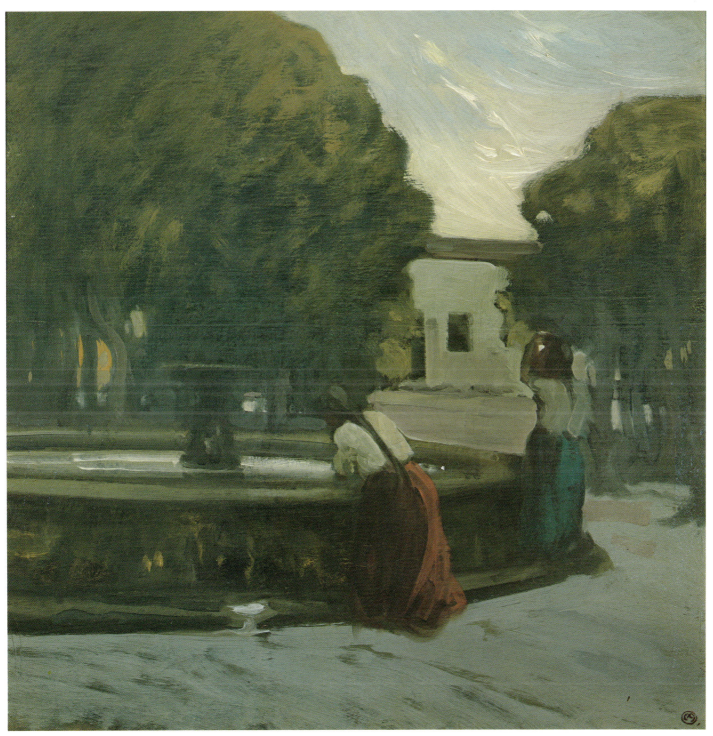

XAVIER MARTINEZ
Women at the Well
Oil on canvas, 20 x 20 inches
Courtesy Robert Canete

ARTHUR FRANK MATHEWS (1860–1945)

BORN
October 1, 1860, Markesan, Wisconsin

DIED
February 19, 1945, San Francisco, California

TRAINING AND STUDY
Académie Julian (Gustave Boulanger and Jules Lefebvre)

STUDIO LOCATIONS
Oakland and San Francisco

RESIDENCES IN CALIFORNIA
Oakland and San Francisco

MEMBERSHIPS
The Bohemian Club
San Francisco Art Association

AWARDS
Grand Gold Medal, Académie Julian, Paris, 1886
James D. Phelan Award, San Francisco Art Association, 1896
Gold Medal, American Institute of Architects, 1923

PUBLIC COLLECTIONS
California Historical Society
Hirshhorn Museum and Sculpture Garden, Washington, D.C.
M. H. de Young Memorial Museum, San Francisco
The Metropolitan Museum of Art
Monterey Peninsula Museum of Art
National Museum of American Art, Washington, D.C.
The Oakland Museum

LUCIA KLEINHANS MATHEWS (1870–1955)

Photos courtesy Art Department, The Oakland Museum

BORN
August 29, 1870, San Francisco, California

DIED
July 14, 1955, Los Angeles, California

TRAINING AND STUDY
Mills College, Oakland
California School of Design (Arthur Mathews)
Académie Carmen, Paris (James McNeill Whistler)

STUDIO LOCATIONS
San Francisco

RESIDENCES IN CALIFORNIA
San Francisco

MEMBERSHIPS
San Francisco Art Association
The Sketch Club, San Francisco

AWARDS
Silver Medal, Panama-Pacific International Exposition,
 San Francisco, 1915

PUBLIC COLLECTIONS
The Oakland Museum
Virginia Museum of Fine Arts, Richmond, Virginia

Arthur and Lucia Mathews held a preeminent position in the artistic life of Northern California in the years between 1890 and the early 1920s. Their confident and ingenious leadership was a major aesthetic force in the rebuilding of San Francisco after the 1906 earthquake and fire. This talented and versatile couple excelled not only as easel painters but also, both individually and in collaboration, as graphic artists and designers of furniture, frames, and decorative objects executed in their distinctive personal style now identified as California Decorative Style.

The word "decorative" as applied to the works by the Mathewses and many of their contemporaries in Europe and America did not carry the pejorative connotations often associated with its use today. It was not uncommon for well-trained artists of the nineteenth century to apply their talents to the designing of architectural interiors complete with murals, furniture, and furnishings.

The California Decorative Style combines historical aspects of the American Renaissance style, which was inspired by the European Renaissance culture with its sources in classical antiquity, along with the English and American Arts and Crafts Movements and their emphasis on simple functional design.

This eclectic inspiration was given color, form, and a regional sense of place by involving the indigenous colors, contours, and atmosphere of the characteristic Northern California environment. In the California Decorative Style, Arthur and Lucia Mathews merged painting with the decorative arts and brought tangible form to their belief that the arts were an integral and indispensable part of daily life.

Arthur Frank Mathews was born 1 October 1860 in Markesan, Wisconsin, and came to California with his family at the age of six. His early training in art included work as an apprentice draftsman in his father's architectural firm in Oakland. Mathews' two brothers also chose architecture as their profession. In

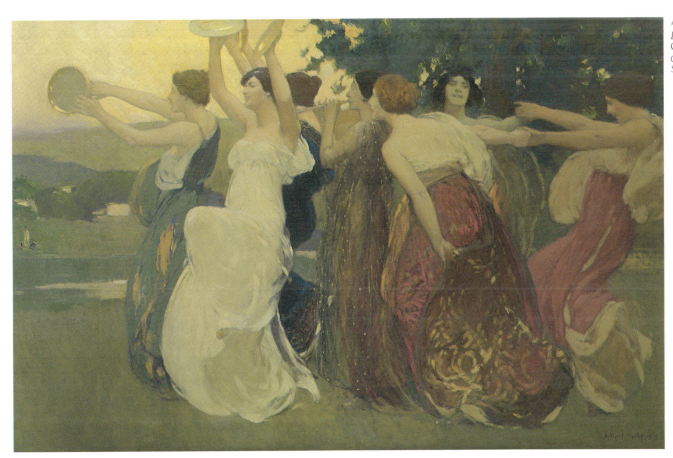

ARTHUR MATHEWS
Dancing Ladies, 1917
Oil on canvas, 34 x 52 inches
Courtesy John H. Garzoli Fine Art, San Francisco

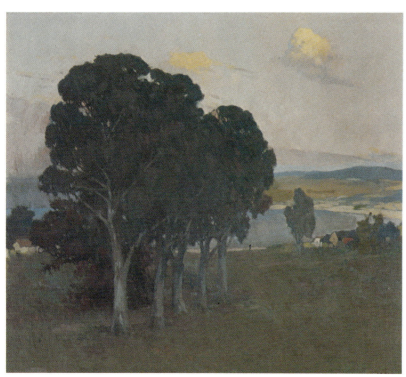

ARTHUR MATHEWS
The Bay of Monterey
Oil on canvas, 34¼ x 38¼ inches
Courtesy Gibson, Dunn & Crutcher

recognition of his exceptional talent, the San Francisco firm of Britton and Rey, lithographers, gave Arthur Mathews a position as a designer and lithographer, where he remained for three years. Following additional early encouragement from several awards in competitive design contests, in 1885 he began a five-year period of study in Paris at the Académie Julian. As a pupil of two academicians, Gustave Boulanger and Jules Lefebvre, prominent painters of historical and allegorical subjects, Mathews distinguished himself as a prize-winning student of drawing and painting. He was further honored to have his work exhibited in the Paris Salons. Upon his return to San Francisco in 1889 Mathews began teaching at the San Francisco Art Association's School of Design where he soon became its director and where he remained during the school's existence in the Mark Hopkins Institute until 1906. As director he instituted major reforms in the curriculum and staffing of the school to establish its fine reputation, not only in this country but in Paris as well. Mathews' somewhat autocratic approach to teaching and criticism, presumably patterned after the style of Whistler, was not appreciated. After sixteen years of teaching, Mathews' position as director was terminated when the school relocated following the destruction of the Mark Hopkins Institute in the 1906 San Francisco earthquake and fire. Following the great disaster, Mathews headed a committee for distribution of relief funds for San Francisco artists and designed and had built the first artist's studio in the city's reconstruction. The building provided studios for William Keith and Arthur Mathews and housed facilities for the Furniture Shop, a commercial enterprise for which he was chief designer.

Arthur Mathews embodied the concept of a Renaissance man of the arts perhaps more than any other artist in California. Throughout his long career he was devoted to a wide range of artistic pursuits that embraced architecture, city planning, furniture design, graphic design, writing, teaching, and virtually all aspects of painting, in his quest for obtaining the highest levels of art and architecture for San Francisco. Mathews' ability as a mural painter established his unique reputation among California's artists. In 1923 the American Institute of Architects awarded Mathews its Gold Medal for Distinguished Achievement in Painting in recognition of his many contributions to muralist art. Included among his more than

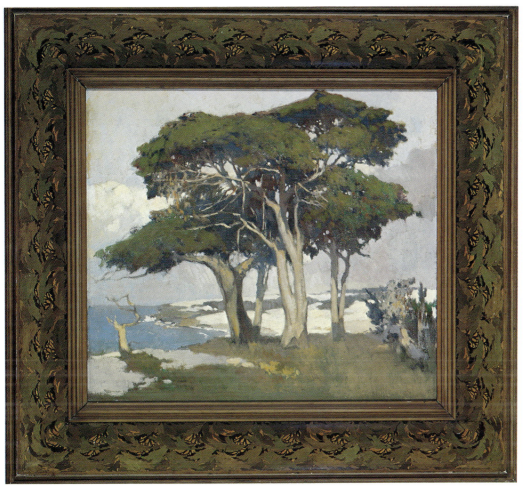

ARTHUR MATHEWS
Monterey Cypress, 1930
Oil on canvas, 25½ x 29½ inches
*Courtesy Collection of The Oakland Museum,
Gift of Concours d' Antiques,
Art Guild of the Oakland Museum Association*

twenty major mural commissions were those for the Panama-Pacific International Exposition, the Oakland Public Library, and the State Capitol Building. Arthur Mathews established a figurative tradition in California painting that had been dominated by landscape subjects. Characteristic paintings in his California Decorative Style include groupings of or individual classical-inspired female figures set in a carefully composed architectural or landscape setting. Flat decorative contours and subdued color harmonies in the tonal mode derived from the California landscape are dominant features of his paintings. The California poppy represented a recurring decorative element in the paintings and decorative frames which constituted a virtual trademark of the California Decorative Style. Influences on Mathews' painting style included his early architectural and academic training, and perhaps more evident, the progressive influences of Puvis de Chavannes and Whistler whose works inspired the young Arthur Mathews during his years in Paris.

Although best remembered for his figure compositions, Mathews was a prolific painter of landscape. He was frequently asked why an artist of his remarkable ability should prefer San Francisco to the art centers of the Eastern Seaboard or of Europe. "Why do I stay in California?" he asked, "California is an undiscovered country for the painter. It hasn't been touched. The forms and colors of our countryside haven't begun to yield their secrets…"[1] His frequent trips to the Monterey peninsula over the years provided the sources of some of his favorite subjects. Mathews' landscape paintings employed a form of decorative tonalism characterized by flowing linear contours and flat patterns of interlocking shapes that describe the dramatic silhouettes of the Monterey

cypress and the towering coastal pine trees. A low-keyed palette of close color harmonies emphasized a poetic interpretation of the drifting marine fogs and the soft contours of California's golden hills in summer rendered in the muted tones of twilight. It is in these decorative landscapes that the Mathews influence was evident in the works of some of his students and associates. The paintings of Francis McComas, Gottardo Piazzoni, and Xavier Martinez represent the shared aesthetic of the tonalist style that, along with Arthur and Lucia Mathews, stands in contrast with the Impressionist-inspired paintings by artists working *en plein air*, the other prevailing style of the period.

Mathews maintained an analytical attitude toward his work that included the technical as well as the philosophical. He had no faith in general movements in art which he considered largely to be fads. Following a brief experimentation with impressionist techniques, he abandoned the approach in favor of his own. In a conversation which took place early in 1909 Mathews outlined his approach to painting:

"I consider the subject first, the color second, the arrangement of color third, the drawing last. I put most stress on composition, especially on composition of color and tone."[2] It was largely owing to Whistler's influence that Mathews adopted the use of dominant monochromatic coloring and the shallow spatial illusions appropriate to murals.

He would frequently sketch in the out-of-doors, sometimes doing studies in pastel which could be worked up later as paintings. The inspiration for some of Mathews' typical color and light effects is suggested by his statement that: "I never work outside until after four o'clock in the afternoon. For to me the most extraordinary color effects that we find here in the West come only in the diffused afternoon lights."[3] Looking back on his training as an artist in a letter printed in the *San Francisco Chronicle* in 1934, Mathews said: "And then after all schooling, nature is the teacher."[4]

Lucia Kleinhans Mathews was born 29 August 1870 in San Francisco, California. Following a brief period of study at Mills College in Oakland, she enrolled at the School of Design in San Francisco where she became a pupil of Arthur Mathews. He soon recognized her exceptional ability and placed her in his advanced class over the objections of some of her other teachers. In response to them he stated: "That girl can draw better than you can. In fact, I don't know but what she can draw better than I can, so into the class she goes, and she stays."[5] In June of 1894 Arthur Mathews and Lucia Kleinhans were married, thus beginning a long life together that often included collaboration on the creation of decorative frames, furniture, and interiors. In 1898 they began a year-long European tour which included visits to London, Milan, Venice, Rome, and Paris. Early in 1899 Lucia attended Whistler's Académie Carmen in Paris where she absorbed directly the Whistlerian influences in color and form that characterize her protraits in oil from that period. As her work matured Lucia began to establish her separate identity within the California Decorative Style. Showing a preference for watercolor and pastel, with emphasis on landscape and floral subject matter, Lucia Mathews created works with an intimacy and immediate appeal that was sometimes lacking in her husband's more ambitious creations on a large scale. She exhibited a watercolor titled *Monterey Pine* in the Panama-Pacific International Exposition in 1915 and was awarded a

LUCIA MATHEWS
Self Portrait, c. 1899
Oil on wood panel, 10 x 10⅔ inches
Courtesy Collection of The Oakland Museum, Gift of Dr. William S. Porter

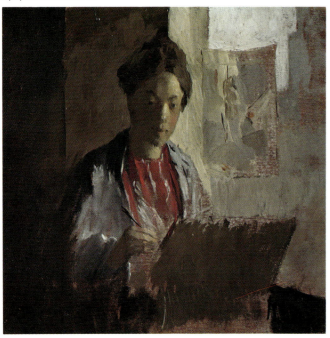

silver medal. Lucia was active in the artist community of San Francisco where she was involved with a women artists' association called the Sketch Club. She was at various times an exhibitor, board member, and president of the prestigious organization. Lucia Mathews is perhaps best remembered for her richly painted and gilded decorative furnishings done in collaboration with Arthur's designs for the Furniture Shop. As a painter her work maintains a separate identity within the general characteristics of the California Decorative Style she helped create, and critical assessment of her work today frequently agrees with Arthur Mathews who said on more than one occasion that Lucia might have been the greater artist.

Arthur and Lucia Mathews enjoyed the patronage of some of San Francisco's leading citizens and counted among their friends many of the most prominent artists in America as well as California. Their many exhibitions and public works received the formal recognition of awards and medals as well as popular appreciation. Their legacy of art survives in a few public and private collections and is reflected in the works of many California artists who received the influences both directly and indirectly of this remarkable couple.

Harvey L. Jones

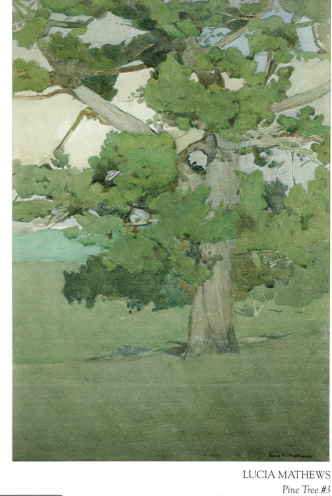

LUCIA MATHEWS
Pine Tree #3
Watercolor, 21 x 14⅔ inches
*Courtesy Collection of The Oakland Museum,
Gift of Mr. Harold Wagner*

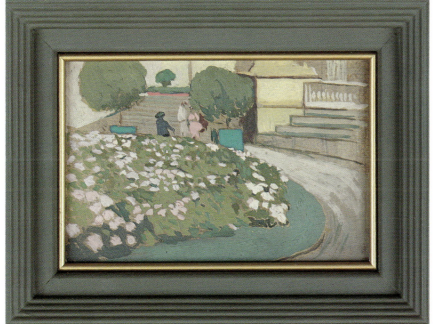

LUCIA MATHEWS
Scene, Panama-Pacific International Exposition, San Francisco, 1915
Oil on wood panel, 3⅞ x 5⅞ inches
*Courtesy Collection of The Oakland Museum,
Gift of Mr. Harold Wagner*

FRANCIS JOHN McCOMAS (1874–1938)

Photo courtesy California Historical Society, San Francisco

BORN
October 1, 1874, Fingal, Tasmania

DIED
December 27, 1938, Monterey, California

TRAINING AND STUDY
Sydney Technical School, Sydney, Australia, 1890-94
 (Julian Ashton)
California School of Design
Académie Julian, Paris

STUDIO LOCATIONS
San Francisco
Monterey

RESIDENCES IN CALIFORNIA
San Francisco
Monterey

MEMBERSHIPS
American Watercolor Society
The Bohemian Club
Philadelphia Watercolor Club
Salmagundi Club, New York City
San Francisco Art Association

AWARDS
Gold Medal, Philadelphia Watercolor Club, 1918
Hudnut Prize, American Watercolor Society, 1921

PUBLIC COLLECTIONS
M. H. de Young Memorial Museum, San Francisco
The Metropolitan Museum of Art
Mills College Art Gallery, Oakland
Monterey Peninsula Museum of Art
The Oakland Museum
Palace of the Legion of Honor, San Francisco
San Francisco Museum of Modern Art

Born in Fingal, Tasmania on October 1, 1874, the watercolorist Francis John McComas began his art career far from America, making illustrations for a Sydney, Australia advertising firm. In 1898, conscious of his need for more systematic art training, McComas set sail, serving as a crewman, on a vessel bound for San Francisco.

On arrival he enrolled at the Mark Hopkins Institute of Art's California School of Design, joining Xavier Martinez and many others and studying from a curriculum recently revamped by the school's director, Arthur F. Mathews. After a brief matriculation, McComas continued eastward, finally stopping in Paris in early 1899 and paying his fees for classes at the Académie Julian. Evidently a facile learner, McComas paused in Paris only slightly longer than he had in his first visit to San Francisco. He retraced his steps to the West Coast in 1900, continuing on to Australia, then returning once again to San Francisco in the same year.

From 1900 to 1906, McComas' signature style as a painter began to crystallize—acutely stylized volumes and a muted, deftly harmonized palette. It is this

FRANCIS McCOMAS
California Twilight, 1912
Watercolor, 23½ x 30 inches
Courtesy Collection of The Oakland Museum, gift of Mrs. Lucy Sprague Mitchell

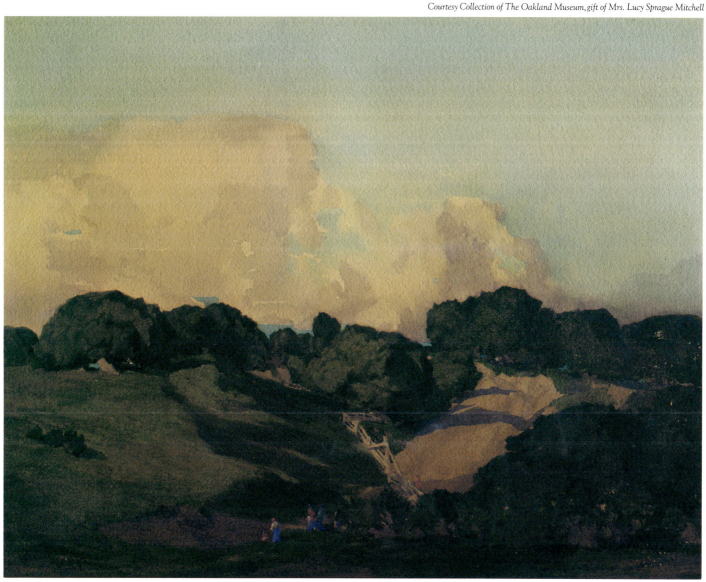

FRANCIS McCOMAS
The Mountain
Watercolor, 21½ x 27 inches
Courtesy Mrs. Justin Dart

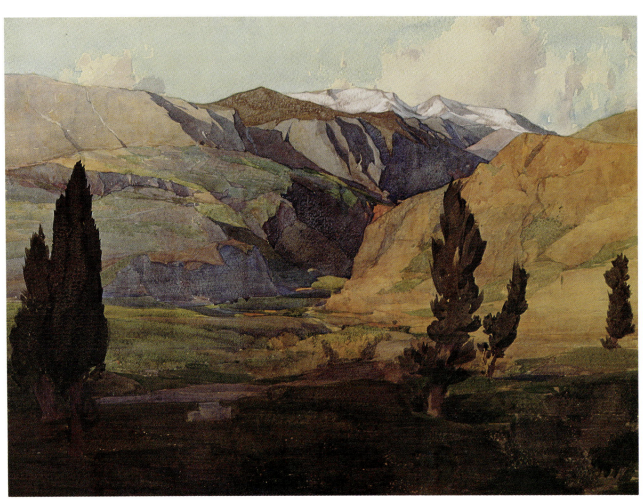

austere graphic beauty which imparts an identity of its own to McComas' characteristic and mature work and sets it apart from the more lyrical and poetic expressions of his mentor, Arthur Mathews.

Making his residence in Monterey, McComas painted the cypresses and oaks and nearby coastal valleys. He began exhibiting locally with solo shows at San Francisco's distinguished Vickery, Atkins and Torrey Gallery, at the 1905 Lewis and Clark Centennial Exposition in Portland, Oregon, and at the Alaska-Yukon-Pacific Exposition held in 1909 in Seattle, Washington. Around this time he joined a pilgrimage of local painters, including Maynard Dixon (1875–1946), Xavier Martinez and Amédée Joullin (1862–1917) to the Southwest to paint the pueblos and the landscape, and some of McComas' best-known work dates from this time and place.

Symbolic of his growing national reputation was an invitation to exhibit at the International Exhibition of Modern Art held in 1913 at New York's Sixty-Ninth Regiment Armory. He showed three paintings, one of which was ultimately acquired by the Metropolitan Museum of Art. An active participant in the gathering preparations for the Panama-Pacific International Exposition, McComas was appointed to the International Jury of Awards, overseeing selections for the exhibit at the Department of Fine Art, and he shared an entire gallery with Arthur Mathews, an honor accorded only the deceased William Keith (1838–1911) among local artists.

Francis McComas had married Marie Louise Parrott, daughter of a prominent San Francisco trading family in 1905. In 1917, they were divorced. Later that year he married the painter Gene Francis Baker (1886–1982) with whom he remained until his death in Monterey on December 27, 1938.

Raymond L. Wilson

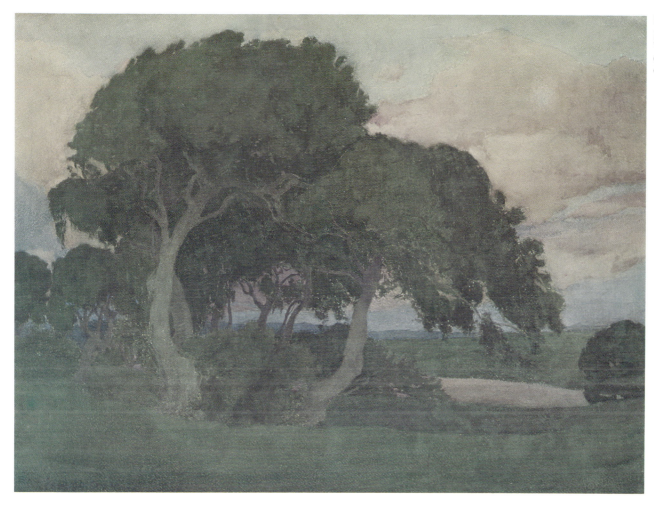

FRANCIS McCOMAS
Monterey Twilight, 1902
Watercolor, 25 x 33½ inches
*Courtesy Penny L. Perlmutter
and Alfredo F. Fernandez*

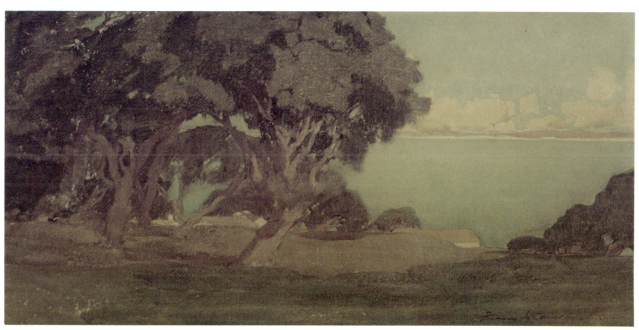

FRANCIS McCOMAS
Monterey Bay (from the Presidio), 1904
Watercolor, 13½ x 28 inches
*Courtesy Raymond L. Wilson
and Susan E. Holmer*

THOMAS A. McGLYNN (1878–1966)

Photo courtesy Archives of Betty Hoag McGlynn

BORN
March 29, 1878, San Francisco, California

DIED
June 21, 1966, Pebble Beach, California

TRAINING AND STUDY
California School of Design (Arthur Mathews)

STUDIO LOCATIONS
San Francisco
Pebble Beach

RESIDENCES IN CALIFORNIA
San Francisco
Pebble Beach

MEMBERSHIPS
American Artists Professional League
American Federation of Arts
Bay Region Art Association
Carmel Art Association
San Francisco Art Association
Santa Cruz Art League
Society for Sanity in Art
Society of Western Arts

AWARDS
Service Award, United States Liberty Fair, Los Angeles, 1918
Honorable Mention, California State Fair, 1924
Honorable Mention, Santa Cruz Art League, 1937, 1938, 1957
Honorable Mention, Society for Sanity in Art, 1938, 1939
First Prize, Santa Cruz County Fair, 1940, 1955
Service Award, Art in National Defense, 1943
First Honorable Mention, American Artists Professional League, 1946

Landscapes by Thomas McGlynn are among the most lyric of the Northern California luminist school. Never photographic, his paintings convey a sense of poetry. He had a special rapport with dramatic cloud formations and trees. During the early years of his life McGlynn was actively involved in the development of the Arts and Crafts movement in San Francisco. After retiring to the Monterey Peninsula he began to flood his canvases with pure golden tones which reflect the happiness he enjoyed the rest of his life.

Thomas A. McGlynn was born March 29, 1878, in San Francisco to a family of Scotch-Irish immigrants. As a youth he was fortunate to be a member of the Columbia Park Boys Club, a precursor of Boy Scouts. Organized into medieval-like guilds, the youngsters were taught a variety of manual crafts. In 1894 Tom was editor of the club's first magazine. He not only served as its business manager, set type, and wrote the editorials and stories, but also cut woodblocks for cover designs and decorated its pages in art nouveau style prophetic of *Philopolis*.

Tragedy struck Tom when he was about thirteen. Playing "cops and robbers," he was trapped under a falling lumber pile which crushed his back. He spent years in-and-out of hospitals and during his youth was forced to use crutches; later on, canes. He never permitted them to interfere with his career as an artist.

In 1899 Tom enrolled at the California School of Design, having been awarded a full scholarship which was renewed every year he was at the school. It was natural that the director, Arthur Mathews, was pleased with this young man who had a crafts background. An enduring friendship was formed.

In 1904 the school was asked to produce a a section of the University of California's 1905 yearbook, *The Blue and Gold*. Tom was one of the editors and did much of the art work. Among his sketches are those of a sprightly girl who had entered the school on a 1902 scholarship. Eventually Gertrude Gorter would become his wife. Often Gertrude took Tom to visit at her family's summer home on the Russian River. They liked to paint in this area, an artists' haven ever since Bohemian Club members had discovered it in the late 1870s.

The month of April 1906, found the couple busy preparing for graduation. However, the tragic eighteenth day altered life for all residents of the City

THOMAS McGLYNN
Quietude
Oil on canvas, 34 x 36 inches
Courtesy John Dowling Relfe Collection

115

THOMAS McGLYNN
The Grove
Oil on wood panel, 5½ x 7 inches
Courtesy Mr. and Mrs. Jean Stern

by the Golden Gate. Following the earthquake and fire, San Franciscans struggled to rebuild their world. Gone was the California School of Design. There were no graduation exercises that year to award "C.S.D. pins" and diplomas; Gertrude and Tom's class received them by mail later in the summer. Almost before the embers cooled, the art association began building a new headquarters and school on the property. The association's board did not reappoint Arthur Mathews as dean, but gave the position to a less controversial man, Theodore Wores.

Most San Francisco artists lost their studios in the fire. There was a general exodus to other places. Arthur Mathews was one person who decided not to desert his city. He formed a partnership with wealthy John Zeile. The latter's home at 1717 California Street had burned to the ground. On the lot the men built the Furniture Shop which opened in October of 1906. Until 1907 Tom McGlynn did free-lance designing for several businesses, including Beach-Robinson which had offices in the Furniture Shop. Also, he taught for a short time at the University of California. In 1909 Mathews made Tom his full-time chief assistant, a position he would hold for a decade. His duties included mural installation, supervision of the craftsmen (usually about fifty men, most of them European-trained woodworkers), and apparently a great deal of original design. He contributed to the shop's publication, *Philopolis*; it is suspected that he attended to much of the magazine's mechanization.

In 1909 Tom and Gertrude married and moved

THOMAS McGLYNN
Sunshine and Shadow, c. 1940
Oil on canvas, 30 x 36 inches
Private collection

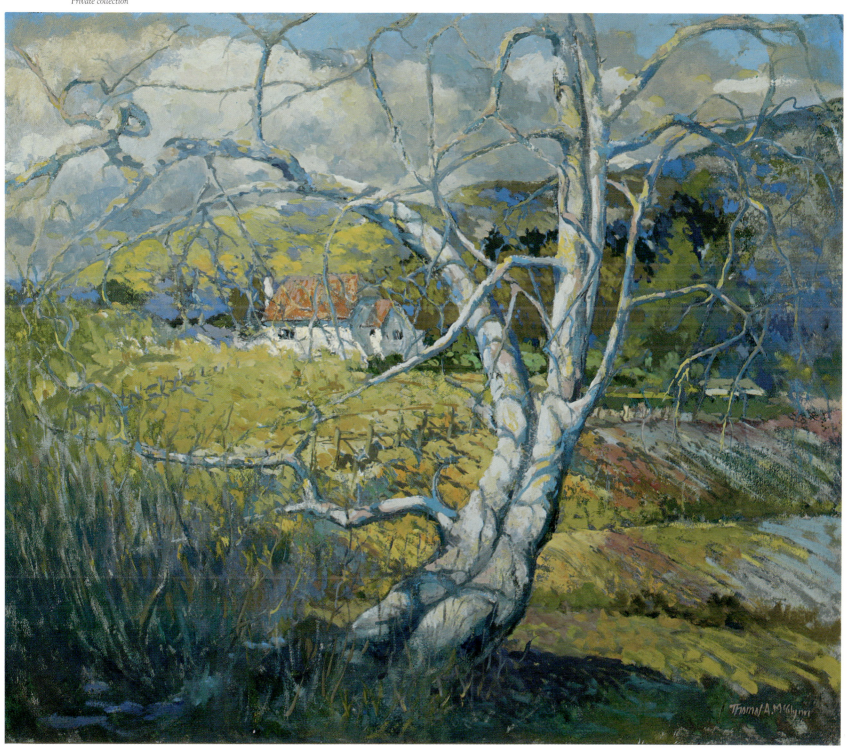

THOMAS McGLYNN
Winter's Lace
Oil on canvas, 25 x 30 inches
Courtesy Monterey Peninsula Museum of Art

THOMAS McGLYNN
Mighty Oak
Oil on canvas, 30 x 36 inches
Courtesy G. Breitweiser

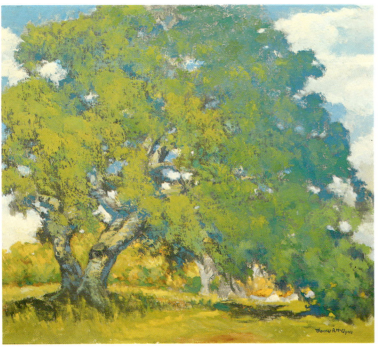

into a home they had built at 1919 Clement. During the next few years the most momentous event in the Bay Area was the 1915 Panama-Pacific International Exposition. Mathews was on the International Jury of Awards. No doubt Tom had his hands full, managing Mathews' business while that man was hosting celebrities from all over the world. Like all local artists, Tom welcomed the wonderful opportunity to study original Impressionist paintings at the fair. As a result, his work became less decorative, less fraught with symbolism, more concerned with the study of light. And he was able to pursue his own painting career all the time he worked at the Furniture Shop. With the advent of World War I there was a slowing of activities there. Workmen were siphoned off to war industries or the armed forces. *Philopolis* was discontinued in 1916. Gertrude taught briefly at a private school in 1917, probably because Mathews had had to curtail Tom's salary.

Tom left the Furniture Shop in 1918, two years before it closed. He then began twenty-seven years of teaching craftsman methods to a new generation. His days at Girls' High School were devoted to stagecraft, drawing and art history. In 1924 he added a late afternoon manual training course for young boys at the Hebrew Orphanage. Early in the 1930s a third art class at Galileo Evening School was included. The schedule was grueling but had important compensations: weekends were free, and there were long summer vacations. That was when the family made trips, the father sketching wherever they went—from British Columbia to Baja California. However, Tom had painted on the Monterey Peninsula since the turn of the century and it remained his favorite place. He was convinced that the air had a unique rarity which produced greater intensity of color.

A successful artists' cooperative was formed in 1927 at Carmel-by-the-Sea. Tom wrote this Carmel Art Association in 1934, requesting membership and sending three examples of his work, as was the custom. A swift answer came from the president, Armin Hansen, saying that Tom "had been elected unanimously, in less than twenty seconds." Armin had been in the McGlynns' 1906 graduating class and was now the leading art teacher on the Monterey Peninsula. He added a postscript, regretting that Tom saw fit to remain as a teacher in San Francisco and urging him to "join the great tribe of us, out here in the open—just to paint." It was a kind of clarion *plein air* appeal

that Thomas McGlynn could not resist. In 1938 Tom and Gertrude bought a house on Padre Lane in Pebble Beach. Here they came on weekends and their sons added a studio for Tom in a quiet corner of the estate's spacious garden.

A few years later the McGlynns moved permanently to the Monterey Peninsula, where Tom devoted full time to landscape painting. It was a strenuous second career. After serving on the board of the Carmel Art Association, he became its president twice (1951 and 1952). His work was regularly exhibited there, and two times he was given large solo shows. He was often juror of shows and was accorded special honors. In addition to the Carmel Art Association, he was an active member of the Santa Cruz Art League, the American Artists' Professional League, and the Society of Western Artists.

A charter member of the San Francsico chapter of the Society for Sanity in Art, Tom witnessed its impact on all Northern California art exhibitions. Entries and judging began to be divided into three categories: Radical, Intermediate and Conservative. McGlynn paintings were always entered in the last category.* Nearing the end of his life, Tom gave his painting titles which attest to the beauty he saw about him: *Majesty, Tranquility, Day Unto Day*, etc. The canvases are treescapes filled with clear sparkling colors. They seem to pulsate pure air. Thomas A. McGlynn died on June 21, 1966, at his Pebble Beach home.

*A favorite of the Society for Sanity was his *Winter's Lace* which had won an award at Santa Cruz in 1928. The Society gave it another the next year. In 1940 the organization chose it as their entry for the Golden Gate International Exposition on Treasure Island. *Winter's Lace* received its highest accolade in 1941 when it represented the San Francisco chapter in Chicago at the second annual national meeting of the Society for Sanity in Art. Today the Monterey Peninsula Museum of Art owns the painting which is still mounted in the California Decorative frame carved by Thomas McGlynn and gilded by Myron Oliver.

Betty Hoag McGlynn

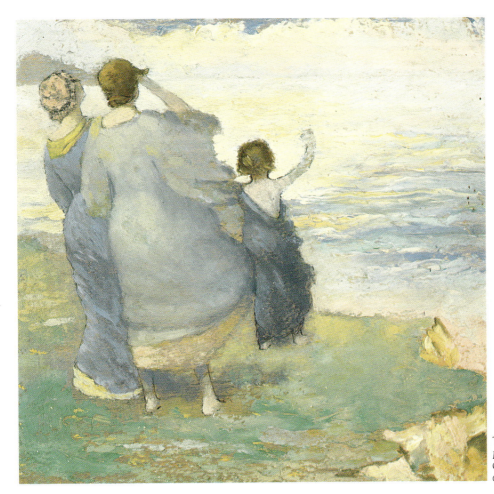

THOMAS McGLYNN
Figures on the Shore
Oil on board, 12½ x 13½ inches
Courtesy G. Breitweiser

MARY DeNEALE MORGAN (1868–1948)

BORN
May 24, 1868, San Francisco, California

DIED
October 10, 1948, Carmel, California

TRAINING AND STUDY
California School of Design (Virgil Williams, Emil Carlson, Amédée Joullin)
Additional Studies with William Keith

STUDIO LOCATIONS
Oakland
Carmel

RESIDENCES IN CALIFORNIA
Oakland
Carmel

MEMBERSHIPS
American Federation of Art
Artists Guild, Chicago
California Water Color Society
Carmel Art Association
Carmel Club of Arts and Crafts
Laguna Beach Art Association
National Association of Women Painters and Sculptors
San Francisco Art Association
West Coast Arts

PUBLIC COLLECTIONS
Los Angeles County Museum of Art
Monterey Peninsula Museum of Art
Stanford University Art Gallery
University of Southern California
University of Texas

For over thirty-five years one of the most active members of the art community on the Monterey Peninsula was Mary DeNeale Morgan. A truly regional artist, Morgan rarely traveled outside of that community, finding all that she needed for inspiration just outside the window of her studio in Carmel.

Mary DeNeale Morgan was born in San Francisco on May 24, 1868, the second of seven children of Thomas Nicholson Morgan and Christina Ross. Her maternal grandparents were Scots who had emigrated first to Canada and then to the Monterey Peninsula in 1856.[1] In 1870 Thomas Morgan, a civil engineer and graduate of Yale, moved his family to Oakland where he became the city engineer. Mary attended public schools there and at an early age showed an interest in and talent for drawing.

In 1886 Morgan enrolled in the California School of Design, studying briefly under Virgil Williams (1830–1886). Until 1890 she studied there with Emil Carlsen (1853–1932) and Amédée Joullin (1862–1917).[2] She also worked with William Keith (1838–1911).

In 1896 Morgan opened her own studio in Oakland. For a time she taught art at Oakland High School, the exact dates not known. She became a frequent exhibitor in San Francisco and Oakland and, in 1907, had her first "one-man" show at Hahn Gallery. After the earthquake and fire in 1906, the artist toured the city, recording the effects of the calamity in crayon and pastel.

She made her first visit to Carmel around 1903. She was at once enchanted with the area and several years later acquired the studio of the late Sidney Yard (1855–1909).[3] After settling in the area she began

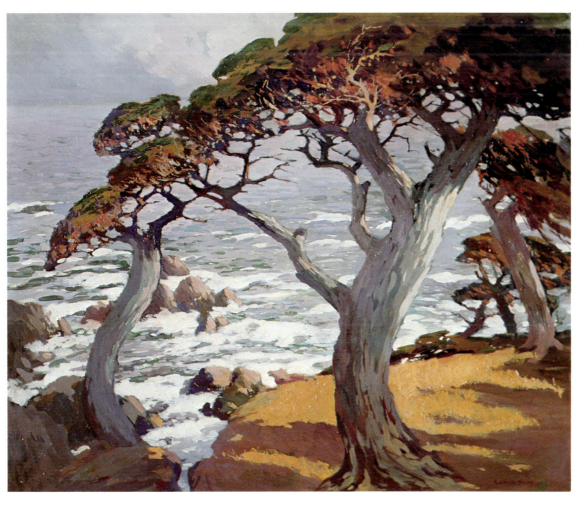

MARY DeNEALE MORGAN
October Golden House
Oil on canvas, 40 x 48 inches
Courtesy Maxwell Galleries Ltd., San Francisco

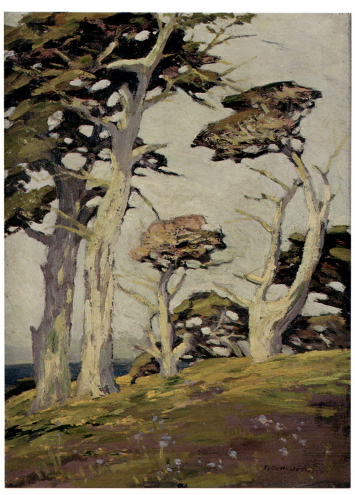

MARY DeNEALE MORGAN
Monterey Cypress
Oil on canvas, 24 x 18 inches
Courtesy John Dowling Relfe Collection

holding private classes for students. She became active with the Carmel Club of Arts and Crafts and, for several years directed the Carmel Summer School of Art which had been founded by that club.[4] At the urging of E. Charlton Fortune, Morgan invited William Merritt Chase to teach at the school in 1914, an event which had a profound influence on the artists in the area.[5]

In 1922 Morgan exhibited sixty works—forty-one paintings and nineteen monotypes—at the Van Bosckerck Studio in the Greenwich Village section of New York City. The exhibit, her first in New York, was one of many exhibitions she would have outside of San Francisco.[6] The paintings exhibited in New York were not oils, but "oleo tempera," i.e. tempera in which the emulsifier was oleoresin.[7] By using this kind of tempera Morgan was able to achieve the brilliant color effects for which she became known.

After 1924, she began to work in oil as well as tempera. The subjects of her works included the rocky shoreline of the Monterey Peninsula with its characteristically twisted cypress trees, the bustling harbor, the verdant and colorful fields of flowers, and the picturesque architecture of Monterey and Carmel. When her work was exhibited in 1925 at the gallery of the Hotel Oakland, it was praised for its simplicity and individualism which gave it strength.[8] The same year, Eleanor Taylor Houghton, writing for *Overland Monthly* observed:

> Many, many people paint Carmel each in his or her own way. No one has achieved as much individuality of interpretation as she has. She is preeminently decorative but she never employs the flatness of mere murals. Her canvases have unmistakable depth, perspective. She has chosen technique peculiarly fitted to suggest things just the way she sees them.[9]

In 1926 Morgan exhibited again in Oakland, at the Hotel Leamington, her paintings described as "broadly expressive" with "brilliant coloring."[10]

The artist always signed her work "M. DeNeale Morgan," a fact which tended to conceal her sex from some of her patrons, although whether this was deliberate is not known. When her work first began appearing in galleries in Los Angeles, it was thought that paintings of such vigor and strength surely were the work of a man.[11] Antony Anderson described those works as:

MARY DeNEALE MORGAN
Carmel Valley Ranch
Oil on board, 12 x 12 inches
Private collection

Simple in design almost to the point of the purely decorative,…yet three-dimensional in the solidity of its structural forms, and its color, though subdued to the artist's scheme…yet very vital.[12]

Morgan achieved these effects by painting rapidly, capturing the color and light of her subject *en plein air*. The pigment was applied with broad, sweeping strokes, considered by some to be a masculine approach.

Throughout the 1920s, 1930s, and 1940s, Morgan was very active in both the art and civic affairs of Carmel and Monterey. She was described as a kind and gentle person, always warmly receptive to those who came to see her. Her studio was virtually a continuous open house.[13] Visitors to her studio found it decorated with many of her paintings, providing a colorful panorama of the Monterey Peninsula. Her love of the area was clearly reflected in her work and inspired the work she did during the 1930s for the Public Works of Art Project, painting scenes of Old Monterey.

In the summer of 1934 a major exhibition of Morgan's works was held at the Del Monte Art Gallery. Sixty paintings were shown along with groups of temperas and pastels, monotypes, and etchings. The titles of the works were simple, yet poetic, such as *Garden by the Sea, Cypress Silhouette, Skyline Parade, Sparkling Sea,* and *Springtime Lavenders*. At this time her work was considered conservative by contemporary standards. However, its lack of appeal to the so-called moderns did not concern her. She, in fact, was appreciative of the new art styles, as long as they were "based upon a firm foundation."[14]

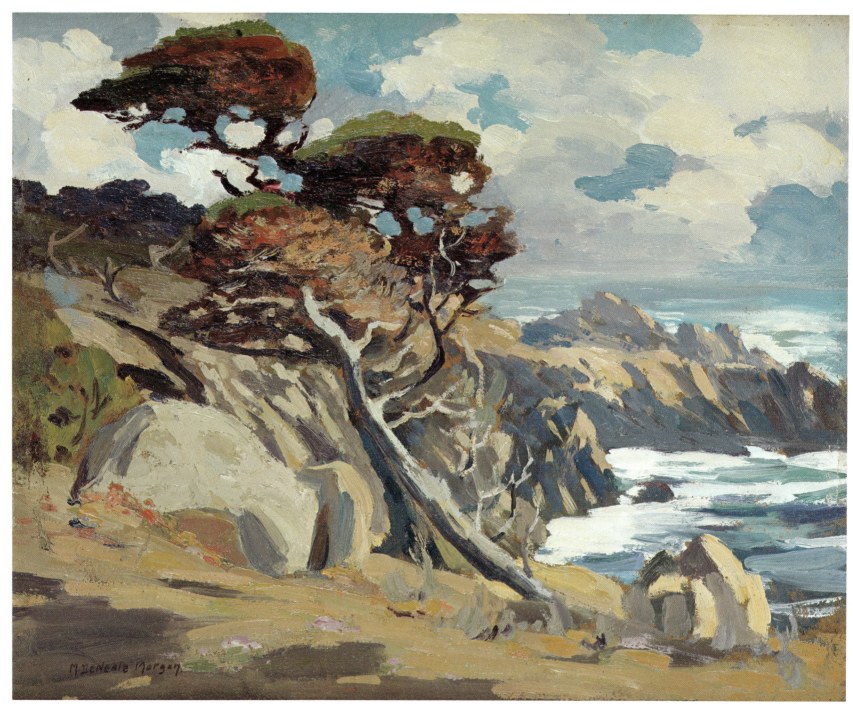

MARY DeNEALE MORGAN
Monterey Coast
Oil on board, 18 x 22 inches
Courtesy Penny L. Perlmutter

During the war years Morgan spent many hours visiting nearby Ford Ord Hospital where she made silhouettes for the servicemen who were patients there. In 1944, just four years before her death, the artist had a "one-man" show at the gallery of the Carmel Art Association. She was hailed as a "pioneer artist" for whom "the term Carmel Artist belongs most indisputably."[15]

Morgan died in 1948 at the age of eighty. After her death, and for many years thereafter, her studio was maintained by her sister, Jennie Klenke, who had lived with the artist for many years.[16] Perhaps the best tribute to Morgan was made by Brother Cornelius, biographer of William Keith, who inscribed her copy of his book as follows:

> To Miss DeNeale Morgan, master painter of the strange form, color and texture, the weather beaten toughness, the ancient fantastic weirdness, in a word, of the truth of our beloved Monterey cypresses...[17]

Janet B. Dominik

MARY DeNEALE MORGAN
A Bit of Pacific Grove
Gouache, 12 x 9 inches
Courtesy Timothy L. Fielder

ERNEST BRUCE NELSON (1888 – ?)

Bruce Nelson in Cooperstown, New York, 1918

BORN
June 13, 1888, Santa Clara, California

DIED
Unknown

TRAINING AND STUDY
Stanford University (Robert B. Harshe)
Art Students League, New York City
Woodstock Summer School, Art Students League (Birge Harrison, John F. Carlson)

STUDIO LOCATIONS
Palo Alto, California
San Jose, California
Pacific Grove, California

RESIDENCES IN CALIFORNIA
Palo Alto
San Jose
Pacific Grove

MEMBERSHIPS
San Francisco Art Association

AWARDS
Honorable Mention, Woodstock Summer School, New York, 1911
Silver Medal, Panama-Pacific International Exposition, 1915

PUBLIC COLLECTIONS
M. H. de Young Memorial Museum, San Francisco
The Oakland Museum
San Francisco Art Association

n the late 1910s one of the most promising of the Northern California Impressionists was Bruce Nelson who began attracting critical attention shortly after his return to California from his studies in the East.

Ernest Bruce Nelson was born on June 13, 1888 in Santa Clara, California, the son of Jesse Nelson and Emilie Bruce.[1] There is little if any information on his family background, childhood, or early education.

In 1905 Nelson began studying civil engineering at Stanford University. After three years he transferred his interests to architecture and met Robert B. Harshe (1879-1938) who was, at that time, head of the art department. Harshe proved to be very influential in encouraging Nelson's artistic pursuits.

After leaving Stanford, Nelson worked briefly in an architect's office in San Francisco. He then went to New York City and enrolled in the Art Students League. He also studied under Birge Harrison (1854-1929) at the Woodstock Summer School of the Art Students League, which Harrison had founded in 1906. In addition he worked with John F. Carlson (1875-1947) who was the director of the summer school from 1911 to 1918.[2] At Woodstock, in 1911, Nelson received an honorable mention for his painting *The Catskills*.[3]

In 1912 the artist returned to California, where, in November, an exhibition of twenty paintings was held at the galleries of Helgesen & Marshall in San Francisco. The *San Francisco Chronicle* praised the young painter, then only twenty-four years of age:

> He has an unusual constructive ability, coupled with the perception of the colorist and his values are true and in good taste, with a blend of shades that is gradual and melting especially in atmospheric effects.[4]

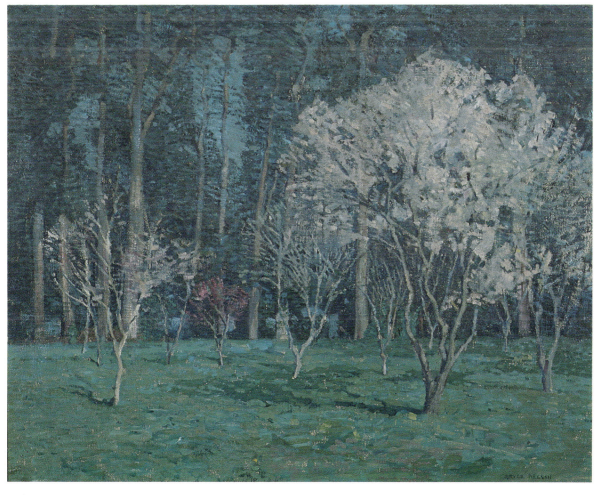

BRUCE NELSON
Orchard in Santa Clara Valley
Oil on canvas, 24 x 30 inches
Courtesy of The Oakland Museum, Gift of Jean Haber Green

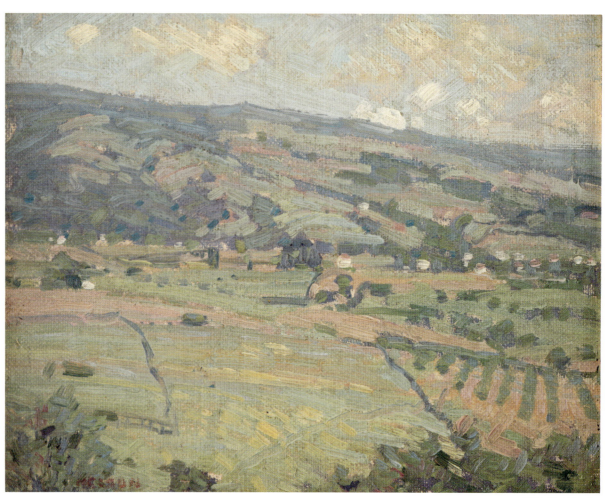

BRUCE NELSON
Santa Clara Valley
Oil on canvas on board, 8¼ x 10¼ inches
Courtesy James L. Coran and Walter A. Nelson-Rees

In the summer of 1913 Nelson opened a studio in Pacific Grove which was allied with the Del Monte Gallery. There he offered classes both individually and in a group setting, including taking students into the field to paint *en plein air*. Reportedly, at that time, Nelson had been offered a position at Stanford and was also being invited to return to Woodstock to teach. However, the artist was making plans to go to Europe in January for a stay of eight months to a year.

For some reason, the trip to Europe was not made. Perhaps Nelson was heeding the advice of Birge Harrison who was writing to the artist on a regular basis.[5] Harrison apparently told him not to further his education in Paris because "Paris might overwhelm him, as it has overwhelmed so many promising young Americans, flattening out his individuality to the level of Gallic uniformity."[6]

In May 1914, an exhibition of Nelson's work was held in Los Angeles at Merick Reynolds. The exhibition received high praise from both Antony Anderson of the *Los Angeles Times* and Alma May Cook of the *Los Angeles Tribune*. Cook predicted that Nelson would some day "occupy a very high place in the annals of American art," noting that the young artist had already developed a distinctive style.[7] Anderson described his works as "lively and delicate, full of light and air, of brooding sunshine and permeating mists" with the artist utilizing a direct technique with a brush full of pure pigment.[8] A number of works in the exhibition were purchased by Los Angeles patrons.

In November 1914, Nelson exhibited twenty-four paintings of the Monterey area at the Helgesen Gallery. Included in that exhibition was *The Summer Sea* which received a silver medal at the Panama-Pacific International Exposition the following year. Nelson exhibited three other works in the PPIE: *Along the Shore*, *The Golden Shore*, and *Sea and Sky*.

In February 1916, the Oakland Art Gallery opened its first municipal exhibit. The new gallery was directed by Nelson's friend and mentor Robert B. Harshe. Nelson was one of a few artists given a room to himself. Laura Bride Powers noted that Nelson was Harshe's "pet" but that regardless of that fact, his work demanded more than one visit.[9]

For the next few years Nelson continued to exhibit paintings in the San Francisco area, at the Helgesen Gallery and with the San Francisco Art Association. In November 1916 the *San Francisco Chronicle* described his colorful, impressionistic style:

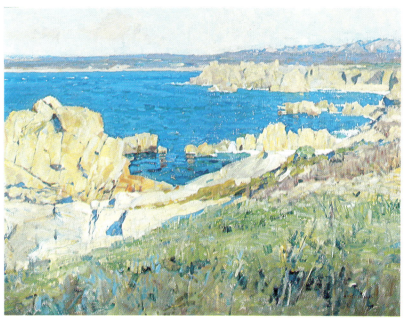

BRUCE NELSON
The Summer Sea
Oil on canvas, 30 x 40 inches
Courtesy Petersen Galleries, Beverly Hills

BRUCE NELSON
Pacific Grove Shoreline
Oil on canvas, 24 x 30 inches
Courtesy Mr. and Mrs. Anthony R. White

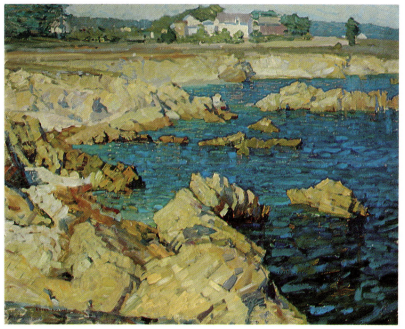

> In expressing strong vibration of light and color he had applied paint "brokenly," and in several pictures depicting the radiant beauty of the Saratoga hills Nelson has seen fit to garnish his canvases very freely with pigment.[10]

In 1981 four paintings by Nelson were included in the Oakland Museum's exhibition *Impressionism: The California View*. His work was singled out as an example of a style which blended decorative effects with impressionistic technique, as seen in *Pacific Grove Shoreline* and *The Summer Sea*, Nelson's prize-winning painting.[11]

Comments in the press were frequently made regarding Nelson's accomplishments at such a young age and what seemed to be a bright future for the artist. The last record of exhibition in California by him however, is with the Fifth Annual Painters and Sculptors Exhibition at the Los Angeles Museum in April, 1924.[12] Neither The Oakland Museum Archives of California Art nor *Who Was Who in American Art* have a record of the artist's death. Apparently the last entry on Nelson in the *American Art Annual* was in 1917.[13] It is, therefore, indeed perplexing that at this writing the life of Nelson after 1918 remains a mystery.

Janet B. Dominik

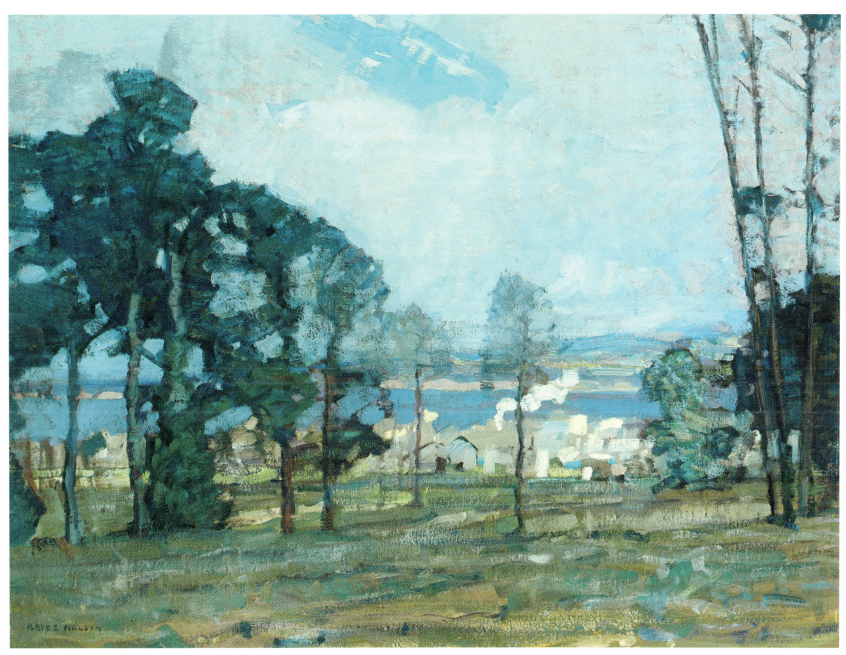

BRUCE NELSON
The Village
Oil on canvas, 18¼ x 24¼ inches
Courtesy the Fine Arts Museums of San Francisco,
Skae Fund Legacy

EUGEN NEUHAUS (1879–1963)

BORN
August 18, 1879, Barmen, Germany

DIED
October 29, 1963, Berkeley, California

TRAINING AND STUDY
Royal Art School, Kassel, Germany
Royal Institute for Applied Arts, Berlin

STUDIO LOCATIONS
San Francisco
Berkeley
Pacific Grove, California

RESIDENCES IN CALIFORNIA
San Francisco
Berkeley
Pacific Grove

MEMBERSHIPS
American Society for Aesthetics
The Bohemian Club
San Francisco Art Association
San Francisco Society of Artists

AWARDS
Second Prize (Landscape), San Francisco Art Institute
Medal, Alaska-Yukon-Pacific Exposition, Seattle, 1909

PUBLIC COLLECTIONS
Crocker Art Museum, Sacramento
The Haggin Museum, Stockton, California
Los Angeles County Museum of Art
M. H. de Young Memorial Museum, San Francisco
Mills College Art Gallery, Oakland
Monterey Peninsula Museum of Art
The Oakland Museum
San Francisco Museum of Art
Stanford University Art Gallery
University of California

PUBLICATIONS
The Art of the Exposition, 1915
Galleries of the Exposition, 1915
The Appreciation of Art, 1924
The History and Ideals of American Art, 1931
William Keith: The Man and the Artist, 1938
The Art of Treasure Island, 1939

Educator, lecturer, critic, artist, Eugen Neuhaus, a professor of art at the University of California at Berkeley for more than forty years, played a key role in speeding the general acceptance of impressionist styles in northern California. He lectured widely and his observations were often collected and published in book form. He sat on the juries of important exhibitions and his teachings influenced a generation of art students.

Born in Barmen, Germany on August 18, 1879, Eugen Neuhaus studied drawing and design at the Akademie in Kassel and later in Berlin. In search of opportunity, Neuhaus emigrated to America, arriving in the summer of 1904. He made the cross-country trek with a stop in St. Louis to inspect the art exhibition at the Louisiana Purchase Exposition. Locating in San Francisco, Neuhaus took a studio across the hall in the same building in which the venerable William Keith kept court.

The fire of April 18, 1906 that destroyed Keith's studio also consumed Neuhaus's and his pre-1906 paintings including most of his European work, driving the artist and his wife, Louise Ann Yoerk of Sacramento, south to the Monterey Peninsula and a new residence in Pacific Grove, a religious-centered community just north of Carmel. It was here and during this time that Neuhaus's mannerisms as an Impressionist painter became clear. The broad, rather deliberate and methodical brushstrokes and especially his deeply saturated colors suggest his earlier training in Germany and the general outlook

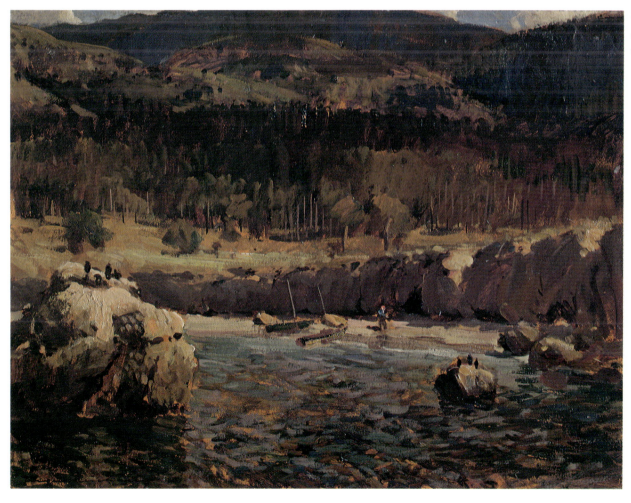

EUGEN NEUHAUS
Whaler's Cove, Point Lobos
Tempera on paper, 17 x 23 inches
Courtesy Collection of The Oakland Museum, Lent by Robert K. Neuhaus

EUGEN NEUHAUS
Berkeley Hills and San Pablo Bay
Oil on canvas, 18 3/16 x 20 inches
Courtesy The Mills College Collection

EUGEN NEUHAUS
L'Avenue de la Vacherie, 1922
Oil on canvas, 14 3/4 x 20 5/8 inches
Courtesy The Mills College Collection

Eugen Neuhaus at Bohemian Club Grove, 1907

of the first generation of Impressionist painters from that country. His favorite subjects were carefully focused and limited scenes around Monterey—its small, ramshackle Chinatown, the dunes near the beach, and later, the eucalyptus trees standing in rows across the Berkeley and Oakland hills.

In the summer of 1907 Neuhaus was invited to join the faculty of the rebuilding California School of Design, whose parent had been renamed the San Francisco Institute of Art, a decision taken following the extinction of the Mark Hopkins mansion in the catastrophe of the previous year. In 1908 he began his career at the University of California across the Bay, teaching a course in the Drawing Department, a forerunner of the Department of Art, the latter established in 1920.

Public notice came to Neuhaus as the tempo of preparations for the Panama-Pacific International Exposition quickened. He began offering a series of unexpectedly well-attended lectures on the art of the Exposition. His lecture notes were collected and shortly edited and published in book form by Paul Elder of San Francisco. They were called *The Art of the Exposition* and *The Galleries of the Exposition*. Neuhaus additionally exhibited six paintings at the Exposition's Department of Fine Arts and he was made a

member of the International Jury of Awards.

In 1920 a Department of Art was launched on the Berkeley campus and Neuhaus was appointed one of its first faculty members. He continued to paint, traveling up and down the California coast, returning frequently to the inland valleys near San Luis Obispo and to the old lumbering town of Gualala at the mouth of the Russian River to the north. An influential figure in the University's Department of Art, Neuhaus was instrumental in bringing such distinguished American artists as Rockwell Kent, Grant Wood, and Thomas Hart Benton to the campus as speakers. He continued to reside in Berkeley, retiring from teaching in 1950. Eugen Neuhaus died at the age of eight-four on October 29, 1963.

Raymond L. Wilson

EUGEN NEUHAUS
Landscape
Oil on canvas, 31 x 35½ inches
Courtesy Collection of the Santa Barbara Museum of Art

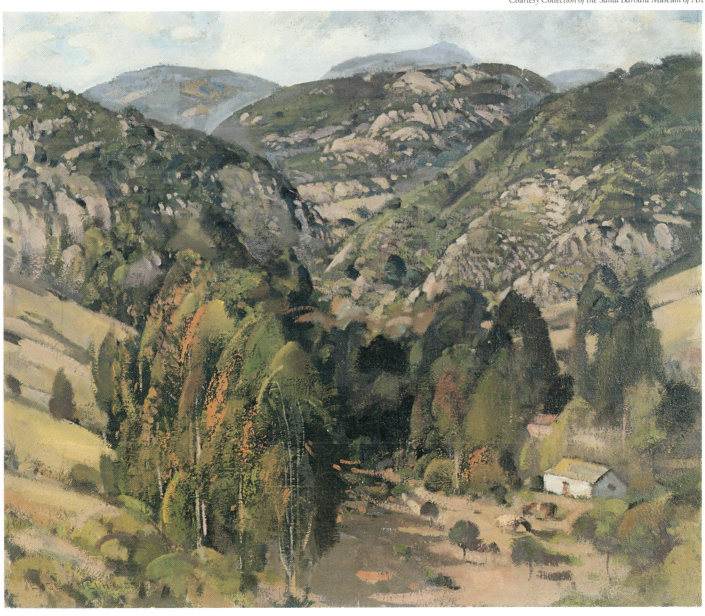

JOHN O'SHEA (1876–1956)

BORN
October, 1876, Ballintaylor, Dungarvan, County
 Waterford, Ireland

DIED
April 29, 1956, Carmel, California

TRAINING AND STUDY
Adelphi Academy, New York City (John Barnard Whitaker)
Art Students League, New York City (George Bridgman)
Charles Harry Eaton

STUDIO LOCATIONS
Pasadena, California
Laguna Beach, California
Carmel, California
Sherwood Studios, New York City

RESIDENCES IN CALIFORNIA
Pasadena
Laguna Beach
Carmel

MEMBERSHIPS
American Watercolor Society
The Bohemian Club, San Francisco
California Art Club
Carmel Art Association
Carmel Arts and Crafts Club
The New Group, Monterey, California
San Francisco Art Association
San Francisco Bay Region Art Association
Society of Independent Artists, New York City
Society for Sanity in Art

AWARDS
First Prize (Decorative Class), California State Fair, 1941

PUBLIC COLLECTIONS
The Bohemian Club, San Francisco
City of Carmel
Harrison Memorial Library, Carmel
Mills College Art Gallery, Oakland
Monterey Peninsula Museum of Art
Museum of Modern Art, Dublin
Sheldon Swope Art Gallery, Terre Haute, Indiana

John O'Shea, c. 1921, by Arnold Genthe
Photo courtesy James L. Coran and Walter A. Nelson-Rees

One of the leading artists in the Carmel area between 1917 and 1945 was John O'Shea. Although trained in the East, it was through his travels in the Southwest, the South Seas, Mexico, and Hawaii, that O'Shea was to develop his unique style—a blend of American Impressionism, realism, and abstraction. A highly versatile artist, he left a legacy of over five hundred works in oil, watercolor, and charcoal.

John O'Shea was born in October, 1876 in Ballintaylor, Dungarvan, County Waterford, Ireland, the second son of Patrick Shea and Catherine Egan.[1] The elder Shea (the surname "O'Shea" is listed on the baptismal certificates for John O'Shea's younger brother and sister) was a farmer. Little is known of O'Shea's childhood or of his introduction to art, although the artist at one time stated that he had studied in Dublin and in Cork.

O'Shea emigrated to the United States in the late 1890s and settled in New York City. He studied at the Adelphi Academy for two years with John Barnard Whitaker (1836–1916). In addition he studied with Charles Harry Eaton (1850–1901) and with George Bridgman (1864–1940) at the Art Students League for one year. The exact dates of his studies are not known.

In the spring of 1913 O'Shea moved to California establishing residency in Pasadena. In December an exhibition of his work was held at the studio of Kenneth Avery in Pasadena, and another exhibition the same month at the Friday Morning Club in Los Angeles. Both of these exhibitions were well-received, Antony Anderson describing O'Shea's works as "beautiful interpretations of our landscape."[2]

Late in 1915 O'Shea moved to Laguna Beach.[3] Several watercolors of Laguna Beach are extant which show O'Shea's fluid dot-and-dash technique. Anderson described those works as "full of light and color, very vital in expression."[4]

In October 1916 O'Shea visited the Monterey area, and sometime in 1917, he moved north, settling in Carmel Highlands. In December he participated in a joint exhibition of the Carmel Arts and Crafts Club. He became active in the art community in both Carmel and San Francisco, participating in the San Francisco Art Association's Spring Exhibition in 1918. His first one-man exhibition was held at the Helgesen Gallery in which he displayed twenty-two works in oil, both landscapes and marines. Included

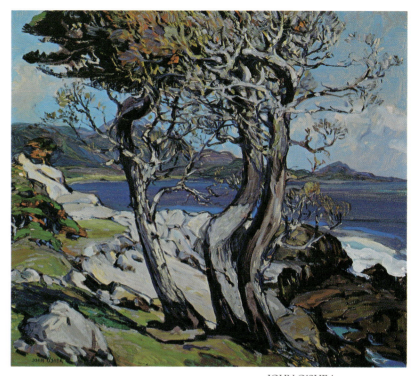

JOHN O'SHEA
Point Lobos from Pescadero Point
Oil on canvas, 28 x 32 inches
Courtesy Jeanette Parkes Ewing

JOHN O'SHEA
Sea Pool
Oil on canvas, 36 x 40 inches
Private collection

in the exhibition was *The Blue Sea*, a painting which showed O'Shea's penchant for rich, pure color and simplified form.

In 1921 O'Shea returned to New York City where his paintings were exhibited at Kingore Galleries. Included in the exhibition were paintings depicting a variety of subjects, among them coastal scenes of California and of Maine. O'Shea had apparently gone to Maine and to scenic Monhegan Island off the Maine coast before he had gone to California. Monhegan had been a favorite painting spot of many Eastern painters since the 1890s including Robert Henri (1865-1929) who first went there in 1903 and thereafter encouraged his students to go there as well.[5] O'Shea's works have a marked affinity with that of Henri and of one of Henri's students, Rockwell Kent (1882-1971), who had painted on Monhegan in 1905.[6]

In March 1922, at the Annual Exhibition of the Society of Independent Artists, O'Shea exhibited a portrait of artist George Overbury ("Pop") Hart (1868-1933). The portrait was executed at the Sherwood Studios in New York City which O'Shea listed as his New York residence during this period. The portrait, now in the collection of the Bohemian Club in San Francisco, was critically acclaimed and also shows the influence of Henri.

In May O'Shea married Molly Pollock Shaughnessy, a young widow he had met around 1912 in New York. They honeymooned in Europe and the British Isles and, after their return, moved back to the Monterey area. In 1924 they built a home near Smugglers Cove in Carmel Highlands which they dubbed "Tynalacan." The O'Shea's led a very active social life, often entertaining friends at their home or attending parties. One of their neighbors was artist Theodore Morrow Criley (1880-1930) who would become O'Shea's closest friend and painting companion. Other friends included poet Robinson Jeffers and his wife, writer Una Call Kuster, and photographer Edward Weston.

In 1926 and 1927 O'Shea made a number of painting trips to the Arizona desert, once spending several months camping and painting with Theodore Criley. O'Shea enjoyed making rapid sketches on the spot from which he would later enlarge in his studio to a finished painting. In February 1928, an extensive exhibition of his paintings was held at Grace Nicholson Galleries in Pasadena. In the exhibition were several paintings from his Arizona trips, including *Upland Solitude*. The exhibition traveled to the Temple Art Gallery in Tucson (March-April) and to the Beaux Arts Galerie in San Francisco (April-May). One reviewer noted the strength and power of the canvases. "In their purity of color, we find a direct contradiction to the muddy blacks and murky blues and browns of the most recent Modern School, and still they must be called 'modern'."[7]

In August O'Shea and his wife left for a two and one-half month trip to the South Pacific. Inspiration for the trip may have come from artist William Ritschel who had already made a number of journeys to the area. O'Shea's paintings from that trip—landscapes, seascapes, still lifes, and figure studies—are richly colored and broad in application. One of the still lifes, *Tahitian Bananas*, was exhibited in the July-August 1929 exhibition of the Carmel Art Association for which O'Shea was also a juror.

JOHN O'SHEA
Sea Beyond the Rocks
Oil on canvas, 30 x 36 inches
Courtesy Mr. and Mrs. Morris R. Jeppson

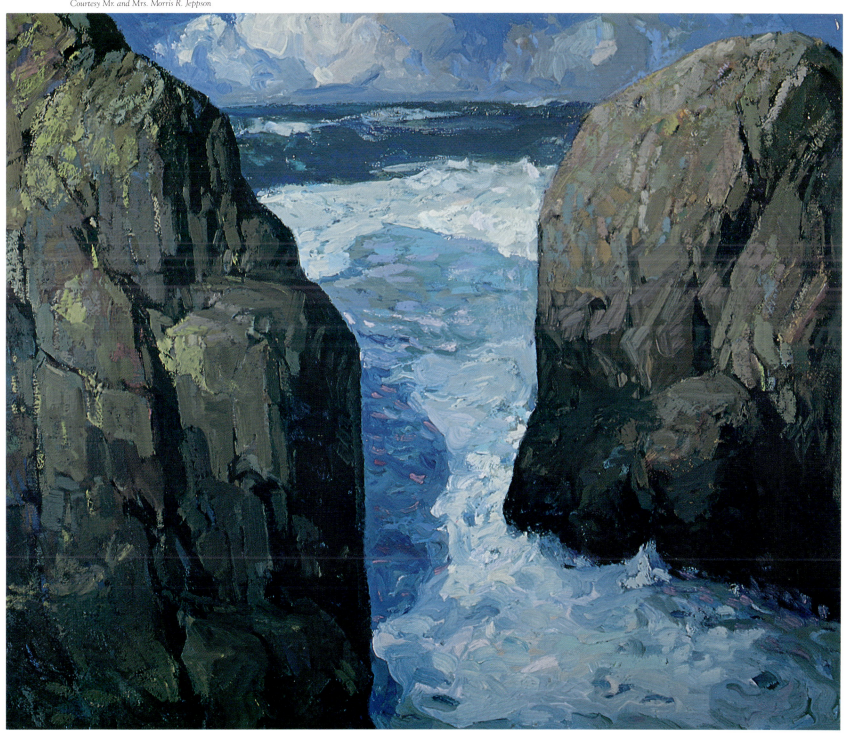

JOHN O'SHEA
Upland Solitude
Oil on canvas, 34 x 36 inches
Courtesy James L. Coran and Walter A. Nelson-Rees

Around 1930 O'Shea painted in New Mexico, in and around Taos. He was undoubtedly drawn to the area by "the land—the brilliant colors, vast expanses, strong masses and shapes often juxtaposed—all ingredients of the decorative lyricism [he] often expressed in his work."[8] He also painted in Hawaii, and, in the spring of 1931, the Denny-Watrous Gallery in Carmel showed paintings from both these trips.

In 1933 O'Shea began working with charcoal on paper, exploring line and form in black and white, a decided departure from the brilliantly colored paintings which had become his trademark. Thirty charcoal works were shown at the Denny-Watrous Gallery in February. Photographer Edward Weston enthusiastically reviewed the exhibition in the *Carmel Pine Cone*. Una Jeffers, in writing about the abstract nature of the works, noted that they had "the power to bring those seeing them that instantaneous quickening and enhancement of life that is the chief function of true art."[9]

It was also in 1933 that San Francisco philanthropist Noel Sullivan first saw O'Shea's work and wrote about it to Lloyd Leroy Rollins, Director of the Legion of Honor in San Francisco. As a result of Sullivan's urging, a large, retrospective of O'Shea's work was held at the California Palace of the Legion of Honor in April and May of 1934. Sixty-three works were exhibited—oils, watercolors, and charcoals. O'Shea's versatility was noted by Junius Cravens of the *San Francisco News*:

> But for the true artist, subject is only a means to an end. One feels that O'Shea is first and always an artist...That he is ever experimenting, ever feeling his way along new paths, is evident not only in his oils but also and more particularly in his drawings in charcoal. Consequently his approach, whether it be to landscape or still life, portrait or abstraction is fresh and vigorous.[10]

Three works from the exhibition were purchased by art patron Albert Bender to be presented to the Municipal Art Gallery in Dublin.[11]

The success of the exhibition at the Palace of the Legion of Honor resulted in more successful exhibitions for the artist throughout the 1930s. In March 1935, twenty-one paintings were exhibited at the E.B. Crocker Art Gallery in Sacramento, an exhibition sponsored by the Kingsley Art Club. The same year, O'Shea spent six months painting in Mexico. Works from that trip were exhibited at the Del Monte Art Gallery the following year. Included were a number of figure studies, many done in watercolor. The large work, *Comida, Market Day*, undoubtedly completed after his return, was acquired by the city of Carmel in 1937 through the Federal Art Project and hung in the Harrison Memorial Library. In May 1937, an exhibition of his work was held at the William Rockhill Nelson Gallery of Art, Atkins Museum of Fine Arts in Kansas City, Missouri.

Throughout the 1930s O'Shea was an active member of the Carmel Art Association. He was a frequent exhibitor and juror, was the director in 1934, and elected president twice, in 1937 and 1938.

In 1938 O'Shea and his wife moved to Pebble Beach. The following year he participated in the Golden Gate International Exposition, showing an early work, *Tahitian Bananas*. When the exposition was extended into 1940, O'Shea showed another, more recent painting, *Sea Rhythm*. He was also a member of the Monterey Bay District Committee and Jury of Selection for that exhibition.[12]

In the fall of 1940 O'Shea and Burton Boundey (1879–1962) exhibited jointly at the Del Monte Art Gallery, which was the last exhibition of that gallery. O'Shea showed a group of watercolors. His skill in the

handling of that medium was praised by Josephine Blanch:

> ..., the facility with which O'Shea handles this flowing intractible medium, at the same time preserving richness of color and losing nothing in texture and characterization, is a marvel to one who studies his art critically.[13]

In October 1941, O'Shea's wife, Molly, died of cancer. Just one month earlier, O'Shea had received first prize in the Decorative Class of the Eighty-sixth Annual Exhibition of Paintings at the California State Fair. The same year he became a member of the Bohemian Club of San Francisco and began participating in their annual exhibitions. In 1942 he moved from Pebble Beach back to Carmel Highlands. He continued to be active with the Carmel Art Association. In 1944 he moved once again, to a small bungalow in Carmel Woods. Although he essentially stopped painting in the late 1940s because of failing health, he still sent works to various exhibitions through 1955, the year before his death.

John O'Shea died on April 29, 1956, at his home in Carmel Woods. In October of that year the Carmel Art Association held a memorial exhibition of twenty-nine of his paintings. He was remembered as "one of Carmel's most distinguished artists."[14]

Janet B. Dominik

JOHN O'SHEA
Cove and Bathers, Laguna Beach
Watercolor, 9½ x 12½ inches
Courtesy The Fieldstone Company

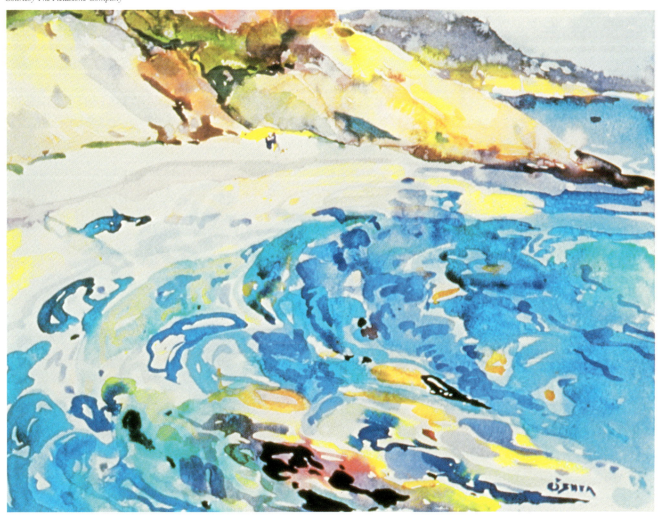

JULES EUGENE PAGES (1867–1946)

BORN
May 16, 1867, San Francisco, California

DIED
May 22, 1946, San Francisco, California

TRAINING AND STUDY
Académie Julian, (Jules Lefebvre, Benjamin Constant, Tony Robert-Fleury)

STUDIO LOCATIONS
San Francisco
Paris
Brehat, Brittany

RESIDENCES IN CALIFORNIA
San Francisco

MEMBERSHIPS
Bohemian Club, San Francisco
International Society of Sculptors and Painters, Paris

AWARDS
Honorable Mention, Paris Salon, 1895
Gold Medal (Third Class), Paris Salon, 1899
Premier Medal des Ateliers Reunis de Paris, 1898, 1899, 1900
Gold Medal, *Hors Concours*, Paris Salon, 1905
Chevalier de la Legion d'Honeur, 1910

PUBLIC COLLECTIONS
Boggs Collection, Shasta State Historic Park, California
California Historical Society
California Palace of the Legion of Honor, San Francisco
Luxembourg Museum, Paris
M. H. de Young Memorial Museum, San Francisco
Mills College Art Gallery, Oakland
Musée de Pau, France
Musée de Toulouse, France
The Oakland Museum
San Diego Museum of Art

Photo courtesy Victor Reiter Jr.

ules Pages was one of the few of the early California painters who established residency in France after initially going there to study. For over forty years he lived and worked in Paris and in the province of Brittany while traveling and painting throughout Europe. The artist and his work, however, always remained American and Californian with Pages making frequent and prolonged trips home.

Jules Eugene Pages was born on May 16, 1867 in San Francisco, the son of J. F. Pages, an engraver, and Annette Perrin.[1] He received his first art instruction as a child from his father. He was also introduced to noted San Francisco painters, such as Julian Rix (1851–1903) and Jules Tavernier (1844–1889), who frequented his father's engraving shop. It was Tavernier who instilled in Pages the desire to travel to Paris to study.[2]

In the mid 1880s Pages worked as an illustrator for the *San Francisco Call*. Around 1888 or 1889 he had saved enough money to finance his first trip to France. He enrolled in the Académie Julian where he studied for eighteen months under Jules Lefebvre (1836–1911) and Benjamin Constant (1845–1902). He returned to San Francisco in June 1890 and obtained employment at the *San Francisco Examiner*. He returned to Paris in 1892 and continued his studies at the Académie Julian with Lefebvre and Tony Robert-Fleury (1837–1912). He exhibited for the first time at the Paris Salon and received an honorable mention there in 1895. Shortly thereafter Pages returned once again to San Francisco and resumed working for the *Examiner*. Around 1897 he again returned to Paris. His reputation there was firmly established when, in 1899, he won a gold medal at the Salon for his painting *A Corner of the Studio*.[3] The painting was

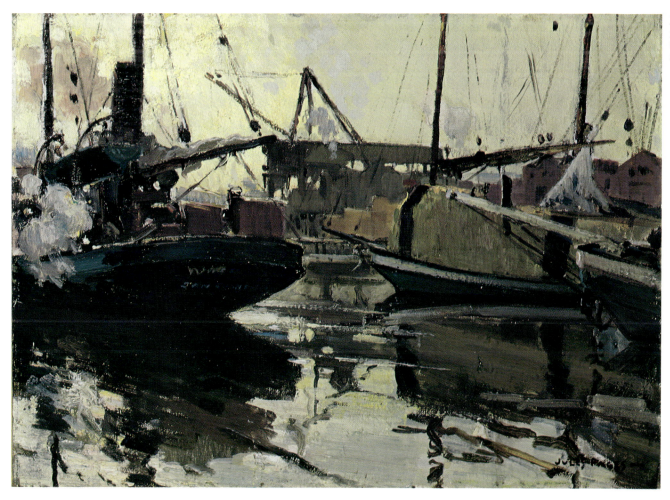

JULES PAGES
San Francisco Harbor c. 1920
Oil on board, 10 x 14 inches
Private collection

purchased for the Mark Hopkins Art Institute and shown there the following year.

Pages did not return again to California for several years. In 1900, in Paris, he married Jeanne Fusenot. In 1902 he began teaching night classes at the Académie Julian, reportedly the only American teacher at that prestigious school.[4] He traveled and painted in France, Italy, Holland, Spain, and Belgium.

In June 1906, Pages, accompanied by his wife, returned to San Francisco, this time not as a student, but rather as a painter who had "attained enviable prominence in art circles" in Paris.[5] He had won another gold medal at the Salon in 1905 and was thus adjudged *hors concours*. In April 1907 an exhibition of twenty-four paintings was held at the Steckel Galleries in Los Angeles. Ten paintings were scenes of Venice and fourteen of Brittany. *Los Angeles Times* art critic Antony Anderson described Pages as a realist whose "unerring sense for the pleasantly picturesque leads us to the most exquisite beauties of line and color.[6]

Before returning to France, Pages created a monumental painting entitled *The Reconstruction of San Francisco*. The work, which was Pages' tribute to the spirit of San Francisco after the great earthquake, measured twelve by six feet. It apparently created a sensation when exhibited at the Paris Salon in 1909.[7] It was shipped back to San Francisco in October and displayed at Gump's Galleries.

It was during Pages' last visit to California that M. Julian, Director of the Académie Julian, had died. At the Académie Pages' responsibilities now included administrative work in addition to his teaching.[8] Although unable to return to California as often as he wished, he sent works for exhibition to both Los Angeles and San Francisco on a regular basis. In the

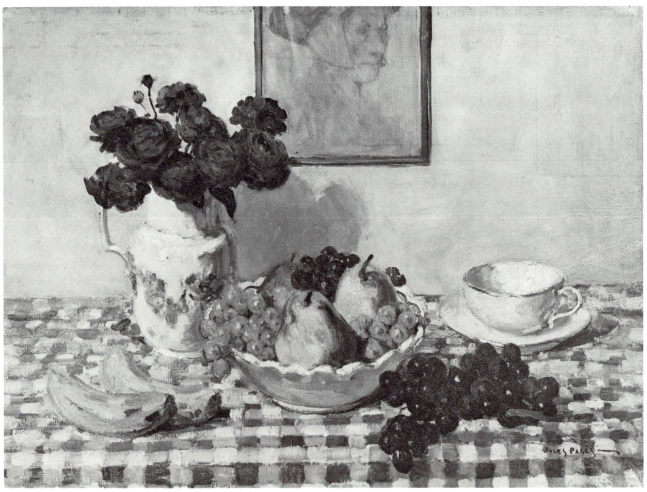

JULES PAGES
The Blue Tablecloth
Oil on canvas, 18 x 24 inches
Courtesy DeVille Galleries, Los Angeles

Jules Pages with his grand-nephew, Victor Reiter Jr., in front of the Hotel Oakland, 1915
Photo courtesy Victor Reiter Jr.

JULES PAGES
Lucky Baldwin Ranch, Arcadia
Oil on canvas, 20 x 16
Private collection

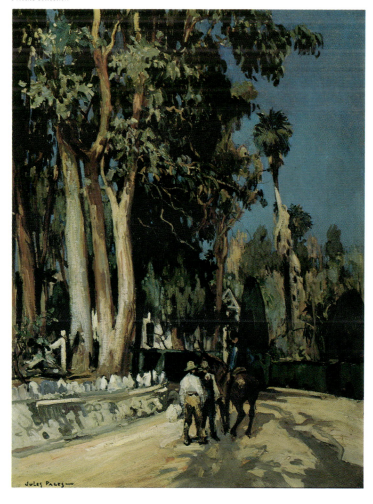

March 1909 exhibition at the Steckel Galleries, his painting *My Garden at Brehat* was shown, a work described as a "small tour de force" in the depiction of "geraniums and hollyhocks and old stone walls."[9] Pages frequently stayed at his studio-home in that town in the province of Brittany, an area which inspired some of his best work.[10]

In 1910 Pages was made a *Chevalier de la Legion d'Honeur*. In 1912 eight paintings were sent to California where they were exhibited in February at the Grace Nicholson Galleries in Pasadena and, in June, at Steckel Galleries. At that time the artist was hoping to return to California in the fall of 1912.[11] However, it was not until the summer of 1913 that he was again in California. During this visit he spent several months traveling and painting throughout the state. In March 1914, for the first time, an exhibition solely of California paintings was held at the Steckel Galleries.[12] As in his European paintings, Pages focused on the picturesque—painting the railroad yards in San Pedro, the harbor backwater in Oakland, and a remarkable triptych of the skyline of Los Angeles. He often included figures in his works, and of particular note was a scene in Los Angeles' Chinatown showing a mother and two young children in their colorful, native dress. According to Antony Anderson, the most salient characteristic of the works was a "clean, direct and vivid impressionism, air and sunlight, a delightfully facile technique."[13]

JULES PAGES
Brittany Hills
Oil on canvas, 18 x 22 inches
Courtesy Maxwell Galleries Ltd., San Francisco

In April an exhibition of European paintings was held at Rabjohn & Morcom in San Francisco. Anna Cora Winchell described the artist's method as a mingling of the realism of the old school with the imaginative qualities of the modern.[14] That same month, an article by Pages entitled "A Definition of Art" was published in the magazine *Western Art*. In the article Pages stated his belief that Impressionism had been "the real renaissance of modern art."[15]

Pages was in California again in 1915 when he served as a juror for and participated in the Panama-Pacific International Exposition in San Francisco. He did not return again until the fall of 1919 at which time an exhibition held at Rabjohn & Morcom was described as the "big event of the artistic season."[16] The exhibition, which included paintings from France, Holland, and Belgium, was shown in Los Angeles at Cannell and Chaffin Galleries in January

1920. In May several members of the Bohemian Club purchased *Sur le Quais, Paris* and presented it to that institution. The painting had been exhibited in the Paris Salon of 1912 and at the P.P.I.E. in 1915.[17]

During the 1930s Pages continued to send works to California for exhibition. One such exhibition was held at the Bohemian Club. Consisting of forty works, it was perhaps the largest exhibition of Pages' work to be shown in California. The *San Francisco Chronicle* noted that the artist had "become recognized both in France and other European countries as perhaps the finest portrayer of French life."[18] The French government had, in fact, honored the artist by acquiring his paintings, beginning in 1906 and a number of his works were owned by the Luxembourg Museum in Paris.

There is little information on Pages during the 1930s except for a brief mention of a visit to Los Angeles in February 1937 for an exhibition of his work.[19] In 1941, driven out of France by the War, he returned permanently to San Francisco. He continued to paint and participated in exhibitions of the Society for Sanity in Art in the early forties. In 1942 he was made an honorary member of the Bohemian Club. In the spring of 1944 an exhibition of both early and recent paintings was held at the Pent House Gallery in San Francisco. The small catalogue included a warm tribute to the artist from his friend, noted sculptor Haig Patigan (1876–1950), who placed Pages in "the ranks of great contemporary masters."[20]

On May 22, 1946, Pages died of a heart attack. Even though he had spent the greater part of his career in France, he was remembered as "one of the most revered and respected figures in San Francisco's art world."[21] Indeed, Pages never considered himself an expatriate—simply an American artist "working in the atmosphere most conducive to his best effort."[22] In his heart he always remained a San Franciscan. He said:

> Whenever I go back, and I am on the ferryboat crossing the bay to San Francisco, the feeling sweeps over me, the emotion of homecoming that comes to me only there. The seagulls, the water, the sky, the hills, my friendships, associations, memories, there.[23]

Janet B. Dominik

JULES PAGES
Rags, Bottles and Sacks
Oil on canvas, 9 x 12¼ inches
Courtesy Dr. and Mrs. Oscar Lemer

CHARLES ROLLO PETERS (1862–1928)

BORN
April 10, 1862, San Francisco

DIED
March 1, 1928, San Francisco

TRAINING AND STUDY
California School of Design (Virgil Williams, Chris Jorgensen)
Jules Tavernier (Privately)
Ecole des Beaux-Arts (Jean-Léon Gérôme, Fernand Cormon)
Académie Julian (Gustave Boulanger, Jules Lefebvre)
T. Alexander Harrison (Privately)

STUDIO LOCATIONS
Benicia, California
Greenbrae, California
Monterey, California
San Francisco
Dorset, England
London
Penzance, Cornwall, England
Long Island, New York
Paris

RESIDENCES IN CALIFORNIA
Benicia
Greenbrae
Monterey
San Francisco

MEMBERSHIPS
The Bohemian Club, San Francisco
The Guild of Arts and Crafts, San Francisco
Lamb's Club, New York City
Lotos Club, New York City
Old Capital Club, Monterey
Players' Club, New York City
Salmagundi Club, New York City
San Francisco Art Association

AWARDS
Medal, Pan-American Exposition, Buffalo, 1901
Medal, Louisiana Purchase Exposition, St. Louis, 1904

PUBLIC COLLECTIONS
M. H. de Young Memorial Museum, San Francisco
Monterey Peninsula Museum of Art
The Oakland Museum

Charles Rollo Peters by Arnold Genthe
Photo courtesy G. Breitweiser

Charles Rollo Peters is best known for landscapes transformed by the witchery of moonlight. Usually an S-shaped path winds into the composition. In these dark nocturnes there is always at least one small spot of light coming from the moon or a cloistered window. His work is cerebral, strong in brushwork, subtle and suggestive in tone, evocative of mystery. Inevitably he earned such titles as "Poet of the Night" and "The Prince of Darkness." For a half century art historians have tried to categorize him as a member of the Barbison School, or the Impressionists, the Tonalists or the American Luminists. Peters had some attributes of all those styles, thanks to both his education and his own experimentation. However, he remains unique, a painter obsessed with the study of night light *en plein air*—air more chilly than most artists would like to brook.

"Scion of a wealthy family": if ever it were appropriate to use that hackneyed newspaper cliche, it certainly is with Charles Rollo Peters. His father, Charles Rolla Peters,[1] adventured from New England to San Francisco in 1848. He established a business and married the daughter of a mercantile family, the Warrins, perennial members of San Francisco's Blue Book society. Charles Rollo was the couple's only son. The lad was sent to military academies while his parents lived in hotels.

He was enrolled for two years at the Art Association's School of Design and also studied privately with Jules Tavernier. In 1886, when he was twenty-four, Peters began four years' study at the Ecole des Beaux-Arts and the Académie Julian in Paris. In 1888 his impressionistic painting, *Legend of Brittany*, received honorable mention in Munich. The following year *The Gossip* attracted attention at the Salon.

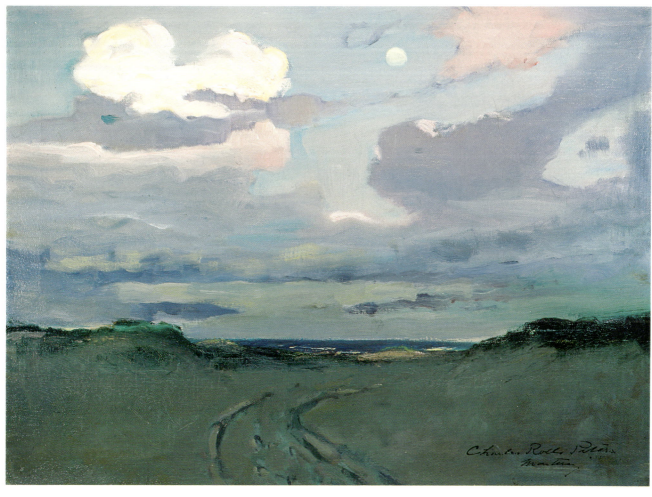

CHARLES ROLLO PETERS
Monterey Landscape–Dusk
Oil on canvas, 17 x 22½ inches
Private collection

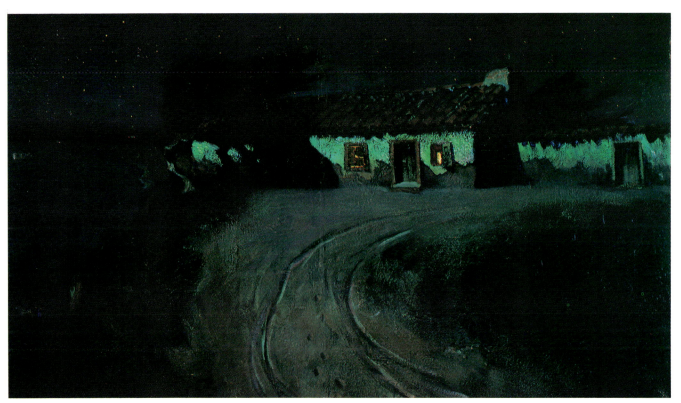

CHARLES ROLLO PETERS
House on the Rim
Oil on canvas, 35 x 60¼ inches
Courtesy G. Breitweiser

During this period he renewed a California friendship with Thomas Alexander Harrison. Now living in Paris, "Alex" was rapidly become a prominent Impressionist marine painter. It was he who convinced young Peters to specialize in romantic nocturnes.

After extensive touring in Europe, Peters returned to San Francisco in 1889, joined the Bohemian Club, and became one of the city's liveliest bachelors, although his art was not neglected. In 1891 he painted a charming portrait, a sunny afternoon scene: in a daisy field stands a statuesque brunet gowned in pink and holding a Victorian parasol. The young lady was Kathleen Mary Murphy, a San Francisco belle whom Peters would marry on December thirtieth. Next day he whisked her away to a five-year sojourn in France where he painted notable Breton landscapes.[2] Charles Rollo Peters, Jr., was born in Paris on September 25, 1892.[3]

Late in 1894 the Peterses returned to San Francisco, bringing with them a Breton nursemaid, Leoni, who would become a devoted member of the household. Charles held a large exhibit of his paintings in the city and sold most of them. The family promptly moved to Monterey and began what would be a very happy period. On December 4, 1896, they had a second son, Warrin Hugh.

Charles was fascinated by his state's crumbling adobes and missions; he painted them in dramatic chiaroscuro arrangements. When exhibited in the East these pictures, like Gertrude Atherton's novels of the same time, directed international attention to California's cultural heritage.

In 1899 Charles made an extended tour with his paintings, to Chicago, Maine, and Long Island. Unexpectedly he was granted a large solo exhibition at New York's Union Club. So much favorable pub-

CHARLES ROLLO PETERS
Houseboats and Wharf Nocturne, 1925
Oil on canvas, 19¼ x 25¼ inches
Courtesy G. Breitweiser

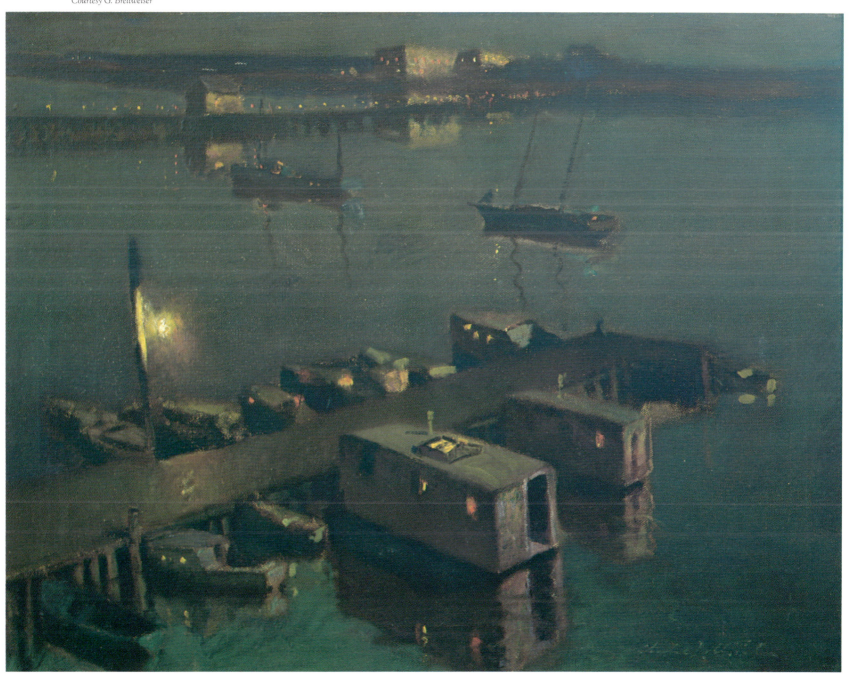

licity followed, the artist was invited to become a member of both the Lotos and Salmagundi Clubs.

In July of 1900 Peters purchased thirty acres in Monterey. Soon an elaborate estate developed atop a hill with magnificent views of the Monterey Bay. It was called "Peters Gate" because of the wall which his Bohemian Club friends helped build. Then, in 1902, tragedy struck. On March 15, Kitty died from complications after having given birth to twins. Charles was inconsolate. He built a shrine to his wife in his house and decorated it daily with flowers. Two years later, on December 10, his baby daughter tottered into an unguarded fireplace and died of burns. In his grief Charles threw himself into a frenzy of painting. It would be easy to read his sadness into these tristful nocturnes.

Peters also began to entertain constantly and lavishly—too lavishly. This patrician little man of great dignity and courtly manners was proud of being called "The Duke of Monterey." Nothing was too good for his friends. Few of them realized that "Peters Gate" was indentured, that Charles was hosting from an empty pocketbook. Following the 1906 earthquake, his home became the social hub for artists who established the Hotel Del Monte's art gallery. Opening April 20, 1907, it was the first one devoted to California work only, and for many years was remarkably successful.

In 1909 Charles met a charming artist who was wintering at the hotel. Constance Mabel Prudhomme Easley had been born in South Africa to French-English parents. She made her home in Wales and was said to be "a widow of means." A great traveler, she had recently shown her delicate landscapes in the Bay Area. Cosmopolitan and sophisticated, she would be recognized today as a "liberated woman." Everyone was surprised when the pair wed. They spent a year in England, accompanied by Leoni and the children. Charles painted the cottages and kirks of Dorset and Wales in the same Whistlerian manner as many of his California pictures. In August of 1910 his London exhibit was a tremendous success. The family started home. In route, Warrin Hugh underwent an emergency mastoid operation in New York and did not survive. When the family finally arrived at Monterey in 1911 they found that the sheriff had foreclosed on "Peters Gate."

Charles' alcoholism became habitual, increasingly a detriment to both his career and his marriage. Painting sporadically, he yet managed to give frequent exhibitions; people loved his work. In 1915, an early 1898 Peters seascape, *The Oregonian*, was prominently displayed at the Panama Pacific International Exposition. Conversely, Charles was elected president of "Artists of California," a group who displayed their work at the de Young Museum in protest to the policies of the P.P.I.E.'s Hanging Committee!

Charles and Constance lived frugally in various places around the Bay before separating in 1920. Constance went abroad, but six years later, learning that Charles was seriously ill in Paris, she interrupted her own painting career to care for him. She brought him back to California and was at his side on March 1, 1928, when he died in San Francisco.

Betty Hoag McGlynn

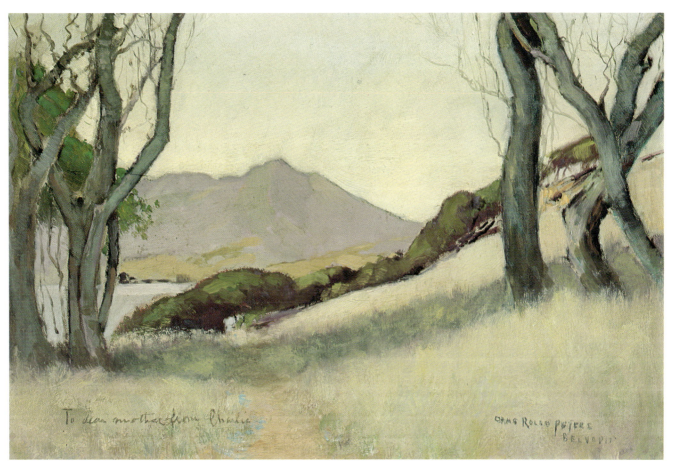

CHARLES ROLLO PETERS
Tamalpais from Belvedere
Oil on canvas, 12 x 18 inches
Courtesy G. Breitweiser

GOTTARDO F. P. PIAZZONI (1872–1945)

BORN
April 14, 1872, Intragna, Switzerland

DIED
August 1, 1945, Carmel Valley, California

TRAINING AND STUDY
California School of Design (Raymond Yelland, Arthur Mathews)
Académie Julian
Ecole des Beaux-Arts

STUDIO LOCATIONS
San Francisco

RESIDENCES IN CALIFORNIA
San Francisco
Carmel Valley
Mill Valley
Belvedere

MEMBERSHIPS
The Bohemian Club, San Francisco
California Society of Etchers
Chicago Society of Etchers
Club Beaux Arts, San Francisco
San Francisco Art Association

AWARDS
Gold Medal, California School of Design, 1893
Honorable Mention, Louisiana Purchase Exposition, St. Louis, 1904
Emanuel Walter Purchase Prize, San Francisco Art Association, 1919
Gold Medal, San Francisco Art Association, 1924
Purchase Prize, Arizona State Fair, 1924
First Prize (Sculpture), San Francisco Art Association, 1927
Second (Ann Bremer) Prize, San Francisco Art Association, 1927

PUBLIC COLLECTIONS
California Historical Society
California Palace of the Legion of Honor, San Francisco
M. H. de Young Memorial Museum, San Francisco
Mills College Art Gallery, Oakland
Monterey Peninsula Museum of Art
The Oakland Museum
San Francisco Museum of Modern Art

Photo courtesy Mireille P. Wood (Mrs. Philip R. Wood)

In an interview in the late 1930s, Gottardo Piazzoni summarized his artistic beliefs:

> I have devoted my life to a study of landscape...not to a copy of the natural scene but to an expression of what it means to me. I am concerned not with the external aspect of the landscape, but with its inward life. For landscape is a living thing, constantly changing, moving, growing, evolving life, like life itself.[1]

That philosophy was a guiding vision for the artist who, for over fifty years, created subtle, lyrical interpretations of the Northern California landscape, works which are most noteworthy for their simplicity and the quiet mood which they convey.

Gottardo F.P. Piazzoni was born in Intragna, Switzerland on April 14, 1872. His parents, Paolo Piazzoni and Teresa Cavalli, Swiss by birth, were descendents of Italian immigrants.[2] In 1876 Paolo Piazzoni emigrated first to Australia where he made a fortune in gold, then to the United States where he settled in the hills of the Monterey area and established a dairy ranch. His wife remained in Switzerland with their children, Gottardo and his younger brother, Massimo. Gottardo attended local schools until, at the

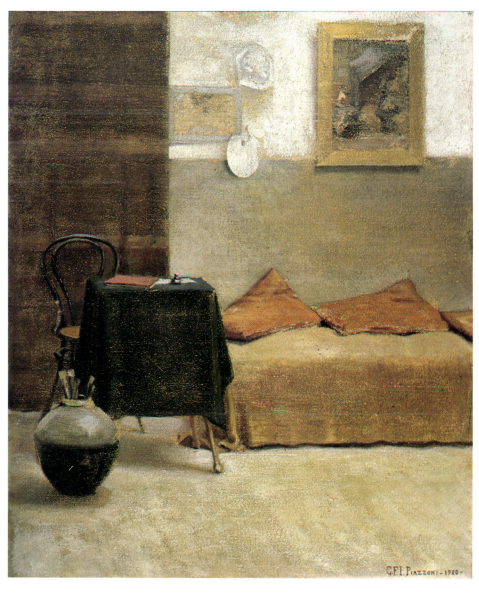

GOTTARDO PIAZZONI
In the Studio, 1900
Oil on canvas, 22 x 18½ inches
Private collection

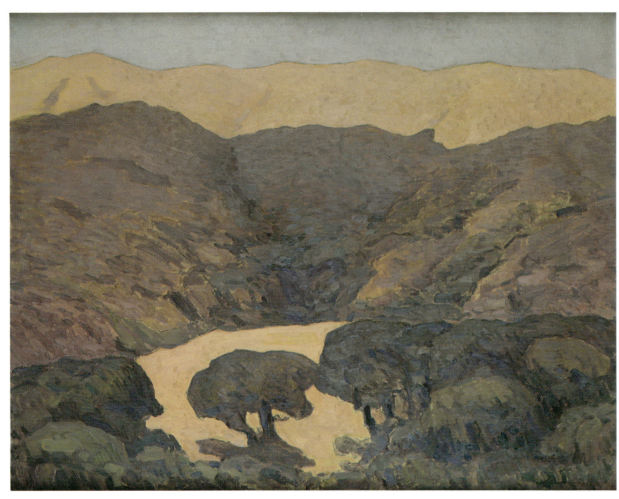

GOTTARDO PIAZZONI
California, 1924
Oil on canvas, 37½ x 48½ inches
*Courtesy Mireille Piazzoni Wood
(Mrs. Philip R. Wood)*

age of 14, he was sent to the Ginnasio in Locarno. There he was impressed by the local mural artists who decorated the chapels and churches of the city.

It was not until 1887 that Paolo Piazzoni sent for his wife and sons to join him in California. Another son and a daughter were born there in 1888 and 1890. For a few years Gottardo assisted his father in running the ranch. However, the desire to be an artist was already strong. He painted his first mural on the ceiling of the living room of their ranch house. In 1891, after a moderate amount of discussion, Piazzoni prevailed upon his father to take him to San Francisco where he enrolled in the California School of Design. For the next few years he studied with Raymond D. Yelland and Arthur Mathews. He became friends with fellow classmates Joseph Raphael, Xavier Martinez, Maurice Del Mue, and Granville Redmond. In 1893 he received a gold medal for drawing.

In 1894 Piazzoni went to Paris to continue his education. He enrolled at the Académie Julian in 1895 where he studied with Benjamin Constant, Henri Martin, and Jean-Paul Laurens. From 1896 to 1898 he attended the Ecole des Beaux-Arts working under Jean-Léon Gérôme.

In 1897 Piazzoni's mother and brother Massimo both died. His father prevailed upon him to return to California to assist in running the ranch. Setting aside his artistic aspirations, Piazzoni reluctantly returned to California in 1898. After two years, however, he convinced his father to retire and return to Switzerland with the two younger children. He accompanied them to Intragna, then visited Paris, and returned to California.

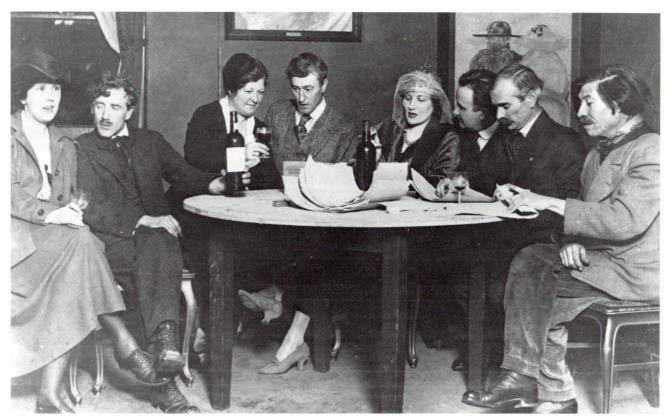

Group designing posters for Artists' Ball, Hotel Oakland, 1919, Piazzoni, second from right, Xavier Martinez, far right
Photo courtesy Mireille P. Wood (Mrs. Philip R. Wood)

In 1901 the artist established two studios, one on Sacramento Street and another on Montgomery Street which he shared with his friend, sculptor Arthur Putnam (1873–1930). Within a short time Piazzoni became an active member of the San Francisco art community. In 1904 he exhibited works at the Mark Hopkins Institute, at the Bohemian Club, and at the Louisiana Purchase Exposition in St. Louis, where he received an honorable mention. Early reviews of his paintings were favorable although one critic remarked upon their "strangely attractive" qualities and "weird effect[s]."[3] Soon he began attracting patrons who started buying his works.[4]

Piazzoni's first major one-man exhibition was held in April 1905, at the Mechanics Institute Pavilion. Included in the exhibition were works from his years in Paris. He sold several more paintings that year, and, with his financial situation seemingly assured, Piazzoni arranged to go once again to Europe. He arrived in Rome early in 1906 accompanied by his bride, Beatrice Del Mue (sister of Maurice Del Mue), whom he married on December 5, 1905, and Arthur Putnam and his wife. For the next two years the couples traveled throughout Italy, Switzerland, and France. Piazzoni participated in the International Exposition of Fine Arts in Rome in 1906 and at the Paris Salon in the winter of 1907. He received enthusiastic reviews in the Italian press, one critic aptly calling him a "poet-painter,...with a deep spiritual insight into nature,..."[5]

Late in 1907 Piazzoni and his wife returned to San Francisco. His studio on Sacramento Street had been destroyed by the earthquake and fire.[6] He opened another studio on Presidio Avenue. In 1908, at his

157

Montgomery Street studio, he began working on the first of his mural commissions for the First National Bank Building. His mural work reflected his belief in the integration of art and architecture. He felt that "art should be in places where people of all classes could see and enjoy it."[7]

Piazzoni also gave classes at his studio. His students described him as infinitely patient and skilled in teaching the fundamentals of art.[8] Interested in *plein air* effects, he took his students to paint at various locations around San Francisco.

Piazzoni's interests extended beyond painting and mural decoration to include a relatively new art form, the monotype.[9] In February 1909, he exhibited over twenty monotypes at his studio on Montgomery Street. A few months later over forty such works were exhibited at Helgesen Gallery. The works were described as revealing "a mastery" of the technique in which the success of the composition relied solely on the juxtaposition of dark and light.[10] One reviewer noted that one piece had such a "dazzling effect of light" that it created a sense of color and warmth.[11]

For the next several years Piazzoni worked in and around San Francisco, participating in joint exhibitions as well as one-man shows. The responsibilities of his family, which now included two daughters, precluded extensive traveling. However, he did make many brief trips throughout California, often accompanied by other artists including Granville Redmond and Maurice Del Mue. He received more mural commissions and continued to sell his paintings at a steady rate. His exhibition notices were always favorable. One reviewer noted:

> There is always a lure and a mystery about his canvases,—nothing of broad, bare outline and brutally frank portrayal. His creations are clothed in delicacy of expression that shows no lack of strength.[12]

At the Panama-Pacific International Exposition in 1915, Piazzoni exhibited his paintings *Lux Eterna* and *The End of Day*, along with several etchings. The following year an exhibition was held at Paul Elder Galleries. Included were some of his small paintings, works measuring less than seven by nine inches. One critic called them "landscape miniatures" and noted that the artist had "caught a single aspect of nature in an appealing mood, and rendered the salient impression strongly and serenely. They are to the art of painting what the short story is to fiction, or the lyric to poetry."[13]

Piazzoni expanded his teaching efforts by becoming an instructor of painting at the California School of Fine Arts, a position he retained through 1935.[14] He was very influential and receptive to modern ideas. In 1921 he visited France and Italy with his friend, sculptor Ralph Stackpole. He also visited artist Joseph Raphael who was living in Uccle, a suburb of Brussels. He returned with a new conviction of the importance of the modern movements including Impressionism and Post-Impressionism.[15]

In 1925 *The American Magazine of Art* featured Piazzoni in an article on three California painters (the others being Maynard Dixon and Armin Hansen). The subtle power of his painting was described:

> That which seems utter simplicity becomes with study an interesting complexity. The canvases grow upon the vision with peculiar subtlety. They have a charm that partakes more of the spiritual than the material—[16]

In 1929 Piazzoni began work on his most ambitious mural project. The Board of Trustees of the San Francisco Public Library approved a project for the decoration of the library with ten murals. The contract award of $25,000 was paid for by private donors including Mr. and Mrs. Ansley K. Salz who were staunch patrons of Piazzoni.[17] Completed in 1932, the ten panels, five depicting "The Sea" and five depicting "The Land," were the most modern of his murals, utilizing economy in line and form and subtle tones of gray, blue, and tan.

It was the simplicity and quiet mood of his work which most endeared Piazzoni to his followers. In 1934 his painting *Summer*, exhibited at the Adams-Danysh Galleries, inspired author William Saroyan to send a poetic tribute to the artist. It said, in part:

> A tree eternal, of the leaf of summer, the eternal summer, of the reflection of the eternal sun, timeless universe, softly, gently, humbly, in admiration, in gratitude, by the grace of God, by the humility of man. A moment of quiet tree, prayerfully of this earth, our life, quietly of our eternality, deathless, a moment only, but somehow everlasting.[18]

Piazzoni died at his home in Carmel Valley on August 1, 1945 at the age of seventy-three. In 1959 he was remembered with an exhibition at the California Historical Society's gallery in San Francisco. It was noted that "he had a flair for transposing onto canvas the rare beauty that Nature gave to California and in

a manner that was completely his own."[19] In 1976 two of his works were included in an exhibition at the Museum of Modern Art in New York, *The Natural Paradise—Painting in America, 1800–1950*. His paintings were described as having a modernist style of "near abstract purity."[20]

Janet B. Dominik

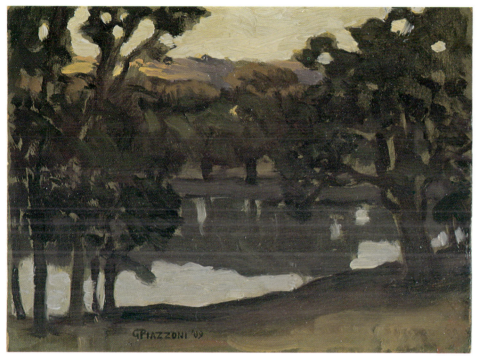

GOTTARDO PIAZZONI
Reflections '09, 1909
Oil on board, 6¼ x 8⅝ inches
Private collection

JOSEPH RAPHAEL (1869–1950)

BORN
June 2, 1869, Jackson, California

DIED
December 11, 1950, San Francisco, California

TRAINING AND STUDY
California School of Design (Arthur Mathews, Douglas Tilden)
Ecole des Beaux-Arts
Académie Julian (Jean Paul Laurens)

STUDIO LOCATIONS
San Francisco
Paris
Uccle, Belgium
Oegstgeest, Holland

RESIDENCES IN CALIFORNIA
San Francisco

AWARDS
Honorable Mention, Paris Salon, 1906
Silver Medal, Panama-Pacific International Exposition,
 San Francisco, 1915
Gold Medal, Panama-California Exposition, San Diego, 1915
Purchase Prize, San Francisco Art Association, 1916
Gold Medal, San Francisco Art Association, 1918
Los Angeles Museum of History, Science and Art Purchase Prize,
 Third Annual Traveling Exhibition of Western Painters, 1924

PUBLIC COLLECTIONS
Los Angeles County Museum of Art
M. H. de Young Memorial Museum, San Francisco
Mills College Art Gallery, Oakland
The Oakland Museum
San Diego Museum of Art
San Francisco Museum of Modern Art
Stanford University Art Museum

JOSEPH RAPHAEL
Self Portrait, 1910
Oil on artboard, 16½ x 13
Courtesy John H. Garzoli Fine Art, San Francisco

One of the few painters of his era born in California, Joseph Raphael, who became a master of the Impressionist style, lived the majority of his life in Europe. Nevertheless, during his mature years he maintained an influential artistic presence in California through friends and agents and lived the last decade of his life there.

Born in Jackson in Amador County, he was the first of four children born to Nathan Raphael, a tailor, and his wife Elizabeth Moses. Through his teenage years he helped support the family by working at a variety of jobs in San Francisco and in gold mining and trading companies of Amador County, the Arizona Territory and California's Mother Lode region. In this period he began to draw for pleasure, copying the work of illustrators he admired such as Charles Dana Gibson (1867–1944). By the time he was eighteen his idle occupation with art had evolved into a serious intent and he began night classes with two European teachers.[1] His interest continued to grow and at twenty-four he enrolled in the Mark Hopkins Institute of the San Francisco Art Association. There he began four years of study, coming under the tutelage of Arthur Mathews and Douglas Tilden (1860–1935). A promising student, he was awarded a scholarship and became a teaching assistant. During this time he also helped support himself by working at a settlement house known as the Columbia Park Boys' Club. It was there that he probably met Albert Bender, a wealthy philanthropist, who became his life-long admirer and loyal patron.

For nearly a decade Raphael continued to paint and exhibit locally. Described as a "promising young medalist"[1] he supported himself first as an illustrator for local papers and later as a pictorial sign painter.[2]

In 1903, at the age of 34, he had sufficient savings to go to Paris where he pursued studies at the Ecole de Beaux-Arts and the Académie Julian under Jean-Paul Laurens. The first of many "long business-like envelopes" from Albert Bender began to arrive, as that generous patron, among others, helped to support the artist, who was contributing to his own support by doing illustrations for French journals.[3]

In 1903, he discovered Laren, an artists' colony southeast of Amsterdam and until 1911 divided his time between that Dutch community and Paris. His work of this period reflects the influence of the academy and the Dutch genre painters. His palette was dark and tonal and his subjects often interiors in the tradition of the Hague School. In 1906, he received an honorable mention at the Paris Salon for *La Fete du Bourgmestre*, described at that time as "one of the most solid pieces of painting encountered in the Salon."[4] The same year another strong academic piece, *The Town Crier* was exhibited by the San Francisco Art Association and purchased by a group of patrons for the M.H. de Young Museum.

In 1910, Raphael returned to San Francisco for a visit and remained eight months. His "Dutch Series," in which figure painting predominated, was exhibited at the Art Association. On his return to Laren he married Johanna Jongkindt and the following year, 1912, the two moved to Uccle, a suburb of Brussels, where their son Pieter was born.

The artist continued regular correspondence with Bender, sending him and the Helgesen Gallery much of his output which now began to contain luminous outdoor work. The influence of his visits to Paris was reflected in a lighter palette and broader brush strokes. He also began etching, a medium in which he worked into the 1920s. His first finished prints were shown in San Francisco at the California Society of Etchers as early as 1913.

In 1915, he was awarded a silver medal at the Panama-Pacific International Exposition (P.P.I.E.)

Joseph Raphael in his garden *Photo courtesy Albert Bender Library, Mills College*

where six of his oils were exhibited. And in 1916 he won the First Purchase Prize of the San Francisco Art Association for *The Garden*, described as "vibrant with light."[5]

By 1919 Raphael was the father of five, a son and four daughters. This large family, living in a tiny cottage in Uccle, had been relatively unaffected by the War. Here the artist cultivated a flower and vegetable garden which became a familiar subject of his impressionistic canvases. But the shortage of essential art materials and the cramped living conditions undoubtedly contributed to what was a decline in his intense creative activity of earlier times. It was during this period that he turned to pen and ink drawing, the materials being more readily available. At a later time he began applying color washes to many of these drawings, and it is likely that this was the origin of his interest in watercolor painting. In 1922, he wrote about a large number of watercolor sketches, some with an appearance of "Japanese Impressionism," that he considered better than his oils of that period.

At this time he also began experimenting with woodcuts, being totally self-taught in this medium and influenced strongly by Japanese woodcuts and prints he had seen in Brussels and Leiden. His interest in Leiden's Enthnographic Museum and Print Cabinet likely contributed to his decision to move there in 1928.

Throughout the 1920s and early 1930s he continued to send work to his agent in California, with H. Valdespino apparently succeeding Helgesen about 1924.[7] His oils, etchings, watercolors, and woodcuts,

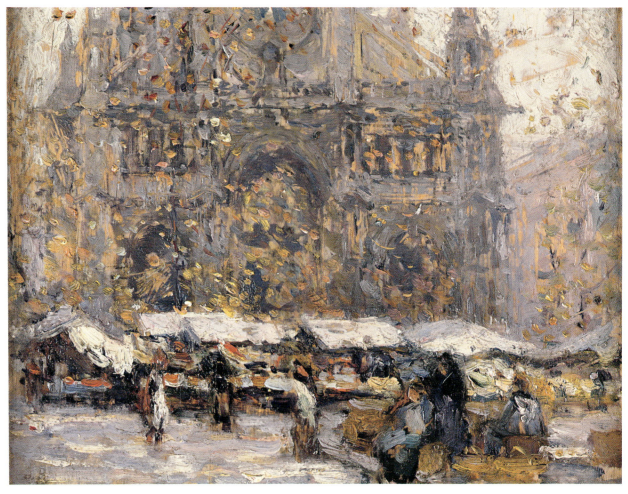

JOSEPH RAPHAEL
Autumn Market, c. 1916
Oil on wood panel, 9½ x 7¼ inches
Courtesy Carlson Gallery, San Francisco

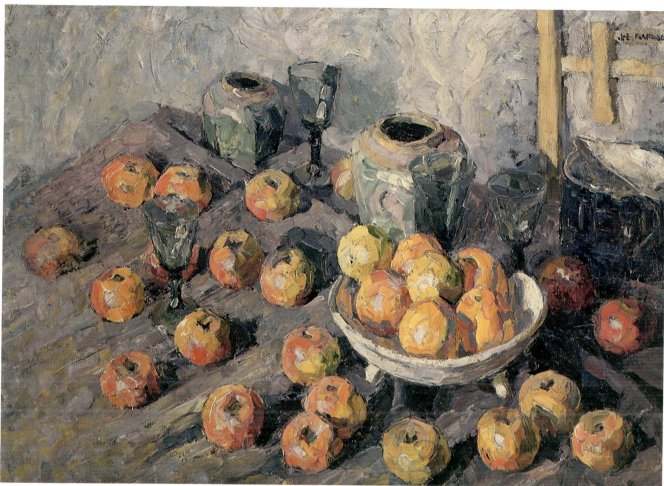

JOSEPH RAPHAEL
Apples, c. 1912
Oil on canvas, 27¾ x 38¾ inches
Courtesy John H. Garzoli Fine Art, San Francisco

all were a strong and continuing presence in the Bay Area art world. Testifying to Raphael's influence in California, Clapp wrote,

> In 1917 when I returned to California after many years of absence, Joe was practically idolized by the younger generation of painters, an idolatry that continued until the ultra-modern movements gradually replaced Impressionism.[8]

The Depression years were difficult for Raphael and his family. Earnings from his wife Johanna's piano lessons were essential to the family income. In 1934 increasing rent finally forced them to move to Oegstgeest, a suburb of Leiden, where the artist again had space for a vegetable and flower garden, by now a favorite subject.

In 1939, Raphael left to visit San Francisco, taking with him many unsold paintings and prints from his output during the Depression years. With the outbreak of World War II he was prevented from returning home. He was not to see his wife again for she died at the close of the War in 1945. He was to live the remainder of his life rather modestly in San Francisco. Boldly colorful woodcuts and watercolors testify to his wanderings from Chinatown to the Cliffs at Land's End.

While Joseph Raphael chose to live his life elsewhere, he has been acknowledged as one of the foremost exponents of Impressionism in California. His vibrant works, shipped regularly from Europe, depicted his rural surroundings and family scenes and included sunlit portraits and still lifes. And not unlike

WILLIAM F. RITSCHEL (1864–1949)

BORN
July 11, 1864, Nuremberg, Bavaria

DIED
March 11, 1949, Carmel, California

TRAINING AND STUDY
The Royal Academy, Munich

STUDIO LOCATIONS
New York City
Carmel, California

RESIDENCES IN CALIFORNIA
Carmel

MEMBERSHIPS
Academy of Western Painters
American Watercolor Society
The Bohemian Club, San Francisco
California Water Color Society
Carmel Art Association
Salmagundi Club, New York City
San Francisco Art Association
Société Internationale des Beaux-Arts et des Lettres

AWARDS
Carnegie Prize, National Academy of Design, 1913
Gold Medal, National Arts Club, 1914
Gold Medal, Panama-Pacific International Exposition, San Francisco, 1915
Gold Medal, California State Fair, 1916
Gold Medal, Philadelphia Arts Club, 1918
Ranger Purchase Prize, National Academy of Design, 1921, 1926
Isidor Prize, Salmagundi Club, 1923, 1930
Harris Prize, Art Institute of Chicago, 1923
Honorable Mention, Paris Salon, 1926
Purchase Prize, Springville, Utah High School, 14th Annual Exhibition of American Art, 1935

PUBLIC COLLECTIONS
Bowers Museum Foundation, Santa Ana, California
Crocker Art Museum, Sacramento
Los Angeles County Museum of Art
Minneapolis Art Museum
Monterey Peninsula Museum of Art
National Museum of American Art
The Oakland Museum
St. Louis Art Museum

William Ritschel, 1930, by Edward Weston
Photo courtesy Monterey Peninsula Museum of Art

In December 1926 Antony Anderson, art critic for the *Los Angeles Times*, happened upon William Ritschel as he was walking along Spring Street in Los Angeles. Ritschel, a resident of Carmel Highlands, was in town for an exhibition of his work at Cannell and Chaffin. Anderson remarked upon the artist's vitality. Ritschel told him: "'Create something,... Keep your mind always in shape to create, else what's the use of living'."[1] At the time the artist was at the zenith of his career, his reputation firmly established both nationally and internationally as a master of marine painting.[2]

William Frederick Ritschel was born on July 11, 1864, in Nuremberg, Bavaria, the son of Josef and Elise Ritschel. His father was a government official. In his youth he spent several years as a sailor before entering the Royal Academy in Munich where he studied under Friedrich August von Kaulbach and Karl Raupp.[3] His talent as an artist combined with his love of the sea resulted in marine painting being the primary focus of his work. His earliest paintings were done exclusively in watercolor, but after about six years he began to work in oil as well. He traveled through Europe—to France, Italy, Holland, Norway, Spain, and Portugal—and exhibited in shows in Paris, Berlin, and Munich.

In 1891 Ritschel married Gabriel von Hornstein. Their union was marred by the tragic death of their two children, both of whom died in infancy.[4] In 1895

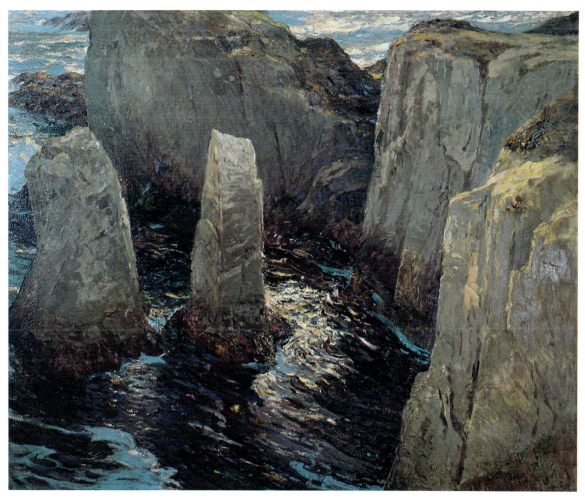

WILLIAM RITSCHEL
Mammoth Cove
Oil on canvas, 50¼ x 60½ inches
Courtesy Monterey Peninsula Museum of Art

Ritschel emigrated to the United States, settling in New York City. Within a few years he was exhibiting and winning awards alongside well-known Eastern artists including Paul Dougherty, Ernest Lawson, Childe Hassam, Edward Redfield, Willard Metcalf, and J. Alden Weir.[5] He became a member of the Salmagundi Club in 1901 and was also a member of the New York Water Color Club and the American Watercolor Society. In 1910 he was elected an Associate Member of the National Academy of Design. In 1913 he received that Academy's Carnegie Prize and the following year received the gold medal and was elected a National Academician.

Ritschel moved to California some time after 1909.[6] He exhibited at the San Francisco Art Institute in 1911, at the Panama-Pacific International Exhibition in 1915 where he won a gold medal, and at the California State Fair in 1916.[7] In 1917, the artist, now a widower, married Belle Zora Hollingsworth of San Antonio, Texas. The following year they moved into the unique, castle-like, stone studio-home he had built high on a bluff overlooking the ocean in Carmel Highlands. From his "Castel a Mare" Ritschel said that he watched the sea "until 'he made himself master of a marine color-magic…'"[8]

Although then living in California, Ritschel continued to be an active exhibitor throughout the United States and Europe. Galleries in San Francisco, New York, and Los Angeles featured his work. Bartley Cannell of Cannell and Chaffin in Los Angeles was a personal friend.[9] In December 1922, Cannell and Chaffin was the first gallery to exhibit paintings from Ritschel's year's sojourn in the South Seas where he lived on the island of Moorea. Ritschel had painted the fjords of Norway and the dykes of Holland, but he found the islands of Moorea and Tahiti to be "a heaven for artists."[10] His masterful interpretations of the land, the sea, and the native people were well-received. Antony Anderson noted:

> Strength in drawing, beauty in color, breadth in feeling—these splendid qualities have always characterized William Ritschel's pictures, and we find them in full force in these quick studies from the South Seas—and added to them a new richness, a new depth, both expressed with the most admirable simplicity and directness imaginable.[11]

Ritschel exhibited works in both oil and watercolor, including: *Gathering Storm, Tahiti*; *Approach of South Sea Storm, Tahiti*; *Tropical Shores*; *On the Lagoon*; and *Between the Coral Reefs of the South Seas*, a watercolor "study of strange forms and brilliant colors under water,…a decorative scheme of astonishing brilliancy and beauty."[12] The exhibition continued at Milch Galleries in New York City in January of 1923.

Ritschel responded to the lure of travel to exotic lands throughout the 1920s. Late in 1924 he traveled to Capri and the Orient, and in 1926 he made a trip around the world "for the purpose of observation and work."[13] These extensive travels and his abiding love of the sea perhaps gave an added validity to his work. Anderson noted, "Few living marine painters know

WILLIAM RITSCHEL
Thaw on 125th Street, N.Y.C., c. 1908
Oil on canvas, 24 x 20 inches
Courtesy Carlson Gallery, San Francisco

William Ritschel in his studio
Photo courtesy Carlson Gallery, San Francisco

WILLIAM RITSCHEL
No Man's Land, (formerly Dat Devil Sea) c. 1931
Oil on canvas, 50 x 60 inches
Courtesy Carlson Gallery, San Francisco

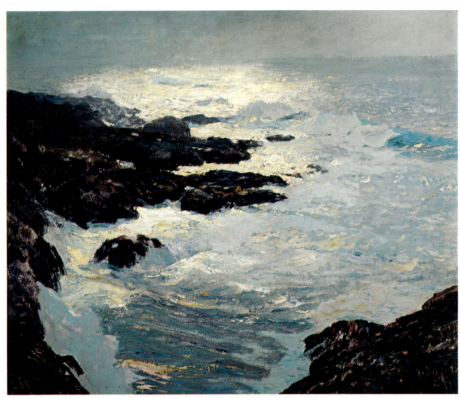

WILLIAM RITSCHEL
The Path to the Sun, c. 1918
Oil on canvas, 20 x 24 inches
Courtesy Donald W. Crocker

the sea as Ritschel does…when he paints a fine marine you feel in it the beauty and the danger, the cruel, barren ocean-love which will not release the enthralled painter."[14]

The artist returned to his lovely castle at Carmel Highlands. He filled the studio garden with objects and sculpture collected on his many trips. Visitors remembered seeing him painting along the cliffs, clad in a colorful sarong, a momento of his South Seas trip. It was his superb interpretations of the California coast that earned him the title of "Dean of American Marine Painters."[15] Ritschel was a master of any mood—the violence of a storm-tossed surf, the reverent beauty of a Pacific sunset, the ethereal-like feeling of a moonlit lagoon in the South Seas. In *Storm Lashed Coast* he brilliantly captured the sunlight gleaming through the spray of the surf. In *Salmon Fisher's Fleet*, considered to be "one of the most amazing marines ever painted,"[16] the viewer looks directly into the bright glare of the sun as reflected on the ocean, the pattern of the sea broken only by the dark, geometric shapes of the boats.

Ritschel's marriage to Belle had not been happy. In 1930, in Reno, Nevada, the artist divorced her and married Elenora Havel, who had been his secretary for many years. That same year Ritschel won the Isidor Prize at the Salmagundi Club for the third time and was declared *hors concours* at the California State Fair. In 1931 a one-man exhibition of his marine paintings was held at the Oakland Art Gallery in Oakland, California. That same year Eugen Neuhaus wrote:

> Artistically Ritschel is a realist seeking to interpret nature in her more obvious moods without ever becoming commonplace. His sense of design is marked, and the grotesque and colorful rock formations of Carmel reflected in the blue waters he has worked into many decorative canvases which may be enjoyed in our museums of art.[17]

In 1935 his painting *The Sea Rover* received the purchase prize at Springville, Utah High School's 14th Annual Exhibition of American Art. The painting,

measuring 50 by 60 inches, was considered a masterful example of the depth and force of Ritschel's style.[18]

During the war, the artist, who was known to be warm and generous, exchanged his numerous gold medals for dollars which he then donated to the American Red Cross. In reflecting on art he stated that "an artist should be an optimist, seeking beauty and giving pleasure."[19] In 1942, seven years before his death, an exhibition of his work was held at the Biltmore Salon in Los Angeles. Arthur Millier referred to the then 78 year old artist as "a grizzled veteran of the brush," and described two works as ranking "among the finest paintings of the sea:"

"Carmel Highlands Coast" is a powerful symphonic painting of the waves which ceaselessly surge upon the wild, mysterious, somehow threatening coast…Its color captures another dramatic element peculiar to that coast—the conflict between sun and fog…

"Song of the Sea" is a masterpiece in opposite vein. We are transported to the open sea for a playful, lyrical dance of blue and green water and tossed diaphanous spray.[20]

Ritschel died on March 11, 1949, at his home in Carmel Highlands. A memorial exhibition of his work was held at the Carmel Art Association in October of that year.

Janet B. Dominik

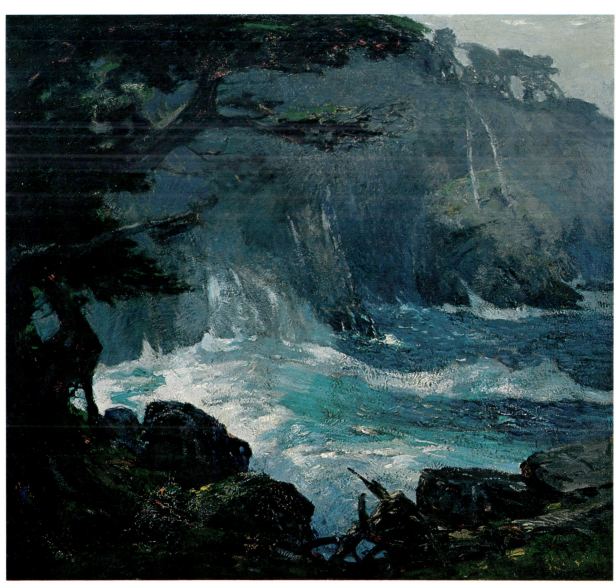

WILLIAM RITSCHEL
Bit of California Coast—Pt. Lobos
Oil on canvas, 36 x 40 inches
Private colletion

THEODORE WORES (1859–1939)

Photo courtesy Drs. Ben and A. Jess Shenson

BORN
August 1, 1859, San Francisco, California

DIED
September 11, 1939, San Francisco, California

TRAINING AND STUDY
California School of Design
Royal Academy, Munich

STUDIO LOCATIONS
San Francisco
New York City
London

RESIDENCES IN CALIFORNIA
San Francisco

MEMBERSHIPS
Art Society of Japan, Tokyo (Honorary)
The Bohemian Club, San Francisco
Century Association, New York City
Salmagundi Club, New York City
San Francisco Art Association

AWARDS
Bronze Medal, Royal Academy, Munich, 1876, 1878
Gold Medal, Alaska-Yukon-Pacific Exposition, Seattle, 1909

PUBLIC COLLECTIONS
Boggs Collection, Shasta State Historic Park, California
The Bohemian Club, San Francisco
California Historical Society
Crocker Art Museum, Sacramento
Los Angeles County Museum of Natural History
M. H. de Young Memorial Museum, San Francisco
Monterey Peninsula Museum of Art
The Oakland Museum

Perhaps one of the best known and most respected artists in Northern California during the period from the 1880s through the 1920s was Theodore Wores. Though not one of the leaders or innovators of his time, he was a prominent member of the artistic milieu.[1] He was remembered as quiet, courteous, and dignified, a man who did not seek publicity but found that it sought him.[2]

Wores was born on August 1, 1859, the son of a Hungarian immigrant, Joseph Wores, and his German born wife, Gertrude Liebke.[3] He showed a predilection for drawing at a young age, and his parents arranged for him to have lessons after school in the studio of Joseph Harrington (1840–1900). At the age of fifteen Wores enrolled in the California School of Design.

In 1875 Wores was encouraged by artist Toby Rosenthal (1848–1916) to come to Munich and seek admission to the prestigious Royal Academy where Rosenthal was a student. Wores was accepted and for the next several years studied traditional academic methods with Ludwig Loefftz (1845–1910) and Alexander von Wagner (1839–1919). He developed a "highly polished, detailed painting technique"[4] and won two bronze medals as well as a $300 cash prize with free rental of a studio for two years.

While in Munich Wores joined the American Art Students Club whose membership included Frank Duveneck, William Merritt Chase, John Alexander, and Joseph de Camp. Wores became one of the "Duveneck Boys" who traveled together to Florence and Venice in 1879. While in Venice he met Whistler who introduced him to the art of Japan and encouraged him to visit there.

Wores returned to San Francisco in 1881 and rented a studio adjoining that of William Keith. He became interested in the Chinatown area, a subject which dominated his work for the next few years.[5] One of the best paintings from this period is *Chinese Fishmonger* for which he was praised for his technical mastery.[6]

Wores began to receive portrait commissions and, in 1882, painted a portrait of Oscar Wilde who was staying at the Bohemian Club of which Wores was a member.[7] He also gave private as well as studio lessons and, in 1884, became an instructor at the newly founded San Francisco Art Students League.

Bohemian Grove, 1925 — *Photo courtesy Drs. Ben and A. Jess Shenson*

THEODORE WORES
Garden of the Potter Hotel, Santa Barbara, c. 1905
Oil on canvas, 35⅛ x 25⅛ inches
Courtesy Collection of the Santa Barbara Museum of Art, Gift of Drs. Ben and A. Jess Shenson

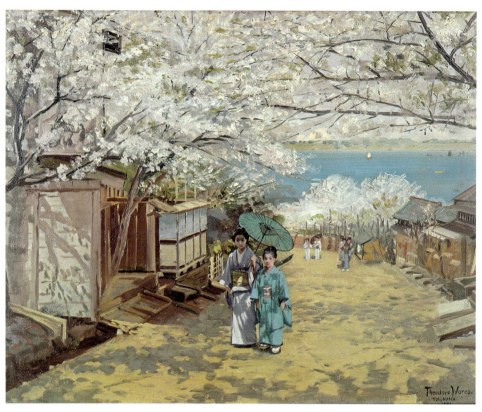

THEODORE WORES
Sunshine and Cherry Blossoms, Nogeyana, Yokohama, 1893
Oil on panel, 16 x 20 inches
Courtesy Drs. Ben and A. Jess Shenson

Remembering Whistler's advice, Wores made plans to visit Japan and began his trip in 1885. Arriving in Yokohama he reported being "dazed and confused by the great mass of picturesque material" available to him.[8] He stayed for over two years, working primarily in Tokyo, painting many portraits and landscapes, most *en plein air*. These works "combine the interest in exotic genre with high coloration, flecks of pure pigment and sometimes dappled patterns of light and shade."[9]

After his return to the United States in 1887, Wores exhibited his Japanese paintings in San Francisco, New York, Boston, Washington, D.C., and Chicago. The paintings were generally well received and Wores was praised for his skills as a draughtsman and as a colorist.[10] One critic, however, admitted that Wores' excessive attention to detail sometimes resulted in a "loss of artistic effect;...[leaving] little room for the imagination."[11]

In 1889 Wores traveled to London and rented a studio in Chelsea. He renewed his acquaintance with Whistler who introduced him to the London galleries. He participated in several exhibitions and returned to the United States in 1891 having sold all of the paintings he had taken to England.

In San Francisco he again began work on paintings depicting Chinatown, continuing his "predilection for the exotic" in his work.[12] A second trip to Japan, which included a stop over in Hawaii, was made in 1892. During the fifteen-month trip he produced over one hundred paintings.

In 1893 Wores participated in the World's Columbian Exposition in Chicago. He exhibited in the California Midwinter International Exposition in San Francisco in 1894. That same year the Bohemian Club honored him with a one-man show. In the fall he traveled again to New York where he exhibited, lectured, and wrote articles about his Japanese travels.[13] In the summer of 1899 he rented the guest house of Thomas Moran in East Hampton, Long Island and painted several views of Moran's home and beach scenes.[14]

In 1901 Wores was once again lured by the exotic and traveled to Hawaii and Samoa. In 1903 he traveled to Spain where he saw the works of Velasquez which made a profound impression on him.[15] He painted in the picturesque areas of Alhambra, Grenada, and Seville. Wores was in fact more impressed with the landscape and architecture in Spain than he was with that of either Japan or Samoa.[16] Reynolds stated that in the "use of intense, glowing colors and fluid brushwork, the Spanish scenes are perhaps some of Wores' most successful paintings."[17] Gerdts concurred, noting that the works are his finest "in terms of a sensitivity to light and color relationship."[18]

THEODORE WORES
The Golden Gate from Baker Beach
Oil on canvas, 36 x 48 inches
Courtesy James L. Coran and Walter Nelson-Rees

THEODORE WORES
Plum Blossoms, Los Gatos, California, 1920
Oil on canvas, 20 x 28 inches
Courtesy Adamson Duvannes Galleries, Los Angeles

Wores returned to the United States and exhibited his Spanish paintings at the Century Club in New York in 1904. He returned to San Francisco in 1905 and for a brief period painted in Santa Barbara. In 1907 he was appointed director of the Mark Hopkins Institute of Art. Maurice Logan (1886–1977) remembered Wores as " 'a natural-born teacher' " quiet, reserved, " 'even formal to strangers, but a courtly and courteous person'."[19]

In 1910 Wores married Carolyn Bauer whose portrait he had painted the previous year. For the next few years he remained at home, painting in and around the San Francisco area. During the summer of 1913 he and Carolyn made a three-month trip to the Canadian Rockies. In 1915 they traveled to Arizona and New Mexico where Wores painted the Indians of the area.[20]

After 1918 and for the next several years Wores concentrated on painting the floral landscape of the California countryside. He said: "Of all the countries I have visited in search of material for my brush, California ranks first as a land of sunshine and flowers, both wild and cultivated."[21] Wores felt that these works, termed his blossom paintings, were his best.[22] He found his flowers in the orchards of the Santa Clara Valley, in the foothills of Saratoga and Los Gatos, and in the sand dunes and rocky cliffs around San Francisco. The paintings were exhibited in both New York and San Francisco. In 1921 a critic for the *San Francisco Call* wrote:

> His blossoms are not simply white paint—they melt into the landscape in green or gray whites or delicate pinks. He paints into his canvases all the elusive charm of those dewy, spring mornings when the yellow-green grass is brocaded with poppies and lupine, and gauzy fog veils the atmosphere.[23]

A retrospective exhibition of Wores' work was held at Stanford University in 1922. Paintings from Japan, Hawaii, Samoa, Spain, Canada, New Mexico, and California were included in the show. Reflecting on his career Wores said:

> From the start I learned to paint not only the elusive atmosphere and mood of the moment—the misty dawn, the glow of sunset, the changing lights and shadows of scudding clouds—but to paint rapidly with a keen eye and sure hand. To that end, as a youth I worked for years, seeking the facility of the old masters, whether painting a human being or a sea of blossoms.[24]

On one of his many trips to Saratoga during the 1920s, Wores discovered an abandoned Methodist Church which he purchased and converted into a gallery, studio, and home. Although he still maintained an apartment and studio in San Francisco, he and his wife welcomed the solitude the Saratoga home afforded them, away from the strife and controversy now occurring in San Francisco over the developments in modern art.

In 1939, his eyesight failing, Wores reluctantly sold his Saratoga home and returned to San Francisco. He entered his last exhibition, the 1939 Golden Gate International Exposition in which he exhibited *Sand Dunes of San Francisco*. On September 11 he died peacefully at home. He was remembered as a fine artist, a "strong social, spiritual and artistic force."[25] Reynolds stated that Wores' "greatest achievements rest in paintings which are a successful synthesis of his interests in picturesque subject matter, expressive brushwork, and intense, outdoor light effects."[26] His paintings were not a true form of Impressionism but rather a realism based on rigid academic training, softened by an awareness of the newer art form.[27]

Janet B. Dominik

Panorama, Corinthian Island *Photo courtesy Belvedere-Tiburon Landmarks Society*

THE SOCIETY OF SIX by Terry St. John

> We do not believe that painting is a language. Nor do we try to "say" things, but we do try to fix upon canvas the joy of vision. To express, to show ... not to write hieroglyphics. We have no concern with stories, with lapse of time, nor with the probability of improbability or hereafter. In other words, we are not trying to illustrate a thought or write a catalogue, but to produce a joy through the use of the eyes. We have much to express, but nothing to say.
>
> William H. Clapp[1]

Increasingly appreciated for their fresh, unsentimental directness are the *plein air* paintings of the Oakland-based Society of Six. In their time, "The Six" avoided the hackneyed potboilers that were the common fare for the majority of landscape artists of that era. All the members of the group, Louis Bassi Siegriest, born 1899, Maurice George Logan (1886–1977), William Henry Clapp (1879–1954), August Francois Gay (1891–1949), Selden Connor Gile (1877–1947) and Bernard James von Eichman (1899–1970), discovered, during their long association, what it meant to be an artist as well as a member of a closely-knit group of painters with a strong unifying sense of visual purpose. Their dynamic and independent personalities helped them avoid the studied and artificial attitudes that had been adopted by past generations of "Europeanized" California artists.

The Society of Six was intensely devoted to a self-imposed set of rough-and-tumble attitudes that they found necessary for the maintenance of the visual purity in their works. They sensed that they were not making new art merely for the sake of newness, but with an exhilaration that was born from an overthrowing of subservient visual posturing over various sanctified art modes. Although they were a part of the San Francisco Bay Area modernist art scene in the 1920s, they had an allegiance primarily to themselves, and they were forced to be their own best audience. Influences upon them ranged from nineteenth century Impressionism to European Abstractionism. Although it is fairly easy to trace the more obvious influences, "The Six," nonetheless, managed individually to fashion their own painting styles into fresh and ingenuous outdoor paintings which appear generally American and specifically Californian. They were regional painters in the best sense of the word.

"Will Bohemia arise in Oakland," was the question asked in an article in the *Oakland Tribune* on April 22, 1917. The reporter told of the formation of an artist's club of the East Bay with a membership of more than 30 painters, sculptors and art students including Selden Gile, William H. Clapp and William A. Gaw (1891–1973). Many of the things that made the area seem so desirable to "The Six" were mentioned in that review, such as the picturesque waterfront and the sunny rolling hills above the Bay. Oakland was depicted as "...a Bohemia where kindred spirits meet with art and the great adventures that stimulate art to color its atmosphere."

For almost 10 years, 1917 to 1927, until Selden Gile moved to Belvedere,[2] his cabin on Chabot Road in Oakland was the weekly meeting place for "The Six." The "Chow House," as it was called, had electricity but no toilet or bath.[3] What the accommodations lacked in convenience was more than made up for by the heated art discussions and garlic-laced meals that Gile, the generous host, provided. He frequently

SELDEN GILE
Sausalito, 1913
Oil on board, 8 x 10 inches
Courtesy Maxwell Galleries Ltd., San Francisco

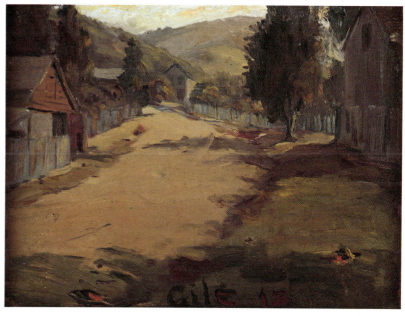

Louis Siegriest and Selden Gile, Tiburon, 1927
Photo courtesy Art Department, The Oakland Museum

offered a formidable home-brewed beer to wash down his famous meals and, occasionally, the proceedings were enlivened by the bottles exploding. In addition to the beer, they fortified their meetings with at least two gallons of "dago red" wine which were delivered to Gile every week by an Italian bootlegger friend.[4] Occasionally, von Eichman showed up with his "San Jose Cheer," a prune whiskey that helped to lubricate their discussions.[5] Clapp, the sedate curator, was dubbed "Ho-Ho-Ho" by Gile because that was Clapp's usual exclamation when he arrived at their meetings. He was considered to be the gentleman of the crowd.[6] As Siegriest recalls, "Clapp was a very quiet sort of fellow, polite and quiet." He also remembers with discomfort, "the way these guys would talk in front of him…he looked embarrassed but he would join in."[7] "The Six" friends rarely missed a Saturday or Sunday evening get-together at Selden Gile's place.[8]

William Clapp was the only member of the group who had received formal instruction in France.[9] Born in Canada, in 1879, but reared in Oakland, Clapp returned to Canada, in 1900. He studied there and at the Académie Julian in Paris under Jean-Paul Laurens, as well as the Académie Colarossi and at the Ecole de la Grande Chaumière. Before returning permanently to live in Oakland, about 1917, Clapp had been considered a radical painter in Montreal. In fact his studies in Europe and Paris, and his later familiarity with the modernist Canadian "Group of Seven" who showed for the first time together in Toronto in 1920, contributed immensely to "The Six's" cohesiveness. Not coincidentally, "The Six" had initially been called "The Group of Six," undoubtedly prompted by Clapp's knowledge of the Canadian painters.[10] His previous studies in Paris and Montreal had acquainted him with an attitude that considered manifestos and closely-knit groups to be essentially supportive of art. An *Oakland Tribune* critic finally named the Oakland-based group of artists "The Society of Six," perhaps cribbing the title from a contemporary group of vanguard French musicians led by Eric Satie, "Les Six," who had been in the news as musical innovators.[11] In 1923, Clapp initiated a policy of annual shows for "The Society of Six" as part of a progressive exhibition program in the Oakland Art Gallery.

August Gay and Selden Gile were the first of "The Six" artists to become acquainted with each other and exchange ideas.[12] Although Gile may have seemed at times to be a misanthrope, he was, in fact, unusually generous and sensitive to the needs of others, particularly artists. He supported August Gay on and off from 1911 to 1920, and helped the young Frenchman, the son of recent immigrants, to realize his early dream of becoming an artist.[13] Gay's family was extremely poor, and there was no room for him to paint in their overcrowded house in Alameda so he finally appealed to Gile for help.[14]

Although William Clapp became curator of the Oakland Art Gallery in 1918, it has been suggested that he met Gile earlier, in 1917.[15]

Louis Siegriest, a native of Oakland, first met Selden Gile and August Gay in 1914 when they were both living on James Avenue nearby. When Gile later moved to Chabot Road, Oakland, he became a neighbor and friend of Maurice Logan and they began to paint together. The last member of the group to be

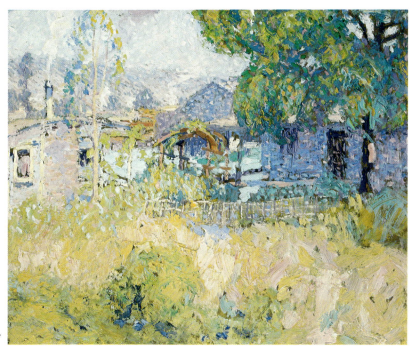

WILLIAM CLAPP
Houses along the Estuary
Oil on panel, 15 x 17¾ inches
*Courtesy Collection of The Oakland Museum,
Gift of Donn Schroder*

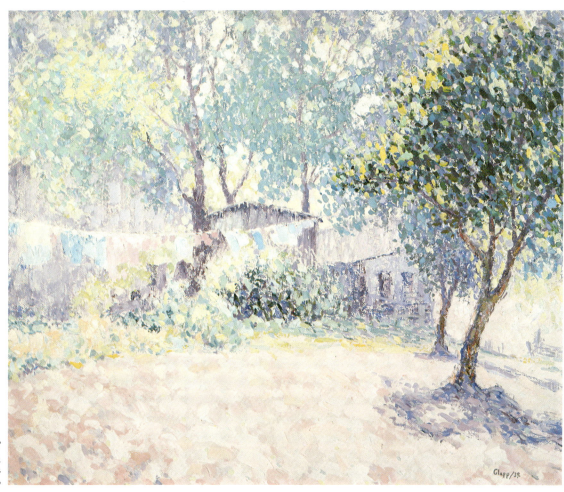

WILLIAM CLAPP
Monday Wash
Oil on canvas, 30 x 36 inches
Courtesy Maxwell Galleries Ltd., San Francisco

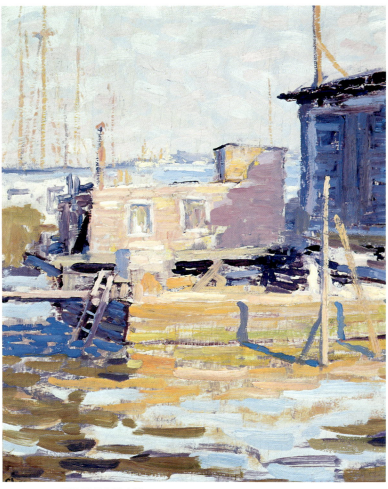

WILLIAM CLAPP
Estuary Dwellings
Oil on wood panel, 20 x 16½ inches
Courtesy Collection of The Oakland Museum, Gift of Donn Schroder

SELDEN GILE
Fisher Houses, 1925
Oil on canvas board, 18 x 15 inches
Courtesy of Dr. and Mrs. Bernard H. Wittenberg

"enlisted" was Bernard von Eichman.[16]

Siegriest remembers well the evening when their association was formalized, because it helped to shape his mature career; "I was damn pleased to be included," he said. William Gaw (1891–1973), an often brilliant, pioneering modernist, was a regular associate of the group but he was excluded from it by Gile, who said, "I am going to keep it to six, no more."[17]

Gile, and for the most part the others of "The Six," worked outdoors on most holidays and weekends, usually after hiking short distances in the open fields around North Oakland.[18] They were, however, not confined to the immediate East Bay area. Painting expeditions in search of interesting subjects often took members of the group to Marin County, up and down the California coast from Mendocino to Monterey, and throughout Contra Costa County, the California Mother Lode country and to Taos, New Mexico.

In spite of the inherent limitations of weekend painting, they managed to maintain an intense involvement with art, often completing as many as four or five conveniently-sized, sixteen-by-twenty inch canvases a day.[19]

Even though Selden Gile approached his subjects with a rare spontaneity, his work can be readily identified, not because he employed tired formulas, but, rather, because he approached his themes with an

incisive directness that saw each new picture as being unique. He achieved his distinctive color and spatial relationships without resorting to stock recipes, and not only had a flexible palette but also utilized a variety of painting techniques.[20] If it seemed to fit the occasion, he would use a palette knife, while on another, he would use a brush. In any event, he used whatever seemed appropriate at the time.

After Gile moved to Tiburon in 1927, he painted larger canvases which occasionally approached forty by forty-eight inches in size. In a letter to Louis Siegriest, he mentioned that he had difficulties with canvases larger than thirty-four by forty inches.[21] Although Gile did succeed later in painting some fine larger canvases, they frequently appeared labored in technique and static in color. In general, all six artists did their best work in pictures of small format that could be done quickly and "on the spot." Larger canvases seemed to inhibit their work.[22]

August Gay's earlier paintings clearly show Gile's influence in his use of thick paint and a small brush stroke. Gay's immense talent became apparent by the mid-1920s, and at that time he also developed the creative strength to grow in an independent direction from the other members of "The Six." After 1920, his color became more inventive and personal and he developed a remarkable ability to organize shapes into spatial patterns that pursued a type of realism that was very similar to that practiced later by some of the Northern California artists who were working in the Bay Area Figurative Style in the 1950s and 60s. Gay's painting, *Ranch in Carmel Valley*, is one of

SELDEN GILE
View of Bridge
Oil on canvas, 14¾ x 18 inches
Courtesy Collection of The Oakland Museum, Gift of Helen Baer Gaw

AUGUST GAY
Hatton Dairy Ranch, Carmel, c. 1929
Oil on cardboard, 20 x 23½ inches
Courtesy James L. Coran and Walter Nelson-Rees

the clearest examples of this coincidental similarity.

Unlike the works of the other members of "The Six," William Clapp's paintings show that the artist's mature career was chiefly spent working in a style that can be placed somewhere between French Impressionism and Post-Impressionist pointillism. His paintings, at their best, display an inspired use of high-keyed reds, greens and yellows that hint of Monet. Clapp tended to theorize a good deal about art, but had very little impact on the group. According to Louis Siegriest, most of "The Six" were intuitive in their approach to art, and Clapp's intellectual approach to art theory and techniques was barely tolerated.[23]

Maurice Logan, who painted with more authority than Clapp, made some remarkably fine paintings during the 1920s, occasionally working in straightforward impressionist manner. More typical, however, is his *Point Richmond* of 1929, in which he employed a palette much more akin to the Spanish virtuoso Post-Impressionist, Joaquin Sorrola y Bastida (1863–1923), whom he greatly admired.[24] Logan became well-known during his lifetime as a highly successful commercial artist and as a watercolorist, depicting scenes of the Oakland Estuary, Alameda and San Francisco Bay.

One of the youngest members of "The Six," Louis Siegriest, had formal art instruction, but preferred to learn from the older members of the group. "I never missed a get-together at Gile's," he later recalled. It wasn't for the good food and drink, either. Because of his youth the discussions on art by the members of the group made a great impression on him. "You had better not show up at their get-together either on Saturday or Sunday without a few paintings done that day," recalls Siegriest.[25]

Although he produced some excellent paintings in the 1920s, he was destined to do his finest work after World War II, when he parlayed his long involvement with the California landscape into lyrical abstractions of western deserts.

The youngest member of "The Six," Bernard von Eichman, studied at the Frank Van Sloun School of Art in San Francisco between 1918 and 1920. Unlike Siegriest's, von Eichman's growth as an artist is comparatively difficult to evaluate because he burned a large number of his early paintings thus making an accurate assessment of the evolution of his work difficult.[26] Many artists considered "Red," as he was known, to be very progressive for his time and various

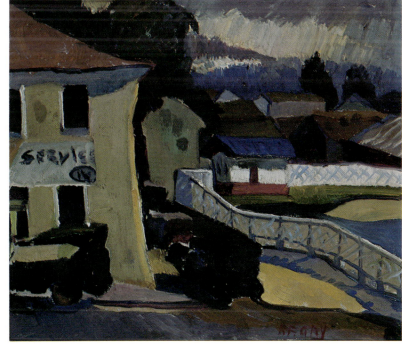

AUGUST GAY
Monterey Street Scene
Oil on canvas, 12 x 14 inches
Courtesy Mr. and Mrs. William A. Karges Jr.

MAURICE LOGAN
Point Richmond, 1929
Oil on canvas, 15 x 18 inches
*Courtesy Collection of The Oakland Museum
Gift of Louis B. Siegriest*

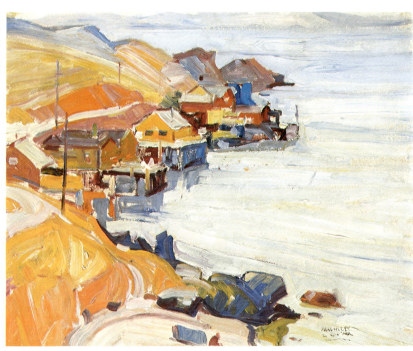

Belvedere Flat *Photo courtesy Belvedere-Tiburon Landmarks Society*

newspapers and periodicals called his paintings "ultra modern."[27] In a 1926 *Oakland Tribune* review by H.L. Dungan, an abstract landscape was reproduced and the reviewer indicated that von Eichman was considered to be the extreme radical of "The Six."[28] Von Eichman's unconventional behavior added considerable excitement to the gatherings of "The Six," but he was, in addition, an intellectual spark to the group. He was an insatiable reader, and although not formally educated, he had travelled widely as an oiler in the merchant marine. Whenever his ship docked at a major port, such as New York, he would go to the local art museums and buy their latest art publications. After his return, he would report to "The Six" on what he had seen. He brought armloads of art magazines to Gile's house and the group perused them.[29]

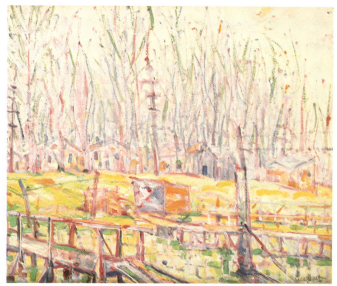

LOUIS SIEGRIEST
Trees in Fall, c. 1921
Oil on board, 15 x 18 inches
Courtesy James L. Coran and Walter Nelson-Rees

LOUIS SIEGRIEST
Untitled (House with Garden)
Oil on panel, 11¾ x 15¾ inches
*Courtesy Collection of The Oakland Museum
Gift of Louis B. Siegriest*

Although the group had an intensive association of remarkably long duration—the years from 1917 to 1928 were their most cohesive—they continued to get together until the beginning of World War II. Their meetings became increasingly social rather than art-producing in nature, however, and relatively infrequent, as Gile's alcoholism worsened and his conviviality waned.[30]

Changes also occurred in the essentially exuberant and optimistic mood of "The Six," when the great depression of the 1930s began to alter their outlook. All of them, with the possible exception of Clapp, made stylistic changes that either reflected a somber mood or changing attitudes towards their previous visual concerns.

Successive years and time's momentum have enhanced the visual achievements of "The Six" because their fundamental integrity and abilities are authentically rooted in the mainstream of California art. Their work continues to surface because of its inherent validity and the archetypal beauty of their images.

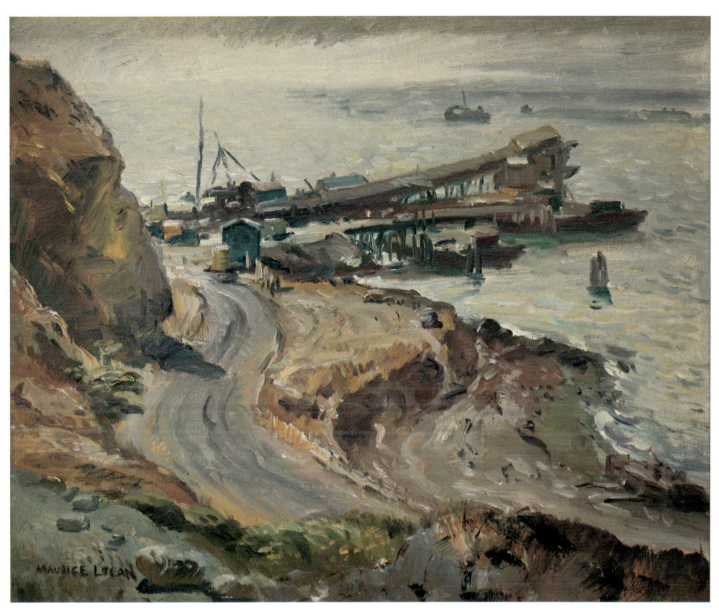

MAURICE LOGAN
The Grand Chute
Oil on canvas, 25 x 30 inches
Courtesy James L. Coran and Walter Nelson-Rees

BERNARD VON EICHMAN
China Street Scene #2, 1923
Oil on cardboard, 21 x 14 inches
Courtesy Collection of The Oakland Museum
Gift of Louis B. Siegriest

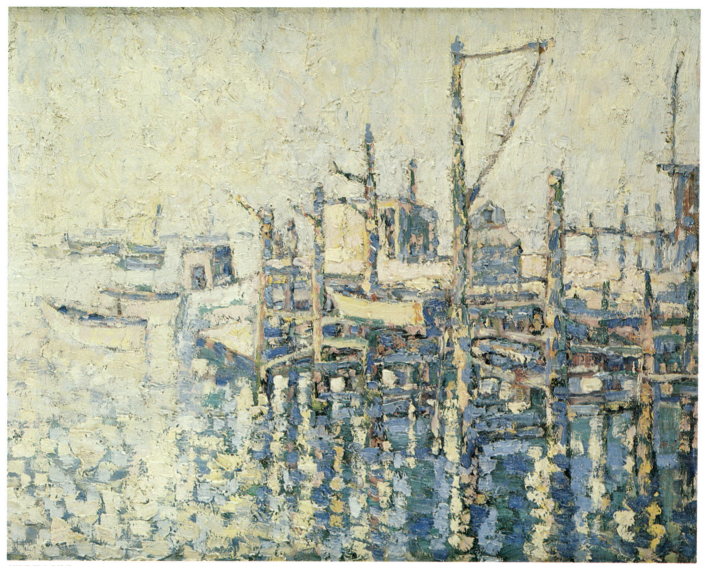

SELDEN GILE
Oldag's Wharf, Tiburon
Oil on board, 23 x 30 inches
Courtesy James L. Coran and Walter A. Nelson-Rees

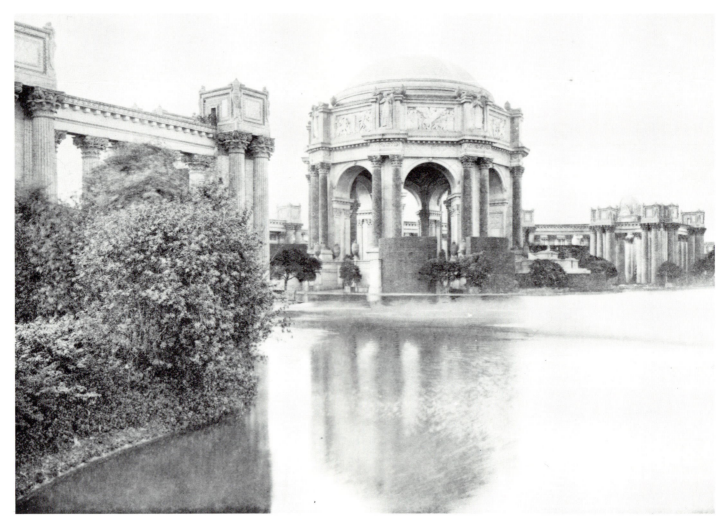

Panama-Pacific International Exhibition, 1915

NOTES

INTRODUCTION

1. Ruth Lilly Westphal, *Plein Air Painters of California: The Southland*, (Irvine, California: Westphal Publishing, 1982).
2. *Impressionism: The California View* (Oakland, California: The Oakland Museum, 1981), p. 9.
3. William H. Gerdts, *American Impressionism*, (New York: Abbeville Press, 1984).
4. John I. Walter, "The San Francisco Art Association," in *Art in California* (San Francisco: R. L. Bernier Publisher, 1916), p. 99. "In open competition entered into by all of the art schools of the United States and Canada for the scholarships awarded by the Art Students League of New York, the San Francisco Art Institute has led during the past three years. During the year 1913 five awards out of eleven were won by students of the San Francisco Institute of Art. During the year 1914 five awards out of seventeen were won, more than was granted to any other school. During the year 1915 the greatest number of awards was again received."

TOWARDS IMPRESSIONISM IN NORTHERN CALIFORNIA

1. Gene Hailey, ed., *Abstract from California Art Research*, W.P.A. Project 2874, O.P. 65-3-3632, Vol. 4 (San Francisco: Works Progress Administration, 1937), p. 39.
2. "Collections in San Francisco," in Earl Shinn, *Art Treasures of America*, Vol. 2 (Philadelphia: George Barrie, 1880), p. 56. See also *Painting and Statuary Belonging to Irving M. Scott*, Sixteenth Annual Industrial Exhibition (San Francisco: Mechanics Institute of San Francisco, 1881).
3. Several American artists, Cecilia Beaux and Robert Henri, for example, wrote of life at Julian's. A description of the curriculum and requirements can be found in Alice Fessenden Peterson, "The American Art Student in Paris," *New England Magazine* (2 August 1890): 669–676.
4. See *The Americans in Paris* (Paris: published for the author and editor, 1887).
5. Reproduced in Herschel B. Chipp, ed., *Theories of Modern Art* (Berkeley: University of California Press, 1968), p. 100.
6. See Klaus Berger, *Japonismus in der Westlichen Malerei, 1860–1920* (Munchen: Prestel-Verlag, 1982).
7. Brother Cornelius, *Keith: Old Master of California* (New York: G. P. Putnam's Sons, 1942), p. 216.
8. *Spring Exhibition, 1891: San Francisco Art Association*, exhibition catalogue (San Francisco, 1891).
9. *San Francisco Daily Alta California*, 17 May 1891.
10. Mentioned in *The Art Digest* (1 October 1930): 13. The painting was later bought by A. Livingston Gump, son of the founder of the well-known store bearing his name.
11. Charles Dorman Robinson, "A Revival of Art Interest in California," *Overland Monthly* (June 1891): 649–652.
12. *Art Loan Exhibition of Foreign Masters: San Francisco, California*, arranged by W. K. Vickery, March 1891 (San Francisco: Woodward and Co., 1891).
13. Robinson, p. 650.
14. *California at the World's Columbian Exposition, 1893: Report of the World's Fair Commission* (Sacramento, California, 1894).
15. *Official Catalogue, Fine Arts: California Midwinter International Exposition, 1894* (San Francisco: Harvey, Witcher, and Allen, 1894). The fine arts gallery was the first home of the Golden Gate Park Museum, now the M. H. de Young Memorial Museum.
16. *San Francisco Alta California*, 29 February 1888. A copy is contained in Box 4 of the Keith-McHenry-Pond Papers, Bancroft Library, University of California.
17. *Spring Exhibition, 1884: San Francisco Art Association*, exhibition catalogue (San Francisco: Bosqui Eng. Co., Lith., 1884); *Spring Exhibition, 1886: San Francisco Art Association*, exhibition catalogue (San Francisco: Bosqui Eng. Co., Lith., 1886).
18. For a discussion of the change in taste to Barbizon, see Peter Bermingham, *American Art in the Barbizon Mood* (Washington, D.C.: National Collection of Fine Arts, 1976).
19. *Circular of the California School of Design, 1890*.
20. Keith claimed that he lost over two thousand paintings to the fire, but this figure seems excessive and may have been a shrewd attempt at boosting the market for his "remaining" canvases.
21. *Art Gallery, Hotel Del Monte, California, 1907*, exhibition catalogue. William Merritt Chase, a member of The Ten, taught at the Carmel Summer School of Art in 1914, seven months before the opening of the P.P.I.E.
22. *Official Catalogue of the Department of Fine Arts, Panama-Pacific International Exposition* (San Francisco: The Wahlgreen Co., 1915).

THE ARTS IN SANTA BARBARA

1. Unidentified newspaper clipping from the files of the Santa Barbara Public Library. Written notation indicating date of 12 January 1947.
2. Hamilton McFadden, "Community Arts Association, Santa Barbara, California," *The American Magazine of Art* 15 (June 1924): 303. The Community Arts Association is also discussed at length in John A. Berger, *Fernand Lungren: A Biography* (Santa Barbara, California: The Schauer Press, 1936), pp. 221–243.
3. Stella Haverland Rouse, "Fernand Lungren, local artist, one of many who painted turn-of-century Western scenery." Unidentified newspaper clipping from the files of the Santa Barbara Public Library. The author quoted from a 1914 interview by a *Santa Barbara Daily News* reporter.
4. L. W. Wilson, "Santa Barbara's Artist Colony," *The American Magazine of Art* 12 (December 1921): 411–414.
5. The Treasurer's Report for the year October 1, 1928 to September 30, 1929, indicated the School of Arts received $9,500 from the Carnegie Fund and $28,875 from contributions.
6. Berger, p. 271. See also "The Interesting Work of the Community," *California Southland* (c. 1925): 14. Copy of article without notation in files of the Santa Barbara Public Library.
7. Berger, pp. 273–274.

CALIFORNIA ART AT THE OAKLAND MUSEUM

1. There were some awfully good art philosophers and historians at the University of Washington then, too. Suzanne Langer, author of *Philosophy in a New Key* and *Feelings and Form*; Sherman Lee, then Assistant Director of the Seattle Art Museum, later Director of the Cleveland Museum of Art; Orientalist Millard Rogers, recently back from India, among them.
2. Years later, in 1976, to mark the gift of a fine

and unusual Boudin view of Abbeville I had long cultivated, we, in Santa Barbara, initiated the first one-man exhibition of Boudin's work held in a museum in forty years and the tour of this exhibition. There was a great deal of satisfaction for me in being able to accomplish something like this early dream.

3. Good friends and fine people such as Esther Fuller, Albert and Taylor Churchill, and Dixie Stoll, founders of the Oakland Museum Association, helped make progress possible and the project satisfying.

4. The Western Association of Art Museums is now the Art Museum Association. That organization's Ilo Liston was a great friend and ally. Dr. Grace L. McCann Morley, the founding director of the San Francisco Museum of Modern Art, was an especially helpful mentor.

5. Brother F. Cornelius, *Keith: Old Master of California*, Vol. 2 (New York: G.P. Putnam Sons, 1942; Fresno, California: Academy Library Guild, 1956).

6. *Mathews: Masterpieces of the California Style* (Oakland, California: The Oakland Museum, 1972).

7. The dedicated people include especially Hazel Bray, Curator of Crafts, Therese Heyman, Curator of Photography, and James Brown, first director of the combined museums. Also important were the Art Guild, the Art Docents, and the Women's Board of the Oakland Museum Association. I am especially fortunate to have had George Neubert as an assistant and then successor as Chief Curator, and I am pleased our work has been so ably carried forward by Christina Orr-Cahall, now Chief Curator, and Harvey Jones, Senior Art Curator, and their staff.

8. *San Francisco Chronicle*, 14 September 1969, p. 36.

CARL OSCAR BORG

1. Raymond E. Lindgren, "The Wanderer: Carl Oscar Borg," *American Swedish Historical Foundation Yearbook* (1962), p. 77.

2. Biographical information, unless otherwise noted was obtained from Helen Laird, *Carl Oscar Borg and the Magic Region* (Layton, Utah: Gibbs M. Smith, Inc., Peregrine Smith Books, 1986).

3. Laird, p. 28.

4. Ibid., p. 29.

5. Ibid., p. 65.

6. Jessie A. Selkinghaus, "The Art of Carl Oscar Borg," *The American Magazine of Art* 18 (March 1927): 147.

7. Laird, p. 85.

8. Nancy Dustin Wall Moure, *Dictionary of Art and Artists in Southern California before 1930* (Glendale, California: Dustin Publications, 1975), p. 22.

9. Laird, p. 94.

10. Undated, unidentified newspaper clipping. Copy in the archives of Thomas McNeill, Redondo Beach, California.

HENRY JOSEPH BREUER

1. *Mr. Henry Joseph Breuer of San Francisco: Landscape Painter* (San Francisco: The Stanley Taylor Company,), p. 26. Consists of transcriptions of press notices and letters from the period 1895 to 1907, not arranged chronologically.

2. Gene Hailey, editor, *Abstract from California Art Research*, W.P.A. Project 2874, O.P. 65-3-3632, Vol. 5 (San Francisco: Works Progress Administration, 1937), p. 64. The compiler of this biography relied heavily on the work cited in note 1 above and was, unfortunately, not careful in checking dates. The biographical notation on Breuer in *Rookwood Pottery Potpourri* (Cincinnati: Leonard and Coleman, 1980) indicates that Breuer studied at the Cincinnati Art Academy. However, this fact cannot be verified in any other source. The same source states that Breuer studied in Munich with Frederick Fehr and Carl Marr, c. 1889 to 1890. This is also unverified. In addition it lists Breuer's date of birth as August 10 and lists his full name as William Henry Joseph Breuer, stating that he dropped the "William" around 1883. *Who Was Who in American Art* lists his birth date as August 16, 1860. See Peter Hastings Falk, ed., *Who Was Who in American Art* (Madison, Connecticut: Sound View Press, 1985), p. 76.

3. Ibid. It is not clear whether his work as a lithographer began in Cincinnati or New York.

4. Dates given for his visit to Europe vary from 1893 to 1903. *Who Was Who* indicates that he studied in Paris in 1893. One can deduce the following chronology: 1880–82, Rookwood Pottery, Cincinnati; 1882–84, lithographer, probably also in Cincinnati; 1884–88, muralist, New York City; 1888–90, lithographer, San Francisco; 1890–92, art editor, *San Francisco Chronicle*; 1893, to Paris; 1894–1902, editor, *The Californian*, San Francisco; 1903 (?) possibly a second trip to Europe. See Hailey, pp. 65–67.

5. *Mr. Henry Joseph Breuer*, p. 26. Quotation from the *Chicago Times-Herald*, 1895.

6. Ibid., p. 36.

7. Ibid., p. 8. Quotation from the *Cincinnati Times-Star*, June 1904.

8. Ibid., p. 16.

9. Hailey, p. 74.

10. *Mr. Henry Joseph Breuer*, p. 20. Quotation from the *San Francisco Chronicle*, 4 December 1905.

11. Ibid.

12. Ibid., p. 28 and 30.

13. Adolphus Busch to H. J. Breuer, 19 December 1906. Quoted in *Mr. Henry Joseph Breuer*, p. 30.

14. *Mr. Henry Joseph Breuer*, pp. 32 and 34.

15. Ibid.

16. Ibid., p. 16. See also Hailey, p. 71.

17. *San Francisco Chronicle*, 14 September 1919. This is the last documented exhibition of Breuer's work other than the memorial exhibition in 1932.

18. Hailey, p. 89.

GIUSEPPE CADENASSO

1. Hugh Gordon Maxwell, "Giuseppe Cadenasso," *Impressions Quarterly* 5 (December 1904): 101.

2. Gene Hailey, ed., *Abstract from California Art Research*, W.P.A. Project 2874, O.P. 65-3-3632, Vol. 11 (San Francisco: Works Progress Administration, 1937), p. 1. General biographical information for this essay was obtained primarily from this source. Date of birth from Peter Hastings Falk, ed., *Who Was Who in American Art* (Madison, Connecticut: Sound View Press, 1985), p. 95.

3. Ibid, p. 5.

4. Ibid., p. 7. Also noted in Edward F. O'Day, *Varied Types* (San Francisco: Town Talk Press, 1915), p. 47. O'Day referred to a "mute student named Redmond."

5. O'Day, p. 49.

6. Hailey, p. 12.

7. Maxwell, p. 105.

8. During the early years of his career, financial constraints precluded his traveling to Europe. Later he may have simply viewed it as unnecessary.

9. Maxwell, p. 101.

10. Hailey, p. 15.

11. Christina Orr-Cahall, ed., *The Art of California: Selected Works from the Collection of The Oakland Museum* (Oakland, California: The Oakland Museum of Art Department, 1984), p. 73. Inness apparently established a western studio with Keith. As noted in *Tonalism: An American Experience*

(New York: Grand Central Art Galleries Art Education Association, 1982), p. 85.

12. *San Francisco Chronicle*, 10 November 1912. Quoted in Hailey, p. 23.
13. *Wasp*, 21 February 1914. (San Francisco weekly)
14. *San Francisco Call*, 15 October 1915. Quoted in Hailey, p. 17.
15. Ibid.
16. *San Francisco Examiner*, 17 February 1918.
17. Hailey, p. 28.

EMIL CARLSEN

1. Gene Hailey, ed., *Abstract from California Art Research*, W.P.A. Project 2874, O.P. 65-3-3632, Vol. 4 (San Francisco: Works Progress Administration, 1937), p. 34.
2. *San Francisco Examiner*, 27 September 1891.
3. Eugen Neuhaus, *The History and Ideals of American Art* (Stanford, California: Stanford University Press, 1931).

COLIN CAMPBELL COOPER

1. Paul C. Mills, *An Exhibition of Paintings by Colin Campbell Cooper* (Santa Barbara, California: James M. Hansen, 1981).
2. *Memorial Exhibition, Colin Campbell Cooper, N. A.* (Santa Barbara, California: Faulkner Memorial Art Gallery, 1938).
3. Cooper was also interested in literature, especially drama. During the years in Santa Barbara he authored several plays which were performed in Pasadena and Santa Fe.
4. Colin Campbell Cooper, a letter, unsigned, undated in Library, Fine Arts Society of San Diego, San Diego, California.
5. Mills, *An Exhibition*.
6. Ibid.
7. Colin Campbell Cooper, letter.

PAUL DOUGHERTY

1. *Handbook of the Minneapolis Institute* (Minneapolis, Minnesota: The Minneapolis Institute, 1917).
2. *Artnews* 29 (28 February 1931): 12.

E. CHARLTON FORTUNE

1. J. Nilsen Laurvik, "Art in California: The San Francisco Art Association's Annual Exhibition," *The American Magazine of Art* 9 (May 1918): 277.
2. Gene Hailey, ed., *Abstract from California Art Research*, W.P.A. Project 2874, O.P. 65-3-3632, Vol. 12 (San Francisco: Works Progress Administration, 1937), pp. 54–76. General biographical information for this essay was obtained primarily from this source.
3. Fortune was honored when Chase purchased her painting *Interior of San Carlos Mission at Carmel* which had won a silver medal at the Panama-Pacific International Exposition in 1915. Hailey, p. 61.
4. Terry St. John, "California Impressionism after 1915," in *Impressionism: The California View* (Oakland, California: The Oakland Museum, 1981), p. 17.
5. *San Francisco Chronicle*, 23 June 1969, p. 20.
6. Much to her amusement, the certificate of award was made out to "Monsieur Charlton Fortune." Hailey, p. 65.
7. Hailey, p. 62.
8. *San Francisco Chronicle*, 22 November 1914, p. 49.
9. Hailey, p. 64.
10. John Caldwell, "California Impressionism: A Critical Essay," in *Impressionism: The California View* (Oakland, California: The Oakland Museum, 1981), p. 14.
11. *San Francisco Chronicle*, 30 January 1921.
12. Hailey, p. 65.
13. Porter Garnett, "California's Place in Art," in *Art in California* (San Francisco: R. L. Bernier, Publisher, 1916), p. 46.
14. Hailey, p. 66.
15. St. John, p. 21.
16. Ibid.
17. *Liturgical Arts* 18 (November 1949): 73.
18. *Liturgical Arts* 5 (Second Quarter 1936): 71.

JOHN GAMBLE

1. *Santa Barbara News Press*, 3 April 1956.
2. *Santa Barbara News Press*, 19 August 1951.
3. *Los Angeles Times*, 12 February 1911.
4. *Santa Barbara News Press*, 29 November 1955.
5. *Official Catalogue, Department of Fine Arts, Louisiana Purchase Universal Exposition, St. Louis,* 1904. The author wishes to thank Fred E. Keeler of Oakland, California, for making available this publication.
6. *San Francisco Chronicle*, 20 March 1904.
7. *San Francisco Chronicle*, 27 November 1904.
8. John M. Gamble to unknown philanthropic organization, 21 May 1906, Archives of California Art, The Oakland Museum. In this handwritten letter, Gamble was applying for financial assistance following the San Francisco earthquake and fire.
9. The Alaska-Yukon-Pacific Exposition had several concurrent art exhibitions during its term. The *Official Catalogue* of the principal exhibition describes a show of historical and contemporary artists which was displayed without competition. The exhibit where Gamble won the gold medal was probably the art show at the California Building, one of several state-sponsored exhibits at the exposition. Thus Gamble's claim that he won a gold medal at the Alaska-Yukon-Pacific Exposition is somewhat misleading. The author wishes to thank Joseph L. Moure for making available source materials on this subject.
10. *Los Angeles Times*, 12 June 1927.
11. *Los Angeles Times*, 11 December 1938.
12. *Santa Barbara News Press*, 8 April 1957.
13. *Los Angeles Times*, 12 February 1911.
14. *Los Angeles Times*, 6 February 1916.

CLARK HOBART

1. General information on Hobart was obtained from Gene Hailey, ed., *Abstract from California Research*, W.P.A. Project 2874, O.P. 65-3-3632, Vol. 12 (San Francisco: Works Progress Administration, 1937), pp. 77–103. Additional information was obtained from the Archives of California Art, The Oakland Museum.
2. A national art journal, the magazine ceased publication in 1911.
3. Helgesen later published a monograph, *The Color Monotypes of Clark Hobart* (1915) in which the favorable criticisms of the artist's work were annotated.
4. Hailey, p. 80.
5. Helgesen, *The Color Monotypes*, no pagination.
6. *San Francisco Examiner*, 28 April 1915. Quoted in Helgesen.
7. *Art in California* (San Francisco: R. L. Bernier, 1916), p. 120.
8. Hailey, p. 80. The Society of California Etchers, founded in 1916, accepted the monotype as a "hybrid form of graphic art." Ibid., p. 82.
9. This may have been only a temporary move as within a few months his studio was listed as being on Sutter Street.
10. Hailey, p. 85.
11. Ibid., p. 87.
12. *San Francisco Bulletin*, 15 February 1919.
13. Hailey, p. 86.

14. *Oakland Tribune*, June 1916. Copy in the Archives of California Art, The Oakland Museum. Specific date not noted.
15. The exhibition was held in the Don Lee automobile showrooms which were converted for the exhibition into ten galleries.
16. Information from letterhead of the Hobart Studio. Copy in the Archives of California Art, The Oakland Museum.
17. Ibid.
18. *San Francisco Chronicle*, 24 February 1948. Transcript in the Archives of California Art, The Oakland Museum.

XAVIER MARTINEZ

1. Gene Hailey, ed., *Abstract from California Art Research*, W.P.A. Project 2874, O.P. 65-3-3632, Vol. 10 (San Francisco: Works Progress Administration, 1937), p. 54. General biographical information for this essay was obtained primarily from this source.
2. It was noted that he later substituted the Indian name, Tizoc, for Timoteo, affirming his pride in his Indian heritage. *California Design 1910* (Pasadena: California Design Publications, 1974), p. 41. He also Anglicized the spelling of Javier to Xavier.
3. It was reported that Coney was his "foster mother" who took charge of Martinez after his mother's death, no date cited. Hailey, p. 37.
4. *Fifteen and Fifty: California Painting at the 1915 Panama-Pacific International Exposition* (Davis, California: Art Department, The University of California, 1965), p. 22. Arnold Genthe wrote that Martinez was a "pupil of Whistler" although no other documentation of this fact has been found. Hailey, p. 54.
5. Hailey, p. 43.
6. Ibid., p. 44.
7. Ibid.
8. Ibid., p. 47. This work was exhibited in 1907 at the Del Monte Gallery in Monterey, the first gallery devoted solely to the work of California artists, which was founded by William Keith, Charles Rollo Peters, and Martinez. As noted in *Tonalism: An American Experience* (New York: Grand Central Art Galleries Art Education Association, 1982), p. 87.
9. Their daughter, Micaela, was born in 1913.
10. Hailey, p. 48. Others included were George Sterling, Gelett Burgess, Anna Strusky, and Francis McComas. A photograph of Jack London posing for Martinez was reproduced in the *Oakland Tribune*, 30 October 1966.
11. *California Design*, p. 41. The date has been variously reported as 1907 (*Fifteen and Fifty*, p. 22) and 1909 (Hailey, p. 53).
12. *San Francisco Call*, 7 February 1909.
13. *Tonalism*, p. 22. Porter Garnett stated that Martinez painted "under the canon of Whistler." See Porter Garnett, California's Place in Art, in *Art in California* (San Francisco: R. L. Bernier, Publisher, 1916), p. 44.
14. *Tonalism*, p. 34
15. *San Francisco Chronicle*, 3 March 1922.
16. *Tonalism*, p. 28.
17. Garnett, p. 44.
18. George W. Neubert, *Xavier Martinez* (Oakland, California: The Oakland Museum Art Department, 1974), p. 44.
19. Ibid., p. 57 and p. 59 n. 29.

ARTHUR MATHEWS

1. *San Francisco Call-Post*, 28 March 1925, sec. 2, p. 1, p. 23.
2. Quoted by Sophia T. Comstock, "Painters of Northern California: Part I," (Paper presented at the Kingsley Art Club, Sacramento, California, 15 March 1909).
3. *San Francisco Call*, 6 August 1893, p. 6.
4. *San Francisco Journal*, 16 July 1922.
5. *San Francisco Chronicle*, 18 June 1934, p. 10.
6. Gene Hailey, ed., *Abstract from California Art Research*, W.P.A. Project 2874, O.P. 65-3-3632, Vol. 7 (San Francisco: Works Progress Administration, 1937), p. 8.

MARY DeNEALE MORGAN

1. General biographical information for this essay came from material in the Archives of California Art, The Oakland Museum and from the Baird Archives at the University of California, Davis. Both archives contained notes from an interview of the artist's sister, "Jeanie" Klenke, by Lewis Ferbraché, held at Morgan's studio in 1967. (See also Note 16)
2. Various references list Xavier Martinez as one of Morgan's classmates. However Martinez attended the school from 1893 to 1897. One newspaper clipping mentioned that Morgan had studied an additional year at the Mark Hopkins Institute in 1895, the year before she opened her studio in Oakland. *Carmel Pine Cone-Cymbal*, 14 January 1944.
3. Yard, an Eastern-trained artist, had opened his studio in 1904 and established his reputation as a watercolorist. His daughter, Elizabeth, married artist C. Chapel Judson (?–1946). See Helen Spangenberg, *Yesterday's Artists on the Monterey Peninsula* (Monterey, California: Monterey Peninsula Museum of Art, 1976), p. 49 and p. 56.
4. There is conflicting information on the exact dates of Morgan's involvement with the Carmel Summer School, or even when the school was established. Spangenberg indicates the founding year to be 1910, yet a brochure from the school, dated 1918, indicates "Fifth Season," which would establish the founding year as 1914. The dates of Morgan's directorship vary from 1913 to 1924; 1917 to 1925; and 1918 to 1925. Morgan's sister told Lewis Ferbraché that Morgan had founded the school in 1913.
5. Terry St. John, "California Impressionism after 1915," in *Impressionism: The California View* (Oakland, California: The Oakland Museum, 1981), p. 17.
6. Morgan also exhibited in Chicago and Washington, D.C., the exact dates not known.
7. Tempera paints of this type resist moisture and may be burnished with a soft cloth to achieve a lacquer-like effect. See Ralph Mayer, *The Artist's Handbook of Materials and Techniques*, 3rd ed. (New York: The Viking Press, 1970), pp. 239–240.
8. *San Francisco Chronicle*, 6 December 1925.
9. Eleanor Taylor Houghton, "A Woman's Painter," *Overland Monthly* 83 (February 1925): 63.
10. Copy of exhibition catalogue, Archives of California Art, The Oakland Museum.
11. *Touring Topics*, April 1929.
12. Ibid.
13. It was noted that by the 1940s Morgan had fourteen guest books filled with the names of her visitors, famous and not-so-famous alike. *Carmel Pine Cone-Cymbal*, 14 January 1944.
14. Undated and unmarked clipping, [c. 1930s], Archives of California Art, The Oakland Museum.
15. *Carmel Pine Cone-Cymbal*, 14 January 1944.
16. The name of Morgan's sister appears as "Jennie," *Carmel Pine Cone-Cymbal*, 14 January 1944; "Jeannie," *Monterey Peninsula Herald*, 29 October 1960; "Jeanie," typed notes of Lewis Ferbraché; and "Jeanie," Spangenberg, *Yesterday's Artists*, p. 51.
17. *Carmel Pine Cone-Cymbal*, 14 January 1944.

BRUCE NELSON

1. Peter Hastings Falk, ed., *Who Was Who in American Art* (Madison, Connecticut:

Sound View Press, 1985), p. 445. Some sources list Nelson's birthplace as San Jose, e.g. *San Francisco Chronicle*, 21 November 1912. Nelson's parents are listed on his file card at the California State Library. All information on the artist was compiled from newspaper articles, copies of which are in the Archives of California Art, The Oakland Museum.

2. Falk, *Who Was Who*, pp. 101 and 265. Carlson and Harrison are both listed as Nelson's teachers on his California State Library file card.
3. *San Francisco Chronicle*, 21 November 1912.
4. Ibid.
5. *Los Angeles Tribune*, 17 May 1914. The artist may have made a brief visit to Europe, before 1917. *Oakland Tribune*, 17 June 1917, stated that the artist went to London and Paris "a few years ago... feveryishly seeking to absorb overnight" the work of "the avowed moderns." No other reference to a trip to Europe could be found.
6. *Los Angeles Times*, May 1914. Undated clipping, Archives of California Art, The Oakland Museum. Reviews the May, 1914 exhibition at Merick Reynolds in Los Angeles.
7. *Los Angeles Tribune*, 17 May 1914.
8. *Los Angeles Times*, May 1914.
9. *Oakland Tribune*, February 1916. Undated clipping, Archives of California Art, The Oakland Museum.
10. *San Francisco Chronicle*, 26 November 1916.
11. John Caldwell, "California Impressionism: A Critical Essay," in *Impressionism: The California View* (Oakland, California: The Oakland Museum, 1981), p. 14.
12. Nancy D. W. Moure, *Artists' Clubs and Exhibitions in Los Angeles before 1930* (Glendale, California: Dustin Publications, 1975), p. B-80. Nelson was also one of eight San Francisco painters shown in the special exhibition organized by N. R. Helgesen at the Don Lee automobile showrooms in December 1923.
13. Falk, *Who Was Who*, p. 445.

JOHN O'SHEA

1. Walter A. Nelson-Rees, *John O'Shea, 1876–1956: The Artist's Life As I Know It* (Oakland, California: WIM, 1985), p. 13. Nelson-Rees' thoroughly researched, definitive biography is the basis for this essay.
2. *Los Angeles Times*, 14 December 1913, part 3, p. 7. Quoted in Nelson-Rees, p. 18. O'Shea exhibited again at the Friday Morning Club in the spring of 1915.
3. *Los Angeles Times*, 9 April 1916, part 3, p. 2. Noted O'Shea had been painting in Laguna Beach "for the past six months."
4. Ibid.
5. Sarah L. Fasoldt, "Monhegan: One Hundred Years of Island Painting," *Down East* 31 (August 1984): 78–88, 120–122.
6. Ibid., pp. 78, 85. No actual contact between O'Shea and Henri has been established. However, it is clear that O'Shea was influenced by both his style and technique.
7. *The Carmelite*, 16 May 1928. Quoted in Nelson-Rees, p. 55.
8. Nelson-Rees, p. 72.
9. *Monterey Peninsula Herald*, 9 March 1933. Quoted in Nelson-Rees, p. 72.
10. Junius Cravens, "O'Shea, After Six Years Among South Sea Natives, Desert Indians, Exhibits at Palace," *San Francisco News*, 28 April 1934. Quoted in Nelson-Rees, p. 85.
11. Nelson-Rees, p. 91. Today in the permanent collection of the Hugh Lane Municipal Gallery of Modern Art in Dublin are three works by O'Shea: *Fish*, watercolor; *Colourman*, charcoal; and *Tree Bark*, charcoal. All are noted as gifts from Bender.
12. Nelson-Rees, p. 117. The other members were Ferdinand Burgdorff (1883–1975); Paul Dougherty, N.A. (1877–1947); Arthur Hill Gilbert, A.N.A. (1894–1970); Armin Hansen, N.A. (1886–1957); and Myron Oliver (1891–1967).
13. *Monterey Peninsula Herald*, 24 September 1940. Quoted in Nelson-Rees, p. 118.
14. *Carmel Pine Cone-Cymbal*, 3 May 1956. Quoted in Nelson-Rees, p. 138.

JULES PAGES

1. California State Library artist file card. See also Nancy D. W. Moure, "Jules Pages" (Archives of California Art, The Oakland Museum, 1974). Much of the biographical material for this essay came from this source.
2. *Los Angeles Times*, 7 April 1907, part 6, p. 2. See also Louise Taber, "Jules Pages," *Everywoman* (March 1915), p. 15. Transcribed copy in the Archives of California Art, The Oakland Museum. Moure indicated that Pages studied at the Mark Hopkins Institute of Art, but this fact could not be verified in any other source.
3. R. H. Fletcher, "Memorandum of Artists," n.d. Transcribed copy in the Baird Archives, University of California, Davis.
4. Unidentified newspaper clipping, Archives of California Art, The Oakland Museum (Probably *San Francisco Chronicle*, 1 December 1906).
5. Ibid.
6. *Los Angeles Times*, 7 April 1907, part 6, p. 2.; 14 April 1907, part 6, p. 2.
7. *San Francisco Call*, 3 October 1909.
8. It was reported that Pages assumed the directorship of the Académie, but that fact was never verified.
9. *Los Angeles Times*, 7 March 1909, part 3, p. 2.
10. *Los Angeles Times*, 9 December 1923, part 3, p. 25.
11. *Los Angeles Times*, 18 February 1912, part 3, p. 23.
12. *Los Angeles Times*, 22 March 1914, part 3, p. 4; 29 March 1914, part 3, p. 4.
13. *Los Angeles Times*, 22 March 1914, part 3, p. 4.
14. *San Francisco Chronicle*, 19 April 1914.
15. Moure, "Jules Pages," pp. 6–7.
16. *San Francisco Chronicle*, 26 October 1919.
17. *San Francisco Chronicle*, 12 May 1920.
18. *San Francisco Chronicle*, 12 April 1924.
19. Moure, "Jules Pages," p. 8.
20. *Exhibition of Early and Recent Paintings by Jules Pages*, exhibition catalogue (San Francisco: The Pent House Gallery,).
21. *San Francisco Life* (July 1946), p. 22.
22. *San Francisco Chronicle*, 1 January 1928.
23. Ibid.

CHARLES ROLLO PETERS

1. There has always been confusion about the middle names of these California Charles Peterses due to mistakes at their christenings by ministers. "Charles Rolla" was supposed to have been "Charles Rogers" (after his father); "Charles Rollo" was supposed to have been "Charles Rolla" (after his father).
2. Kathleen's portrait was finished in Paris and there dedicated "To Kitty, Sonoma, 1891." Today it is owned by the city of Monterey and often exhibited at the Monterey Peninsula Museum of Art.
3. Rollo would later become a founder and managing director of the New York Theater Guild. A noted actor, he also was a designer of costumes and stage sets and an interior decorator.

GOTTARDO PIAZZONI

1. The Baird Archives, University of California, Davis.

2. Intragna is located in the southern part of Switzerland on a branch of the river Maggia close to the Italian border. General biographical information was obtained from Gene Hailey, ed., *Abstract from California Art Research*, W.P.A. Project 2874, O.P. 65-3-3632, Vol. 7 (San Francisco: Works Progress Administration, 1937), pp. 31–87. Additional information was provided by the artist's daughter, Mireille Piazzoni Wood.

3. Hailey, p. 38.

4. Ibid. His first major sale was of two small paintings to Mrs. Helen Salz.

5. The Italian review was quoted by Josephine Blanch in *The Overland Monthly* in 1909. Quoted in Hailey, p. 42.

6. Fortunately, Piazzoni had stored many paintings with his friends, and those works survived the fire. Hailey, p. 41.

7. Theodore W. Lilienthal, "A Note on Gottardo Piazzoni, 1872–1945," *California Historical Society Quarterly* 38 (March 1959): 7.

8. Hailey, p. 49.

9. A monotype is a single edition print created by placing a sheet of paper over a painting that has been done on a sheet of metal or glass. Piazzoni was also an etcher and founding member of the California Society of Etchers in 1914.

10. *San Francisco Chronicle*, 7 February 1909.

11. Ibid. Fellow artist Robert Harshe commented that Piazzoni's monotypes were "extremely subtle," not unlike a "lithotint by Whistler." Quoted in Hailey, p. 57.

12. *San Francisco Call*, 23 July 1911. Quoted in Hailey, p. 56.

13. *San Francisco Examiner*, 14 April 1916. Quoted in Hailey, p. 61.

14. Piazzoni was on the faculty prior to 1917. See Beatrice Judd Ryan, "The Rise of Modern Art in the Bay Area," *California Historical Society Quarterly* 38 (March 1959): 1.

15. Ryan, p. 1. It was also noted that Piazzoni, called "Piazz" or "Poz" by his friends, was respected by both "conservatives" and "moderns" during the 1930s. *San Francisco Chronicle*, 10 May 1959.

16. Hailey, p. 71.

17. A petition on Piazzoni's behalf, signed by twelve fellow artists, was presented to the board. Other patrons who supported him included Albert Bender and James D. Phelan. Hailey, p. 75.

18. Copy of original provided by Mireille Piazzoni Wood.

19. Lilienthal, p. 8.

20. Robert Rosenblum in *The Natural Paradise: Painting in America, 1800–1950*, exhibition catalogue (New York: Museum of Modern Art, 1976). Quotation provided by Mireille Piazzoni Wood.

JOSEPH RAPHAEL

1. Joseph Raphael to Dutch art critic Albert Plasschaert July 1933, translation by Morgan Sibbett (Archives of California Art, The Oakland Museum). The teachers were referred to as "Christian Jorgensen, a Dane and Walters, a type from Vienna."

2. Ibid.

3. Johanna Raphael Sibbett and Morgan Sibbett, "Joseph Raphael, A Brief Chronology," 29 May 1980, the Archives of California Art, The Oakland Museum.

4. *Exhibition of Paintings by Joseph Raphael*, exhibition catalogue (San Francisco Institute of Art, 1910). Copy in the Archives of California Art, The Oakland Museum.

5. *The Oakland Tribune*, 13 November 1916.

6. Sibbett and Sibbett, "Joseph Raphael."

7. President, Los Angeles Museum of History, Science and Art to H. Valdespino, 9 June 1924. Announces the awarding of a purchase prize to Raphael. Copy in the Archives of California Art, The Oakland Museum.

8. William Clapp, "Joe Raphael." Unsigned, undated, handwritten manuscript, the Archives of California Art, The Oakland Museum.

9. *The Oakland Tribune*, January 1934.

WILLIAM RITSCHEL

1. *Los Angeles Times*, 5 December 1926.

2. Christine Turner Curtis, "Painters and Sculptors in the West: William Ritschel, California's Painter of the Sea," *California Southland* 9 (August 1926): 10.

3. One record indicates that Ritschel entered the Royal Academy at the age of eighteen, his admission apparently arranged by a ship captain who had been impressed by his artistic abilities. Undocumented notes, Thomas McNeill Archives, Redondo Beach, California.

4. Gabriel also died although the date and circumstances are not known. Unpublished notes, the Baird Archives, University of California, Davis. The information regarding Ritschel's marriages is contradictory. One source listed his first wife as "Minna Stuckert," yet this was not verified by any other source. Information in notes at the Archives of California Art, The Oakland Museum.

5. *Impressionism: The California View* (Oakland, California: The Oakland Museum, 1981), p. 93.

6. The exact year is not known.

7. Ritschel exhibited five works at the PPIE: *Tide Pool, Carmel; In the Shadow of the Cliffs, Monterey: Fog and Breakers, Carmel; Summer Night, Point Lobos;* and *Blue Depths, Carmel.*

8. "California Artists," *Pictorial California and the Pacific* (May 1930): 18.

9. *Los Angeles Times*, 17 December 1922.

10. *Los Angeles Times*, 3 December 1922.

11. *Los Angeles Times*, 17 December 1922.

12. Ibid.

13. Curtis, "Painters and Sculptors."

14. *Los Angeles Times*, 23 March 1924.

15. The Baird Archives, University of California, Davis. At the same time, Ritschel's paintings made famous the California shoreline. *Glory of Morning*, which depicted the coast at Carmel, was exhibited at the Royal Academy in London in 1926. See Curtis, "Painters and Sculptors."

16. "California Artists."

17. Eugen Neuhaus, *The History and Ideals of American Art* (Stanford, California: Stanford University Press, 1931), p. 302.

18. *Art Digest* (15 May 1935): 17.

19. Unpublished notes, the Baird Archives, University of California, Davis.

20. *Los Angeles Times*, 8 November 1942.

THEODORE WORES

1. Gary A. Reynolds, "A San Francisco Painter: Theodore Wores," *American Art Review* 3 (September–October 1976): 102. Reynold's essay is an excellent scholarly examination of Wores' work.

2. Lewis Ferbraché, *Theodore Wores: Artist in Search of the Picturesque* (Alameda, California: David Printing, 1968), introduction (no pagination).

3. Reynolds, p. 102. The year of Wores' birth has been variously reported as 1858, 1859, or 1860. Most biographical information on Wores is based on Gene Hailey, ed., *Abstract from California Art Research*, W.P.A. Project 2874, O.P. 65-3-3632, Vol. 10 (San Francisco: Works Progress Administration, 1937), pp. 91–148.

4. Reynolds, p. 105.

5. Ibid., p. 107.

6. *The Californian*, December 1881 as quoted in Ferbraché, p. 10.

7. The portrait of Wilde was apparently destroyed by fire at Wores' studio after the 1906 earthquake. Reynolds noted that Wores' portrait paintings are of secondary importance in relation to his other work. Reynolds, p. 102.

8. *Cosmopolitan Magazine* (May 1898) as quoted in Ferbraché, p. 18.

9. William H. Gerdts, "Theodore Wores and American Art of His Times" in *Theodore Wores and the Beginnings of Internationalism in Northern California Painting: 1874–1915* (Davis, California: University of California Press, 1978), p. 7.

10. Hailey, p. 111.

11. Ibid.

12. William H. Gerdts, *American Impressionism* (Seattle: The Henry Art Gallery, 1980), p. 109.

13. Some of the critical acclaim Wores received may also be attributed to the public's fascination with the exotic subject matter.

14. It is interesting to note the more impressionistic appearance of these works such as *Thomas Moran's House*. The colors are more subdued and the brushwork looser than in his Japanese paintings.

15. Ferbraché, p. 42.

16. Joseph A. Baird, Jr. and Dennis Forbes, *Catalogue of the Paintings of Theodore Wores*, (San Francisco: Saint Francis Memorial Hospital, 1974), p. 4.

17. Reynolds, p. 114.

18. Gerdts, *American Impressionism*, p. 109.

19. Ferbraché, p. 48.

20. Fifty of these paintings were donated by Mrs. Wores to the Los Angeles County Museum of Natural History.

21. Ferbraché, p. 57.

22. Ibid., p. 58.

23. Hailey, p. 132.

24. Ibid., p. 133.

25. Ferbraché, p. 60.

26. Reynolds, p. 102.

27. Gerdts, "Theodore Wores and American Art," p. 7.

THE SOCIETY OF SIX

1. William H. Clapp, "We Believe," Society of Six Manifesto presented at the Third Annual Society of Six Exhibition, Oakland, California, 1926. See Terry St. John, *Society of Six*, exhibition catalogue (Oakland, California: The Oakland Museum, 1972).

2. Selden Gile to Louis Siegriest, 15 November 1927, Archives of California Art, The Oakland Museum.

3. Laura Bride Powers, *Oakland Tribune*, 15 April 1923. This term was commonly used to describe Gile's cottage, according to Louis Siegriest.

4. Louis Siegriest and Lundy Siegriest, "Louis Bassi Siegriest Reminiscences," interview by Corinne L. Glib, 1954, University of California Regional Oral History Office, Bancroft Library, Berkeley, p. 76.

5. Louis Siegriest and Maurice Logan interview, Oakland, California, 13 January 1972.

6. Louis Siegriest and Lundy Siegriest, p. 77.

7. Rudolph Schmidt and Louis Siegriest interview, Oakland, California, 15 June 1972.

8. Louis Siegriest and Lundy Siegriest, pp. 80–81.

9. William H. Clapp to Fernand Perret, 30 September 1940, Archives of California Art, The Oakland Museum. Also cited in *Oakleaves*, publication of the Oakland Public Library (6 May 1954).

10. J. Russell Harper, *Painting in Canada: A History* (Toronto, Ontario: University of Toronto Press, 1966), pp. 257 and 365.

11. Glenn Wessels to Laetitia Meyers, 7 April 1972, Archives of California Art, The Oakland Museum.

12. Schmidt and Siegriest interview.

13. Olympe Allegretti (August Gay's sister), interview, 9 June 1972.

14. Ibid.

15. "Will Bohemia Rise in Oakland?" *Oakland Tribune*, 22 April 1917.

16. Schmidt and Siegriest interview.

17. Ibid.

18. Siegriest and Siegriest, p. 19.

19. Ibid., p. 20.

20. Siegriest and Siegriest, p. 19.

21. Selden Gile to Louis Siegriest, 29 November 1927, Archives of California Art, The Oakland Museum.

22. Siegriest and Siegriest, p. 20.

23. Louis Siegriest interview, Oakland, California, 23 July 1972.

24. Louis Siegriest, personal communication, Oakland, California, 13 June 1981.

25. Siegriest and Siegriest, pp. 80–81.

26. Mildred von Eichman, interview, Monterey, California, 23 June 1972.

27. Schmidt and Siegriest interview.

28. H. L. Dungan, *Oakland Tribune*, 3 May 1925. Gile, Gay, Siegriest and von Eichman were described as moving away from Impressionism, with the latter three labeled as "ultra moderns."

29. Schmidt and Siegriest interview.

30. Louis Siegriest interview, 23 July 1972.

Louis Siegriest

Photo courtesy Art Department, The Oakland Museum

SELECTED BIBLIOGRAPHY

BOOKS

Art in California. San Francisco: R. L. Bernier Publisher, 1916.

Benezit. E. *Dictionnaire critique et documentaire des peintres, sculpteurs, dessinateurs et graveurs*. 10 vols. Paris: Librairie Gründ, 1976.

Berger, John A. *Fernand Lungren: A Biography*. Santa Barbara: California: The Schauer Press, 1936.

Berger, Klaus. *Japonismus in der Westlichern Malerei: 1860–1920*. Muchen: Prestel-Verlag, 1982.

Bermingham, Peter. *American Art in the Barbizon Mood*. Washington, D. C.: National Collection of Fine Arts, 1976.

Brinton, Christian. *Impressions of the Art at the Panama-Pacific Exposition*. New York: John Lane Co., 1916.

California Design 1910. Pasadena: California Design Publications, 1974.

Chipp, Herschel B., ed. *Theories of Modern Art*. Berkeley: University of California Press, 1968.

Cornelius, Brother F.S.C. *Keith: Old Master of California*. New York: G. P. Putnam's Sons, 1942.

Dawdy, Doris Ostrander. *Artists of the American West*. 3 vols. Athens, Ohio: Swallow Press, 1985.

Falk, Peter Hastings. *Who Was Who in American Art*. Madison, Connecticut: Sound View Press, 1985.

Ferbraché, Lewis. *Theodore Wores: Artist in Search of the Picturesque*. Alameda, California: David Printing Co., 1968.

Gerdts, William H. *American Impressionism*. New York: Abbeville Press, Publishers, 1984.

Hailey, Gene, ed. *Abstract from California Art Research: Monographs*. W.P.A. Project 2874, O.P. 65-3-3632. 20 vols. San Francisco: Works Progress Administration, 1937.

Hoopes, Donelson F. *The American Impressionists*. New York: Watson-Guptill Publications, 1972.

Hughes, Edan Milton. *Artists in California: 1786–1940*. San Francisco: Hughes Publishing, 1986.

James, George Wharton. *California: Romantic and Beautiful*. Boston: The Page Co., 1914.

Johnson, Robert E. and Whitton, Donald C. *Percy Gray: 1869–1952*. San Francisco: East Wind Printers, 1970.

Jones, Harvey L. *Mathews: Masterpieces of the California Decorative Style*. Santa Barbara and Salt Lake City: Peregrine Smith, Inc., 1980.

Laird, Helen. *Carl Oscar Borg and the Magic Region*. Layton, Utah: Gibbs M. Smith, Inc., Peregrine Smith Books, 1986.

Mallett, Daniel Trowbridge. *Mallet's Index of Artists*. New York: Peter Smith, 1948.

McCoubrey, John W. *American Art, 1700–1960: Sources and Documents*. Englewood Cliffs, New Jersey: Prentice-Hall, Inc., 1965.

Millier, Arthur. "Growth of Art in California." In *Land of Homes* by Frank J. Taylor. Los Angeles: Powell Publishing Company, 1929.

Moure, Nancy Dustin Wall. *Artists' Clubs and Exhibitions in Los Angeles before 1930*. Glendale, California: Dustin Publications, 1975.

_____. *The California Water Color Society: Prize Winners, 1931–1954; Index to Exhibitions, 1921–1954*. Glendale, California: Dustin Publications, 1975.

_____. *Dictionary of Art and Artists in Southern California before 1930*. Glendale, California: Dustin Publications, 1975.

Mr. Henry Joseph Breuer of San Francisco: Landscape Painter. San Francisco: Stanley Taylor Company, [c. 1907].

Nelson-Rees, Walter A. *John O'Shea, 1876–1956: The Artist's Life As I Know It*. Oakland, California: WIM, 1985.

Neubert, George W. *Xavier Martinez*. Oakland, California: The Oakland Museum Art Department, 1974.

Neuhaus, Eugen. *The History and Ideals of American Art*. Stanford, California: Stanford University Press, 1931.

O'Day, Edward F. *Varied Types*. San Francisco: Town Talk Press, 1915.

Opitz, Glenn B., ed. *Mantle Fielding's Dictionary of American Painters, Sculptors and Engravers*. New Completely Revised, Enlarged and Updated Edition. Poughkeepsie, New York: Apollo Book, 1983.

Orr-Cahall, Christina, ed. *The Art of California: Selected Works from the Collection of The Oakland Museum*. Oakland, California: The Oakland Museum Art Department, 1984.

Shinn, Earl. *Art Treasures of America*. Vol. 2. Philadelphia: George Barrie, 1880.

Spangenberg, Helen. *Yesterday's Artists on the Monterey Peninsula*. Monterey, California: Monterey Peninsula Museum of Art, 1976.

Theodore Wores and the Beginnings of Internationalism in Northern California Painting: 1874–1915. Davis, California: University of California Press, 1978.

Westphal, Ruth Lilly. *Plein Air Painters of California: The Southland*. Irvine, California: Westphal Publishing, 1982.

Whitton, Donald C. *The Grays of Salisbury*. San Francisco: East Wind Printers, 1976.

CATALOGUES

Andersen, Timothy J.; Moore, Eudorah M.; and Winter, Robert W.; ed(s). *California Design 1910*. 2nd ed. Santa Barbara and Salt Lake City: Peregrine Smith, Inc., 1980.

Baird, Joseph A. Jr. and Forbes, Dennis. *Catalogue of the Paintings of Theodore Wores*. San Francisco: Saint Francis Memorial Hospital, 1974.

Carl Oscar Borg, A.N.A., 1879–1947. Los Angeles: Cowie Galleries, 1948.

The Color Monotypes of Clark Hobart. San Francisco: The Helgesen Gallery, 1915.

Exhibition of Paintings by Joseph Raphael. San Francisco: San Francisco Institute of Art, 1910.

Fifteen and Fifty: California Painting at at the Panama-Pacific International Exposition, San Francisco on its Fiftieth Anniversary. Davis, California: University of California, 1965.

Gerdts, William H. *American Impressionism*. Seattle: The Henry Art Gallery, 1980.

Impressionism: The California View. Oakland, California: The Oakland Museum, 1981.

Joseph Raphael: 1869-1950. Laren, New Hampshire: Singer Museum, 1981-1982.

Memorial Exhibition, Colin Campbell Cooper, N.A.. Santa Barbara: Faulkner Memorial Art Gallery, 1938.

Mills, Paul C. *An Exhibition of Paintings by Colin Campbell Cooper*. Santa Barbara, California: James M. Hansen, 1981.

Moure, Nancy Dustin Wall. *Painting and Sculpture in Los Angeles: 1900-1945*. Los Angeles: Los Angeles County Museum of Art, 1980.

Official Catalogue (Illustrated) of the Department of Fine Arts: Panama-Pacific International Exposition. San Francisco: The Wahlgreen Company, 1915.

Paul Dougherty: A Retrospective Exhibition. Portland, Maine: Portland Museum of Art, 1978.

St. John, Terry. *Society of Six*. Oakland, California: The Oakland Museum, 1972.

Southern California Artists: 1890-1940. Laguna Beach, California: The Laguna Beach Museum of Art, 1979.

Theodore Wores, 1859-1939: A Retrospective Exhibition. Huntsville, Alabama: Huntsville Museum of Art, 1980.

Tonalism: An American Experience. New York: Grand Central Art Galleries Art Education Association, 1982.

PERIODICALS

"California Artists." *Pictorial California and the Pacific* (May 1930): 18-19. (William Ritschel)

Carmel Pine Cone-Cymbal. Selected issues of the period.

Curtis, Christine Turner. "The Community Arts Association of Santa Barbara." *The American Magazine of Art* 17 (August 1926): 415-418.

_____. "Painters and Sculptors in the West: William Ritschel, California's Painter of the Sea." *California Southland* (August 1926): 8-10.

"Dean of Western Painters." *Western Woman* 7 (1944):3-4. (Armin Hansen)

Houghton, Eleanor Taylor. "A Woman Painter." *Overland Monthly* 83 (February 1925): 63. (Mary DeNeale Morgan)

"Henry Joseph Breuer—A Note." *The International Studio* (December 1909): xlix.

Kurtzworth, H. M. "John M. Gamble." *Saturday Night*, 18 April 1936, p.2.

Laurvik, J. Nilsen. "Art in California: The San Francisco Art Association's Annual Exhibition." *The American Magazine of Art* 9 (May 1918): 275-280.

Lilienthal, Theodore W. "A Note on Gottardo Piazzoni, 1872-1945." *California Historical Society Quarterly* 38 (March 1959): 7-9.

Los Angeles Times. Selected issues of the period.

Maxwell, Hugh Gordon. "Giuseppe Cadenasso." *Impressions Quarterly* 5 (December 1904): 101.

McFadden, Hamilton. "Community Arts Association, Santa Barbara, Calif." *The American Magazine of Art* 15 (June 1924): 300-303.

Millier, Arthur. "William Ritschel and Others in the South." *The Argus* 4 (March 1929): 5.

Monterey Peninsula Herald. Selected issues of the period. Also, special issue, 29 October 1960.

Oakland Tribune. Selected issues of the period.

Reynolds, Gary A. "A San Francisco Painter, Theodore Wores." *American Art Review* 3 (September-October 1976): 101-117.

Ryan, Beatrice Judd. "The Rise of Modern Art in the Bay Area." *California Historical Society Quarterly* 38 (March 1959): 1-5.

San Francisco Call. Selected issues of the period.

San Francisco Chronicle. Selected issues of the period.

San Francisco Examiner. Selected issues of the period.

San Francisco Journal. Selected issues of the period.

Selkinghaus, Jessie A. "The Art of Carl Oscar Borg." *The American Magazine of Art* 18 (March 1927): 144-147.

"Studio Talk." *The International Studio* (June 1913): 334- 339. (Carl Oscar Borg)

Taber, Louise. "Jules Pages." *Everywoman* (March 1915): 14.

_____. "Jules Pages." *Art and Progess* 5 (September 1914): 385-387.

"The Touch of the Master Hand." *Western Woman* 13 (1950): 6-8. (Armin Hansen)

"Wild Gardens of California Interpreted by John M. Gamble." *California Southland* (March 1928): 12-13.

Wilson, L. W. "Santa Barbara's Artist Colony." *The American Magazine of Art* 12 (December 1921): 411-414.

INDEX

Academic painting, French, 5
Académie Carmen, Paris, 108
Académie Colarossi, Paris, 75, 180
Académie Julian, Paris, 9, 39, 59, 75, 106, 111, 143–144, 149, 156, 161, 180, 197 n. 8; described, 5–6
Académie Royale de Peinture et Sculpture, Paris, 5
Adams-Danysh Galleries, San Francisco, 158
Adelphi Academy, New York, 137
Akademie Kassel, 133
Akademie Stuttgart, 87, 88
Alaska-Yukon-Pacific Exposition, Seattle, 50, 77, 112, 195 n. 9
Alexander, John, 173
American Art Students Club, Munich, 173
American Impressionism, 3
American Impressionism, 3
American Watercolor Society, 75, 168
Anderson, Antony: friend of Borg, 33; on Gamble, 78; on Morgan, 122–123; on Nelson, 129; on O'Shea, 137; on Pages, 144, 145; on Ritschel, 167, 168, 169
Architectural League, 94
The Archives of California Art, The Oakland Museum, 26
Arkelian, Marjorie, 28
Armory Show, 112
Art League of Santa Barbara, 20
Art Students League, New York, 69–70, 82, 93, 127, 137
Atherton, Gertrude, 150
Avery, Kenneth, 137
Baird, Joseph, 2
Baird Archives, University of California, Davis, 2
Bancroft Library, Berkeley, 28
Barbizon, 8, 9, 12, 14, 43, 50, 149
Bay Area Figurative Style, 183
Beaux Arts Galerie, San Francisco, 70, 72, 138
Bender, Albert, 140, 161, 198 n. 17
Benton, Thomas Hart, 135
Berkeley Water[color] School, x
Bierstadt, Albert, 7; comparison to Breuer, 44
Biltmore Salon, Los Angeles, 20
Bing, Samuel, 6
Blakeslee, William, 53
Blanch, Josephine, 141
Blanchard Gallery, Los Angeles, 34
Blue Four, x
Blum, Robert, 93
Bohemian Club, San Francisco, 2, 17, 43, 44, 50, 54, 96, 100, 138, 141, 147, 150, 152, 157, 173, 174, 196

Bonnard, Pierre, 6
Borein, Edward, 20, 35
Borg, Carl Oscar, 1, 20, **32**; biography, 33–37; 94
Bouguereau, William Adolphe, 5, 6
Boulanger, Gustave, 6, 106
Boundey, Burton, 140
Bowman, Barbara, 28
Bray, Hazel, 194 n. 7
Bremer, Anne M., 10, 11, 14, **38**; biography, 39–41
Breuer, Henry Joseph, 11, **42**; biography, 43–45
Bridgman, George, 93, 137
Brown, Florinne, 54
Brown, James, 194 n. 7
Bruton (sisters), x
Burgdorff, Ferdinand, 197 n. 12
Burgess, Gelett, 196 n. 10
Burr-McIntosh Monthly magazine, 93
Busch, Adolphus, 44
Bush, Norton, 8
Cadenasso, Giuseppe, x, 8, 12, **46**; biography, 47–51
Caldwell, John, on Fortune, 72
California Art Union, 17, 54
California Arts and Crafts Movement, 115
California Decorative Style, 105, 107, 108, 109
California Midwinter International Exposition, 8–9, 174
California, painting: changes, post-World War II, 2; developments, late nineteenth century, 5; French influence, 6–7; Impressionism, 3, 12, 14; influence of Inness, 5, 7, 8; influence of Keith, 5, 9; influence of Mathews, 8, 9–10; influence of Panama-Pacific International Exposition, 11–12
California School of Arts and Crafts, 101
California School of Design, 7, 14, 17, 47, 81, 108, 111, 116, 121, 134, 149, 156, 173; illustrated, 16; under Carlsen, 5, 39, 54, 56; under Mathews, 8, 9–10, 106
California School of Fine Arts, 17, 96, 160
California Society of Artists, 2, 39
California Society of Etchers, 161
The Californian, 43
Cannell, Bartley, 168
Cannell and Chaffin Galleries, Los Angeles, 146, 167, 168
Cannon, Jennie Vennerstrom, 19
Carlsen, Soren Emil, 5. 39, **52**; biography, 53–57; 75, 81
Carlson, John F., 127
Carmel-by-the-Sea, 18–19, 70

Carmel Art Association, 118, 119, 125, 138, 140, 141, 171; history, 18; illustrated, 18
Carmel Arts and Crafts Society, 18
Carmel Club of Arts and Crafts, 122
Carmel Pine Cone, 140
Carmel Summer School, 70, 122, 193 n. 21, 196 n. 4
Carnegie Corporation of New York, 20
Carnegie Institute, 66
Carrière, Eugène, 99
Century Club, New York, 177
Cezanne, Paul, comparison to Hobart, 94, 96
Chase, William Merritt, 14, 69, 70, 82, 84, 122, 173, 193 n. 21
Chicago Art Institute, 53
Circle Theatre, Carmel, 18
Clapp, William Henry, 24, 69, 179, 180, 185; on Raphael, 163; on Society of Six, 179
Cole, William A., 33
Colton, General D. D., 5
Community Arts Association of Santa Barbara, 20, 193 n. 5
Conmy, Dr. Peter T., 25
Constant, Benjamin, 6, 75, 156
Cook, Alma May, on Nelson, 129
Cooper, Colin Campbell, 20, **58**; biography, 59–63
Corcoran Gallery, 57
Corot, Camille, influence on Breuer, 44
Cox, Kenyon, 53
Cravens, Junius, on O'Shea, 140
Criley, Theodore Morrow, 138
Crocker, Charles, 5
Crocker, Mrs. W. H., 8, 9
Crocker, William H., 56; loan exhibition, 7–8
E. B. Crocker Gallery, 140
Culbertson, Josephine, 19
Davies, Arthur B., 101
Deakin, Edward, estate, 28
de Camp, Joseph, 173
Del Monte Art Gallery, 1, 11, 82–83, 93, 123, 129, 140, 152, 196 n. 8
Del Mue, Maurice, 156, 157, 158
Denis, Maurice, 6
Denny-Watrous Gallery, Carmel, 140
Detroit Institute of the Arts, 26
de Young, M. H. 8
de Young, M. H., Museum, 24, 83, 96, 152, 161, 193 n. 15
Diaz, Narcisse, 9
Dixon, Maynard, 8, 33, 82, 96, 100, 112, 158
Donovan, John, 43
Dougherty, Paul, 11, 19, **64**; biography, 65–67;

168, 197 n. 12
Drexel Institute, Philadelphia, 61
DuMond, Frank Vincent, 69
Dungan, H. L., on Raphael, 164; on Society of Six, 187, 199 n. 28
Duveneck, Frank, 5, 173
"Duveneck Boys," 172
Eakins, Thomas, 59
Earle, L[awrence] C[armichael], 53
Earthquake and fire, San Francisco, 10, 17, 40, 50, 77, 82, 87, 100, 105, 106, 115–116, 121, 133, 144, 150, 157; illustrated, 10, 11, 17
Earthquake, Santa Barbara, 20, 77
Eaton, Charles Harry, 137
Ecole de la Grande Chaumière, Paris, 180
Ecole des Beaux-Arts, Paris, 5, 99, 149, 156, 161
Edinburgh Royal College of Art, 20, 69
Eisen, Dr. Gustavus, 35
English Art Club, London, 44
Fairbanks, Douglas, 35
Faubourg Studios, Paris, 6
Ferbraché, Lewis, 28
Fletcher, Frank Morley, 20
Fortune, Euphemia Charlton, 2, 11, 12, 14, 40, **68**; biography, 69–73
Frankenstein, Alfred, on opening of Oakland Museum, 30
Frank Van Sloun School of Art, 185
French painting, influence on California art, 5–7
Friday Morning Club, 137
Furniture Shop, 106, 109, 116, 118
Gamble, John Marshall, 11, 14, 20, 54, **74**; biography, 75–79
Garnett, Porter: on Cadenasso, 51; on Fortune, 72; on Martinez, 100, 102
Gauguin, Paul, 6–7
Gaw, William A., 179, 182
Gay, August Francois, x, 2, 179, 180, 183
Genthe, Arnold, 18; on Martinez, 196 n. 4
Gerdts, William H., on Tonalism, 102; on Wores, 175
Gérôme, Jean-Léon, 4, 99, 156
Gibson, Charles Dana, 161
Gibson, Mary, 33
Gilbert, Arthur Hill, 19, 197 n. 12
Gile, Selden Connor, x, 179, 180, 182–183
Golden Gate International Exposition, 140, 177
Grace Nicholson Galleries, Pasadena, 138, 145
Graser, Elizabeth B., 28
Gray, Percy, 11, 54, **80**; biography, 81–85
Grethe, Carlos, 87, 88, 89
Group of Seven (Canadian), 180
Gump, A. Livingston, 193 n. 10
Gump's Galleries, San Francisco, 144
Haggin, James Ben Ali, 7
Hahn Gallery, Oakland, 121
Haley, John, x

Hals, Frans, 96
Hansen, Armin, x, 8, 10, 11, 14, 19, 69, **86**; biography, 87–91; 96, 118, 158; 197 n. 12
Hansen, H. W., 87
Harper's Magazine, 70
Harper's Weekly, 26, 81
Harrington, Joseph, 47, 173
Harrison, Birge, 127, 129
Harrison, Thomas Alexander, 150
Harshe, Robert B., 127, 129; on Hobart, 94; on Piazzoni, 198 n. 11
Hart, George Overbury, 138
Hassam, Childe, 57
Hearst, Phoebe Apperson, 34–35
Hearst, William Randolph, 34, 82
Heath, Frank, 18
Helgesen, N. R., 94, 96, 197 n. 12
Helgesen Galleries, San Francisco, 50, 129, 137, 158, 161
Helgesen & Marshall, San Francisco, 127
Henri, Robert, 65, 96, 138
Henry Art Gallery, Seattle, 23
Herter, Adele (Mrs. Albert), 20
Herter, Albert, 20
Hertzberg, Constantin, 65
Hill, Thomas, 8, 9
Hinkle, Clarence, 1
Hobart, Clark, 2, 69, **92**; biography, 93–97
Homer, Winslow, comparison to Dougherty, 66
L'Hote, Andre, 39
Hopkins, Mark, 8
Houghton, Eleanor Taylor, on Morgan, 122
Howell, Warren, 28
Hubacek, William, 54
Huntington, Collis P., 9
Impressionism, American, 3
Impressionism, California, 3, 12, 14
Inness, George, 5, 7, 8, 9, 50
International Exposition, Treasure Island, 73
International Exposition of Fine Arts, Rome, 157
Jackson, William F., 8
James D. Hahn Galleries, 50
Japanese prints, 6, 7, 162
Jeffers, Robinson, 138
Johnson, Frank Tenney, 33
Jolly Daubers, 18
Jones, Harvey, 2, 28
Jorgensen, Christian, 18
Joullin, Amédée, 6, 7, 112, 121
Judson, C. Chapel, 196 n. 3
Julian, Rodolphe, 6
Kahn Collection, 28
Karlsruhe Akademie, 88
Karlstrom, Paul, 26
Keith, William, 5, 7, 8, 9, 10, 11, 28, 51, 106, 121, 173, 194 n. 11, 196 n. 8
Kennedy & Company, 94

Kent, Rockwell, 135, 138
Keppel's Gallery, Chicago, 43
Kingore Galleries, New York, 138
Kleinhans, Lucia. *See* Mathews, Lucia
Knowland family, 25
Kohler, Melvin, 23
Krumpke, Anna, 6
Kuster, Una Call, 138, 140
Laguna Beach Art Association, 19
Langer, Suzanne, 193 n. 1
Laurens, Jean-Paul, 75, 156, 161
Laurvik, J. Nilsen, on Cadenasso 51; on Fortune, 69
Lawson, Ernest, 168
Lee, Sherman, 193 n. 1
Lefebvre, Jules, 6, 106
Lewis, R. E., 26
Lewis and Clark Centennial Exposition, Portland, Oregon, 112
Lindgren, Raymond E., on Borg, 33
Liston, Ilo, 194 n. 4
The Little Corner of Art, 33
Liverpool Art Gallery, 70
Loefftz, Ludwig, 173
Logan, Maurice George, 177, 179, 180, 185
London, Jack, 101, 196 n. 10
Los Angeles Museum, 94, 130
Los Angeles Times, 129
Los Angeles Tribune, 129
Lotus Club, New York, 152
Lotz, Matilda, 6
Louisiana Purchase Universal Exposition, St. Louis, 76, 133, 157
Lummis, George, 33
Lungren, Fernand, 20
MacBeth Galleries, New York, 66, 100
Manet, Edouard, 96
Mannheim, Jean, 1
Mark Hopkins Institute of Art, 8, 10–11, 17, 56, 81, 87, 93, 111, 134, 157; illustrated, 16
Martin, Henri, 156
Martinez, Xavier, 8, 10, 11, 12, 82, **98**; biography, 99–103; 108, 112, 156
Mathews, Arthur F., 6, 7, 39, 47, 56, 69, 99, **104**, 111, 112, 115, 116, 118, 156, 161; biography, 105–109; estate, 28; on his art, 108; teaching, California School of Design, 8, 9–10, 11, 106
Mathews, Lucia Kleinhans, 8, 10, 11, 28, 40, **104**; biography, 105, 108–109
McComas, Francis John, x, 8, 10, 11, 12, 99, 108, **110**; 196 n. 10; biography, 111–113
McGlynn, Thomas A., 10, 12, **114**; biography, 115–119
McKenzie, Colonel John W., 47
Mechanics Institute, 17, 157
Meissonier, Jean-Louis, 5
Merick Reynolds, Los Angeles, 129
Metcalf, Willard, 168
Metropolitan Museum of Art, 57, 66, 112

204

Milch Galleries, New York, 168
Millier, Arthur: on Borg, 36; on Ritschel, 171
Mills, Paul C[hadbourne], 2, 23, 24, 26, on Cooper, 61
Mitchell, Morton, 47
Monet, Claude, 185
Monhegan Island, Maine, 138
Monotypes, 94, 195 n. 8, 198 n. 9
Mora, F. Luis, 69
Moran, Thomas, 20, 35, 174
Morgan, Mary DeNeale, 14, **120**; biography, 121–125
Morley, Grace L. McCann, 194 n. 4
Municipal Art Gallery, Dublin, 140
Nabis, 6, 11
Nahl, Charles Christian, 8
Narjot, Ernest, 9
National Academy of Design, 54, 57, 65, 89, 94, 168
National Gallery of Art, 66
Nelson, Ernest Bruce, 11, 14, 69, 96, **126**; biography, 127–131
Neubert, George, 194 n. 7
Neuhaus, Eugen, 11, 14, 57, **132**; biography, 132–135; on Ritschel, 170
Nevada silver boom, 5
New York Journal, 82
New York Water Color Club, 168
Oakland, California, 26, 179
Oakland Art Gallery, 24, 70, 129, 170, 180
The Oakland Museum, 2, 22–30, 130; beginnings, California collection, 25–26; Deakin estate, 28; early history, 24; illustrations, 22, 24; Keith estate, 28; Mathews estate, 28; opening, 30
Oakland Public Library, 25
The Oakland Tribune, 25, 179, 180, 187
Oliver, Myron, x
Orr-Cahall, Christina, 194 n. 7
O'Shea, John, **136**; biography, 137–141
Out West magazine, 33
Overland Monthly, 7, 81–82, 122
Pages, Jules Eugene, 6, 11, 12, **142**; biography, 143–147
Palace of the Legion of Honor Museum, San Francisco, 24, 44, 140
Pan-American Exposition, Buffalo, 93
Panama-California Exposition, San Diego, 70
Panama-Pacific International Exposition, 5, 17, 24, 35, 40, 44, 70, 83, 89, 94, 96, 107, 108, 112, 129, 134–135, 146, 147, 152, 156, 161, 168; illustrated, 13, 192; influence on California painting, 11–12
Paris, art in, late nineteenth century, 5–7
Paris International Exposition, 99
Paris Salon, 53, 66, 106, 143, 144, 149
Parshall, DeWitt, 20
Parshall, Douglass, 20
Patigan, Haig, 147
Paul, Stella, 26
Pearson, Billy, 28

Paul Elder Galleries, 158
Peixotto, Ernest, 6
Pennsylvania Academy of Fine Arts, 57, 59, 70, 94
Pent House Gallery, San Francisco, 147
Peters, Charles Rollo, 6, 8, 101, 102, **148**; biography, 149–153
Phelan, James D., 198 n. 17
Philadelphia Art Club, 75
Philopolis, 115, 116, 118
Piazzoni, Gottardo, x, 8, 10, 12, 96, 108, **154**; biography, 155–159
Portland Museum of Art, Portland, Maine, 66
Powers, Laura Bride: on Cadenasso, 51; on Nelson, 129
Price, C. S., x
Pritchett, Dr. Henry Smith, 20
Putnam, Arthur, 157
Puvis de Chavannes, Pierre, 6, 7, 107
Rabjohn & Morcom, San Francisco, 44, 50, 146
Rabow, Alexandre, 26
Raphael, Joseph, 8, 11, 12, 69, 82, 96, 156, 158, **160**; biography, 161–165
Raupp, Karl, 167
Redfield, Edward, 72
Redmond, Granville, 1, 47, 82, 156, 158
"A Revival of Art Interest in California," 7–8
Reynolds, Gary, on Wores, 175, 177
Richardson, E. P., 26
Richardson, Mary Curtis, 8, 54
Ritschel, William, x, 11, 14, 19, **166**; biography, 167–171
Rix, Julian, 143
Robert-Fleury, Tony, 6, 143
Robinson, Charles Dorman, on art revival in California, 7–8
Rogers, Millard, 193 n. 1
Rollins, Lloyd Leroy, 140
Rose, Guy, 54
Rosenthal, Toby, 5, 173
Royal Academy, Copenhagen, 53
Royal Academy, Edinburgh, 70
Royal Academy, London, 70
Royal Academy, Munich, 5, 173
Royal Salon, Brussels, 89
Royal Scottish Academy, 70
Ruskin Art Club, 33
Russell, Charles M., 33, 35
St. John's Wood School of Art, London, 69
St. Tropez, 70
Salmagundi Club, New York, 54, 152, 168, 170
Salz, Ansley K. (Mr. and Mrs.), 158
San Francisco, museums in, 24–25
San Francisco Art Association, 2, 5, 9, 39, 43, 50, 54, 75, 93, 96, 106, 116, 129, 137, 149, 161, 162, 193 n. 4; after 1906 earthquake, 115–116; history, 17; loan exhibition, 1891, 7–8
San Francisco Art Institute, 56, 168

San Francisco Art Students League, 9, 39, 54, 173
San Francisco Artists' Union, 17
San Francisco Call, 51, 82, 143; on Wores, 177
San Francisco Chronicle, 8, 14, 30, 43, 51, 57, 72; on Nelson, 127, 129–130; on Pages, 147
San Francisco Examiner, 143
San Francisco Institute of Art, 17, 72, 134
San Francisco Museum of Art, 25
San Francisco News, 140
San Francisco Public Library, 158
San Francisco School of Design, 17
San Francisco Society of Artists, 17
Santa Barbara Art Club, 20
Santa Barbara, Art League of, 20
Santa Barbara Community Arts Association, history, 20
Santa Barbara Museum of Art, 2, 23
Santa Barbara School of the Arts, 20, 35, 61
Santa Cruz Art League, 18, 117
Sargeant, Geneve Rixford, 54
Sargent, John Singer, 96
Saroyan, William, 158
Schussler's Gallery, San Francisco, 44, 50
Scott, Irving M., 5, 7, 8, 9
Sérusier, Paul, 6
Sezessionist movement, German, 88
Short, Jessie, 18
Siegriest, Louis Bassi, x, 179, 180, 182, 185
Silva, William P., 18
Sketch Club, 39–40, 109
Sloan, John, 66
Society of Independent Artists, 138
The Society of Six, x, 2, 178–191; decline, 188; meetings, 179–180; origin of name, 180; painting trips, 182; philosophy, 179
Sorrola y Bastida, Joaquin, 185
Society for Sanity in Art, x, 84, 117, 147
Society of Scottish Artists, 70
Sparks, Will, 6, 82
Spreckels, Claus, 7
Springville, Utah, High School, 170
Stackpole, Ralph, 158
Stanford University, 127, 129, 177
Steckel Galleries, Los Angeles, 144, 145
Stendahl Galleries, Los Angeles, 78
Sterling, George, 196 n. 10
Sterner, Albert, 69
Strobridge, Idah Meacham, 33
Strong, Elizabeth, 6
Strusky, Anna, 196 n. 10
Sullivan, Noel, 140
Sunset Magazine, 28
Tavernier, Jules, 8, 26, 47, 143, 149
Temple Art Gallery, Tucson, 138
Tevis, Hugh, 47
Tilden, Douglas, 161
Tillman, Frederick, 44
Tivoli Opera House, San Francisco, 47

205

Trask, J. E. D., on Hobart, 94
Twachtman, John, 53
Union Club, New York, 150
University of California, Berkeley, 8, 132, 134, 135
Vachell, Arthur, 18
Valdespino, H., 162
Van Bosckerck Studio, New York, 122
Van Gogh, Vincent, 6
Vickery, Atkins & Torrey Gallery, San Francisco, 100, 112
Vickery's Art Gallery, San Francisco, 101
Volk, Leonard W., 53
von Eichman, Bernard James, x, 2, 179, 180, 182, 185, 187
von Kaulbach, Friedrich, 167
von Wagner, Alexander, 173
Vuillard, Edouard, 6
Wachtel, Elmer, 11, 77
Wagner, Harold, estate, 28
Watts, William C., 18
Weir, J. Alden, 53, 72, 168
Welch, Thaddeus, 5
Wendt, William, 33
Western Art, 146
Weston, Edward, 138, 140
Whistler, James A. McNeill, 99–100, 173, 174; influence on Mathews, 106, 107, 108
Whitaker, Herman, 100
Whitaker, John Barnard, 137
Whitney Museum of American Art, 3
Wilde, Oscar, 173, 199 n. 7
Williams, Michael, 14
Williams, Virgil, 54, 75, 121
Willoughby, Howard, 28
Winchell, Anna Cora, on Fortune, 72; on Pages, 146
Wood, Grant, 135
Woodstock Summer School, 127, 129
Woolfenden, William, 26
Wores, Theodore, 5, 14, 84, 116, **172**, biography, 173–177
World's Columbian Exposition, 8, 9, 174
Wright, Willard Huntington, on Hobart, 96
Yard, Sydney, 18, 121, 196 n. 3
Yelland, Raymond, 7, 8, 9, 10, 47, 156
Zeile, John, 116
Zuloaga, Ignacio, x, 96